Sewn Product Quality: A Management Perspective

by

Doris H. Kincade, Ph.D.

*Department of Apparel, Housing,
and Resource Management*
Virginia Tech

PEARSON

Prentice
Hall

Upper Saddle River, New Jersey 07458

Library of Congress Cataloging-in-Publication Data

Kincade, Doris H.
 Sewn product quality : a management perspective/by Doris H. Kincade.
 p. cm.
 ISBN 0-13-188647-9
 1. Clothing trade—United States—Quality control. I. Title.
 TT496.U6K56 2007
 687'.068—dc22

 2006100838

Editor in Chief: Vernon R. Anthony
Editorial Assistant: ReeAnne Davies
Production Editor: Sarvesh Mehrotra
Production Liaison: Janice Stangel
Production Manager: Mary Carnis
Senior Design Coordinator: Miguel Ortiz
Cover Designer: Linda Punskovsky
Cover Photo: Courtesy of Getty Images/Photographer: Malcolm Piers
Marketing Director: David Gesell
Marketing Assistant: Les Roberts

This book was set in New Century Schoolbook by Techbooks. It was printed and bound by R R Donnelly VA. The cover was printed by R R Donnelly VA.

Pearson Education Ltd.
Pearson Education Singapore Pte. Ltd.
Pearson Education Canada, Ltd.
Pearson Education—Japan

Pearson Education Australia Pty. Limited
Pearson Education North Asia Ltd.
Pearson Educación de Mexico, S. A. de C.V.
Pearson Education Malaysia Pte. Ltd.

10 9 8 7 6 5 4 3
ISBN-13: 978-0-13-188647-6
ISBN-10: 0-13-188647-9

can be included in this type of computer presentation. With this level of communication, maintaining standards and increasing quality is more viable than with hand drawings and small swatches of actual fabric.

In Figure 3–7 (see also Color Plate 5), the sketches were generated on the computer and cut from printer paper to mix and match on the storyboard.

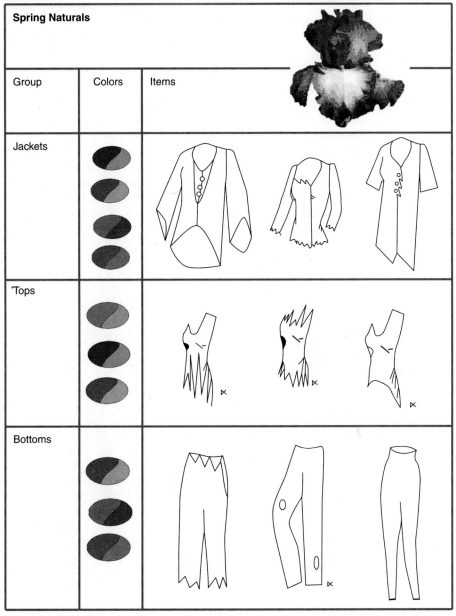

Figure 3–7
Storyboard for multiple group line.

achieve some measure of structural stability to make the trip down the pipeline to market, retail, and home.

Outcomes of Line Development

The line development stage concludes with a **slush meeting.** At the slush meeting, the design team presents storyboards to the management group that participated in the format meeting. **Storyboards** (see Figure 3–6; see also Color Plate 4) contain theme, fabric swatches, fashion or technical sketches, and colors from the colorways. At the meeting, final decisions on color, fabrics, and styles are made. A large assortment of merchandise is picked and will be reevaluated with further eliminations at a later meeting.

Storyboards, as with concept boards, may be rendered by hand or on the computer. A few designers may continue to use draped forms for the slush meeting in addition to or in replacement of the storyboard. When sketches are generated by the computer, the design team may then create the board by using additional industry software or PowerPoint and other generally available presentation software. If the boards are rendered on the computer, the presentations then may be communicated worldwide by using e-mail attachments or placing them on CDs and shipping them to employees or personnel located in other countries. Videos showing movement of fabric

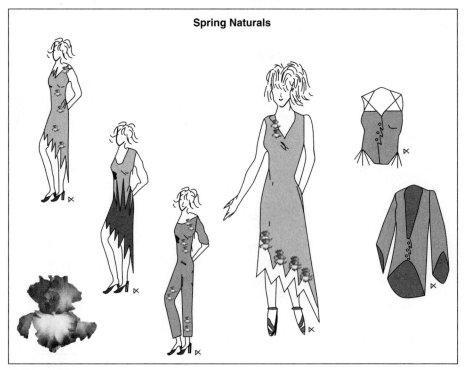

Figure 3–6
Storyboard for the slush meeting.

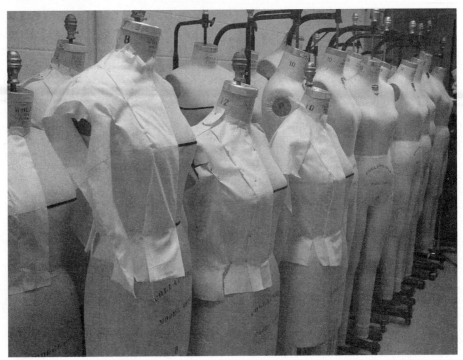

Figure 3–5
Forms for apparel standards.

for this stage. The company may have a brand image that depends on certain **brand colors** or color combinations, which are a visual recognition cue for the brand. For example, the consumer sees the combination of lemon yellow, lime green, and hot pink in a merchandise mix or display and knows immediately that the apparel items are from the X Beach brand.

Because both internal and external customers of every process must be satisfied in order to have a quality product, standards for fashionality outcomes should be based on target consumer expectations, images expected by retail buyers, and the image that the production company wishes to project. In general, fashionality may include the basic aesthetic purpose to enhance the face and the figure of the wearer for an apparel product or to enhance the beauty and style of the interior for a home furnishing product. If aesthetics are to be judged, art elements such as line, silhouette, color, texture, and pattern, and principles such as proportion, balance, rhythm, emphasis, harmony, and unity could be used as measures. However, images of beauty and aesthetics are cultural, temporal, and situational. The product development team will have to use standards of fashionality either predetermined by the company or expressed by the consumer. When a product's main outcome is fashionality, the work done in production development, the next stage, may be very limited because major concerns with the production development stage are oriented toward the outcomes of functionality and fit. However, even the most fashionable product must

look attractive, to cover a picnic or other table, and to provide some protection against spills. When the event is completed, the consumer will be willing to dispose of the product because it served its intended function, has no care possibilities, and was inexpensive to purchase.

Company croquis showing target consumer features and size dimensions are useful in maintaining the desired style look and proportions for the consumer. Size and shape of a product may be unique to the company or the brand. The use of a foot would be seen when the company is a shoe manufacturer or a footwear firm, and the hand would be used for a company that specializes in gloves or rings or other accessories for the hand. The croquis has features that are representative of the target customer, and the size or dimensions of the croquis should be compatible to the body dimensions of the target customer. A croquis for a preteen sportswear company would be different in size and proportions from the croquis for a company that made suits for petites. Croquis that represent the ideal fashion model for apparel items are generally available and may be used by companies that lack their own standards, but this practice is not compatible with the quality or the other consumercentric marketing strategies. Croquis are also used for designing any other sewn products such as the basic outline in proportion of a chair, valance, or other soft home furnishing.

When product forms are used for draping, the designer should use **customized product forms** (e.g., dress forms, shoe last, car seat frame). These forms are customized to represent the size and shape of the target consumer or the target end product size. The use of these customized product forms provides a standard for the fit of the product. Customization varies for various products. Forms can be made to be the size and dimensions of the ideal target customer for apparel products (see Figure 3–5), to be the industry standard for bed products, and to represent the average or standard window sizes for draperies and curtains. This perfect-sized product represents the **sample size** for the company. With many women's wear products, this size is usually numbered as a size 8, although the average woman may not be a perfect size 8. A recent Size USA study was conducted by a number of universities, retailers, and manufacturers in collaboration with [TC]2. [TC]2 was founded in 1981 as the Tailored Clothing Technology Corporation, which was later changed to the Textile Clothing Technology Corporation ([TC]2, 2006). In 1988, [TC]2 opened the teaching factory called the National Apparel Technology Center. Size USA is one of their many projects in support of the global apparel industry. The researchers found that size 12 or 14 would be a more appropriate sample size for the average woman (Cotton Incorporated, 2005). With other product lines, the sample size would be adjusted to be an average for the product, such as the average window for window treatments.

When selecting colors as well as other images and product features, the designer team must consider many standards that were established in the idea development stage in addition to the color forecasts. Some colorways may be preselected by company policy and would be considered as standards

are consumercentric, this waste of time and resources can be alleviated with quality strategies such as the use of measurable and well-communicated standards in the quality analysis process.

Implementation of computer technology has reduced redesign time for companies that can afford the technology and have the skilled employees to use the technology. **Computer tools** become important for maintaining adherence to standards. Designers who work directly on CAD systems can more quickly alter their designs than can designers who work in fabric or with hand-rendered sketches. The CAD systems also allow designers to store product sketches and fabric designs and to scan pictures from other sources. This pictorial storage can save time and increase accuracy in creating the sketch and in creating the storyboards used in communicating the design solutions. For some manufacturers, the cost of equipment and incompatibility between units are restrictions that reduce the technology adoption; however, these companies should consider the cost of quality failures. Two basic premises of quality are pertinent to this stage in product development: "The cost of quality is the expense of doing things wrong" and "It is always cheaper to do the job right the first time" (Crosby, 1979, pp. 11, 232). The cost of computer equipment can be offset by the reduction of waste and unsold products.

Standards in Line Development

The standards for this stage must include the desired outcomes from the product process. Designers and others who are making decisions must examine the fashionality, functionality, and fit of the product. The quality of any design is determined by how well it fulfills its intended purpose (Crosby, 1979). For some products, the intended purpose may be only fashionality. The major reason the item is chosen is for its looks and how it will aesthetically please the consumer or others that view the product. Other products must perform well in one, in two, or in all three product outcomes. The expectations of the consumer as well as the reputation and the intentions of the company or product line must be carefully examined at this stage and used as benchmarks when measuring and evaluating the quality level of the designs.

For products that must have certain levels of functionality or fit, company **standards for fabric quality** are needed to establish guidance for fabric selection from outside vendors. These standards help the designer know the characteristics of the fabric that must be considered in addition to any aesthetic concerns that the designer may have. Expectations by the consumer for health and safety, occupational protection, sports performance, or other outcomes should be considered when evaluating the fabric at this time. Even when consumers only expect one season's wear from a product, they will generally have expectations of some limited fabric care including cleaning from unexpected spills or stains. A few products may have a one-time use, and the functional outcomes of the consumer for the fabric could be very limited in expectations. For example, a tablecloth of disposable fabric is used once and then tossed in the trash. For this product, the consumer will expect it to

style appropriate for the product. This basic outline or sketch becomes the basis for the product sketch. The company croquis can be considered both a tool and a standard for this stage of the product development process.

Some product designers create **fashion sketches,** which may not be made to scale or in proportion. They may create visual images that are very artistic and that express the theme of the line but are not exact in detail. **Technical sketches** are more exact in detail, including the correct proportions, horizontal dimensions, and details of styling. Some companies use both fashion sketches and technical sketches or some designers create work directly with technical sketches. The use of the two sketch types also varies with the fashion level of the product and the newness of the product.

Some designers prefer to transfer their ideas directly to the fabric through draping by hand. In **draping,** designers work with samples of actual fabric to create half- or full-scale products of their ideas. The fabric is cut, draped, and pinned on forms, sized to company specifications. Draping by hand is a technique that may be used when the fabric is very new and the entire sensory experience is desired or if the style has many unique features or details, which are new for this season. In addition, some designers prefer to work through draping with the actual fabric. When created from actual fabric, images of draped sample products may be captured with a digital camera and included in a computer presentation of a storyboard. Some draping techniques can be achieved on computerized sketches with specialized CAD programs. Items that are represented in a computer presentation, both from digital pictures or from CAD programs, are more likely to be repeatable and communicated accurately to other personnel within the product development process; therefore, adherence to consumer expectations becomes more than just luck.

Product designs, regardless of how they are created, have traditionally been rendered in isolation from consumers, production managers, and financial officers. Implementing and maintaining quality standards at this stage are often difficult. Information determined in the format meeting, theme and concepts, price points, target consumer information, and other company specifications, is not always tracked closely during the line development stage. The normal operating procedures for some companies place them at risk for losing sight of the expectations of the customer and producing a product that is not of the desired quality. For example, in some companies, target consumer profiles may not be concrete descriptions. Sometimes product designers place the creation of the design before considerations of cost, manufacturability, or other restrictions. In fact, some designers consider these restrictions to be the concern of other company personnel. For this reason, product designers may spend long periods with reiterations. If the standards set in the idea development stage are not clearly stated and closely followed, many product modifications may be needed to bring the product into alignment with company specifications. The entire product development process may include multiple loops or **design process reiterations** as the design is reviewed, rejected, and redesigned. Most companies in a competitive environment can no longer afford this reiterative and untargeted process. For companies that

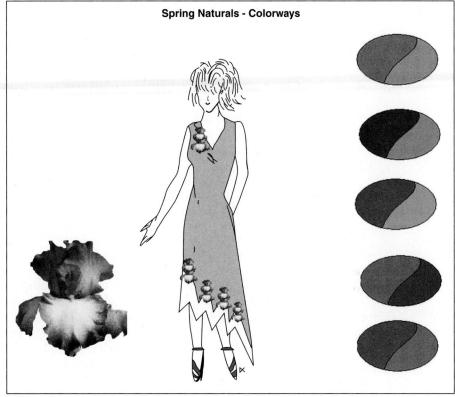

Figure 3-3
Colorways for a single product design.

pencil or computer tools, the designer may use croquis as tools when sketching. These tools give the designer a quick way to start a drawing. A **croquis** is a sketch of the body, frame, or part that will be wearing or using the product. For example, the croquis can represent a human body, a foot, a head, or other appropriate body parts for apparel items (see Figure 3-4); a car seat or other chair type for upholstery items; or a window or bed in the

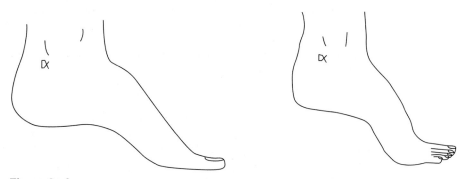

Figure 3-4
Croquis of feet for high heel shoes used by shoe designer.

begins to create the fabric designs and the overall specific appearance for the sheets and other items. Additional designs for sheets and other items are drawn with the images, including the various trims, print placement, and colors selected. For even a midsized company, the average product line could contain as many as 300 products for one season. Early in this stage, the design team for a large, high-fashion manufacturer creates over 600 designs for one season with over one-half of these being eliminated or rejected by the end of the line development stage.

Activities in Line Development

The activities for this stage include product design, fabric and color selection, and silhouette selection. The outcomes of these activities again affect the subsequent stages of the product development process. The team working on this aspect of product development traditionally has been the designer and design assistants. Some industry personnel call this stage the design stage. Many others say that design is more than just developing the specifications of the product.

In the previous stage, designers spent time scanning the environment and thinking about their past design experience as they prepared for line development. During the past stage, they collected ideas about products and about the needs, desires, and characteristics of their target customers. Sorting through this information and making conclusions about specific needs and trends are activities in **problem recognition.** Product design reflects social, economic, political, and technological changes in a culture. Quality design must be suitable for the customer and for the situation in which the customer uses the product. Ideas for designs can come from a myriad of sources, both current and historical. The actual characteristics or style features of the product are detailed during the line development stage.

Those personnel working at this stage make selections for specific colors and fabrics. Colorways are chosen for the products and are used to represent the many varieties of color combinations including the patterns of stripes and prints as well as the solids that can be offered within a product group (see Figure 3–3; see also Color Plate 3). **Colorways** are the assortment of color combinations that will be used in a product line. Multiple colorways are needed in consumercentric product development to provide selection for as many customers as possible. In addition, silhouettes and other style features are also selected and coordinated across the product line. Many storyboards may be needed to represent all the design ideas originating at this stage.

Tools in Line Development

In the line development stage, designers use many tools, some work with more **traditional tools** of paper, pencils, and other media, while some designers use CAD tools, and others use a combination. Sketches may be as elementary as hand drawings on a piece of scrap paper or as sophisticated as scaled CAD drawings with complete fabric details. Using paper and

Figure 3–2
Colorways in thread or a color board for idea development.

thread buttons. Companies may be very creative in their presentations. Final decisions on the exact colors and selections of colors for specific products are made in the line development stage.

Line Development

The **line development stage** is when the actual product designs are created and the grouping of designs becomes a product line. A **product line** is a set of five to ten groups of products. A group contains as many as thirty individual pieces or product items. For example, a company wishes to create a line of bed linens (e.g., sheets, pillow cases, duvet covers), and the product development team knows that the line will be themed for a tropical island look. By using the images determined in the format meeting, the designer

Spring Naturals

Figure 3–1
Concept board for format meeting.

theme-related material that will drive the decisions at the next stage. **Swipes** are cut outs from magazines, pictures, images from advertisements, and packaging and other visual images representing the look, shapes, colors, and other visuals desired for the products. Concept boards may also contain fabrics, threads, yarns, and other textile material that either have the color or textures desired or that represent the actual fabric to be used. Concept boards do not contain actual product images at this stage because the team is in the idea development stage and is working only with broad trends, multiple ideas, and general images.

At the meeting, a theme associated with the desired concepts is selected that will provide a direction for the rest of the product development process. The theme should be based on the market research and the information about the target customer. The theme provides direction for all the activities to be done in the next stages of the product development process. The concept board tells a story that the company wishes to have placed in the minds of the target market. Proposed themes will appear on sample concept boards.

A basic **color theme** is established at this stage. As part of the theme, a color family or a single strong color message is decided. A **color board** with sample fabrics or thread swatches might be used to suggest the combination and "feeling" that is desired in colors to support the theme. The theme may include a country look that will imply the use of rusts, browns, and natural greens. An urban or city chic theme might suggest grays and blues with some brighter reds (see Figure 3–2; see also Color Plate 2). The exact format of these color boards can vary from loops of yarn and minute skeins of thread to paper spools and

Standards in Idea Development

The quality standards for this stage of product development should be formal, standardized, and written in a policy handbook, but in most companies, these standards are written only in the minds of the participants. As stated in Chapter 2, the more concrete and precise the company standards are, the more likely they are to be communicated, used, and followed. However, with the qualitative nature of many sewn products and the secretive operating policies of many companies, this information is often not written or visually captured. Company culture, chief operating officer's opinion, tradition, and opinions of sales representatives often provide the standards for the product development process. **Controls** or additional quality standards may be introduced to govern the process such as restrictions on numbers of groups in a line, numbers of pieces in a group, price points, or retention of a base color or design. Standards may also be creative or descriptive such as brand image, target customer, retailer image, and company style. **Basic bodies** (e.g., a plain cardigan with raglan sleeves, a shell T-shirt with a scoop neck, a corded pillow with one center button) that are important to the brand or that are traditionally purchased by the consumer are important standards. For example, a certain style, color, and fit of a basic T-shirt can be the foundation of a number of new styles such as a T-shirt type dress or an embroidered and fancy knit shell. In addition, the T-shirt may be so popular that the product should not only align with the standard but also replicate this basic body.

The idea development team should also consider carryover styles from last year's or last season's **hot sellers**. A company with a strong brand image or a conservative look might keep a high percentage of styles with slight design modifications. Sales records and opinions of sales representatives would be examined to determine items that were best sellers from previous markets. Styles, bodies, or colors can be reused from previous seasons. Some companies have a set percentage of carryover styles that are incorporated into every new season. Carry-over styles may reduce design time or may extend the time. Finding new ways to do the same old design is a difficult task.

Outcomes of Idea Development

The idea development stage concludes with a format meeting. The purpose of a **format meeting** is to provide foundation to ideas and information for the line development stage. The format meeting is attended by merchandisers, designers, production managers, sales representatives, and top management. Members in this meeting review the standards for the product and controls for the line, and they finalize the exact target market at the center or focus of this product. Discussion may cover how designers can create a new look or a new line of products while maintaining desired corporate changes.

Output from the format meeting includes the specific target market and the concept boards to approach this market. **Concept boards** (see Figure 3–1; see also Color Plate 1) presented at this meeting contain images, swipes, and

the outcomes of the subsequent stages are measured against the information that is developed and decided at this idea development stage. The information generated during the idea development stage is the primary tool for determining the expectations of the consumer. At this stage, the product development team must have direct interaction with consumers. In a traditional production process the interaction may be with retailers who know the consumers' expectations.

Activities in Idea Development

Activities in the idea development stage needed to determine or operationalize the consumer's expectations for the product are as follows: color predictions, fabric development, market research, and theme development. Many of the activities during idea development depend on gathering information about consumer needs and desires and about market trends. Much information both within the company and across the market is gathered at this stage. In addition, ideas may be generated from internal sources or previous products, and direct input from consumers is needed to maintain the consumercentric process. At the beginning of this stage, the **idea development team,** which includes designers, researchers, and other specialists, are given information about corporate plans for expansion, change in product lines, shifts in image, or other marketing and operating strategies.

During the idea development stage, the focus is on the consumer and not just any consumer but on the designated target customer. If the company is expanding, this target market could be new to the team or the company could be trying to increase the product range sold in a current target market. Regardless of how well the team thinks they know the target market, they should seek new information because today's consumers are constantly changing, both in demographics and in preferences. Expectations that were solid standards for a company could now be passé.

Tools in Idea Development

Tools used at this stage enable the idea development team to know the consumer and to capture ideas. These tools include computers, scanners, Internet access, e-mail, travel, and forecasting services. Some teams use traditional methods of gathering swatches, swipes, sample products, and related products through their travels and shopping experiences. These teams work with corkboards, notebooks, and filing cabinets.

Other teams use electronic access and media for gathering and storing information about the market and their consumers. Forecasting services can provide physical products such as swatches, color samples, and style sketches, or they may provide password access to elaborate Web sites containing this graphic information. In addition, forecasting services provide detailed information about target customers and about markets and competition.

Table 3–1
Product Development Calendar with Four Stages and Time before Retail

Product Development Stage	Final Meeting for the Stage	Time Before Retail Sale
Idea development	Format	1–2 years
Line development	Slush	9–12 months
Production development	Freeze	6–9 months
Sales development	Market show	3–6 months

or newness of the product, or the brand or label desired for the product. However, regardless of the exact process, implementation and performance of quality procedures are important to the outcomes of the products.

A manufacturer with the average five seasons will have five different product development processes in various stages at any point in time. The entire product development process takes an average of three to six months and generally originates nine months before the retail-selling season. Many companies are trying to compress or shorten this long development process. By compressing the calendar, companies move their decision-making processes closer to the consumer use time. With decisions made closer to the user's season, forecasting should be more accurate. Compression of time also involves the use of computers, **just-in-time (JIT)** strategies, and **Quick Response (QR)** activities. JIT involves reducing wait time, eliminating redundant testing, and having raw materials available when needed (Schonberger, 1986). QR activities include flexible manufacturing, computer-aided design (CAD) tools for product design, and electronic data interchange (EDI) transmission for logistics (Kincade, 1995). With a consumercentric strategy, many of these activities may happen simultaneously or with less reiteration and decision time, and the entire process may be shortened to weeks or days.

For a company that uses a quality strategy for operations, the product development process must have standards appropriate for all activities within each stage. In addition, specific outputs or products are expected at the end of each stage. The standards are guideposts or benchmarks that assist personnel in evaluating the outputs of the stage to ensure that the focus remains on consumer expectations. Some standards will be set for the product or line that is being developed, and other standards will be company generic and always in place with each line that is developed. This approach is particularly true when the company has a strong brand image or a very loyal consumer following.

Idea Development

The **idea development stage** is the initial stage in the product development process. The entire product development process is dependent upon the best choices, directions, and guidance made during this stage. Many of

Product Development

Product development for consumers' sewn products is usually a multistage process that starts at idea conception and ends before production. In a traditional linear pipeline process (see Figure 1–4), these activities take place during the second major stage of the pipeline and are usually performed by personnel at product manufacturers but may be performed in design houses that contract with cut and sew operations. Fabric development and production may be concurrent with, preceding, overlapping, or following product development. Product design is usually considered part of the product development process. Designers may be included in the product development team or may form a separate team or department.

The overall process of product development is used to develop a single product or a complete line of products. The typical activities within the **product development process** can be categorized into the following four stages: (1) idea development, (2) line development, (3) production development, and (4) sales development (see Table 3–1). Some products (e.g., private label, basic replenishment goods) may not cycle through all stages. The end of each stage is clearly marked with a meeting or other activity to finalize the decisions made within that stage. Idea development in a traditional process may start as early as two years before retail sales but is usually within one year of retail. Line development occurs nine months or more ahead of retail, and production development is approximately six months ahead. Sales development occurs immediately before the market sales for a season, which are normally three to six months ahead of retail. Some aspects of the process may change with the type of manufacturer, the product style, the fashionality

Hiegel, J. (2005). Apparel and sewn production automation: Addressing the need for data exchange. *ASTM Standardization News* (pp. 34–37). Available from http://www.astm.org

Kincade, D. H., A. Redwine, and G. R. Hancock. (1992). Apparel product dissatisfaction and the postcomplaint process. *International Journal of Retail & Distribution Management, 20*(5), 15–22.

Review Questions

1. What are the four steps in the quality analysis process?
2. What is the first absolute of quality?
3. What are the old ways of determining consumer expectations?
4. Why do the old ways not work?
5. How can you accurately identify what consumers want in a product?
6. What are standards?
7. How do standards differ from consumer expectations?
8. How are standards similar and different from specifications?
9. From the "standards/specification must be" list, what are three things that standards must be?
10. How can you be assured that standards are understood by many people?
11. Why do standards need to be electronically communicable?
12. When might translations of measurements be needed?
13. Why would the knowledge and skill of Photoshop be important if you worked in San Francisco for Gap and had a job to write standards for a cut and sew contractor in Hong Kong?
14. What are three organizations that prepare standards to guide quality practices?
15. What are the five steps in the measurement process?
16. What is the outcome of the measurement process?
17. What is a sampling plan?
18. Who writes sampling plans?
19. What is a sample? Give examples.
20. What is a frequent timing of drawing samples?
21. Who can draw a sample?
22. Why would a company want to have an outside firm do the sampling and testing?
23. Why would a company want to do their own sampling and testing?
24. List at least four types of tests that could be done in measurement.
25. Why is the human hand useful in testing for sewn products?
26. What other measuring equipment is used in testing apparel products?
27. What type of numbers might be seen in data from testing?
28. What test might provide you with a chart after testing is done?
29. How are pictures useful as data in testing?
30. What is evaluation?
31. What are the three major categories of tools used in evaluation?
32. How can the human eye be useful in evaluation for quality?
33. How do you know in the evaluation stage if the product is a quality product?
34. What is the decision about quality if the data are greater than the standard? For example, what if the fabric weighs more per ounce than the standard requires? Is this a quality product? Why or why not?
35. What are two things that are inaccurately used to describe quality?
36. What type of data will get the retailer a satisfied customer?

References

Crosby, P. (1988). *Quality work group education*. Winter Park, FL: Philip Crosby Associates.

Gilmore, J. H., and B. J. Pine, II. (1997). The four faces of mass customization. *Harvard Business Review, 75*, 91–101.

describe the product. A company faced with this overwhelming number of standards may select a few of the standards that seem most critical to the consumer's satisfaction. Primary to this choice would be standards that, if not met, would immediately represent a product failure to the consumer. For example, shrinkage in jeans or fading of a bright red towel usually renders the product unacceptable to the consumer with the first washing of the product. Setting and achieving the standard for shrinkage or fading, respectively, would be critical to the quality of the product.

For a merchandiser or retailer, the quality process ends with information that can be used to help ensure consumer satisfaction. If data are not equivalent to the standard, either lower or higher, then the consumer will probably be dissatisfied with the product. **Consumer satisfaction** with the product or service can only be achieved when the data are equal to the standard. The product that results in data equal to the expectations of the consumer as represented by the standard should have characteristics that are pleasing to the consumer during both the shopping phase and the in-use phase of the product's life. Satisfied consumers tell other consumers of their satisfaction with the company and the product. Positive word of mouth is a very powerful advertising tool for a company. Satisfied customers also tend to be repeat customers. The final measure of the company's success is the sale of the product and the repeat business from the customer. Companies can only survive in a competitive market with quality products sold to satisfied customers at a satisfactory price and with continued growth in sales from repeat customers and from new customers.

Key Terms

Biases
Branded products
Census
Consumer
Consumer satisfaction
Consumercentric firms
Data
Dimensions of the swatch
Drawing samples
Easily understood
Electronic communicable
English system
Evaluation of data

Expectations of consumer
External customer
Fabric swatch
Final customer
Internal customers
Interpreting the expectations
Market research
Mass customization
Measurable
Niche markets
Nth sample
Numbering systems
Numerical data

Process of conformance
Qualitative data
Quality analysis process
Random selection
Results
Sampling plan
Specifications
Standards
Tester
Testing
Wear testing
Written standards

Evaluate Data

The major activity in the last step in the measurement process is the **evaluation of data** or the comparison of the measurement data to the standard, which is based on consumer expectations. At the beginning of the quality analysis process, the expectations of the consumer should be interpreted and expressed in concrete and precise standards that are measurable through readily understood and accepted methods. Tools used for evaluation include mathematical calculations, standardized pictures or graphs, and the human eye and hand. Mathematical calculations may include basic calculations (e.g., average or range), statistical formulas, and graphical models. Standardized pictures or other visual images may be used to compare with test data. A prototype, sample product, or design sketch may be used for a standard image. Comparisons of this nature may be mechanical and quantitative.

For evaluations of the sewn product, the test personnel or **tester** often has to use qualitative methods in the measure process. This involves judgment of the tester using the hand or eye. Because the product is often complex, made of multiple raw materials, and is used for aesthetic as well as practical reasons, human judgment, in addition to mathematical evaluations, is needed in evaluations of the product. For example, the sample product may be felt by the human hand (i.e., perform test step) and compared mentally by the test personnel to the sample product (i.e., evaluate data) to determine whether the sample has the same amount of "fluffiness" as the standard. The data really exist only in the mind of the tester, and the steps of test performance and data evaluation are virtually simultaneous as one step instead of two. In another evaluation, the tester may observe the color of the sample in the test step and compare it with the standard color on a test square of paper or fabric. These color tests are most difficult because of the difference in visual color when represented on various media such as computer screen, paper, rough fabric, smooth fabric, or other materials. Digital imagery has made the use of pictures easier, more available and certainly more readily transmittable; however, color and hand are not always accurately represented through equipment readings and in electronic media.

At the end of the measurement process, someone must make the final judgment of whether the product is a quality product. According to the definitions of quality, the product, process, or service is a quality item if the data are equal to the standards in the evaluation comparison. If the data do not equal the standard then the product is not a quality product. By inference then, the product is a quality product if the data from that product meet the expectations of the consumer because the standard was established on the basis of an interpretation of consumer expectations. For most products or processes, a number of standards would be necessary to determine overall quality of the item. Sewn products often need hundreds of standards to best

Figure 2–6 Chamber for performing flammability tests.

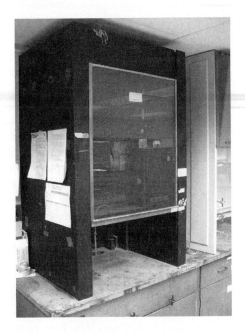

other companies, governments, or independent organizations. When an organization establishes a standard, that firm may also describe the test that is associated with that standard for collecting data in order to evaluate the product or service to the standard. For this reason, standards such as those written by ASTM or AATCC may be stated to represent both the standard and the measurement process.

Tests may be required by governments or companies. Within the United States, fabric must meet minimum flammability standards, and children's sleepwear must adhere to very strict standards. Testing for flammability is done in a specified chamber as shown in Figure 2–6 with controlled conditions, and the burn or lack of burn is timed.

Outcomes from the tests of samples are called **data** or **results.** The format of the data may be numbers, charts, graphs, descriptive words, or pictures. The format of the results is determined by the type of tests. **Numerical data** is the most common outcome of tests from laboratory equipment. These data may include counts, percentages, ratios, weights, lengths, or other physical measurements. Both the number and the units are important to the report of the data. The accuracy in unit reporting is especially important when the data may be used in cross-cultural situations where the unit of measurement may not be the same across cultures. Some laboratory equipment may result in charts or line graphs, pictures or other digital images. Tests that depend on the human hand may produce data that is verbal or written. These **qualitative data** may be difficult to evaluate but are often most descriptive for sewn products. A set of key terms or pictures may be used to help standardize or remove interpretation bias in this type of data.

The test equipment may include sophisticated and expensive textile laboratory equipment such as the spectrophotometer that measures color. The human eye and hand are also important tools for testing sewn products. The human hand or eye can often feel or see differences that cannot be captured or described with test equipment. For example, the sensation of silkiness or softness is often measured by the human hand because it is actually a combination of several physical features in combination with the sensation on the skin. Fashionality is often tested with human observation or the human eye. For example, the cuteness of a style for children's clothing would be measured by observation. People who do hand or eye observations for testing must have clear standards to direct their inspection and need training to be consistent and reliable in their judgments or evaluations of the raw materials or products. People who are easily persuaded or who cannot maintain a consistent image in their mind would not be good testers for hand or eye testing. Samples and descriptions can be used to help testers maintain objectivity and consistency in their evaluations. Training and cross matching with multiple testers are also important.

The power of the human eye can be enhanced by use of various microscopes. Some low power scopes are used for counting yarns or for evaluating texture (see Figure 2–5). More powerful electron microscopes can be used for examining finishes and fiber details. These microscopes provide excellent detail and can be attached to printing equipment, computers, or projection units for sharing visual information electronically with vendors and customers in any country.

Tests may be devised by a company for a product or service characteristic that is unique for that product or that company. Tests are also created by

Figure 2–5 A microscope used for evaluating fabric texture.

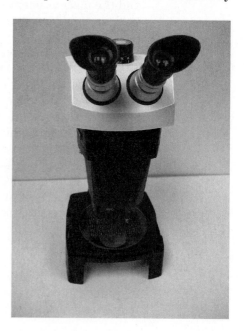

products are still meeting their consumers' expectations. Independent textile testing labs are also available for testing. Testing labs for textiles may include very expensive and complex technical equipment and cost thousands of dollars to outfit and maintain. However, testing of the final product, such as measurements for sizing, may be as simple as a table that is placed at the end of the assembly line and is marked with a grid for sizes.

Testing done for a service or process may be done in a laboratory that simulates the activity with experimental treatments to create a variety of situations, on the plant floor or wherever the activity is performed. Actual use or **wear testing** is conducted by asking consumers or people who are similar to the actual consumers to wear the sewn product or to request the service. Wear testing is an important aspect of the entire measurement stage and may be used in conjunction with other equipment or objective testing. Once the person has worn or used the product he or she must verbalize his or her opinions and emotions about the product as well as return the product for equipment testing of physical features and other functionalities.

Testing equipment for physical tests may be as simple as rulers or scales (see Figures 2−2 and 2−4). Scales are used to measure the weight of the fabric, and the measured weight is reported in ounces or kilograms per square inch (centimeter) or per yard (meter).

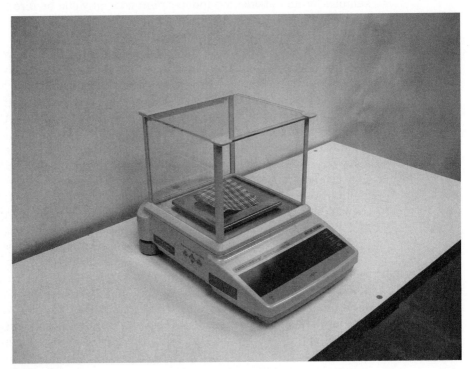

Figure 2−4
Electronic scales used for measuring fabric weight.

During a production process or service activity, samples may be drawn every minute, every hour, or any segment of time. The samples may also be drawn according to a numbering system such as every tenth item that is produced is taken as a sample. The numbering process is often described as every **nth sample** (e.g., ten in the previous example), and the "n" is determined by a mathematical system. Such a system is often delineated in statistics books or other test method books. The samples could also be drawn continuously, which is equivalent to the concept of taking a **census** and not a sample. Samples may also be taken at some **random selection,** which is not to imply a vagueness of method but a purposely disordered arrangement of sample so that biases from time or other sequential events are not introduced into the sampling method. The samples must be drawn or collected according to the sampling plan or method. When the entire measurement step is done according to the plan, **biases** from human emotions and other sources are removed or are, at least, reduced. With less bias from testing processes, the user of the test information can be assured that the results are related to the product or process and not from error. The sampling plan must also include an explanation of who will do the tests and where the tests will be performed.

Samples can be drawn by the production or service people who are in direct contact with the product or service. The company may also have an in-house quality staff who come to the plant floor, office spaces, or retail area and collect samples; or an outside and independent company can be hired to come to the plant or other locations and draw samples.

The hiring of an outside company is another way to further reduce bias in the measurement process. An independent company should have no positive or negative feelings about the outcome of the results, is less likely to change results to suit the purpose of the measurements, and should have higher levels of skill in sampling and testing than the sales or production staff of a company. However, the hiring of a company that is well skilled in quality techniques and is knowledgeable about the product or business of the company in question may be unavailable or priced too high for the company. Extensive research should be done by a company before hiring someone to perform quality procedures within that company. The decision is an important one because the results of the quality process can influence the marketability of the product or service and the viability of the entire company. As stated in Chapter 1, the quality process must be ongoing and show a high level of management commitment.

Testing is the fourth step in the measure product process. Testing may include observations or physical measurements with instruments. When these tests are performed on a physical sample, they may be done with no alterations to the sample or the sample may be subjected to simulated use or actual use. Consumer activities such as washing, burning, tearing, or rubbing may be simulated through equipment normally stocked in a textile testing laboratory (e.g., tear tester, rub accelerator). Textile testing laboratories may be located at manufacturing plants for fiber, fabric, or sewn product companies. In addition, large retail corporations often keep their own textile testing labs to evaluate new products and to be assured that continuing

Table 2–2
Examples of Sample Characteristics for Various Sample Types

Sample Type	Other Descriptors	Size
Fiber	Cotton staples	6 oz
Fabric	Swatch	2" × 2"
Product: shirt	Sleeve length	From underarm seam to cuff
Product: couch	Cushion, swatch	An entire cushion, or a swatch taken from one or more locations
Product: jacket	Swatch	Taken from the center back
Sewing process	Attach collar	30 sec of sewing time

level of the production process and for any process within this total production system.

Figure 2–3 shows the back of a newly produced jacket that has a swatch of fabric removed so that the fabric and seams could be tested. The outer fabric was cut from the back of the jacket, leaving a big hole in the outer fabric. The lining is visible. This type of testing is done either as part of the final inspection or is done by a manufacturer, designer, or retailer who has had a production sample made to evaluate the work of the contractor. The retailer who has a private label program that is administered or directed by designers or buyers at the retailer's corporate office works with contractors to produce the desired products.

How frequently samples are drawn for this type of testing is another question that must be answered when writing the sample plan. The samples can be taken at any interval but should be taken at some preset time or rate.

Figure 2–3 Jacket with fabric swatch being removed for testing.

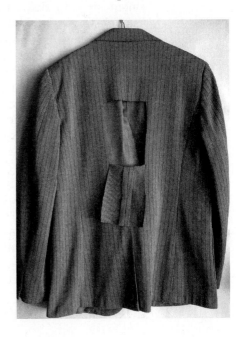

Measure Product

Measurement of a product, a service, or any activity is needed to provide data for the comparison with the standard that is expected. The measurement stage can be described as testing samples selected from the production or other activity stage and tested with various standardized methods. The activity of measuring a product, process, or service results in data that is used in the evaluation stage. The measurement process involves the following five steps: (1) devise a sampling plan, (2) draw samples, (3) send samples to test site, (4) perform tests on samples, and (5) collect data from the tests.

A **sampling plan** is a method used for selecting the samples that will be tested during the measure product step of the quality analysis process. When creating a sample plan, numerous decisions must be made. These decisions may be made by the buyer or the designer as they set the parameters of the product selection or creation. Alternatively, the decisions may be made by upper management or a quality team within the company. Some companies depend on the use of standardized measurement processes that have preset sampling plans. Such processes are available from organizations such as the American Association of Textile Chemists and Colorists (AATCC). All activities within the measurement step may be dictated by the standard information from the AATCC manual.

When creating his or her own sampling plan, the buyer or designer has to decide how many samples should be taken or drawn during the measurement step. In **drawing samples,** the number of samples taken for the sample testing could range from one through ten and beyond, all of the items within a certain time span, or all of the items or activities within the entire product or process lot. If all of the product or activities are sampled, the sample number is considered as a census and not as an actual sample of the total. A census can be important if the product could have critical flaws that would render the product unusable or dangerous. For example, flammability concerns for children's sleepwear encourage a company to test every fabric and every construction. A census in other situations could be time consuming and could actually be misleading so that the buyer begins to focus on the errors instead of on the product or the scope of the issues. The criticality of the flaw and the probability of the flaw's occurrence can help guide the buyer or designer in determining the number of samples to be drawn.

The size and shape or other description of the sample also needs to be determined. When measuring raw materials, the sample could be a length of fiber or a **fabric swatch.** The actual **dimensions of the swatch** would need to be named (see Table 2–2 for examples of these samples). From this table, the variety and uniqueness of sampling for sewn products can be seen. Because sewn products are so complex, sampling must be specified for each product type and for various customers. The product can be sampled at each

Acrobat and Bitmaps or other graphic files from Photoshop are common tools for the sewn product industry. Employees with extensive skills in graphics software are valuable within this competitive and technologically advanced market.

Standards can be formed by a company as needed for a line of products or for a trading partner, or the company may choose to use standards from international organizations. In a few instances, standards may be set by federal or other governmental agencies, and adherence to such standards is mandatory; however, such required standards are rarely found for sewn products. Within the United States, a few minimum level requirements are legislated such as laws regulating flammability for various products and fabrics. Some trade organizations (see Table 2–1) set standards that are available for members to use and for purchase by other firms. The standards are contained in manuals that provide definitions and procedures for the implementation and use of the standards. Some of these organizations are international in reputation and membership, whereas some are country or area specific. Some standards are industry specific, and others are for general industry use with industry-specific sections or divisions. For example, a standard can be set for strength of snap fasteners in general or for snap fasteners used on cushions of upholstered furniture.

Many of these organizations are linked to the International Organization for Standardization (ISO) through partner agreements or affiliations in order to be globally recognized. Some organizations (e.g., ISO, ASQ) have standards, specific to quality activities, and some standards are specific to sewn products. Some transactions with certain trading partners may dictate what standards a company must use. Large retailers may require that their suppliers be certified for quality management; that products meet colorfastness standards; or that the company, its services or its products meet other restrictions.

Table 2–1
Organizations that Publish Industry-Relevant Standards

Organization	Abbreviation	Web site
American Association of Textile Chemists and Colorists	AATCC	www.aatcc.org
American National Standards Institute (official representative to the International Accreditation Forum [IAF] and International Organization for Standardization)	ANSI	www.ansi.org
American Society for Quality	ASQ	www.asq.org
ASTM International (formally American Society for Testing and Materials or ASTM)	ASTM	www.astm.org
International Organization for Standardization	ISO	www.iso.org
U.S. Consumer Product Safety Commission	CSPC	www.cpsc.gov

use of international or other generally accepted terms and standards will assist a buyer or designer in setting standards that are readily accepted and understood. To avoid problems with translations, graphic images and visual models can be used to depict standards. Pictures, sketches, and international symbols are useful in showing the standard and avoiding the use of words. Diagrams that show the product in various stages, sketches with arrows that show the placement for taking dimensions, and digital images of finished products both in flat or two-dimensional (2-D) and three-dimensional (3-D) form are useful in communicating standards across language barriers. Pictures of sewn products on a body are also useful so that proportions of the item and the relationship of the item to key points on the body can be easily seen and noted.

Standards must be **measurable.** The problem with vague and emotional terminology used by consumers has previously been discussed. When measuring and evaluating products, industry personnel need standards that are precise and concrete rather than vague and nebulous like the terms used by consumers. Terms must be given that can be measured, compared, and communicated. These terms must be readily understood by all people in the industry regardless of local custom or language. The standard must be written so that two people who are independently measuring a product or an activity will arrive at the same answer without discussion or explanation. For example, a smooth fabric can be described in terms of the amount of wrinkling or other physical distortions that are found on the surface. Lengths should be given in measurable units, such as the distance from back neck to waist, rather than as a description such as "at regular waist."

The standard must be **electronically communicable.** The need for global sourcing, auto-rebuy, and speed of development and delivery are necessary aspects of a competitive market place. The use of electronics for business-to-business communication improves speed and accuracy in practices. Normal business procedures for the sewn product industry are described in the following scenario. A designer in Country A will have a pattern made in Country B from a sketch that is sent as an e-mail attachment. The pattern is developed either by hand and digitized or through pattern development software and is forwarded to a contractor in Country C for cutting and sewing the fabric that was woven in Country D. The finished product is shipped to Country F. At least three languages, two sets of measuring systems, and four monetary standards are used in this transaction. The need for computer-to-computer transactions is vital to ensure accuracy and speed for the production and delivery of this product. Standards for data exchange are needed to enable and facilitate this computer-to-computer communication. The ASTM Subcommittee D13.66 has been developing standards for the format of data that will allow users to send data from any computer-driven device in the sewn products production process (Hiegel, 2005). For example, ASTM D6959 Practice for Data Exchange Format for Sewn Product Plotting Devices sets standards for data from any marker output equipment. Company personnel must learn to use software and file formats that are appropriate for global sharing. Portable document format (PDF) files from

that **written standards** be translated into multiple languages. The translations are available as needed, to people in whatever country is used for outsourced production or any of the preproduction activities. Often, finding translators is difficult because of the technical and industry specific terminology used in the standard. A translator that is used for doing work for a service business, tourist, or academic researcher may not have the knowledge of the sewn product and processes that are needed to do the translation.

In addition, numbers and measurements may need to be converted to fit the **numbering systems** used by the customers and vendors who provide supplies to the manufacturer or who handle the products (i.e., all trading partners). The needs of both internal and external customers must be recognized. Most U.S. companies, both in manufacturing and in retail, use the Arabic system of numbers and measurements that are based on the "inch–pound system," more traditionally called the **English system.** This system uses the feet and inches in length measurements and pounds and ounces in weight measurements. Figure 2–2 shows fabric being measured with an English system ruler with additional markings for one-eighth inch as used in many sewn products.

Although this system is still widely used in the United States, many countries, including England, use the metric system for measurements. Thus, dimensions used for measuring and sizing systems vary across countries. The

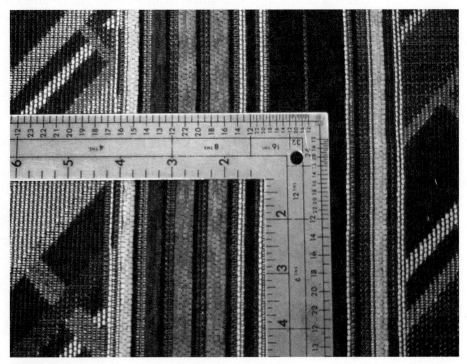

Figure 2–2
Ruler with English system markings.

When general standards are written for specific products, they are usually called **specifications.** Specifications are more specific than standards, and contain additional details beyond the general descriptors used in standards. Specifications are unique to a product and to a company. The specifications for a plain white T-shirt developed for a discount store will be different from the specifications for the same shirt that is developed for a bridge or designer brand or from the one that is placed in an upscale, high price point boutique. All of the shirts may be considered a basic, white, cotton, plain knit shirt that is designed to fit the expectations of the consumer for a soft, serviceable, easy care T-shirt. Nevertheless, the percentage of cotton, the type of cotton fiber, the exact number of stitches per inch in the knit, the gauge of the knit, and other specific features may vary greatly from one shirt to the next.

Each product line has its own set of specifications that are unique and more specific than general industry or company standards. Most company standards just set minimum levels that must be met for all products designed and/or merchandised by the company. If a firm has a narrow product line, the specifications for each product may be used for the entire production process. The comparison of consumer expectations, industry/company standards, and company/product specifications are shown in Figure 2–1.

To be useful to all personnel who use the standards and specifications and to be viable tools in a global market place, standards and specifications must conform to the following three requirements: easily understandable, measurable, and electronically communicable. To be **easily understood,** standards must be clear to the designers and product developers who create them and to many other people around the globe. For most companies, this requirement dictates the need for translation. In the sewn product industry, products are frequently designed in one country, produced in a second country, and may be sold in a third country. This globalization of the industry requires

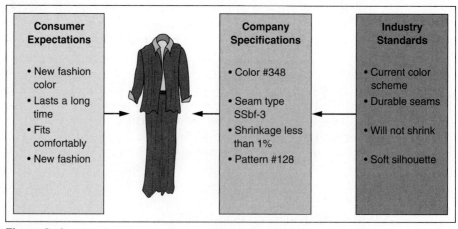

Figure 2–1
Comparison of terminology for consumer expectations, industry standards, and company specifications.

customization, the company provides the consumer with the basic choices of product and allows the consumer to select color, embroidery, or fabrication. The consumer can have red, blue, green, or other colors for the shirt, but the style, fit, length, and other features of the shirt are set by the company. The next more complex level of mass customization allows the consumer to have adjustments in fit of the product. This adjustment includes changes in the dimensions of the item. Finally, the ultimate option in mass customization is the codesign of products. The consumer works directly with a designer to create a product that is specifically addressing all of his or her expectations.

Set Standards

Standards are broad, industry-oriented interpretations of the customer's or consumer's expectations. Consumers discuss products in terms that are often vague and nontechnical. In fact, consumers commonly scramble the information that they know about sewn products. For example, consumers might state that a product is "a cotton fabric." This information is inaccurate because cotton actually refers to the fiber, which would be more accurately stated, as "the fabric contains the cotton fiber," and the construction of the fabric may be any knit, woven or other construction. Consumers also talk about products that are cute, sexy, fuzzy, sleek, shiny, and other emotional or artistic terms. For many of the terms, concrete or direct measurement is not available to determine the level of "cuteness" or "sleekness" that is represented by the product. The consumers also discuss products that are stylish or fashionable. These features also lack specific measurements or laboratory procedures to determine their amount or level. To further complicate the analysis process, the product may be measured as a whole, as a sum of individual parts, or as separate parts. The sewn product is made from fibers that have a multitude of features that are constructed into fabric in one of numerous ways that is further manipulated through cutting, sewing, and other techniques into a final product. Each raw material in this step and each production process along the path to a complete product has unique characteristics that are identifiable both as individual features and as a whole.

The buyer or designer who is trying to meet consumer expectations through a sewn product will find a challenge in **interpreting the expectations** into industry measurements. However, the process of converting expectations to standards is a necessary part of the quality analysis process. Merchandisers, buyers, and designers who develop and select products for consumers must be well trained in a variety of fields to be successful in working with a consumercentric product development or buying team. The skills needed to make these conversions depend on an in-depth understanding of consumer behavior and a detailed knowledge of textiles, sewn product design, and sewn product production.

niche markets that serve a limited number of customers with specialized products. Market research can be done by a team, a department within a retail or manufacturing company, or by outside or independent firms. Manufacturers or retailers may share their consumer information with their trading partners for more efficient development and delivery of products.

Although market research data can be reported in terms of percentages, dollars, and other exacting figures, the designer, merchandiser, and retailer must be constantly aware that forecasting is an inexact and speculative process. For example, an average consumer within a market segment may be reported as having an income of a specific dollar figure. However, the figure is an average because some consumers will have a higher income and some will have a lower income. Not all consumers with the same income spend the same proportion of this income in the same places and on the same products. In addition, consumers with varied incomes may choose to spend their money on products that are seemingly too expensive for them or are very cheap for them. The number of expensive automobiles parked on the lots of discount retail stores is clear evidence that simple information such as income is not enough for a fashion forecast. In addition to detailed research, some industry personnel who have good instincts about fashion are adroit at forecasting, but most planners admit that even the best forecasting is only a forecast and not a firm prediction of what is expected by consumers.

A few companies with strong brands or high-profile designer recognition depend on their own ideas for fashion leadership. **Branded products** are often maintained within a narrow range of change and use standardized cues of select colors, style features, or other product attributes to continue to entice customers for repeat product purchases. High-profile designers may be fashion leaders and set their own direction for style, color, and fabrication. This technique is only successful as long as the designer has a strong following by customers who wish to emulate the image created by the designer. This strategy is successful for very few designers or design firms and is often not a stable approach to market success.

As consumers are becoming more individualistic in their clothing choices, and as the competition presents consumers with more and more choices in clothing, companies are forced to seek additional methods of understanding consumers and forecasting their desired products. A consumercentric company makes specific efforts not only to forecast but also to determine specific expectations of consumers. This process uses a combination of previous traditional forecasting techniques and technology dependent new techniques. Past sales, company history, brand and company images, and fashion leaders are still important for identifying broad trends and company specific information; however, a more direct approach is needed for a firm to be consumercentric.

Consumercentric firms must directly involve the consumer in the product development stage. **Mass customization** is a product development and production process that is dependent on consumer input for product output. Mass customization ranges from consumer-driven color choices to codesigned products (Gilmore & Pine, 1997). In the simplest aspects of mass

Determine Expectations

Companies who are using a TQM strategy will recognize that every customer should receive attention. Customers are both internal and external. The **final customer** for most sewn products is the **consumer** who is shopping at retail. Each trading partner is an **external customer,** and all employees within a firm are **internal customers.** Each supplier, whether internal or external, to the firm, should be aware of customer expectations and try to achieve satisfactory quality levels. Satisfaction can only be achieved when the supplier knows the expectations or requirements of the customer and strives to meet these requirements. According to Crosby (1988), this **process of conformance** to customer requirements is the first absolute of quality. Knowing the expectations of the customer allows a company to create systems to produce products and to provide services that meet these expectations. The more accurately the company knows the customer's expectation before designing and manufacturing begins, the more likely the company is to meet these expectations with the product and service. For example, if the company knows that a bright red color is important to the sale of a towel, the product development team must work with dyes and fibers to create a fabric that will hold the color well. Advanced planning based on customer research will help to prevent errors, defects, rework, returns, and dissatisfied customers in the current and future transactions within the pipeline. Delivering the product that the customer expects is important to keeping that customer satisfied and willing to return for more purchases (Kincade, Redwine, & Hancock, 1992).

Expectations of the consumer have traditionally been forecast by designers or buyers through extensive market research and studies of company information. Occasionally, expectations of consumers have been ignored by industry personnel who either choose products because of the ease and low costs of production or who design and select products on the basis of an image, brand, or other idea. To forecast consumer preferences, buyers, designers, and merchandisers have used company history and retail point-of-sale (POS) data to predict future purchases. This information can assure the buyer as to which previous products have sold well; however, this method is very effective in identifying what has sold well in the past, which may or may not be expressive of what will continue to sell.

To avoid looking backward to predict future trends, designers and buyers have traditionally used **market research** to search for signposts that will provide an indication of what consumers might want in the future. Runway shows from European designers, movies, and music videos with major or new stars and other fashion-forward sources of information have been used to glean style, color, and fabrication information for product development and selection. These sources continue to provide good information about general fashion trends for the broad market. More focused approaches may be needed for

Quality Analysis Process

Buyers, designers, merchandisers, and product developers work at various stages in the pipeline to design, produce, and merchandise products for consumers. All of these industry personnel are trying to produce and promote a product that consumers will buy. To ensure that products are meeting consumer expectations, industry personnel must follow a quality analysis process that will check for conformance to requirements. This quality analysis process fits within the TQM strategy used by companies. At each step of the production and distribution process, quality practices must be in place to create and deliver the right product. To ensure that the prescribed processes are in fact creating the right product, the processes and the product must be analyzed. A four-step quality analysis process is a viable tool for determining whether the outcomes are producing the expected product. The four steps of the **quality analysis process** are as follows: (1) determine expectations, (2) set standards, (3) measure product, and (4) evaluate data. For any activity, product, or service, the quality analysis process may be implemented to ensure that the activity is conforming to requirements and is thereby meeting customer expectations.

development, *Quality Progress,* 28–35. Available from http://www.asq.org

Syrett, M. (1988). Quality: A corporate responsibility. *Director*, 41, 84–86.

Walton, M. (1986). *The Deming management method,* New York: Perigee.

United Nations Statistics Division. (2005). International Standard Industrial Classification of All Economic Activities. Available from http://unstats.un.org

U.S. Census Bureau. (2005). *2002 NAICS definitions*. Available from http://www.census.gov/epcd/naics02/def

References

Branch, S. (2002, July 16). What's in a name? Not much according to clothes shoppers. *The Wall Street Journal*. Available from http://www.wsj.com

Bullington, K. E. (2003, January). 5S for suppliers. *Quality Progress,* p. 56–59. Available from http://www.asq.org

Cawthon, F. (1986, September 7). Atlanta style—Quality that counts. *The Atlanta Journal and The Atlanta Constitution*, S6.

Consumer Reports. (2002, September 5). *Women's Wear Daily*, 9.

Crosby, P. (1979). *Quality is free*. New York: Mentor.

Crosby, P. (1984). *Quality without tears: The art of hassle-free management*. New York: Plume.

DeCarlo, N. and W. Sterett. (1990, March). History of the Malcolm Baldrige National Quality Award. *Quality Progress*, 21–27.

Deming, W. E. (1986). *Out of the crisis*. Cambridge, MA: MIT Center for Advanced Engineering Study.

Feigenbaum, A. V. (1991). *Total quality control*. New York: McGraw-Hill.

Gilmore, J. H., and B. J. Pine, II. (1997). The four faces of mass customization. *Harvard Business Review, 75*, 91–101.

Jiao, R. J., G. G. Q. Huang, and M. M. Tseng. (2004). Editorial: Concurrent enterprising for mass customization. *Concurrent Engineering: Research and Applications, 12*, 83–88.

Juran, J. M. (Ed.). (1988). *Juran's quality control handbook*, New York: McGraw-Hill.

Lazzareschi, C. (1993, December 21). W. E. Deming, Quality control guru dies at 93. *Los Angeles Times*, A36.

Loker, S. (1999). *Mass customization: A multimedia module* [CD-rom]. Ithaca, NY: Cornell University, Apparel Industry Outreach, Cornell Cooperative Extension.

McDonald, M. (2004, June 1). *VF: Brands—Balancing art and science*. A speech to the IAF meeting, Barcelona, Spain.

Mehta, P. (2002, December). Salaries and diversity: A look at how quality has changed accompanies this year's results. *Quality Progress,* 29–31. Available from http://www.asq.org

Milliken. (1992). *Quotes and mottoes on Roger Milliken Center walls* [Brochure]. Greenville, SC: Milliken & Company.

Montgomery, D. C. (1996). *Introduction to statistical quality control*. New York: Wiley.

Motiska, P. J., and K. A. Shilliff. (1990, February). 10 precepts of quality. *Quality Progress*, 27–28.

Nanda, V. (2005). *Quality management system handbook for product development companies*. Boca Rotan, FL: CRC Press.

Pfau, L. D. (1989). Total quality management gives companies a way to enhance position in global market. *Journal of Industrial Engineering*, 21, 17–21.

Pyzdek, T. (1991). *What every manager should know about quality*. Milwaukee, WI: ASQC Quality Press.

Randolph, B. P. (1989). Total quality management: Our ability to manufacture. *Vital Speeches*, 55, 322–24.

Sahadi, J. (2006, February 6). 5 careers: Big demand, big pay. Available from http://www.cnnmoney.com

Salegna, G., and F. Fazel. (1995). An integrative framework for developing and evaluating a TQM implementation plan. *Quality Management Journal*, 3, 73–84.

Seckler, V. (2002, April 11). The new consumer: Shopping crossroads of mass and class. *Women's Wear Daily*, 183, 1, 10–11.

Smith, L. R. (2001, November). Six Sigma and the evolution of quality in product

Review Questions

1. What do surveys reveal about consumers' preferences for sewn products?
2. What do manufacturers, designers, buyers, and retail managers need to know about sewn products quality?
3. What are some terms that are incorrectly used to define quality?
4. What is the retail/consumer definition of quality? What is the comparable industry definition of quality?
5. Why is quality different for different consumers?
6. How does the consumer express his or her satisfaction with quality?
7. How can a quality program benefit a company?
8. How does the consumer view of a product differ from the retailer's view of a product?
9. Why is peer feedback important to a consumer?
10. What are the two categories or situations in which consumers perceive quality?
11. What is the number one aspect of a sewn product that the consumer "sees" first?
12. What is postcare for a consumer?
13. What is a sewn product? What other products are included in addition to apparel?
14. What is the NAICS? Why is this useful?
15. What do the characteristics of sewn products and the consumers of these products contribute to the difficulty of determining sewn product quality?
16. What are the raw materials, processes, and product outcomes for the sewn product?
17. What outcomes can be expected in fashionality for a sewn product?
18. What is the challenge related to quality for those who work in textile, sewn products, and retail firms when trying to satisfy consumers?
19. If you worked for a sewn product manufacturing firm and got consumer data, what prior knowledge would you need to interpret expectations into company standards?
20. What does it mean for a company to be consumercentric?
21. Describe the structure of the traditional sewn products pipeline.
22. What are the four main steps in this pipeline?
23. What do the downward arrows represent in the pipeline in Figure 1-4? What do the upward arrows represent?
24. Describe the consumercentric sewn products process.
25. How does information flow in the consumercentric product process?
26. How does this consumercentric process differ from the traditional pipeline and why?
27. How does the consumercentric process fit with quality strategies?
28. What are problems with implementing a consumercentric process for sewn products?
29. What is Total Quality Management (TQM)?
30. What are the five steps of TQM?
31. Why is top management commitment important for successful TQM implementation?
32. What is continuous improvement in TQM?
33. How can continuous improvement help a company get satisfied customers?
34. How important is training in TQM?
35. Compare the activity of measurement to the implementation of TQM.
36. Why did Japan have quality programs before the United States?
37. How has the perception or focus of quality changed over the past several decades?

the success of a quality program that those who work with quality adhere to the well-known phrase, "The customer is always right." Education, training, and management commitment are vital to the success of any quality program within a company. Because quality and the achievement of satisfactory products is a process, training must address all employees and all members of partner firms and must be continuous, intensive, and rigorous.

Among the many companies that have won the Malcolm Baldrige National Quality Award is the large textile corporation of Milliken & Company. The intensity and devotion that quality demands in the Milliken firm are noted when a customer or business partner walks into the corporate headquarters or in any of their plants around the world. The walls of all buildings within the Milliken firm are covered with quotes and mottoes on quality. Some of the more noted that are located on the walls of the Roger Milliken Center (Milliken, 1992) are: "Continuous renewal"; "Education is the stem that winds the watch"; "The bitterness of poor quality and service remains long after the sweetness of low price is forgotten"; "Tell me and I will forget. Show me, and I may remember. Involve me, and I will understand"; and "Success occurs when opportunity meets preparation."

Key Terms

5S
Conformance to requirements
Consumer
Consumercentric firm
Consumercentric process
Consumercentric sewn
 products pipeline
Continuous improvement
Distribution channel
End use evaluation
End use
External customers
Fabric development and
 production
Fashionality
Fit
Free of deficiencies
Functionality
Gender
Implementation and
 maintenance
Input

Intangible features
Internal customers
International Standard
 Industrial Classification of
 All Economic Activities
 (ISIC Rev.4)
Linear process
Market sales
Mass customization
Measurement system
Meeting customer expectations
National Retail Federation
 (NRF)
North American Industry
 Classification System
 (NAICS)
People intensive
Physical properties
Pipeline
Point-of-sale evaluation
Processes
Product development

Product development process
Product outcomes
Product production
Production
Quality
Quality expectations
Quality policy
Repeat purchase
Retail sales
Sewn product system
Sewn products
Six Sigma
Soft product lines
Standard Industrial
 Classification (SIC)
Standard International Trade
 Classification (SITC)
Total quality management
 (TQM)
TQM strategy
Traditional sewn products
 pipeline

businesses was well supported by the Japanese government, and a Deming Prize as an award for corporate quality was established in his honor.

Since the 1950s, other statisticians and business managers have been important in expanding the field of, and knowledge about, quality. Juran, Taugchi, and Feigenbaum are statisticians who contributed additional ideas about and tools for quality (Juran, 1988; Feigenbaum, 1991; Montgomery, 1996; Nanda, 2005; Pyzdek, 1991). In addition to more statistical techniques beyond those introduced by Deming, Juran is acknowledged as the statistician who implemented the idea of corrective action needed after the comparison of performance to requirements. The emphasis in quality was shifted from identifying problems at the end of the process to fixing the problems as they occurred. Juran is noted for his ten-step quality improvement process. The design of experiments to measure variance and the use of experimental design methods in quality management activities are credited to Taugchi. In the 1960s, Feigenbaum introduced ideas of integrated functions within a company as opposed to functional isolation of activities, and total company participation in quality activities, which became a foundation for the ideas of total quality management (Pyzdek, 1991). He also perceived quality as a four-step process: set standards, appraise conformance, act when necessary to induce conformance, and plan for future improvements.

In the 1970s, the TQM philosophy was formulated as U.S. companies sought ways to remain competitive with growing industries in other countries. The philosophy is formulated from many discrete quality activities (Montgomery, 1996). This management view of quality encompasses all functions within a company and all employees so that all processes and activities are to be centered on customer needs and are fully implemented in actualizing those needs into a satisfactory product. Crosby can be credited with the phrase "conformance to the customer requirements" that is so often used as the definition of quality (Crosby, 1979, p. 15). In addition, Crosby (1979) proposed ideas of "zero defects" (p. 144) and "quality is free," (p. 1) which became buzzwords among U.S. managers in the 1980s and were expanded in his second book (Crosby, 1984). During the 1970s and 1980s, ideas about individual quality activities changed from quality control as a way to fix manufacturing processes to quality control as a means to produce a product that meets a set of specifications to a management philosophy of fixing problems before they occur.

The Malcolm Baldrige National Quality Award is a U.S. award that is presented to companies that embody quality management operations (DeCarlo & Sterett, 1990; Pyzdek, 1991). This National Quality Award, signed into legislation by President Reagan in 1987, recognizes companies that have leadership commitment to quality, total customer satisfaction, long-range work on quality issues, teamwork among employees and among trading partners, ongoing training for all employees at all levels, and benchmarking against the best of the competition. Customer satisfaction is so important to

in Figure 1–7b may be the acceptable quality level for some customers. Quality must be defined by the customer and delivered in the product.

History of Quality

Quality, as a strategy currently used in companies throughout the world, has a relatively short history and corresponds in many ways to the maturing of the fields of marketing, management, and statistics. Historically, U.S. companies have focused on basic goods and quantity of product. This focus parallels the development in the United States of the mass production process and the origins of the automobile industry. For decades, the United States was the leader in manufacturing methods. The large automobile companies developed massive plants with extensive studies in productivity, production processes, and automation. Other industries, including aspects of the sewn products industry, followed these patterns of organization and plant operations. This U.S. leadership in manufacturing continued until the mid 1960s, and U.S. manufacturing firms were building large production plants and supplying many consumer goods, including sewn products, to eager U.S. consumers.

Meanwhile in this post-WWII era, Japan was struggling to rebuild over 90% of its manufacturing industries (Pyzdek, 1991). During the allied occupation of Japan in the late 1940s and early 1950s, the U.S. government sent many experts to Japan to assist with the rebuilding. These U.S. experts assisted Japan with improvements in manufacturing processes and taught managers to use the latest management strategies and technologies. Much of the effort during this period was set to rebuild Japan as an export market for U.S. goods. The focus of quality at this point was final inspection, with the rejection of parts or products that did not meet the expected level of quality.

W. E. Deming was one of the experts sent to work for the United States in post-WWII Japan. While in Japan Deming, who was working for the U.S. Census Bureau at the time, was asked by the Japanese government to provide lectures explaining his quality control ideas (Deming, 1986; Lazzareschi, 1993; Montgomery, 1996; Walton, 1986). These ideas were expressed in his 14 Points and were based on the premise that management failures were the cause of product failures. The points ranged from operational activities such as reducing the number of suppliers to the more humanistic activity of reducing fear among employees. Deming was trained as a statistician, and many of his solutions for improving businesses were a combination of statistical tools and management philosophy. The use of statistical process control as a quality tool has its origins in Deming's work. Deming's philosophies were well received by the Japanese government and by many managers in Japanese businesses. His ideas fit with the Japanese culture and its emphasis on education. The improvement of Japanese

know and practice quality techniques usually gain a bigger paycheck than similar employees without the quality training, and their value in the job market is noticeable in want ads and in salary surveys (Mehta, 2002; Sahadi, 2006).

A company that implements a TQM strategy will find that this implementation has many direct costs, including the time to train personnel, the acquisition of equipment to enable inspections, and the expenses for performing quality audits. These costs lead many observers to comment that implementing a TQM program in a company is expensive and that quality has a cost; however, Crosby (1979) stated that "quality is free" (p. 1), and the real costs are the costs of nonconformance. These costs include rework, scrap, returns and warranty-related activities, and complaint handling. When work is done right the first time, these costs are eliminated from a TQM system. The benefits of this system are many, but the most important benefit is the satisfaction of the consumer, who once satisfied, becomes a loyal spending customer. With a properly implemented TQM system, the consumer should receive the product of choice. A TQM system can help a company produce the precision matched stripe in the couture product in Figure 1–7a. This product would sell at a premium price point and would appeal to a segment of customers. The TQM system could also direct the company to produce alternative products if a certain level of precision is not desired by the customer. The mismatched plaid and wrinkles in the product

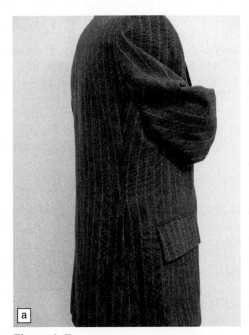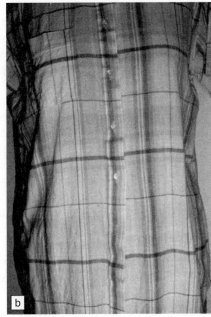

Figure 1–7
Products with varying quality definitions.

so that feedback can be given and action can be taken as part of continuous improvement.

Continuous improvement is a goal of the TQM strategy. Improvement in the performance of the company relative to the specifications and expected outcomes is needed to provide the quality product that is desired by the customer. Improvement may be instigated by input from customers, employees, and vendors. For example, returns of a product may reveal the reasons for customer dissatisfaction. Employees on a production line may have the ability to explain to management how the process can be improved. With input for improvement, processes and products may be redesigned and how the company operates or "does business" may need to be altered. An awareness of the quality policy and the goal of improvement must exist throughout the company and with the trading partners. TQM is an active strategy requiring constant vigilance and continuous actions in a company that is customer oriented. All employees, trading partners, and top management must provide 100% commitment to the goals of quality, and the focus must be on prevention, not repair (Crosby, 1979). Tools, training, and other resources must be provided to enable empowered employees to strive to do their required tasks (Pyzdek, 1991).

Implementation and maintenance of a TQM strategy requires a shift in paradigms for most companies. The vision of top management must be long-term focused with a specific concern for process (i.e., all activities within the company and between the company and its trading partners.) The company must become oriented toward both the internal customer and the external customer. To achieve success, the company must also build trust and respect among its workers, between workers and management, and between the company and its trading partners. Total quality management becomes **people intensive.** A company must develop teamwork, reward team efforts, and provide feedback for continuous improvement. An important aspect of quality is the empowerment of people to provide input and to change the process. Integration of functions and cross-functional teams are a trademark of a firm implementing a TQM strategy and are essential for the accomplishment of quality. Top management must be committed to achieving quality products, must be willing to commit funds for measurement and improvement, and must provide time and leadership for training and change.

Cooperation, not competition, must be achieved between trading partners, and the thrust of expenditures and energies within the company must be on actualization of customer requirements and prevention rather than repair. Quality practices have become a necessity for many companies and their employees. Trading partners may require that a firm implement and practice quality management in order to do business with that firm. Being certified by a national or an international organization as a quality company can make the company more marketable to vendors and to other business customers. Knowledge about and skills with quality practices can enhance the marketability of an employee. Well-trained employees that

Additional activities promoted by the 5S and Six Sigma philosophies are expanding the tactics companies can use to bring quality practices into a firm (Bullington, 2003; Smith, 2001). **Six Sigma** programs focus on the consumer and include assessing consumer needs and wants as an intrical part of design (Smith, 2001). Companies using **5S** focus on activities to sort, set in order, shine, standardize and sustain their plant operations, their products and their supply chain (Bullington, 2003). Researchers note that many of these quality practices are used when a company is managed through the strategy of TQM (Nanda, 2005; Salegna & Fazel, 1995). TQM involves the following five concepts: (1) a top-management directed, quality policy for the company; (2) company-wide standards including all systems within the company; (3) measurements, audits, and goals for individual systems and the total company system; (4) feedback to all participants within the company; and (5) continuous improvement for all aspects of the company and its external partners (Nanda, 2005; Randolph, 1989, Walton, 1986). Companies who implement these concepts into the operations of the company are said to use or follow a **TQM strategy.**

A **quality policy** that is promoted and supported by top management is important to the actualization and continued success of a quality program (Motiska & Shilliff, 1990; Syrett, 1988; Walton, 1986). This policy must be openly discussed, posted for all employees, customers, and vendors to see, and must be implemented so that it impacts the day-to-day activities of the company. Establishing requirements, measuring outcomes of processes relative to requirements, and providing feedback from evaluation is important in integrating the quality policy into every aspect of a company. Requirements must be established for all company activities—not only the product or service but also the internal operation and function of the company and the external activities that involve customers and vendors.

A **measurement system** should be in place to provide information about all aspects of the total system. For a company, all aspects include the products; the processes to design, assemble, and deliver the products; and all vendors delivering raw materials or services to the company. In addition, information should be collected about the company performance as a whole or about the total system. Measurements must be established that will provide information relative to the specifications or the requirements that have been set at this step of the TQM process. Once the measurements are developed, clearly stated, and shared with all personnel involved in the company's systems, information must be gathered and analyzed as an audit to the systems. Inspection processes are needed to implement this gathering of measurements. TQM inspection includes in-process and final inspections. Inspectors must be rigorously trained and perform very exacting and controlled observations and tests to collect appropriate and usable data. This step of TQM draws heavily from such activities as total quality control, quality audits, acceptance sampling, quality assurance programs, and statistical quality control. Responsibility for action within the measurements and audits steps must be clearly delineated

Manufacturing facilities and vendor deliveries often do not have the capacity for the flexibility in production or the short-run production needed to match the level and speed of change to operate in a consumercentric environment. Changes in plant operations, large investments in equipment, and formation of new business relationships are necessary. New ways to create and deliver products must be explored. Product demand must be created by offering products and solutions to both retailers and consumers that even they have not anticipated. Finally, the company that wishes to be successful in today's competitive environment must invest in its people. They must identify, recruit, and hire talented people who are skilled in needed tasks. Then, the company must support, invest in, and retain these valuable human resources.

An Organizational Approach to Quality

Quality practices can and should appear at any point in a distribution channel and can be instituted or managed by any of the trading partners. A business strategy that promotes and uses quality practices allows a company to become focused on their target consumer. Designers, buyers, production workers, and all employees in the product pipeline must work to ensure that consumers "get what they pay for." The use of quality practices can help to assure that the consumer is a satisfied customer. Quality practices should be part of general management practices as well as part of product development, production, and distribution-specific practices. Quality becomes a win–win–win strategy for consumers, retailers, and manufacturing companies. Quality activities can be as large as certification of an entire company and its trading partners or as small as an inspection of one step in a production process. Many strategies, techniques, and activities can be used within an organization to promote, implement, and achieve a quality-producing company.

Total quality management (TQM) is a global or broad term that encompasses many quality activities both large and small and has the constant need and ability to create improvement as its basic concept (Pfau, 1989). TQM involves all systems or aspects of a company, its products, the vendors that provide services and raw materials, and the customers who buy from the company. Any company, from fiber to retail, that handles the raw materials or products of a TQM company may become involved in and changed by the TQM process. TQM is a broader concept than individual activities of quality control, quality improvement systems, quality assurance programs, or statistical process control and often includes many of those activities as well as many others in TQM practices (Crosby, 1979; Feigenbaum, 1991; Nanda, 2005; Salegna & Fazel, 1995; Walton, 1986).

Mass customization uses techniques normally found in mass production facilities but with a focus on an individual consumer to provide services or products that are customized for that person (Loker, 1999). For example, the consumer visualizes the perfect draperies for his or her living room and contacts a designer through a Web site, an e-mail, or a phone call. The designer may suggest and show appropriate fabrics in either samples or digital pictures, or the consumer may visualize both product and fabrics and direct the designer's creation of the item. The fabrics may then be ordered or custom printed to meet the consumer's expectations. The designer or merchandiser will also work with the consumer to develop the correct measurements of the product to be the right size for the consumer's room. Or the merchandiser might promote currently available products that would be possible items for the consumer and might request feedback from the consumer on color or other styling features. With a consumercentric process, the consumer can enter the process at any point and can request changes in raw materials (e.g., fabric development or production), styling (e.g., pattern work during production), or distribution (e.g., market or retail approach).

This consumercentric process is very compatible with the quality process. Producing a quality product means the product is being made and delivered according to the consumer's requirements. This quality process removes waste within the pipeline and increases the probability that only products truly desired by consumers will be delivered to retailers. The consumercentric process has the same goal—to deliver the product that meets the consumer's expectations. Although sounding efficient and logical, the consumercentric process is difficult for sewn products firms to implement and to maintain. Consumers often do not know what they want in sewn products, or if they can express their wants, their feelings may change quickly. For example, research about the operation and validity of focus groups show that many consumers express interest in buying a product but often do not purchase what they say they will. They may say that they like a product and may express an interest in buying the product, but they do not always purchase the product even when it is exactly what they expressed as their expectations. When dealing with sewn products, consumers are often fickle and unpredictable.

Being a **consumercentric firm** may be necessary within a competitive environment and may be enhanced by using quality practices, but the operation and management of such a firm is not easy. Companies that wish to be consumercentric must spend time and other resources to achieve quality products. The early adopters of consumercentric strategies companies provide leadership to those that choose this route (McDonald, 2004). The path to the consumercentric goal requires research about the target consumer. This research must be unique, in depth, and stretch beyond the usual information found in consumer research. Knowing age, size, and income are not enough information. The company must really understand how the consumer thinks and shops. The company must be innovative. Price must be only one consideration when developing a product, and product change must be continuous.

the only person who can say what is "right." For this reason, all activities in the entire pipeline—raw materials manufacturers, sewn products producers, and retailers—must be focused on the wants, needs, and desires of the targeted consumer. To operate with this focus, a firm is said to be consumercentric. At each step of product development, production, and distribution, the process must have predefined checkpoints that continuously evaluate whether the product is correctly targeted to the right consumer.

A **consumercentric sewn products pipeline** is an integrated and non-linear process in comparison to the traditional process used by many sewn product producers. This **consumercentric process** is more accurately represented in a visual model that resembles a circular or a wheel-like structure (see Figure 1–6). With a consumercentric process, there is no beginning or end but a continual flow that is driven by consumer expectations. Information, raw materials, product images, or end products must openly and quickly flow between and among all segments of this model. Each stage in this process is focused on identifying, developing, and delivering a product that fits each consumer's specific expectations for that product. Built into this process must be flexibility and feedback that allow the process to change and develop along with consumer expectations.

The degree of consumer input can vary from selection of color to the direction of design and fabric (Gilmore & Pine, 1997) and influences the strategic approach of mass customization (Jiao, Huang, & Tseng, 2004).

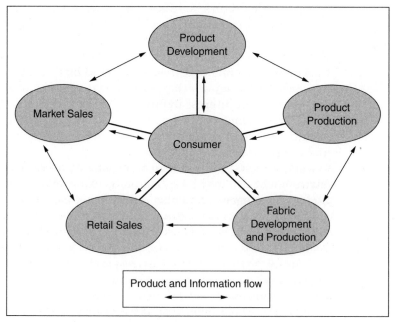

Figure 1–6
Consumercentric sewn products pipeline.

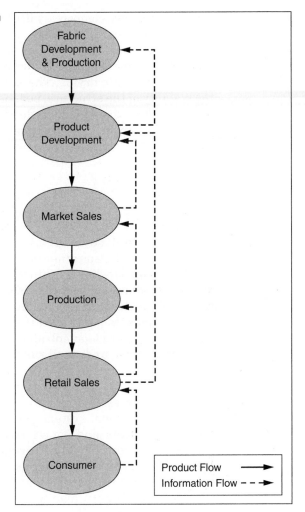

Figure 1–5 Traditional sewn products pipeline.

stage involves converting the selected raw materials into the sewn product items. For some items, the raw materials are custom made as part of the production process. The **retail sales** stage includes the merchandising activities performed to present the product to the target consumer and achieve the final sale. These activities may include Internet marketing as well as in-store sales.

With the myriad of choices presented to the consumer, a single product by a single manufacturer offered in a limited number of retail spots has a very limited chance of being selected by a consumer—unless the product is the right product for the right consumer and is presented at the right time and the right place. To be successful in a competitive and changing market environment, companies must target products to their intended consumers. The consumer is

fibers, so comfort competes with affordability. The easy care is addressed because knits often keep their smooth surface in washing and drying, and cotton comes clean relatively easily in a warm wash. However, cotton and knits can be distorted in the drying process, especially if the heat is high enough to promote drying. The knit structure can be enhanced to increase the stability of the structure, but the increased structure causes an increase in price. Often, the perfect product is not possible—but to achieve a quality product and consumer satisfaction, the industry must try.

Being Consumercentric in a Quality Environment

The **traditional sewn products pipeline** is a **linear process** from product idea and inspiration through manufacturing to retail and consumer purchase. This pipeline contains all of the activities and processes needed to develop, produce, and sell the sewn products. Typically, in this pipeline the product flows downstream and information flows back in short, limited, and indirect segments (see Figure 1–5). The main stages of this process are as follows: fabric development and production, product development, market sales, production, and retail sales. Products flow from the producers of raw materials at the beginning of the pipeline to the final consumer. Information about the products and customer preferences flows back up the pipeline in fragmented pieces.

In this traditional system, consumers converse with retail sales associates or managers and sometimes they return products. Rarely do consumers talk directly to retail buyers. Retail buyers discuss the product with sales representatives of sewn products manufacturers at market weeks and occasionally return products and provide interim comments during the season. Retail buyers may also work with product manufacturers to develop private label or house-brand products, and the discussions involve the product development teams at the raw materials producer and the sewn products manufacturer.

Fabric development and production is the stage in the pipeline when raw materials, including fiber, yarn, and fabrics are conceptualized, manufactured, and sold. This stage may occur prior to, simultaneous with, or after the development of the sewn product. **Product development** is the stage in which ideas for the style of the sewn product and the characteristics of the raw materials intersect, and the product is conceptualized and developed. The **market sales** stage involves the time and activities spent marketing the product to the retail buyers. The activities in this stage traditionally include fashion shows and sales made at major domestic or international market centers, according to a seasonal calendar. This stage may be eliminated if the product is a private label or a house brand and is made in conjunction with a retail partner. The **production**

product. Product design is composed of the following descriptor components: silhouette or outer shape of the sewn product, the style of the item, and the shapes and styles of component parts. **Product production** includes pre-production work on pattern pieces and their individual shapes; layout for cutting the fabric; order of construction, which affects seams, shape and fit; stitches; types of seams and actual product sewing; and finishing processes. To add to the complexity of the product quality definition, characteristics of these textile components interrelate with other product characteristics in developing or controlling the product's outcomes. The characteristics of the textiles become the characteristics of the final item and the integration of the characteristics from each raw material combine in the construction of the item to contribute to the outcomes of a sewn product.

Fashionality, one of the three **product outcomes,** is the look, image or overall visual impact that the item generates (see Figure 1–4). The look of an item could be formal, cute, fashion-forward, or any number of other descriptors. Part of the fashionality or look of the product is the color. The final color of the product is the outcome or characteristic that is most noted by the consumer and is most often used in promotions and other sales efforts. Color attracts the consumer. **Fit** is the conformance of the product to the body or to the user space, and for apparel products it includes the wearing and design ease in the item. Fit is a very qualitative characteristic and is often described by an individual's preferences. For example, some consumers like their jeans to be a snug fit, which is body conforming; whereas, other consumers like a loose fit in their jeans with extra room in the thighs and around the knees.

Functionality includes such components as durability, comfort, and protection. Functionality of a sewn product describes how the item performs for the user. Sometimes this characteristic is described as the use of the item. For example, a raincoat is used to keep one dry when it rains. A policeman uses a Kevlar® vest to keep his chest safe from a bullet. Aesthetics can also be considered a function or use of the item. The user of an item may desire a sewn product to create beauty, to improve the looks of the wearer, or to coordinate with or enhance other sewn products. For example, a bridal gown is used to create a special look for the woman who is getting married. Small decorative pillows may add interest and excitement to a simple sofa. Aesthetics of sewn products are very important to some users and may be considered by some as a separate or fourth outcome or may be considered part of fashionality; however, aesthetics is different from fashionality. The look of an item, its newness or fashionality, may or may not create an aesthetic appearance for the wearer or the user.

A difficulty in making a quality product is the inconsistencies and conflicting outcomes described by a consumer. For example, a consumer may want an affordable, fashionable T-shirt that is comfortable with easy care properties and that does not shrink. The comfort can be achieved with a knit fabric made of 100% pima cotton; however, the pima cotton that adds to the smoothness of the fabric is often more expensive than the average cotton

Table 1–1

Component Properties of Inputs, Processes, and Outputs for Sewn Product System

Inputs, Processes, Outputs	Component Properties
Raw materials	Fiber, yarn, fabric, findings
Product development	Silhouette, style, fabrication, details
Production	Pattern pieces, construction order, stitches, seams
Fashionality	Art elements and principles, fabric hand, color, fabric texture
Fit	Ease, line, grain, set, balance
Functionality	Durability, comfort, easy care, protection

properties of the raw materials and the design, development, and production processes along the sewn products pipeline.

For evaluating product quality, this system can be measured by its inputs, processes, and outputs (see Table 1–1). Creating and delivering a quality sewn product is not easy with the flexible and variable raw materials and the high level of human processing involved in the manufacturing of sewn products. Designers, merchandisers, buyers, and other industry personnel who evaluate raw materials, assembly processes, and finished sewn products must have extensive and functional knowledge of all component properties and processes within the sewn product system. Many procedures continue to depend on human skills because human hands can handle and process the infinite number of combinations of weight, thickness, shape, and texture of the sewn product and its myriad parts. Because of the multiplicity of components and the human interaction, variance in outcomes is to be expected; therefore, quality must be evaluated carefully and thoroughly to obtain a product that satisfies a consumer. For companies trying to achieve a quality product, "do it right the first time" (Crosby, 1979, p. 232) requires that each part and procedure must be "right" (i.e., meets the expectations of the customer and consumer).

Quality begins when the raw materials are created and continues as the parts are cut and fit together to make the product, and the product is presented in sales to the consumer. It cannot be inspected into the product at the end of the process. A quality, sewn product at the end of the system depends on the **input** of quality raw materials at the beginning of the system (see Figure 1–4 and Table 1–1). For sewn products, raw materials include the textile components of fiber, yarn, and fabric, and the needed findings such as thread, buttons, zippers, and labels. Other materials such as fur, metal, plastic, and wood may be used in creating sewn products. Shoes, hats, jewelry, and other personal and household accessories are frequently made of nontextile materials.

Two main **processes** are involved in manufacturing a sewn product—the product development process and the product production process (see Figure 1–4). The **product development process** creates the look or design of the

the vagueness of consumer terminology (e.g., fuzzy, soft, cuddly, romantic, sexy, cute). These terms fail to have exact measurements. A yardstick will not measure cute. A scale cannot provide an accurate measurement of cuddly. In fact, several physical features will be needed to create something that is considered cute by a customer. Although the look of the product is developed through very specific combinations of raw materials and production techniques, the consumer rarely thinks in what is generally considered industry terminology.

Sewn Product Processes and Outcomes

A sewn product is a complex creation made of many parts and assembled through a number of complex procedures. To address both the physical and abstract parts of a product, the quality of a sewn product can be measured through the evaluation of the raw materials (e.g., findings, fibers, fabrics), design and assembly processes, and product outcomes (i.e., fashionality, fit, functionality) of the product. All of these factors combine within the sewn product and become characteristics of the product. To evaluate the overall quality of the item, the quality of each part, the sum of the parts, and the processes that integrate these parts must be evaluated. Figure 1–4 shows an organic or holistic set of activities within the sewn products industry. The entire figure is a **sewn product system** that represents a process with smaller processes within the scope of the whole. This figure shows inputs, outputs or product outcomes, and specific processes that work together to develop the product and services that are required and expected by the consumer. Each input, process, and output, can be described with industry specific terms, which are related to the physical

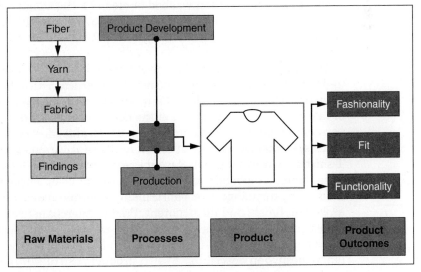

Figure 1–4
Sewn product system with inputs, processes, and outputs.

The **point-of-sale evaluation** is what the consumer does while shopping and purchasing a product. When the consumer is in the store handling and trying on the merchandise, he or she is thinking about a variety of product characteristics. The color is most often the primary feature that the consumer will note and evaluate when shopping. The next feature that "grabs" the consumer is the overall look of the item. Some consumers look at labels and determine the brand, country of origin, or designer for the product as part of their point-of-sale evaluation. Some of this information may also be obtained from the merchandising cues provided by the store. Many retailers package their products with designer names highlighted so that the products are grouped in close proximity to similar products or to other merchandise by the same designer. Some consumers feel the fabric and make a tactile evaluation of the product. A few consumers will read the care labels. Most consumers read the price label either as a first look or at least before time of purchase. A limited number of consumers will try on the product and will evaluate the fit and the overall look of the item while wearing it.

During **end use evaluation,** a consumer will use another set of criteria for evaluating the product. Peer feedback or the opinions of family, friends, coworkers, and strangers will be used as a measure of product suitability. When peers give positive feedback, most consumers feel content or satisfied with a sewn product. Many consumers also evaluate the product for the functionality of the product. Fit and comfort are evaluated when the consumer wears or uses the product. These outcomes are generally perceived by the consumer but can be affected by peer feedback. A friend that says, "Isn't that too big?" will often create the perception of dissatisfaction within the product owner. In addition, the post-use care that is needed and the outcomes of that care affect the consumer's evaluation of the product. When the product is used and then washed or cleaned, the consumer may have an expectation that the product will continue to be as good as new after the care. Shrinking, fading, and distorting of a product are generally unacceptable post-cleaning outcomes.

Industry personnel such as designers, product developers, merchandisers, and buyers use terms to describe product characteristics that are unique to the sewn products industry. Most characteristics describe the **physical properties** of raw materials or the result of the design and assembly processes. Industry personnel tend to view the product in physical terms that can be measured in ounces, in inches, and by other concrete measurements. For example, the T-shirt shown in Figure 1–3 would be described in industry terms as a 4-oz. jersey knit fabric made of 100% cotton, with set-in sleeves, and a scoop neck with a 10% shrinkage rate. Fabric manufacturers consider such characteristics as weight, finish, and fiber content. Product merchandisers consider assembly or design results such as stitch length, pattern size, and seam type.

As noted in Figure 1–3, consumers and industry personnel speak different languages when describing a sewn product. The quality challenge to textile, production, and retail employees is to match the consumer image of the product to the industry criteria. This matching is often difficult because of

classification system, **International Standard Industrial Classification of All Economic Activities (ISIC Rev. 4),** is maintained by the United Nations and can be accessed at http://unstats.un.org (United Nations Statistics Division, 2005). Most sewn products, both apparel and home furnishings, are located in Division 88. Textile, apparel, and leather product manufacturing service is in the 8812 Class.

Sewn products can also be classified by end use. **End use** refers to the occasion or purpose for which the apparel item will be worn. Many of the sewn products items in home furnishings are classified within the category of accessories, linens, or other use classes. This end use method is used primarily by retailers because it relates closely to consumer usage and fits with the market and the promotion activities of retailers. A detailed coding system for end use classifications is described by the **National Retail Federation (NRF)**, the principal trade organization for retailers and can be accessed for a fee from the organization's Web site at http://www.nrf.org. Coding systems improve communication of product information and assist manufacturers, retailers, and researchers in inventory and categorization of products.

The materials, processes, and outcomes used to create and finalize a product are often perceived differently by consumers and by industry personnel (e.g., designers, merchandisers, manufacturers, retailers; see Figure 1–3). Consumers tend to be emotional about sewn products because they wear them close to their skin, sit or lie on them in their automobiles and homes, or hang them on walls in offices, houses, and other interior spaces; spend income on their purchases; often own them for many years; and show themselves wearing, sitting on, or otherwise using the items in front of or with family, friends, and strangers.

For example, a T-shirt for a consumer can be visualized as soft, comfortable, and difficult to wash. Consumers often look for aesthetic, abstract, or other **intangible features.** Whether abstract or concrete, a consumer's perception can be categorized into two areas that correspond to the consumer-buying model: evaluation at the point of sale and evaluation during end use.

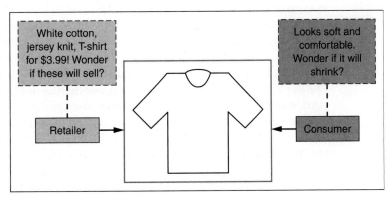

Figure 1–3
Two-sided view of a sewn product.

appeal, and marketing input are multiple forces that push the consumer to purchase items on the basis of feelings of insecurity, desire for aesthetics, or other emotional reasons. Retailers and manufacturers of sewn products are challenged to determine all of the subliminal or the abstract as well as the physical properties of sewn products when considering the expectations of a consumer for a quality product.

Sewn Product Classifications

Sewn products include products that are made from textiles or other similar raw materials and are constructed primarily through the process of sewing. These products include apparel or clothing items (e.g., coats, dresses, shirts, sweaters); many of the apparel-related accessories (e.g., pocketbooks, book bags, shoes, gloves); and home furnishings made from textiles. Sewn products in the home furnishings area include accessories such as pillows, and many of the soft goods such as linens, draperies, and small rugs. Sewn products also appear in other industry products such as the car seats in automobiles, the curtains hung as dividers in airplanes, and the gloves found in the neighborhood building supply store.

The primary classification method for the apparel product is by **gender,** with three main categories: men's wear, women's wear, and children's wear. The primary classification of home furnishings is hard and soft. The **soft product lines** are those that contain fibers and fabrics and are similar in construction and quality evaluation to apparel. Home furnishings can also be categorized by placement within the home. Home furnishings are usually gender neutral, although some product classes or styles of products do appeal more to one gender or to the other, especially in children's items. Although some apparel products are unisex or are very similar across categories, the products are generally categorized by a primary gender category. For example, T-shirts are primarily men's wear items, but, with little or no changes, they may be sold as women's wear or children's wear. Some manufacturers produce products in only one or two categories of merchandise because of specialized sewing or cutting needs for the product.

The **North American Industry Classification System (NAICS;** Information, 2001) is a coding system adopted by the U.S. government in 1997 for coding industries and their products. Most sewn products are within the 31-33 manufacturing codes of the NAICS (U.S. Census Bureau, 2005). The specific codes for apparel items are in the manufacturing sector and start with the 3131 codes and continue through 3169. Furniture and related product manufacturing, including many home furnishing products that are sewn with textiles, are listed in the 337 codes. This system is designed to replace the traditional **Standard Industrial Classification (SIC).** In this previous system, most sewn products were found in SIC 23. Additional information about both the SIC and the NAICS systems can be found on the U.S. Census Web site or at www.census.gov. Other classification systems such as the **Standard International Trade Classification (SITC)** are used elsewhere in the world, particularly in India and in Asian countries. Another

Sewn Product Quality

Quality expectations for most consumers are more than just a listing of the required physical properties in a product. **Quality expectations** also include a consumer's perceptions of timeliness, stylishness, and aesthetic appeal. These nonphysical aspects of the product are especially important for sewn products. Sewn products used for clothing are worn not only for modesty, protection, and warmth but also for beauty, attraction, and power. Sewn products for a house, for an automobile, or for other personal functions are used on a daily basis where consumers sit, eat, and share activities as a family, as an employee, or as a guest. Sewn products are part of the personal space of an individual. The physical properties of sewn products become more than a simple sum of fiber, fabric, and stitches. In fact, the nonphysical or abstract properties are often more important to the sewn products customer than are the physical properties. The consumer may not know whether a sweater contains cotton, wool, or acrylic fibers but he or she does know that the sweater is fuzzy, attractive, and fashionable or that the sweater no longer fits, is covered with unsightly balls, and has faded to an unwanted color. Most consumers have some of these products in their closet or in their home (see Figure 1–2). Peer pressure, snob

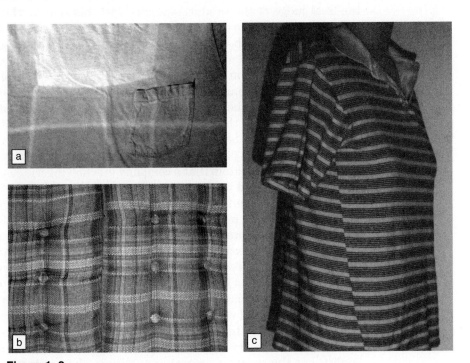

Figure 1–2
Examples of product quality that would not satisfy most consumers:
(a) faded shirt; (b) mismatched seam on sofa cushion; (c) skewed shirt seam.

Although a general or universal set of standards is not found for quality of sewn products, most customers consider that some product deficiencies are generally unacceptable and are not part of a quality product. For this reason, another definition of a quality product is a quality product that is considered to be **free of deficiencies** or defects (Juran, 1988). For sewn products, these general deficiencies include both product characteristics and the services associated with the sale and delivery of the product. For the consumer, products that are not in the store in a timely fashion (i.e., during or immediately prior to the season of use) and products that fail after purchase (i.e., in use or during washing) are not quality products. For retailers, products that are late in delivery or fail and are returned by the consumer are not quality products. For the manufacturer, products that create rework, scrap, or design changes are not quality products. Quality products should be created right the first time, on time, to ensure customer satisfaction (Juran, 1988).

Sewn products are designed, made, and sold through a series of trading partners or a **pipeline** consisting of the following firms: raw materials producers, product manufacturers, and retailers. In this **distribution channel,** each trading partner is a customer of the previous company, and the customer of the retailer is called the **consumer,** who shops for sewn products from that company in the store, on a Web site or from a catalog. For a manufacturer, the customer is both the retail buyer and the retailer's customer (i.e., the consumer). For all firms operating in the pipeline, the consumer is the final judge of the product's quality. For this reason, the consumer's requirements needed to define quality must be established through a rigorous and focused approach. Extensive forecasting and market research is needed to understand the demands of the sewn product consumer. The company must ask the question "What does the consumer want?" before determining any of the product characteristics. The practice of achieving quality depends on understanding the customer and helps to ensure that the company makes the consumer the center of all product-planning activities. The verdict from the consumers is rendered by their purchases or by their lack of purchases in the market place. Continued patronage, loyal customers, and repeat business are all indicators that a company is achieving the consumer's desired quality in the offered products.

Quality is important at all levels of the product pipeline. For a company to achieve a quality product, it must produce a product that satisfies both the **internal customers** (i.e., those working within the company processes) and the **external customers** (i.e., those that purchase or handle the product; Juran, 1988). To deliver the right product to the consumer, quality in raw materials becomes as important as quality in retail service. Quality cannot be restricted to the final inspection of a product prior to shipping, but it must be built into the product and each activity along the entire pipeline, from initial ideas and planning to consumer purchase and use. Each level or segment of the industry may use different words to define and to explain quality, but the outcome or goal of quality is always the same—to produce goods and services that satisfy the customer.

dress is a long shirtwaist dress made of the Qiana fiber created by DuPont to be a synthetic silk. This dress, if hanging in someone's closet today, would still have its vibrant yellow color and would continue to have its smooth, unwrinkled surface. If the consumer wanted a product that would maintain its color and texture for years, this would be the quality product. However, if the consumer wanted a natural look with a soft hand and an airy comfortable feeling, the dress with the Qiana fiber content would not be a quality product.

When consumers define the parameters for quality on products, many products will vary in quality dimensions. For this reason, a universally accepted benchmark of the right seam, fabric, stitch, and other features of a product cannot and does not exist for the perfect quality product. When defining quality by customer expectations, there is no best type of seam, no maximum weight of the fabric, and no specified longevity for the end use of product. For example, dresses for brides maids that have unfinished seams, a simple turned and stitched hem, and no lining are highly cherished by the bride who picks her favorite colors, special style, and shiny fabrics. These sewn product items chosen to be worn for a few hours are then pushed to the back of most closets never to be viewed again. Mothers of the brides maids may complain about the price, and bridesmaids may complain about fit, styling, and color; however, if the bride is happy, then the items are quality products for the bride.

The following classic quote further supports the idea that the consumer's requirements are varying, changing, and demanding, and the product must be formed to meet those requirements to be considered a quality product.

> I am reminded of two items I currently possess, one a "designer" dress in the finest silk that came from a store so exclusive you feel you will be charged for breathing the air . . . the other, a pair of canvas topped deck shoes I purchased on sale . . . at a [discount store]. The dress, divine and flattering, as it is, hangs perpetually in my closet, impressing my other attire . . . The shoes, which make my feet feel like they are 3 years old instead of 39-plus-plus, are seldom given a rest. Now, those shoes are *quality*. I am not as convinced that the dress is. (Cawthon, 1986, p. S6)

Quality is more than a list of product features, and it is more than price. It is also the impression the product makes on the consumer; the image the consumer makes, when wearing or using the product; the reaction the consumer gets with showing the product to friends, family, coworkers, or strangers; and a multitude of other factors related to the marketing, sale, purchase, and use of the product. Quality varies for each consumer and for each use. When a consumer is tired and wants to relax at home alone, a soft cuddly pair of bunny slippers may be quality footwear, but when a night out is planned, a pair of three-inch heels with tiny straps that pinch the toes and angle the foot are quality footwear. Quality is definitely "in the eye of the beholder" and may be stated as simply a matter of the consumer's personal preference. Product usage, past history, price, fashion images, brands and labels, and other situational factors influence a consumer's definition of what is a quality product.

brand-named goods represent quality; however, these product characteristics are not universally accepted as quality and may or may not represent quality to every consumer. Instead, **quality** is more clearly defined as a product that fits the perception or the image held by a consumer. Achieving this quality state is often difficult in sewn products; however, quality can and should be described and measured in objective and quantifiable terms in order to produce a product that is satisfactory to the target consumer. These terms for measuring quality must be directed by the consumer. For this reason, the consumer becomes the final judge of whether the product has the desired quality (Juran, 1988). In other words, quality is **meeting customer expectations.** In industry terminology, quality is the "**conformance to requirements**" (Crosby, 1979, p. 15).

In defining quality through the expectations of the consumer, the exact description, measurements, or features of a product will vary with the expectations of the consumer. In the 1970s, many bright-colored polyester tuxedos were manufactured and worn by young men attending high school proms, weddings, and other special events. At the same time, the young man's date to the prom might have worn a dress such as the one pictured in Figure 1–1. The

Figure 1–1 1970s dress with fabric containing Qiana.

Women's Wear Daily (WWD), 25,000 U.S. women, ages 18 and above, expressed their preferences about products:

- 80% said "Comfort is the most important factor in what clothes I buy,"
- 64% said, "I stick with clothing styles that have stood the test of time,"
- 56% said, "Functionality is the most important factor in what clothes I buy,"
- 33% said "Regardless of the type of clothing I'm shopping for, I always look for my favorite brands" (Consumer Reports, 2002, p. 9).

Findings from this study indicate that the consumer is often looking for a **repeat purchase,** or the same products that he or she has previously bought, and is not concerned about fashion. Over one-half of the respondents in the WWD survey said "Many similarly priced clothing brands look alike," and "Clothes sold at discount department stores are as good as those from department stores" (Consumer Reports, 2002, p. 9). In a similar study of 7,500 consumers by Brand Keys, a marketing research company, 57% of the respondents said that they did not use brands, logos, or labels when making their apparel selections (Branch, 2002). At the same time, about 20% of the consumers in the WWD survey (Consumer Reports, 2002) said that the current clothing market was not meeting their needs. Consumers can be both overwhelmed by the number of choices and bored with the sameness of the products.

Although these surveys cover only a small segment of all consumers in today's marketplace, the findings highlight the fact that information about consumers' shopping habits and preferences is frequently confusing, conflicting, and often difficult to interpret. In this competitive, conflictive, and confused market environment, manufacturers and retailers, in order to sell products and stay in business, must try to get the right products to meet the ever-changing needs of consumers. Doing business the same old way does not work for retailers and manufacturers, who must function in a fast-paced and competitive market. Too many current products are the same, and consumers have too many options of where to get these products. So how does a company distinguish itself from the myriad choices and build a loyal following of happy, spending consumers? One strategy to address the competitive and changing market is to use quality.

The Definition of Quality

Sometimes defining quality is done more easily by saying what quality is not. Quality is not defined by luxury, elegance, high prices, or an intrinsic goodness. Quality is not the use of a certain fiber, and quality is not achieved by having a specific label or brand placed on the product. Being promoted or advertised by a designer or celebrity does not automatically signify quality. To some consumers designer labels, high-price products, or

Quality in a Consumercentric World

When consumers shop for a new sewn product (e.g., coat, hat, gloves, bed sheets, car upholstery), they have an amazing array of options from which to choose. For the product, they can pick color, texture, fiber content, construction, price, country of origin, and countless other features. They can find products at low discounted prices, at high prices, and at prices everywhere in between. The products can vary from high fashion to basic styles. Often, today's consumer is perceptive about brands, prices, and styles. When buying products, they comparison shop, check prices, study fashion styles, and put their money where they wish (Seckler, 2002). In addition, they can shop online or by telephone, order from a catalog, go to a store, or use any combination of these methods. They can shop from small local companies, medium-sized companies, or big international corporations. This range of choice is made even more complex because consumers' preferences are not static but vary across their product uses, current situations, and time frames. Today's choices might not match tomorrow's desires.

Consumers indicate to retailers and to manufacturers the success of products every time they go shopping. When consumers buy products, they are signifying their approval; and when they reject the products and exit the store or a Web site without purchasing, they are showing their disapproval of the products. In a survey reported in the premier trade newspaper

Acknowledgments

Many years ago, I started on this journey about management and quality. A number of people provided leadership along the path. I wish to thank Jim Ward and Joan for the opportunity that they gave me at Cone Mills to start on the journey to understanding quality in business. They sent me to Crosby Training and supported my research by opening many doors. I also thank Melanie who taught me about SPC. In addition, thanks go to the "product guys" at Cone who gave me plant tours, brought me fabric defects, and answered hundreds of questions. Extra thanks go to Susan and her patience in training me on computers and software and for not yelling when I deleted files that took hours to create.

My permissions coordinator, Fay Gibson, deserves rich praise and lots of thanks for working with companies so that we could get pictures of equipment in industry and in laboratory settings. I am thankful for her friendship as well as her good business sense and professional work.

Finally, I have deep and profound gratitude for the assistance that my husband, Jim Kincade, gave with the multitude of photographs in this book. Some of these come from the days when he was a genius with slide film and now he's a wizard with a digital camera. His patience and exactness brought rich color, depth of field and clarity to so many images that were only ideas in my head. This book would have never become a reality without his help. His photographs are the epitome of quality.

can be developed, managed, and evaluated to provide the customer with the right product.

Within the topical sections on materials and process, the book provides answers to the questions of what is quality, how quality is built into the product, and how a company can plan for and control quality. The perspective is a business perspective because that is my perspective. I have been an employee in the industry and have owned my own retail businesses. Section I provides the background including information about consumer behavior, the sewn products industry, the history of quality, and product development. This information becomes a foundation of industry terms, the workings of the sewn products pipeline, the plan for a quality product, and the definitions and explanations of *quality*. Section II examines quality of raw materials, including fiber, yarns, fabric, and findings. The right raw materials are critical to obtaining the right product for the consumer. Section III covers information on quality in the production stage of the supply pipeline, including standards for stitches, seams and fit. Section IV examines in more detail the business of quality—basic tools and some advanced tools and philosophies needed in a business that expects to produce or sell a quality product.

Each chapter includes industry specific information about the sewn product and its related materials and processes as well as quality standards and management decisions needed to develop, produce, and sell a quality product. Much of this information is based on my own experiences as an employee in a quality control department for a major raw materials producer, as an intern at both a major product manufacturer and [TC]2, the National Textile Center, and from years of teaching production and quality classes—both lectures and labs. Merchandisers, retail buyers, product development managers, designers, and others need to know how to plan for quality and how to ensure that quality is maintained in the products that they plan and process. As a buyer, merchandiser, or designer, your students may never go into a factory and use a 40-pound vertical knife to cut 300 ply of fabric according to an intricate marker, but they must know how it is done, why it is done, and what it will do for the quality of the product they are managing.

As a teacher, a business owner, and a manufacturing employee, I have spent numerous years owning a retail business; working in quality control; interning in apparel manufacturing; and teaching sewing, production, and retail courses. From this perspective, I am presenting information in the book that is designed to give you and your students the **managerial perspective on quality** that is needed for many of our students as they start and continue successful careers in this fast paced, quick change, and bottom-line oriented industry.

Preface

This book provides a management perspective about the **business of quality.** Using this book, students and other readers will learn what personnel, who manage the design, development, production and presentation of a sewn product, need to know about quality. Specifically, information is presented in the chapters on how quality affects and is affected by raw materials including textiles, product development, production, and costing. Although textile science, product development and production are vital components to know and understand to use the information in this book, this book is **not** a textile science textbook, a "how to sew" or production textbook, or a product development textbook. This book is about **managing quality** within those fields.

The sewn product is a complex and integrated product with various raw materials as its origin and with various processes to reach its completion. Understanding the sewn product requires an understanding and appreciation of the science of textiles, the creativity of design and development, and the management of business. Employees, including our alumni who work in quality, must be multiskilled and multitasking individuals. In the technical world of fabric and sewn product production, they must be the voice of the consumer; and in the retail world they must be the interpreter of scientific and engineering information for the buyer and the consumer. They need to know and use information from all facets of the industry because developing a quality product through design, production and delivery is both a science and an art.

As an author and a teacher, I recognize that not every student will come to this book with a complete understanding and advanced skill level in every aspect of the sewn product industry. Product quality classes are now housed within clothing and textiles, fashion merchandising, product design and product marketing programs. Students in these programs may complete a very diverse set of courses. For this reason, components of textiles, production, and product design are introduced as needed so that the basic nomenclature and industry terminology can be used when discussing how quality

Steps for Making SPC Charts 316
Reading SPC Charts 320
Using SPC Charts 323
• Key Terms 326 • Review Questions 326
• References 327

Chapter 14 Costing in the Sewn Products Industry 329

Quickie Costing 330
 Quality Considerations in Quickie Costing 331
Market-Price Method of Costing 332
 Quality Considerations for Market Pricing 333
Cost-Plus Method of Costing 334
 Labor Costs 335
 Quality Considerations for Labor Costs 336
 Fabric Costs 337
 Quality Considerations for Fabric Costs 339
 Findings Costs 340
 Quality Considerations for Findings Costs 341
 Miscellaneous Costs 342
 Total Manufactured Costs 342
 Overhead Costs 342
 Wholesale and List Prices 343
 Quality Considerations for Wholesale and Retail
 Prices 345
Recosting to Meet Quality and Cost Standards 345
 Reducing Raw Materials Costs 345
 Reducing Production Costs 347
Activity Based Accounting 349
Future for Sewn Product Costs 349
• Key Terms 350 • Review Questions 351

Index 353

Fit Standards for Specific Products 245
Consumercentric Fit 256
• Key Terms 258 • Review Questions 258
• References 259

SECTION IV QUALITY ANALYSIS TOOLS

Chapter 11 Product Specifications 261

Definitions 262
Format 263
Design Specifications 265
Fabric and Findings Specifications 267
Size Specifications 270
 Sizing 271
 Grading 273
Cut and Sew Specifications 274
Fit Specifications 279
Final Inspection Specifications 282
• Key Terms 284 • Review Questions 285
• References 285

Chapter 12 Basic Tools for Performing Quality Analysis 287

Overview of the Quality Analysis Process and
 the Use of Tools 288
Basic Mathematical Tools—Mathematical
 Calculations 290
Visual Representation Tools 292
 Histograms 292
 Pareto Charts 293
 Distribution Curves 294
 Scattergrams 295
Models 299
 Process Flow Diagram 299
 Fishbone Chart 300
Checksheets 302
Other Tools 304
• Key Terms 305 • Review Questions 305
• References 306

Chapter 13 Statistical Process Control 307

Data Sets for SPC 309
Control Charts 311
Calculating Values for the SPC Chart 314

300 Class 184
400 Class 185
500 Class 186
600 Class 188
Physical Characteristics and Associated
 Standards of Stitches 189
Importance of Standards for Stitches 194
Other Characteristics of Stitches Related
 to Quality 195
Stitch Defects 197
• Key Terms 202 • Review Questions 203
• References 203

Chapter 9 Seams 205

Standards and General Quality Considerations
 for Seams 207
Superimposed Seam (SS) 209
 Quality Considerations for Superimposed
 Seams 210
Lapped Seam (LS) 211
 Quality Considerations for Lapped Seams 211
Bound Seam (BS) 212
 Quality Considerations for Bound Seams 213
Flat Seam (FS) 214
 Quality Considerations for Flat Seams 214
Specifying Seams 215
Defects and Other Problems with Seam
 Quality 217
Stitching 223
 Ornamental Stitching 223
 Quality Considerations for Ornamental
 Stitching 225
 Edge Finishing 225
 Quality Considerations for Edge Finishing 227
• Key Terms 227 • Review Questions 227
• References 228

Chapter 10 Fit 229

Definitions and Development of Fit 231
Fit Approval Process 233
Standards for Fit 237
 Ease 238
 Line 239
 Grain 240
 Set 241
 Balance 242

Chapter 6 **Findings Including Thread** 123

General Quality Expectations of Findings 125
Fasteners 128
 General Quality Expectations for the Outcome
 of Fasteners 128
 Buttons and Buttonholes 130
 Outcomes and Quality Considerations for Buttons
 and Buttonholes 131
 Zippers 134
 Styles of Zipper Applications and General Quality
 Standards 134
Thread 138
 Thread and Quality Outcomes as an Impact on the
 Final Product 141
Support Items 143
Labels 144
Trim 146
• Key Terms 147 • Review Questions 147
• References 148

SECTION III SEWN PRODUCTS

Chapter 7 **Sewn Product Production Processes** 149

Marker Making, Plotting, and Laying 150
 Quality Considerations in Marking
 and Laying 152
Spreading 153
 Quality Considerations in Spreading 154
Cutting 157
 Quality Considerations in Knife Cutting 158
 Quality Considerations in Computer-Driven
 Cutters 159
 Quality Considerations in Dies 160
Bundling 162
 Quality Considerations in Bundling 164
Assembly 165
 Quality Considerations in Assembly 167
Finishing and Final Inspection 169
 Quality Considerations in Finishing 169
 Quality Considerations in
 Final Inspection 170
• Key Terms 174 • Review Questions 175

Chapter 8 **Stitches** 177

Stitch Classes 183
 100 Class 183

Standards in Line Development 54
Outcomes of Line Development 57
Production Development 59
Activities in Production Development 59
Tools and People in Production Development 61
Standards in Production Development 62
Outcomes of Production Development 64
Sales Development 65
Activities in Sales Development 66
Tools and People in Sales Development 67
Standards in Sales Development 67
Outcomes of Sales Development 68
• Key Terms 69 • Review Questions 69 • References 70

SECTION II RAW MATERIALS

Chapter 4 **Fibers, Yarns, and Fabrics: Standards, Measurement, and Evaluation** 71
Physical Properties of Fibers 73
Quality Considerations with Fiber 74
Physical Properties of Yarns 76
Quality Considerations for Yarn 79
Physical Properties of Fabrics 79
Quality Considerations for Fabric 82
Performance Tests of Textiles for Examining Product Outcomes 84
Standards and Tests of Fabric for Functionality 85
Standards and Tests of Fabric for Fit 87
Standards and Tests of Fabric for Fashionality 89
Determining the Appropriate Test 93
• Key Terms 97 • Review Questions 97 • References 98

Chapter 5 **Fabric Inspection, Defects, and Flagging** 99
Inspection Process 100
Fabric Defects 102
Set-Up Errors 103
In-Process Errors 104
Finishing Errors 110
Criticality of Fabric Defects 114
Grading Fabric 116
Flagging Defects 117
Defect Prevention 119
• Key Terms 121 • Review Questions 122 • References 122

Contents

Preface xi

SECTION I BACKGROUND

Chapter 1 Quality in a Consumercentric World 1

The Definition of Quality 2

Sewn Product Quality 6

 Sewn Product Classifications 7

 Sewn Product Processes and Outcomes 10

Being Consumercentric in a Quality Environment 13

An Organizational Approach to Quality 17

History of Quality 21

• Key Terms 23 • Review Questions 24 • References 25

Chapter 2 Quality Analysis Process 27

Determine Expectations 28

Set Standards 30

Measure Product 35

Evaluate Data 41

• Key Terms 42 • Review Questions 43 • References 43

Chapter 3 Product Development 45

Idea Development 46

 Activities in Idea Development 47

 Tools in Idea Development 47

 Standards in Idea Development 48

 Outcomes of Idea Development 48

Line Development 50

 Activities in Line Development 51

 Tools in Line Development 51

Dedication

This book is dedicated to the women in my family for what they taught me about quality—the quality of life, love, friendship, family, and, lastly, things. Many thanks go to my maternal grandmother, my paternal grandmother, my mother, my aunt, and my sister for all they have given to me in life and beyond.

Spring Naturals

Color Plate 1
Concept board for format meeting.

Color Plate 2
Colorways in thread or a color board for idea development.

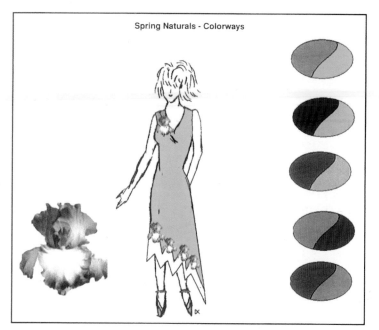

Color Plate 3
Colorways for a single product design.

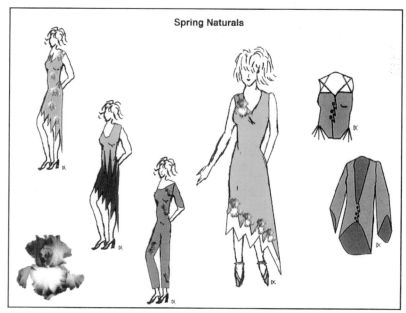

Color Plate 4
Storyboard for the slush meeting.

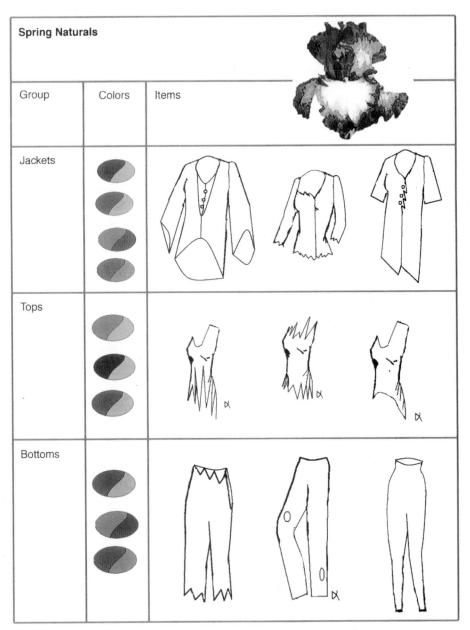

Color Plate 5
Storyboard for multiple group line.

This figure shows a multiple group line and allows the designer to coordinate looks, colors, and fabrics across several groups.

At the end of the line development stage, regardless of media, the design team will have a vast selection of ideas to share with management during the slush meeting. Traditionally, product designers worked alone at this stage and still do at small companies; however, many companies now use design teams that include designers, merchandisers, CAD specialists, and researchers. If a team is involved in the line development stage, the entire team will probably be present at the meeting, even if they are present via video conference call. Computer-rendered storyboards can be shared electronically when the development team and others in the slush meeting are not located physically in the same geographical place. By the end of the meeting, the product line will have been loosely determined with additional adjustments and rejection of products or ideas to be made in the next stage. Selected storyboards with identified colorways are outputs of this stage.

Production Development

The **production development stage** is the process of preparing to produce or manufacture the products. In this stage, the product truly transforms from an idea to reality. The products created at this time are **samples** or **prototypes.** For this reason, the product development team must consider not only the outcomes of the samples but also the projected outcomes of the actual product and must remember that not one single product but thousands or hundreds of dozens of products may be made on the basis of the sample.

Activities in Production Development

Activities needed to operationalize this stage include the following: creation or review of pattern; creation or review of samples (i.e., prototypes); development of standards for specific products (i.e., specifications); and determination of manufacturability, costing, and fit. Each step within this stage includes a variety of tools and standards. The process of creating **sample patterns** from a full-size drape is relatively simple and should adhere to standards of fit, assuming the designer used the appropriately sized dress form. The cut and pinned trim and fabric pieces of the draped product are removed carefully from the form and are outlined on tag board. Creating a sample pattern from a sketch is more difficult and is often an inexact process, especially if a fashion sketch is used as the starting point. When creating a sample pattern from a sketch, the **pattern maker** may draft the pattern from previous patterns (paper or computer) if the product body is a revision of a **carry-over style.** Carry-over styles are products that either repeat previous product styles or are based directly on a style that has been previously used. If the carry-over style information is provided, the sample

pattern maker will have some objective basis for pattern creation, and if computers are used for drafting the pattern, the pattern maker may have the simple job of finding the right file, making needed adjustments by using pattern making software, and printing the pattern. If the design is a new design, the pattern, whether done by hand or on the computer by using pattern making software, must be drafted from measurements or proportions that are inferred from the sketch. Computer software is available to assist with this transformation from the 3-D sketch to the 2-D pattern.

After the sample pattern is made, the **sample room sample** or sample is cut and sewn by a sample hand or sample maker. The **sample hand** is an expert sewer that works with the designer in the sample room. The sample at this stage is made from yardage of the actual fabric intended for the final product. Upon completion, the sample product is returned to the designer or design team for approval. Alternatively, this step in production development may be omitted and the design team may work directly with the production facility that will make the products, as described in the next paragraph. Often the sample requires adjustments. For example, the designer may find that the sample pattern maker did not properly interpret the sketch, or the actual sample may not match the mental image generated by the designer. In both cases, reiterations of pattern making and sample making would be required to **rework** the pattern or the sample. On average, a new design may require two or three reiterations before the designer is satisfied. Rework of samples generally requires adjustments to patterns and a new sample, including additional fabric yardage and sewing time. Rework of samples is common but can be reduced when design teams implement quality practices, for example, by observing the standards set by the company when creating designs and sharing more information about the design with the pattern maker and the sample hands.

A **designer approved sample** or **prototype** is sent to the merchandiser for costing. **Costing** is a process of estimating the wholesale cost and potential retail price of the product. The sample is next sent to an engineer in production management for a check of manufacturability, to determine whether the product can be sewn in the usual production facility. **Manufacturability** provides a measure of how well the product can be manufactured in the production plants. Some companies will send the sample room sample to their usual contractors or production facilities to get a production sample. This **production sample** is a more accurate sample to be used when measuring outcomes relative to the standards. If parts of a design cannot be made in house, the engineer may seek contractors who can make the needed portion of the product. **Contractors** who specialize in a few operations may be found to perform the needed work. If contractors are used, the engineer requests price lists and sample work from the contractor. Precut fabric pieces are sent to the contractor for samples of work in actual fabric. If plant capacity is a problem, contractors who sew the total product may be employed. Samples that meet cost and manufacturability guidelines are ready for a final approval. With computer usage, including data management programs and networking, much of the work of costing and manufacturability can be done simultaneously.

Tools and People in Production Development

Tools for the product development team at this stage include the pattern library, CAD software and computer hardware including scanners, digitizers, and printers. People working with the team include pattern makers and sample hands. Pattern makers may work with traditional drafting tools of boards, rules, paper, and pencil. However, most workers today use CAD, if the equipment is available. Many good software programs exist that can provide satisfactory results with the average computer. Sample hands will use spreading, cutting, and sewing equipment. They may use tables and machines similar to home sewing machines so that they can work on small details and determine process flow, or they may work with industrial equipment to maintain ideas on manufacturability.

The pattern maker may use previously created **slopers** or basic patterns as guides to create the new pattern or to check the dimensions of the drafted or traced patterns (see Figure 3–8). Slopers that represent the company sizes and the desired dimensions of the product are both tools for the pattern maker and standards for the product development team.

Current slopers and previous patterns may be stored as tag board cutouts on cords and hangers along long racks (see Figure 3–9), or these patterns may be digitally entered or created and stored as computer files. Both the

Figure 3–8
Sloper piece made from tag board.

Figure 3–9
Tag board slopers on hangers in traditional pattern library.

hanging tag boards and the computer file format are considered to be the **pattern library** for a company. These patterns are the standards for all pattern work. Some companies keep all previous product patterns for future reference, and many companies that have a long history of design or production work will have an enormous wealth of patterns.

Samples generally are made as a full-size product, with actual fabric. Only one person (i.e., the sample hand) is involved with the sewing of the item; therefore, sample-making methods are different from production methods. Sample hands are usually highly skilled sewing operators, who can often achieve construction methods that are neither feasible nor possible on the production floor.

Standards in Production Development

All of the information and decisions, including standards gathered and established in the previous stages, are used as quality guidelines for this stage. Target consumer and company information continue to be in place from the idea development stage, and fabric guidelines, colorways, and storyboards are standards that are now in place from the line development stage. To maintain a consumercentric focus, the product development team must continue to use the standards to evaluate the outputs from the process.

New standards are developed at this stage to provide guidance or **production controls** for the product. The standards that are product specific become the **specifications** for the product. Standards for sizing, shape, style, and details can be evaluated relative to the company slopers kept in the pattern library. In addition, specific product parts, such as the size of cushions on a three-cushion sofa versus a love seat or neck sizes and sleeve dimensions of a coat, may exist for the company and provide guidance for the dimensions of the pattern. Standards for pattern dimensions must be met to maintain the proper size and fit of products to ensure a quality product as the outcome. The sample patterns are adjusted on the basis of the skill of the pattern maker and limited written directions from the designer. Pattern makers must make adjustments and select dimensions with caution because a disproportional pattern may be the intent of the designer and not a pattern error. Miscommunication between the designer and the pattern maker is intensified when designers are located in market cities and pattern makers are at production facilities in distant areas. For apparel product development, **fit models** (i.e., live models with dimensions equal to the standard sample size) try on the samples so that the fit can be evaluated by the design team.

Standards for costing are coordinated with company price points, established in the first stage of the product development process, and are used as guidelines for checking the final estimated price of the product. These price points may be company standards or may have been set for specific product lines, depending on the market strategy for the product line, or management may allow new products to be finalized at a higher price point than basic or continuing products. In addition, vendor standards that dictate what vendors and under what conditions these vendors can be used are reviewed. Vendor standards are usually written for all company business but may be modified or specified for some product lines.

Manufacturability must be evaluated at the production development stage. The level of manufacturability is estimated on the basis of the skills of the sewing staff, the capacities of the equipment, and the product specifications. The standards for the manufacturability of a product are the structural specifications that are kept by the company or were developed for the product. These standards can include information on the placement and type of seams, the attachment and overall look of closings, the stitching for trims, and other product specifications. These structural specifications are often needed to satisfy consumer expectations but would not be terms or ideas that the consumer would necessarily list for his or her desired outcomes of the product. For example, if the consumer wants a product that will not lose buttons, the type of stitch used to attach the buttons must be specified by the production team and evaluated during manufacturability.

Manufacturability can be affected by the complexity of the design. A change from a thin satin fabric to a heavy plain twill fabric for a product requires a number of adjustments and perhaps different machines for producing the product. For example, the change in weight from an 11-oz. denim to

a 15-oz. denim requires resetting of all pressure controls for each machine foot, may require a heavier thread that requires a different needle, and perhaps a change in stitch or seam type that may require a different machine than was previously used. Small design changes from previous work can have large consequences for manufacturability. Even when these contractors have been used for prior work, precut fabric pieces are sent to the contractor for an evaluation of the work. This evaluation process may add several weeks to the time, but it is essential for checking the production sample against the standards for the product. Samples that do not meet **standards for manufacturing** or standards for costing are returned to designers for modifications. The redesign process may require several reiterations before final designs are ready.

In addition to production-specific standards, the general standards of the target consumer and the company image must be reviewed when the sample product is received back from the company that has sewn the sample. The product development team must also consider the themes, colorways, and other information that were determined as desirable outcomes in the line development stage. **Live models** or fit models may be used at this point to ensure that the fit of the product is in accordance with the company size standards and image.

If changes are recommended as a result of the evaluation of sample to standards and expectations, portions of the two previous stages would also need repeating. Rework at all stages is expected in a traditional product development process and is budgeted in the excess cost estimates; however, rework should be reduced and is neither expected nor desired in a TQM environment. The use of standards and a strict following of a quality analysis process should reduce rework.

Outcomes of Production Development

The production development stage concludes with the **freeze meeting,** which is scheduled to examine the product line offerings from the design team and make final decisions about the assortment of products that the company will offer to its customers. The freeze meeting usually includes the same team assembled for the format and slush meetings. Some manufacturers also include retail buyers at the freeze meetings. For the freeze meeting, the walls of the room are traditionally hung with the samples for final visual approval (see Figure 3–10). The overall look of the samples and the match of the samples to the colorways and other specifications can be double-checked at this point.

Instead of actual samples, the design teams may make computer presentations by using PowerPoint with digital pictures and video clips. Through the use of visual networking, the meeting may include virtual attendance from buyers and sales representatives who are located around the globe. At this time, the team members mentally review the **standards for the line** as written on the specification sheets and evaluate whether the final designs meet these quality controls. In addition, the theme is reviewed and all items are judged for their contributions to this theme. The evaluation process can

Figure 3–10
Samples displayed for freeze meeting.

be quantitative with evaluation sheets and check lists. The process can also be very subjective. Members of the team may veto a design on the basis of fashion instincts, a personal dislike of a color or pattern, or the opinion of a non-team member. In some companies, the owner and/or manager has the final acceptance or rejection for all designs. At any stage, management can request redesigns or new designs. The decisions made at the freeze meeting may be acceptance of a design, rejection of a design, or requests for redesign. Outputs at this stage are the specification sheets and the samples or proto-types that are selected for the season's product line.

Sales Development

The **sales development stage** prepares the product samples for a trip to the market. During sales development, the product is made ready for out-side review. The **market system** or the process of selling sewn product items at showrooms during market weeks in major cities is a unique process that has major implications for the design and manufacturing of the items in a traditional product pipeline. Such products are not usually designed to order. Instead, designers forecast what they think consumers will like; what

they think will sell; and what they think will be new, different, and exciting. In a few companies, the entire product line may be based solely on a designer's instinct or hunch about the products' salability. When the product goes to market, the product development team gets an evaluation of their many months' work. They may find that some of what they have done is rejected, which creates much waste. Improved determinations of the consumer's expectations and rigid evaluations throughout the process can help to avoid costly errors.

Demand uncertainty especially with fashionable and seasonable products is a critical issue to a sewn products manufacturer. The manufacturer has invested a large amount of time and other resources long before any commitments for orders are received. A product line could be completely rejected by the retail buyers; meanwhile, the manufacturer has purchased sample fabric, has paid designers, has expended time at the market, and has lost the window of opportunity to sell for the season. Although the consumercentric product process has new problems of turn time and flexibility, this process can remove the issues of forecasting and speculation. The expectations of the consumer must be accurately interpreted through the expectations of the retail buyer, if this channel is used. In all situations, the standards of the product manufacturer, the retailer, and the consumer must be met for the product to be acceptable.

Activities in Sales Development

Activities within this stage include market sample preparation, premarket selling, and prelining and market research for next season. When the final designs for the line are selected (i.e., output of the freeze meeting), a pattern maker makes a **master production pattern,** and **duplicate samples** (i.e., **dups**) are made for use at market, for sales through factory-trained sales staff often called **sales representatives** (i.e., **sales reps**) or **account executives**, and for photo shoots to create videos, Web pages, and catalogs. The duplications or dups are made by production sewers. Actual fabric has been ordered and is used for the dups, and they must be inspected for conformance to the specifications and the approved sample before being released to the sales reps. When the dups go to market, they are called **road samples**. Presentation of road samples is done through the market system. The market system is a very structured process of showings during specified market weeks in specific market cities. Road samples may be taken to market and shown in showrooms or in runway shows or may be taken directly to the retail buyer or store manager at the store. Other manufacturers use a technique called **preselling** or **prelining**, in which the selections from the freeze meeting are shown to a panel of retailers for opinions and preliminary orders.

During the market or in **market weeks**, the showings may be at the design or market offices of companies or in showrooms in large market or convention buildings. The major **market city** for women's apparel in the

United States is New York City; however, market weeks are also held in Atlanta, Dallas, and other major cities. One major market city for menswear is Las Vegas. The market week for home furnishings is held twice a year in High Point, North Carolina, and a recent addition to the market cities for home furnishings is Las Vegas. Live models are used to display the apparel products in individual presentations or large runway shows for the retail buyers. Over 60 percent of all apparel items sold at wholesale in the United States are sold during market weeks in New York. Some companies are now using catalogs, CDs, or Web sites to do the market presentations. This method is popular with companies that are doing product development with CAD and may result in a virtual product line with no actual production of first samples or road samples. Carrying the samples on the road to retail stores is often done to service the customers who own small independent stores. In a traditional product development process, the road samples are shown to retailer buyers who are intermediaries between manufacturers and consumers. In a truly consumercentric system, an item produced at this stage would not be a road sample for presentation to retail buyers, rather it would be the actual product shipped directly to the consumer, and the sales process at market would be eliminated.

Tools and People in Sales Development

As the product development team prepares for market, they use the first samples and dups for examples of the product. They may also use digital images for computer projection of the products or catalog productions. Live models may be used for company or market produced runway shows and for video images. These images may be shown on Web sites that are available to specific retail customers or used in preparation of CDs or DVDs that are sent to known retail customers or perspective retailers. Production pattern makers and contractors may be used for producing enough samples for sales representatives and the market shows.

Standards in Sales Development

After premarket manufacturing the dups are measured and evaluated against the product specifications, the first samples, and all previous company and target consumer standards. Every standard used during the first three stages must be re-reviewed and used for evaluating these dups. They are going to market. They will be critically viewed by the buyers. A second chance will not be given to any product that fails to excite, enchant, or captivate the buyers. The buyers will have expectations or standards in their minds when they review the products. These retail standards may or may not be known by the product development team. In a consumercentric system, the product development team will be working closely with the buyer and/or consumer to know exactly what is expected. The traditionally operating team may find that the buyer and the consumer have expectations

that were not previously identified or that have changed since the last season's sales.

The final standard for this stage is the **sales volume goal** for this year or this season and its growth or relation to the sales achieved in this season last year. First, the manufacturing firm will evaluate the **sell-in** or the amount of product sold to the retail buyers. Next, **sell-thru** to the final consumer, or the amount of product sold by the retailer to its customers, may be measured and evaluated. Both evaluations are important to ensure that the goals of not only sales to retail buyers but also sales to the final consumer are met at a satisfactory level. The final evaluation is always made by the consumers. A quality product is one that, when purchased and used, meets the consumer's expectations.

Outcomes of Sales Development

Taking the product to market is the final activity of the product development process. Outcomes for the sales development stage are the **racks of dups** that are ready to be shown at market or taken by sales representatives to special retail customers (see Figure 3–11). The **video images,** in CDs, in DVDs, or in catalogs, are also outcomes that are taken to market, sent to customers, and put on the company Web site. Although not a direct outcome of the sales development stage, rather an outcome of the next stage (i.e., market sales), the orders taken at market are very important and are considered at this stage. The goal of the entire product development process is the sale to the retail buyer and the final sale to the consumer. Sell-thru or the sale at retail to a satisfied consumer is very important.

Figure 3–11 Samples on racks in show room.

Key Terms

Account executives
Basic bodies
Brand colors
Carry-over style
Color board
Color theme
Colorways
Company croquis
Computer tools
Concept boards
Contractors
Controls
Costing
Croquis
Customized product forms
Demand uncertainty
Design process reiterations
Designer approved sample
Draping
Duplicate samples
Dups
Fashion sketches
Fit models
Format meeting
Freeze meeting
Hot sellers

Idea development stage
Idea development team
Just-in-Time (JIT)
Line development stage
Live models
Manufacturability
Market city
Market system
Market weeks
Master production pattern
Pattern library
Pattern maker
Prelining
Preselling
Problem recognition
Product designs
Product development
Product development process
Product line
Production controls
Production development stage
Production sample
Prototype
Quick Response (QR)
Racks of dups
Rework

Road samples
Sales development stage
Sales representatives
Sales reps
Sales volume goal
Sample hand
Sample patterns
Sample room sample
Sample size
Samples
Sell-in
Sell-thru
Slopers
Slush meeting
Specifications
Standards for costing
Standards for fabric quality
Standards for manufacturing
Standards for the line
Storyboards
Swipes
Technical sketches
Traditional tools
Video images

Review Questions

1. What is a classification system used in the United States?
2. What are end use of sewn products?
3. How can fashionality and seasonality be used as classifications to identify sewn products?
4. What is turn of sewn products?
5. What are the four stages in the product development calendar?
6. What is the approximate time to retail for each step?

7. How/where does the company get consumer expectation information at the idea step?
8. What standards are used for evaluating consumer expectations at the idea development stage?
9. How can a theme be used for a standard for sewn products?
10. What is the difference between a concept board and a storyboard?
11. What are croquis? How can they be used as a standard?

12. What tools are used in line development?
13. Who are the sample hands?
14. What is the difference between the first sample and the duplication samples?
15. What is a colorway? How is colorway selection different from color selection in Stage 1?
16. When does the company decide upon the choice of fabric? How does the timing of this decision affect the choices?
17. What is a prototype?
18. When does the company "weed the line"?
19. What would be in a pattern library?
20. What is the material used for making slopers?
21. What is manufacturability?
22. How can a fit model be a standard? When are live models used?

23. What is a dup? What is the standard that is used to evaluate a dup?
24. What is the final evaluation for the entire product development process?
25. How can sales goals be a standard during product development?
26. What is sell-in and sell-thru?
27. When does the manufacturer know that a quality product was made?
28. Name at least three activities within each stage?
29. What is the evaluation meeting for each stage?
30. What are two standards that are used in making the evaluation in each stage?

References

Cotton Incorporated. (2005). Sizing it up: Manufacturers take a more realistic approach to fit. *Women's Wear Articles, Cotton Incorporated.* Retrieved April 4, 2005, from http://www.cottoninc.com

Crosby, P. (1979). *Quality is free.* New York: Mentor Books.

Information on SIC and NAICS. (2001). North American Industry Classification System (NAICS). Retrieved August 29, 2005, from www.census.gov

Kincade, D. H. (1995). Quick Response management system for the apparel industry: Definition through technologies. *Clothing and Textiles Research Journal, 13,* 245–251.

Schonberger, R. (1982). *Japanese manufacturing techniques.* New York: Free Press.

[TC]². (2006). Our history. Turning research into history. Retrieved September 7, 2006, from www.tc2.com

Fibers, Yarns, and Fabrics: Standards, Measurement, and Evaluation

The understanding of the raw materials, especially the textile product, used for sewn products is essential to the study of quality of these items in their finished form. **Raw materials** are the building blocks of each sewn product and can be composed of a wide array of materials including textiles, leather, fur, metals, and vinyl films. The primary raw material for sewn products is textiles. **Textiles** are made of fibers and are constructed through weaving, knitting, bonding, or other composition type processing and the final product of these processes is often called a fabric. Additional raw materials include trim, fasteners, and other materials added to the body materials. Each raw material contributes unique characteristics to an item and directly relates to how the item is constructed or processed, to what outcomes emerge, and often to how it is sold. Each raw material has its own physical, sometimes chemical, and associated abstract properties that can be described with component descriptors or other characteristics. For example, cotton is a natural fiber, grown on a stiff bush-like plant in sandy soil fields (see Figure 4–1). The cotton fiber is short, water absorbent, and flexible. The characteristics or properties of the

Figure 4–1
Cotton growing in field with bolls ready to harvest.

fiber contribute to the raw material's and ultimately to the final product's outcomes. The terminology, technology, and mechanics of the origin, production, and outcome of all raw materials in a product become important to the quality analysis process. All of these properties must be considered when determining the desired quality to meet the expectations of the consumer.

Raw materials are the inputs to the entire system and are factors in the decisions that must be made about processes to develop, produce, and deliver the product and anticipated outcomes for the product. A small bag made of leather must be cut and sewn with great care because the raw material is

expensive and each stitch marks the leather. On the other hand, a knit T-shirt can be cut rapidly with an automated process and sewn by operators with limited skills. The resulting products will be sold through various media at price points appropriate for the product, the retailer, and the consumer. To determine quality and evaluate consumer satisfaction, sewn products can be measured by a number of criteria relative to the components of inputs, processes, and outputs for the product. The sewn product is not only a representation of each building component, but also a sum of the whole and must be evaluated at multiple levels when determining the quality of the product and the potential satisfaction of the consumer.

The components of the raw materials affect the handing of these materials in the processes of product development and production (see Figure 1–2 for a review of the product system). Descriptor characteristics of each of the three outcomes (i.e., fit, fashionality, and functionality) are affected by the physical properties of the raw materials. Physical properties of raw materials are affected by the underlying chemical and physical structures of these raw materials.

Physical Properties of Fibers

The smallest component of a fabric for sewn products is the **fiber. Physical properties** of a fiber include such attributes as type, cross-sectional structure, and surface texture. Physical properties for fibers are numerous and can be described with specific textile terminology. Some of the basic physical properties and associated **descriptor characteristics** are listed in Table 4–1. For type, fiber is divided into three categories: natural, man-made, and synthetic. The man-made category indicates fibers with their origins in natural fiber but with changes occurring in the laboratory or production facility to develop altered chemical or physical structures from the original natural fiber. Synthetic fibers are typically generated in production facilities from derivatives of crude oil or petroleum.

Table 4–1
Selected Physical Properties of Fibers

Physical Properties	Descriptor Characteristics
Type	Natural, man-made, synthetics
Cross-section	Tube, dogbone
Surface texture	Scaly, etched
Size or diameter	Thick, medium, thin, fine
Length	Staple, filament
Finish	Crimp, textured

Types of **natural fibers** include but are not limited to the following: cotton, wool, linen, silk, ramie, and cashmere. Each of these fibers has its own unique physical and chemical structures that contribute to their physical characteristics. In general, natural fibers are absorbent, soft to the hand, and can be machine washed, but even this generalization has exceptions. For example, wool is generally best maintained with a dry cleaning approach instead of water washing. The **man-made fibers** include acetate and rayon, which maintain some of the characteristics of their cotton origins (e.g., absorbs water) and have some new characteristics from the manufacturing process (e.g., shiny surface). Some types of **synthetic fibers** are acrylic, nylon, polyester, and spandex. Some of these fibers have **trade names** or company brand as well as their **generic textile names.** For example, polyester created by Dupont and now marketed by INVISTA is called Dacron®, and spandex is sold as Lycra®. In general, synthetic fibers are easy to wash but get oily stains, feel lightweight, and dry quickly. Some new "high-tech" products are combinations of natural and synthetic fibers to form hybrid yarns such as the Dri-release® product.

A set of physical properties can be delineated for each fiber. For example, the cross-section of cotton is seen as a hollow tube in a microscopic view because of its structure from the cotton plant. The fiber is also short in length, called a **staple length,** and tends to have an uneven diameter along the length of the fiber. The naturalness of the fiber is evident when observing the physical characteristics and contributes to its outcomes of ability to be twisted, to have a soft feel, and to absorb moisture. With another fiber, polyester, the set of physical properties is very different from cotton and has differing outcomes. Synthetic fibers, because of their creation in the manufacturing plant from a vat of "chemical soup," can be formed into **filaments** that are miles long, or they can be chopped into short fibers and simulate the staple length of natural fibers. The **surface texture** of polyester is usually smooth as it is formed in manufacturing but can be etched with acid or abrasives or pushed through a specialized spinneret to provide a rough surface. The smooth surface can be used when planning a new product with a slick shiny surface for the product and a lustrous look to the fabric, or the fiber can be altered in further processing to be rough because of an etched surface or to be wrinkly because of fiber crimping.

Quality Considerations with Fiber

Although a fiber is an extremely small building block within a sewn product, the fiber's physical and chemical properties affect the product's outcomes, which become a quality concern when trying to meet the consumer's expectations in a consumercentric environment. The smooth surface and compact chemical structure of a basic polyester means that the fiber is easy to wash and dry, but the petroleum "roots" of this fiber means that it has an affinity for oil-based dirt. For example, if salad dressing is spilled on a polyester content tablecloth, the spill may become a permanent stain because the oil in

the dressing is compatible with the oil-based structure of the fiber. As the fiber is a building block in a series of processes, the fiber characteristics must be considered within the frame of the subsequent product characteristic choices. The choice of fabric structure when forming the fabric contributes to the outcome of product and can mask the original fiber characteristics. A loose weave with a smooth polyester fiber can appear to be rough because of the dimensions of the weave.

In another example, the scaly surface of a wool fiber makes it feel scratchy to the skin of some consumers but enables wool to be insulative and to provide thermal functions for the consumer. A wool blanket has many natural air pockets that can trap air for insulation. This natural property can be enhanced in the processing of the product by constructing the fibers into loose yarns and by weaving the yarns into loose structures. Each choice in selecting the physical characteristics of fibers affects product outcomes and ultimately the quality of the product. A sweater made of cashmere is not necessarily a better quality sweater than one made of acrylic. The decision on quality is dependent on the expectations of the consumer. If the consumer expects a sweater that is washable, long lasting, and low cost, the choice of acrylic for the sweater will be a decision to render a better quality product than the choice of cashmere. Because choice of the right fiber is vital to the development of a product with the expected outcomes, the designer, merchandiser, buyer, and other industry personnel responsible for developing and delivering a quality product to meet a consumer's satisfaction must have extensive knowledge of textiles and the product outcomes to which each raw material can contribute.

Another quality consideration for fibers is the need for standards among natural fibers, especially cotton. Cotton is grown in several places throughout the world and is affected by the climate, native soil, local farming practices, and seed used for the plants (see Figure 4–2). For these reasons, cotton from one geographic location may show much variance in physical properties from cotton grown in another region. The concern is that with variance in the diameter, length, weight and other physical properties among units of cotton, the yarn, fabric, and sewn product made from various cottons will not be standardized in their outcomes. This variance affects the manufacturability of the raw materials into fabrics and the final hand, durability, and other characteristics of the sewn product. The U.S. Department of Agriculture (USDA) has worked on guidelines for standardization of cotton fibers for numerous years because this product has been an important crop for U.S. farmers (Keyes, Knowlton, and Patterson, 2005). Although the USDA has been a leader in introducing standards and pressing for acceptance of standards of cotton, other organizations, including the ISO, have set forth standards on cotton. ISO 2403 and ISO 4911 are two standards that govern the measurement practices for sizing and classifying cotton fibers. As the world becomes more integrated with global trade and end products are produced with raw materials from multiple locations, the need for development and acceptance of standards for fibers becomes more important.

Figure 4–2
Harvested cotton in a field in eastern North Carolina.

Physical Properties of Yarns

The second level or component of raw materials for most sewn products is yarn. **Yarns** are interlaced fibers that form long threadlike structures. Some fibers are naturally long (e.g., silk) or are created long in the fiber manufacturing process (e.g., polyester). Yarns have many descriptive characteristics that are derived from their physical properties (see Table 4–2 for a partial listing). These properties and associated descriptive characteristics can be itemized in specific textile terminology. In addition, each of these properties contributes not only to the overall characteristics of fabric, but also to the many dimensions found in the outcomes of a sewn product.

Each physical property has characteristics that belong uniquely to that yarn. For example, several types of yarns can be considered for products: spun, filament, and multifilament (see Figure 4–3). Most **spun yarns** are made from natural fibers and are created by spinning or twisting together the fibers to create a length that is sufficient for weaving. Synthetic fibers can be spun but are more often used as the long continuous filaments, in

Table 4–2
Selected Physical Properties of Yarns

Physical Property	Descriptor Characteristics
Content	Percentage of fiber
Ply	Single, 2-ply, 3-ply, complex
Size	Yarn number, denier
Twist	S twist, Z twist
Type	Spun, filament, spun-core, multifilament

either single or multiple units, which are created in the fiber manufacturing plant. The **spun-core yarn** is a combination of a filament that is wrapped with a web or a coating of short fibers. This yarn has the combined properties of the spun and the filament yarns.

A second important property of yarns to consider when doing quality analysis is **ply.** The ply indicates the number of basic components that are

Figure 4–3
Types of yarns: a = spun; b = monofilament; c = multifilament.

spun together to make the yarn. For example, a **2-ply yarn** has two yarns that are twisted together to be used as one yarn. The ply varies from a single ply of either a staple or filament yarn to the multi-strand complex ply of specialty yarns. The ply of the yarn affects the flexibility, pilling, drape, and other outcome dimensions of the yarn and therefore of the fabric and the final product. Selecting the yarn ply predetermines some outcomes of the fabric. A **complex yarn** or **complex ply** has multiple yarns twisted together and may have yarns with slubs, loops, or other structure variances. For example, a complex ply structure with large strands can create a yarn that has a large overall diameter, which could be used to create a thick fabric for a warm winter sweater or a very durable upholstery fabric. This yarn can create an aesthetic effect for a product. Samples of several yarns with various plies are shown in Figure 4–4.

Yarn twist is another yarn property that affects the outcomes of the sewn product. The **twist** describes the direction of the spinning as the yarn is constructed. Examples of yarn twist are **Z twist** and **S twist.** Yarn twist is important when selecting sewing threads (see Chapter 6).

Figure 4–4
Examples of yarn ply: a = 1-ply; b = 2-ply; c = complex ply; d = complex ply or bouclé yarn.

Quality Considerations for Yarn

The physical properties of yarns in conjunction with the fiber's properties affect the product's outcomes, especially functionality. For example, a spun yarn made with short staple fibers is fuzzy, has a weak structure, shows a dull surface, collects dirt easily, and produces voluminous lint. In contrast, a multifilament yarn created from long filaments is smooth and strong, shows a slick or lustrous surface, collects less dirt, and is somewhat resistant to pilling. When special aesthetic effects are desired for a yarn, the designer can use a complex ply yarn made from a number of fibers or fibers that differ in textures and content. This yarn could contain fibers with slubs for texture or specialty fibers such as plastic (e.g., Mylar™) or metal (e.g., gold) for color and shimmer. This yarn, because of its complex and lumpy structure, is weak, subject to snags and pilling, and requires specialized care in cleaning. The designer can create a yarn that cannot be cleaned by spinning together wool fibers that are best dry cleaned and plastic fibers that disintegrate during dry cleaning.

Selection of fibers and yarns must be carefully made with consideration of the physical properties and the outcomes rendered by these choices because each component of the raw material affects the outcomes and the quality of the product. A multi-ply yarn is more complex than a single ply yarn, but it is not better or worse when considering its implications for the quality of the product. The multi-ply yarn provides texture for the surface of the product and allows the designer to mix fiber types and to include some nonfiber materials in the fabric. This yarn is a quality yarn if these outcomes are desired by the consumer. The yarn is not a quality yarn if a smooth plain yarn is expected, such as is needed when the consumer has a desire for a luxurious, satiny smooth evening gown or a smooth and soft bed sheet.

Physical Properties of Fabrics

The third level or component of raw materials is fabric. Fibers are spun, twisted, or placed to make yarns, and yarns are combined through various construction methods (e.g., weaving, knitting, bonding) to make **fabric.** Fabrics have their own set of physical properties that contribute unique characteristics for each fabric type in addition to the characteristics contributed by the fiber and yarn within the fabric structure (see Table 4–3 for a partial listing).

A fabric's outcomes are functions of the fibers and the yarns that are integrated into the fabric. Because of the multiple contributing components, the resulting outcomes of a fabric can be very complex and difficult to describe without examining each property of the fiber, the yarn, and the fabric. To add to this complexity for quality evaluation, the combination of various physical properties of the fibers and yarns within the fabric contribute to the characteristics of the product, including the outcomes of the product.

Table 4–3
Selected Physical Properties of Fabrics

Physical Property	Descriptor Characteristics
Color (hue, shade, tint)	Light red, navy blue
Density	Sheer, opaque
Fiber content	100%, 50/50
Finishes	Chintz, water repellent
Surface contour	Fuzzy, satiny, slick
Type (structure)	Woven, knit
Weight (oz./yd.)	Light, medium
Width (selvage to selvage)	45″, 60″
Yarn count (warp + filling/in^2)	100, 120, 180

Type of fabric is generally described by the **fabric construction,** and for most fabrics it is either woven or knitted. The **plain weave** is shown in Figure 4–5. The yarns create a crosshatch pattern with an interlacing of one over and one under for each yarn. If the fabric is placed as it is manufactured, the vertical yarns are the **warp** or **ends** and run parallel to the edge or the

Figure 4–5
Plain weave.

Table 4–4
Fabric Weaves with Examples of Each Type

Weave Type	Fabric Names
Plain weave	• Chintz • Chambray • Crepe de chine • Georgette • Oxford cloth
Rib weave	• Taffeta • Poplin
Twill weave	• Denim • Gabardine
Satin weave	• Satin • Sateen
Pile weave	• Corduroy • Velvet • Terry Cloth
Dobby weave	• Pique • Bird's eye
Jacquard	• Tapestry • Logo patterns

selvage of the fabric. The horizontal or crosswise yarns are the **filling** or filling yarns and are also called **weft**, **woof**, or **picks**.

Woven and knitted structures have specific formations and names for those formations. Table 4–4 provides a list of basic weaves and associated fabric names for these weaves. When combined with specific yarns, fibers, or colors for their inherent properties, the fabrics have trade or common-use names.

Knits have their own unique structure for the formation of fabric with associated names for the subcategories or the types of knits. Knits may be weft or warp knits. One of the simple weft or filling knits is the **plain knit** (see Figure 4–6). Views of both the front or **face** of the fabric and the back of the fabric are shown because the two sides of the fabric are different. The front is characterized by the vertical direction seen in the fabric yarns or the **wales** and is basically a flat surface. The back is characterized by the more horizontal aspect of the yarns or the **courses.** As with woven fabrics, the structures have additional variance when combining specific fibers, yarns, and colors to form unique structures.

Various knit types or structures with associated names are listed in Table 4–5. Texturizing fibers or finishing fabrics can also contribute to the outcome of the fabric characteristic and then to the product outcomes. For example, the pile knit is a plain knit with an additional set of yarns to form the pile. When this pile is deep or long and is dyed colors to simulate animal skins, this pile knit is a fake fur. When the pile surface is cut short and brushed, the pile knit is a suede fabric.

Figure 4–6
Plain or jersey knit: a = front or face; b = back or underside of fabric.

The choices of type of knit and associated components determine the outcomes of the fabric, and these characteristics and outcomes must be selected carefully to deliver the expected quality. In addition to woven or knitted structures for fabrics, a few raw materials used in sewn products are extruded, such as plastic films, and other materials are formed from fibers by matting (e.g., felt) or other web developments (e.g., nonwovens).

Quality Considerations for Fabric

The physical properties of the fabric contribute to the quality outcomes of the fabric and the product. If a consumer desires a T-shirt that is soft, absorbent, and breathable (i.e., functionality), the product designer or merchandiser must understand the physical and chemical characteristics of the fibers to determine which fiber would be the best choice to meet the consumer's expectations for product outcome. An example of the effect that fibers have on product outcomes is seen in the degree of absorbency that cotton fibers contribute to a T-shirt in comparison to the absorbency offered

Table 4–5
Knit Types with Examples

Knit Types	Names of Knits
Plain knit	• Jersey • T-shirt or sweater
Rib knit	• Single width rib for cuffs and collars (knit/purl) • Multiple width ribs for sweaters
Pile knit	• Ultrasuede® • Fake fur • Velour
Double knit	• Double knit
Tricot	• Tricot as used for lingerie
Pattern	• Fisherman's knit

Figure 4–7
Comparison of interfacings: a = low wool content; b = high wool content.

by a blend of 40% cotton and 60% polyester. The 100% cotton content has a higher absorbency than the blended fibers.

In Figure 4–7, the fiber content of the two interfacing fabrics varies from a small percentage of wool content and a high percentage of cotton in Sample A to a high percentage of wool content in Sample B, with a corresponding low percentage of cotton. The fabric with the higher content of wool will react more like the hair fibers and will have more of the desired felting and shaping properties needed for interfacing in a tailored jacket.

In addition, the designer or merchandiser must understand how fibers are combined into yarns and are then knit into the fabric because all raw materials components and associated processes integrate to provide the outcome for the product. Cotton staple fibers that are loosely twisted into yarns and knitted with a large gauge into a fabric will enhance air permeability as opposed to a tightly knitted fabric. However, this loosely twisted yarn results in poor durability, especially in comparison to the performance of a tightly twisted yarn and a smaller gauge or closer packed knit. While creating a product that is cool and comfortable to wear, the designer may be reducing levels of other outcomes for the product, which may also be important to the consumer.

Comprehensive testing is needed when evaluating textile components relative to quality expectations. For the samples in Figure 4–8, the density of the fiber varies. Sample A has a low density, and the lined rule paper behind the sample is visible. Sample B has a high density, and the lined rule paper is not visible behind the fabric. The disposable medical gowns made from fabric such as Sample A will have increased breatheability, but the gowns made from Sample B will have increased capacity to resist spills and provide more protection to the wearer. The person choosing the medical gowns will have to consider the purpose of the gowns and the outcomes and features that the various fabrics will provide to the wearer.

Many product outcomes related to fibers, yarns, and fabrics are measured and evaluated by using data from specific textile tests; however, the consumer usually does not provide his or her expectations in these quantifiable textile terms. Although consumer research is an important division within many companies, designers and buyers often work with limited concrete information

Figure 4–8
Fabric for disposable medical uniforms: a = low density; b = high density.

from the consumer. For these reasons, the designer, merchandiser or product manager must be able to interpret the abstract and often changing terms used by consumers into more precise and concrete dimensions used to measure fiber, yarn, or fabric. For analysis of product outcomes, tests measure performances of the raw materials (i.e., fiber, yarn, fabric) and are consequently used to evaluate the expected outcomes or quality of the sewn product.

Performance Tests of Textiles for Examining Product Outcomes

Many **performance tests** used in testing textiles are established by AATCC or ASTM. Full descriptions of test methods are available through test manuals from these organizations. Lists of tests and their descriptions are also available on line from http://www.aatcc.org and http://www.astm.org. Many of these tests are used and recognized worldwide. The U.S. government has identified appropriate **AATCC tests** or **ASTM tests** with standards that are set for acceptable quality levels of sewn products used by the U.S. government. In addition to tests from ASTM and AATCC, the U.S. government provides a test method standard, Federal Test Method Standard #191, which is designed to test and evaluate fibers, yarns, and fabrics used in preparing sewn products for the U.S. military. Other firms and governments or groups of countries may also have tests with associated standards for sewn products. Businesses selling products in various countries should check to be certain they are knowledgeable about product testing in the targeted location. **Test methods** from AATCC and ASTM include descriptions of the test, conditions for sampling and for performing the test, and, possibly, methods for evaluating outcomes. Some companies have their own tests, test methods, and standards that are acceptable predictors of quality and satisfaction for their specific customer. Although most of these tests are quantitative in test method, some sewn products may be tested with the human visual and tactile senses.

The merchandiser, buyer, or product manager must test at each component level within the product system to ensure the expected outcome. For example, shrinkage rates of fibers, yarns, fabrics, or products can be measured and evaluated for their impact on outcomes. Each of the three broad outcomes (i.e., functionality, fit, and fashionality) can be described with various components or topical dimensions. Groupings of these dimensions can be made relative to general consumer usage and expectations. These **topical dimensions** can be tested for criteria with performance tests that simulate the use of the fabric relative to expected outcomes.

Standards and Tests of Fabric for Functionality

Tests that are frequently used for measuring and evaluating dimensions of the functional outcome include tests in the areas of movement, strength, degradation, and safety. Tests are also used to measure the effects of laundering when the expected functional outcome is easy care, or the effects of dry cleaning if that is the suggested method of care. Because of the complexity of the sewn product and the interaction among properties, the need to test a single dimension through multiple methods or multiple criteria becomes essential. For some criteria of functional outcomes, such as abrasion resistance or breaking strength, several procedures are available, varying with test method (see Table 4–6). Each test method was developed to simulate a specific movement with or use of the fabric. For example, to test for bursting strength, the test can be made with a constant extension pressure from a ball (ASTM D6797-02), with a constant rate of traverse pressure from a ball (ASTM D3787-01), or with an inflated diaphragm (ASTM D3786-01). Each one of these tests simulates a different movement of the body and various types of pressures exerted on the fabric.

The lists in Table 4–6 and in subsequent tables are provided as examples and are not intended to be inclusive. As part of a TQM program, any trading partner must clearly communicate tests and expected outcomes from those tests to all other trading partners. Information about outcomes of the tests can and should be shared along with the transmission of the product. Many manufacturers who are doing cutting and sewing will want to have the results of fabric analysis prior to receiving the shipment of the fabric, especially for overall dimensions and other physical properties that could affect the production process.

In any situation, companies within the sewn products pipeline may depend on other firms for standards or may develop and establish their own standards through research with various fabrics and consumers. When doing business with a company, both vendors and customers must be aware of the standards and tests that are required by that company.

Because sewn products are used by humans, the types and directions of forces placed on the fabric are complex and multitudinous. Many additional dimensions and criteria can be found in standards books or created as company-specific items. Besides testing through multiple methods for one criterion,

Table 4–6

Examples of Topical Dimensions for Functionality Outcome

Topical Dimensions	Criteria	Tests	Standards[a]
Air and water transfer			
	Water repellency: spray test	AATCC 22	n/a
	Air permeability	ASTM D737-96	n/a
Movement			
	Elongation (stretch length)	AATCC 96 5lb load	2.0%
	Elasticity (stretch and return)	ASTM D2594-99a	n/a
	Flexibility (bending)	ASTM D1388	n/a
	Resiliency (bend and return)	ASTM D6720-01	n/a
Strength			
	Abrasion resistance (rub)	ASTM D3884 or AATCC 93	n/a
	Breaking strength	ASTM D5034-95 or D5035-95	17-lbs woven
	Bursting strength (hole)	ASTM D3786-01	n/a
	Tearing strength (rip)	ASTM D1424	Warp 8, Fill 5
	Tensile strength (pull)	ASTM D5034-95(2001)	Warp 150, Fill 80
Degradation			
	Chemical (chlorine, ozone)	Observation	No color change
	Ozone	AATCC 109	4.0 after 2 cycles
	Perspiration (shade change or colorfastness)	AATCC 15	Class 4
	Sun (fading)	AATCC 16	Class 4 after 20 hours
Launderability			
	Bleaching (chlorine)	Observation	No color change
	Button holes	Observation	Negligible change with wash
	Changes in original surface	AATCC 124	None
	Colorfastness to laundering (fading)	AATCC 61	4 gray scale
Safety			
	Flammability: general flame retardant at 45 degree	CPSC Part 1610 or ASTM D1230-01	Class 1
	Flammability: vertical for children's sleepwear	CPSC Part 1615-16 or ASTM D6545-00	As defined by standard
	Bullet retardant	Observation	n/a
	Water repellency: rain test	AATCC 35	Rainproof rating (2 ft./2 min)
	Water repellency: spray test	AATCC 22	Over 70
Overall dimensions			
	Weight, oz./sq. yd.	ASTM D3776-96(2002)	\pm ½ oz. from spec
	Width inside selvage	ASTM D3774	n/a

Note. AATCC = American Association of Textile Chemists and Colorists; ASTM = ASTM International; CPSC = U.S. Consumer Product Safety Commission.
[a]Standards are based on common industry practice or standards used by some major retailers or manufacturers. n/a = no generally accepted standard is available.

some dimensions of the outcomes may need to be tested across several criteria. **Durability,** which describes the ability of the product and/or its components to withstand use, is a dimension of functionality that many consumers say that they desire. When doing a product analysis on a sewn product to evaluate durability, the designer or buyer must first determine what are the consumers' expectations or desired criteria. Durability could mean that the thread in the seams lasts as long as the fabric lasts. Alternatively, durability could mean that the fabric is strong enough to resist rubbing or puncturing. In addition, the consumer may want the fabric on an item of furniture to last for years as multitudes of people sit on and rise from the piece. On the other hand, the fabric on a window shade must resist tearing when it is pulled down and rerolled over hundreds of mornings. Because the dimensions of the outcomes are so varied, multiple tests may be needed to explore some outcomes.

Comfort is another dimension of a sewn product that is often associated with function but is best described as cross-functional. Criteria and tests that are in both the functional outcome and the fit outcome can be used to evaluate comfort. Comfort is often a blend of the consumer's perception of air and water transfer from body to and through fabric as well as the stretch or elasticity that is found in the fabric. Comfort, as well as other dimensions, is also influenced by the structure of the product that is developed in the sewing process. All dimensions are outcomes of the entire system and not just one characteristic or feature of one fiber or other raw material part.

Functional outcomes are also affected by the construction of the product. Several examples can illuminate the need for testing of both raw materials and finished product. Whether seams hold through extended use is affected by the assembly processes; incorrect adjustments on a sewing machine can affect seam outcomes. If a fabric shifts when pressured in sewing or it sags when hung, dimensions may be satisfactory in the fabric but are altered during production or use. Additional standards need to be set to measure functional aspects of a finished product, including construction processes. ASTM has standards that are developed to measure strength of seams (e.g., ASTM D1683-04) or zipper strength (e.g., ASTM D4465-97; D3692-89, 03). In addition, fabrics can be tested by ASTM methods for specific functional purposes such as swimwear (e.g., ASTM D3996-02) and for specific home furnishings uses such as bedspreads (ASTM D4037), slipcovers (ASTM D4113-02), and shower curtains (ASTM D5378-93, 03).

Standards and Tests of Fabric for Fit

Fit is affected by numerous factors within raw materials. Fit for apparel items, or the conformance of the product to the body, is of concern throughout the life of the product as it is donned, doffed, and used. Fit for home furnishings may be of concern only during production as pieces of the body fabric are fit to

cushions, framing, or other structural pieces, or it may be an end-use concern as to how well the product fits within the space for use or how well the body fits in the product when used. Fit, as with other outcomes, is affected not only by the final properties of the fabric but by the properties of the components of that fabric. For example, elasticity can be achieved in a product from the inherent elasticity of the fiber or from the dimensional shifts that can be achieved through knits. In addition, fit can be altered through the care process. Shrinking and other permanent dimensional changes that occur when washing or cleaning a product can negate a fit that was once satisfactory for the customer.

Some of the topical dimensions that are associated with fit are listed in Table 4–7. One of these dimensions is the same as those listed in Table 4–6 because the same physical property of a fiber or a fabric may affect both functionality and fit. As previously mentioned, the expectation of the consumer for the product to provide comfort is often satisfied through a complex integration of raw material properties and product processes instead of through one feature. The evaluation of comfort will then have to be made through multiple tests by using multiple criteria. Describing this outcome may vary greatly with the perception of the consumer and be very difficult to measure with precision and accuracy. Lacking precision, the development of an appropriate product and the evaluation of that product for a decision of quality or nonquality becomes an exceedingly difficult task. The focus of Table 4–7 is on the contributions that fabrics make to the fit of the product.

Fit is an extremely complex outcome for an apparel product. This outcome is very personal and is an individual perception resulting from the interaction of body and product. Humans evaluate fit with physiological criteria such as touch on the skin and tightness around waist, legs, chest, or other body parts.

Table 4–7
Examples of Topical Dimensions for Fit Outcome

Topical Dimensions	Criteria	Tests	Standards[a]
Shape	Drape (hanging)	Not available	n/a
	Malleability (shaping)–stiffness	ASTM D4032-94 (2001)	n/a
Movement	Elongation (stretch length)	AATCC 96 5lb load	2.0%
	Elasticity (stretch and return)	ASTM D2594-99a (2004)	n/a
	Flexibility (bending)	ASTM D1388	n/a
	Resiliency (bend and return)	ASTM D6720-01	n/a
Shape retention	Distortion	Observation	Zero
	Shrinkage fill	AATCC 135	−2.5% or less
	Shrinkage warp	AATCC 135	−2.5% or less
	Skew	ASTM D3882	8% ± 3%
	Yarn slippage, ¼″ separation	ASTM D434	30

Note. AATCC = American Association of Textile Chemists and Colorists; ASTM = ASTM International; CPSC = U.S. Consumer Product Safety Commission
[a]Standards are based on common industry practice or standards used by some major retailers or manufacturers. n/a = no generally accepted standard is available.

Fit is also determined through psychological criteria that are measured according to social mores, personal body images, comparisons to others, and many complex emotional responses to a product. Fit may be determined as a visual perception. The product is perceived to be the correct size for the space or the body or is perceived as fashionably sized. To create standards with test measurements for this outcome is very difficult and many of the criteria are listed in Table 4–7 without standards. Further descriptions of fit and methods of evaluating quality for product fit are discussed in Chapter 10.

Fit is also affected by fabric hand. **Hand** describes how fabric feels to human touch. Hand is usually determined through human touch and mental evaluation of fabric. AATCC Evaluation Procedure 5 gives guidelines for doing subjective evaluations of hand. Several systems have been developed for simulating the human hand in feeling fabric. The Kawabata Evaluation System (KES), developed at Kyoto University in Japan, involves a set of machines to perform numerous tests in order to provide a quantitative analysis of fabric. The two-step KES provides information about the hand or the tactile perception of fabric (Berkowitch, 1996). Other less complex systems, such as the Fabric Assurance by Simple Testing system (FAST), have also been developed (Rees, 1990); however, no system duplicates the human hand and the perception of the consumer's mind to the satisfaction of many merchandisers, designers, and consumers.

Standards and Tests of Fabric for Fashionality

Of the three outcomes, fashionality is the most difficult to test. Fashionality is evaluated by consumers from a number of topical dimensions or criteria, many of which are cultural, temporal, and vague. Fabrics, their components, and other product materials make major contributions to the fashionality outcome of the product. Fabric supplies the color, texture, hand, drape, and other dimensions of the final product. Although some of these dimensions can be altered during construction of the product, fabric is a major contributor to fashionality, and should be standardized, tested, and evaluated to ensure a quality product from the beginning of product conception.

Determining what is "in fashion" is a primary task during product development. The product development team wants to provide standards by which the desired look or outcome can be measured. Table 4–8 contains some of the topical dimensions and associated criteria, tests, and standards used for quality analysis of fashionality. Specific tests and other measurements may be made of fabric characteristics that are generally accepted as contributing to fashionality, such as color, pattern, surface contour, shape, and movement.

When developing the theme for the product line, designers have images and colors that they view as appropriate representations of the theme. These graphic images may be used as standards for evaluating fashionality of the

Table 4–8
Examples of Topical Dimensions for Fashionality Outcome

Topical dimensions	Criteria	Tests	Standards[a]
Surface contour	Luster (dull to shiny-visual)	Observation	n/a
	Smoothness (rough to smooth–tactile)	AATCC 124	DP 3.5
Shape	Drape (hanging)	Not available	n/a
	Malleability (shaping, stiffness)	ASTM D4032-94 (2001)	n/a
Movement	Elongation (stretch length)	AATCC 96 5 lb load	2.0%
	Elasticity (stretch and return)	ASTM D2594-99a	n/a
	Flexibility (bending)	ASTM D1388	n/a
	Resiliency (bend and return)	ASTM D6720-01	n/a
Overall dimensions	Weight, oz./sq. yd.	ASTM D3776	As specified $\pm \sqrt{2}$ oz.

Note. AATCC = American Association of Textile Chemists and Colorists; ASTM = ASTM International
[a]Standards are based on common industry practice or standards used by some major retailers or manufacturers. n/a = no generally accepted standard is available.

fabric and of the final product. For example, a standard for "cuteness" may be needed. To evaluate the product relative to a standard of cuteness may be difficult for many people. Standards such as these often cannot be made measurable or precise; however, without some attempt to qualify and evaluate such imagery, the product development team and the merchandiser or buyer will not be assured that quality is being provided to the consumer. Although ASTM and AATCC lack tests for cuteness, tests have been developed by ASTM to attempt to match the imagery that is desired in fabrics (e.g., the test for yarn hairiness, ASTM D5647-01). Other more standardized topical dimensions that can be used in conjunction with imagery are available for use or may be developed by a company to match the expectations of the consumer.

Several outcomes in fashionality relate to color, especially the identification of the color, which involves hue, chroma, and value (see Table 4–9). The identification or naming of a color becomes extremely important when com-

Table 4–9
Examples of Topical Dimensions for Fashionality Outcome Involving Color and Pattern

Topical Dimensions	Criteria
Color choice	Hue (color name)
	Chroma (intensity)
	Value (shade)
	Color consistency (end-to-end)
	Metamerism (color change in light)
Pattern	Appropriateness of pattern (size, style)
	Pattern consistency (end-to-end)

puters or other communication methods, in the absence of the actual product, are used for sharing information about the product. Numbering the colors, as discussed in Chapter 3, is valuable for this process. Many companies use the **Pantone system** for color numbering or naming (Pantone, 2004). Color naming or numbering in an attempt to provide standardized colors has been developed by Pantone and other color companies. Pantone has created a library of more than 2,000 colors for apparel and home fashions that have standard numbers associated with each individual color (Pantone, 2004). Regardless of the performance of a computer monitor or a printer, the Pantone color number can be used as a standard reference to determine the desired color. One color tool to improve online collaboration for color analysis is a patented system by eWarna that uses the Pantone color numbering system (eWarna, 2005). Systems are now available for integrated product development processes in which the entire product development team shares information digitally.

Another measure of color, important to the fashionality outcome of a product, is **color matching.** In color matching, the fabric is evaluated for its similarity to the color of the sample or the standard. This sample could be a fabric swatch, a print of the fabric, or other nontextile related materials. During the product development process, the team members may find fabric swatches, printed swipes, or other physical products that are used for demonstrating the color that should be used for a product line. Designers, merchandisers, and consumers have been known to use anything from paper clips to tree leaves to be the standard for the desired color. Matching fabric to nonfabric items is most difficult because of the surface textures. Further complicating the analysis of color are the various digital forms of the product that may exist from the preproduction, production, and distribution stages. Products and their fabrics may be shown in fabric, paper, and/or digital forms.

Color matching across these media is difficult. For decades, color matching was dependent upon color masters who had excellent visual acumen for "seeing" color. The color masters could distinguish among multiple shades or values of colored fabric. Color differences often not detected by the average consumer could be sorted by a trained color specialist. Part of the skill for such color specialists was developed through training, but much of the skill was inherent in the person's eye and mental abilities relative to color. With the introduction of computers into the color world, this skill of color matching was replaced with specialized computer equipment. Color differences with computers are determined by detecting the differences between lightness and darkness and values of red to green and yellow to blue. A common system for color matching is the CIELAB (Sharma & Goike, 2003). The CIELAB is a system established by the Commission International de L'Eclairage and is based on the premise that color can be described in the three basic aspects: hue, shade, and intensity. The system qualifies these three aspects on a three-dimensional grid with positive and negative values. Several other systems have been developed to help the product development team and other industry personnel work with color matching of fabrics. Pantone (2004) and other color companies also offer hints, techniques, and systems for color matching.

Shade sorting and end-to-end color consistency are other fabric criteria or processes that will affect the color dimension. **Shade sorting** is the process of identifying the exact color for each roll of fabric, which should all be the same color. In doing the sorting, a map that uses one of the color systems can be made to show how the rolls relate in color to each other relative to the color axis of blue and green and red and yellow. Shade sorting is particularly important to companies that make sportswear separates. Getting an exact match of color from pattern pieces cut from the first roll of fabric to the 100th or 1,000th roll of fabric is just as important as matching from the first roll to the second roll. When the items are together in a merchandise presentation on the retailer's floor or when worn by the consumer, the color of the top and the bottom for a set must match.

End-to-end consistency examines the color within one roll of fabric. The principle of the process is the same as that for shade matching as well as the need for matching within one assembly plant. This quality analysis process is necessary because many rolls of fabric contain over 1,000 yards of fabric, and the fabric dyeing process for the entire roll happens over time. Changes could occur during the production process that cause shade differences from end-to-end. In many production facilities, the seat cushion and the back cushion for an upholstered chair might come from very different locations within a roll of fabric. These two cut pieces must match within an expected tolerance for the completed sofa to appear correctly formed.

Metamerism is the effect that various lights have on the color of fabric and other textured surfaces. Some colors will appear to change colors when seen under various light sources. Fluorescent lights, incandescent lights, and natural daylight emit various colors. This variation can affect how a color appears to the observer. For example, a red fabric may appear more blue when seen under fluorescent light and more orange under natural daylight. In addition, matching colors across fabric content, type, or finish can be important. For example, fabric used to make shoes is often a slubbed silk, in a plain weave. When dyeing these shoes to match a dress made from a nylon fiber, brushed velvet, the merchandiser or retailer will find that a color match is almost impossible. The texture of the fibers, yarns, and fabrics vary greatly. In addition, two fiber types absorb dye differently and, in some cases, must be dyed with different dyestuffs.

In addition, the application of the color or dyeing procedures can affect the outcome of the color. For example, the fabric in Figure 4–9 was yarn dyed, which gives the fabric a sharp, crisp look, with each yarn clearly colored before weaving. Fabrics printed after weaving and product-dyed items can rarely achieve this same definition of line in the coloring process. However, product-dyed items provide retailers with increased flexibility and help to reduce the amount of finished inventory stored in the sewn products pipeline, thereby reducing overall product costs.

Some of the outcomes examined for functionality can also be used to determine fashionality characteristics. For example, the fabric can be examined to determine whether it will retain the desired fashionality characteristics in postuse and postuse care situations such as after wearing, washing, or cleaning

Figure 4–9
Yarn-dyed fabric.

(see Table 4–10). Pilling or fuzzing can occur when wearing the product, when someone sits on the product, or when the product is cleaned. These changes to the surface of the fabric can create a surface that is unsightly to the user and can detract from the desired appearance or fashionality of the product.

Determining the Appropriate Test

Although most of the tests available from AATCC and ASTM are directed toward the analysis of functionality, some tests are useful in examining fit and fashionality. Because the product is made of a complex array of raw materials and the expectations of the consumer are often described in vague or emotional terms, the designer or merchandiser has to determine carefully what tests can provide the best description of the outcomes expected by the consumer. One test alone is rarely satisfactory in analyzing the product for the quality expectations of most consumers. A combination of tests is often needed to achieve a thorough quality analysis for a product. All of the properties of the fiber, yarn, and fabric, or alternative raw materials, must be considered when determining the outcome for the sewn product item. These

Table 4–10
Examples of Topical Dimensions for Fashionality Outcome for Postcare Usage

Topical Dimensions	Criteria	Tests	Standards[a]
Appearance retention	Colorfastness to home laundering	AATCC 61	n/a
	Colorfastness to crocking (color rub off)	AATCC 8	3 Gray scale
	Fuzzing	Observation	No change after laundering
	Grinning	Observation	Negligible
	Pilling (fiber rub off)	ASTM D1375 or D3511-02	Negligible
	Puckering: Class A	AATCC 88B	4
	Snagging	Observation	No change after laundering
Shape retention	Distortion	Observation	None
	Shrinkage fill	AATCC 135	−2.5% or less
	Shrinkage warp	AATCC 135	−2.5% or less
	Skew	ASTM D3882	8% ± 3%
	Yarn slippage, ¼″ separation	ASTM D434	30

Note. AATCC = American Association of Textile Chemists and Colorists; ASTM = ASTM International
[a]Standards are based on common industry practice or standards used by some major retailers or manufacturers. n/a = no generally accepted standard is available.

properties and their resulting characteristics affect the design, construction, fashionality, fit, and functionality of the sewn item. These characteristics must be considered and managed, and their outcomes evaluated in order to meet the expectations of the consumer.

Designers, merchandisers, and buyers must listen to consumers and determine the desired outcomes of sewn products. They must then use their knowledge of textiles to plan the raw materials, design, and production of the product to achieve the expected outcomes for a quality product. The designer may be planning a blanket that is warm, lightweight, and has easy care properties. First, the designer starts with fiber selection. A synthetic fiber will be desired for its easy care, and a hollow synthetic will be specified to provide more insulation with less weight. Second, a loosely twisted yarn will be selected to create many air pockets for enhanced thermal insulation. Third, the designer knows that a fabric that has a high density will be more protective from heat, cold or other environments than a fabric that is less dense. For this reason, the designer chooses fabric that has a high yarn count and a tight weave to compact the yarns within the fabric. Fiber, yarn, and fabric selections will contribute to the overall thermal properties for insulation and continue to be light and easy to wash. A total set of desired outcomes makes a quality product because it meets the expectations of the consumer.

In planning the product, the designer or merchandiser must recognize and consider the interrelationship of the fabric's physical properties in conjunction with the physical properties of yarns and the physical and chemical structures of the fiber. For additional consideration are the additions or

changes made when the product is cut, assembled, and finished. Characteristics of fiber, yarn, or fabric and activities within processes can enhance or negate a planned outcome. For example, a tightly spun yarn has higher durability than a loosely spun yarn, but when the highly durable yarn is placed in a loosely woven fabric, the durability is reduced or negated. The tightly spun yarn is more durable when woven into a fabric with a high yarn count so that only small spaces are located around each yarn. With small spaces among the yarns, less room is made for a foreign object to snag the fabric. In a second example, a plain or jersey knit stretches easily, which provides comfort, fit, and easy donning and doffing (e.g., putting on and taking off the item). The outcomes delivered by the stretchy knit can be negated with the use of a monofilament fiber or a tightly twisted yarn, both of which would have limited stretch. In a third example, the outcome of a rough and multidimensional surface can be created by a complex yarn and an open, loose weave (see Figure 4–10). This outcome can be enhanced by the use of a staple fiber or reduced by the use of a smooth synthetic fiber. The designer and merchandiser must be very clear about the expectations of the consumer for the product outcomes and use the dimensions of fiber, yarn, and fabric to achieve these outcomes.

In addition, features that enhance or negate one outcome may limit other possible outcomes or other dimensions of the product. For example, the

Figure 4–10
Open, loose weave fabric with various yarns.

stretchiness of the knit may improve comfort and initial fit but will make the item dimensionally unstable, which may reduce the fashionality outcomes of a desired smooth and fitted appearance. In a second example, a satin weave appears very smooth and lustrous when made from a synthetic monofilament yarn; however, this smooth surface is not durable because it shows snags with a minor prick. The very smoothness of the fabric makes the surface vulnerable to unsightly picks. In a third example, a fabric that has a fiber content of 50/50 polyester and cotton will have few wrinkles when worn and washed but will show oily stains, which are often difficult to remove.

When color is important, designers, product developers, merchandisers, and retailers all must be aware of the complexity of color management and the interrelation of color within fibers, yarns, and fabrics. Many factors affect the accuracy of color viewing and matching. Personnel must realize that color is affected by the type of light under which the product is viewed and the surface of the item. Color displayed on various media—CDs, computer monitors, and cell phone screens—may not be accurate representations of the color. Color printed on paper or fabric with digital printers and color on screen-printed fabric may not match even when the exact same formulation of the color is used. Tests for color matching and color changes will be important in developing a quality product for the consumer. Designers and merchandisers must train themselves to be aware of color and to use many of the new computer systems and software available to aid in color certification matching.

Any member of a product development, production, or distribution team must recognize that the characteristics of fiber, yarn, and fabric are all individually and collectively important in determining the outcomes of the product. When designing a product or selecting products for a product line, the designer or merchandiser, who is working in a consumercentric environment, must be very knowledgeable about the properties of these textile components. Each team member must contribute knowledge to select and evaluate fibers, yarns, and fabrics that will contribute the best dimensions to the product so that the expectations of the consumer are realized in the product outcomes. The task of selection is not easy and the analysis of the outcomes is also difficult, but some attempt must be made in order to ensure product quality. The complexity of the product adds to both the excitement of the outcomes and the pleasure of the consumer in the discovery, purchase, and use of sewn products.

As the designer, merchandiser, or buyer is determining the correct fabric for purchase, he or she should also note the existence of a document known as the Worth Street Rules or, more formally, as the Worth Street Textile Market Rules (AMTI, 1986). The **Worth Street Rules** have been used in the purchase of textile products since the original rules were set in 1926. Although these rules have an extensive historical background, they continue to be used and anticipated by many companies. Primarily, the Worth Street Rules cover the expectations of a buyer in the purchase, sale, and use of textiles, and provide legal information about the transactions of the sale of textiles. Minimum expectations of width and defect levels are also set in the Worth Street Rules and can be used by buyers of textiles as a starting point for setting standards.

Regardless of the source of the standards, the designer, merchandiser, or buyer who purchases fabric must set and communicate standards for the fabrics so that the expectations of the consumer are clearly met in the sewn product.

Key Terms

2 ply yarn	Filling	Spun yarns
AATCC tests	Generic textile names	Spun-core yarn
ASTM tests	Hand	Staple length
Color matching	Man-made fibers	Surface texture
Comfort	Metamerism	Synthetic fibers
Complex ply	Natural fibers	Test methods
Complex yarn	Pantone system	Textiles
Courses	Performance tests	Topical dimensions
Descriptor characteristics	Physical properties	Trade names
Durability	Picks	Yarn twist
Ends	Plain knit	Yarns
End-to-end consistency	Plain weave	Wales
Fabric	Ply	Warp
Fabric construction	Raw materials	Weft
Face	S twist	Woof
Fiber	Selvage	Worth Street Rules
Filaments	Shade sorting	Z twist

Review Questions

1. What are the raw materials for sewn products?
2. Why are raw materials important to quality?
3. Why should a designer or a merchandiser be able to trace the process from raw material through performance properties to functional characteristics?
4. List several fiber types that could be selected when making a sewn product.
5. What are the basic characteristics of natural and synthetic fibers when considering their contributions to product outcomes?
6. How does the length of a fiber affect a product outcome? Give an example.
7. Give an example of how the fiber can be the controlling property in a product.
8. Describe the fiber needed for an absorbent and easy to wash garment. Explain why.
9. Name a physical property of a yarn, and give a descriptor characteristic.
10. What physical characteristics would a spun yarn give to a product outcome?
11. What contribution does ply give to the product outcome? Give an example.
12. What physical properties of fabrics contribute to the outcome of a sewn product?
13. How does fiber content of the fabric differ from type of fabric?
14. How could density of a fabric affect its functional outcome?
15. Describe two fiber, one yarn, and three fabric properties needed for a warm and fuzzy jacket. Explain why.

16. Describe a fiber, two yarn, and three fabric properties that would combine together to produce a weak, dull, and dirt-collecting sweater. Explain why.

17. For a smooth, strong, and slick jacket, what are two fiber properties and one yarn property that will integrate to get this product? Explain why.

18. Why are fibers, yarns, and fabrics considered integrated components of a sewn product?

19. What can be used to measure product outcomes for testing quality?

20. What are standards, and how do they relate to performance criteria?

21. Where can one find tests for measuring outcomes?

22. What is in a test method?

23. Why does the U.S. government have test standards for sewn products?

24. List four topical dimensions for measuring functionality outcomes.

25. List at least five criteria that could be used to describe functionality outcomes.

26. What is fit?

27. How can fit be measured? Why?

28. What is fashionality? Can it be measured? Why or why not?

29. What are three color considerations that should be evaluated when selecting and preparing fabric for making women's sportswear?

30. How have computers helped with color matching?

31. What is metamerism?

32. Why do designers, merchandisers, and buyers need to know about fibers, yarns, and fabrics?

33. Use the following statements and questions to examine examples for determining appropriate criteria and tests for outcomes.

　1. The consumer wants a pair of pants that fit snugly across hips and thighs. What topical dimension and criteria would you designate, what two tests would you require for measurement, and what physical properties of the fabric and fiber would you need?

　2. The product is smooth, gets an oily stain, and stretches out of shape. What criteria and tests should you have requested before buying this product for your store?

　3. You want to carry a line of sweaters that do not get those unsightly fuzz balls. What topical dimension and criteria would you need to have tested? What fiber and yarn properties would you check?

　4. A customer wants a shirt that does not make him sweaty when doing vigorous exercise. What topical dimension and criteria would you need to have tested? What fiber and yarn properties would you check?

References

American Textile Manufacturers Association (ATMI). (1986). *Worth Street textile market rules*. Washington, DC: Author.

Berkowitch, J. E. (1996). *Trends in Japanese textile technology*. Washington, DC: Office of Technology Policy, U.S. Department of Commerce. Retrieved May 27, 2005 from http://technology.gov/reports/textile/textile.pdf

eWarna. (2005). *Information on the LabWorks Pro software*. Retrieved April 22, 2005 from http://ewarna.com

Pantone. (2004). *Color matching made easy*. Retrieved May 27, 2005 from http://pantone.com

Rees, T. (1990). FAST fabrics. *Apparel Industry Magazine*, 82, 84.

Sharma, A. and T. Goike. (2003, November 1). CIELAB: Measuring color on many different media, *American Printer*. Retrieved May 27, 2005 from http://www.americanprinter.com

Fabric Inspection, Defects, and Flagging

Quality analysis of the fabric at the textile plant is one way of maintaining the quality for the fabric and can be done to meet the standards of the customer or the company. This process involves an array of methods of sampling, measuring, and evaluating the fabric. As described in Chapter 3, samples are drawn from the textile production line to test the fabric for various physical and chemical properties as specified by the company policy or by the customer. Samples of fiber and yarn are also examined by using the quality analysis process during their production prior to their incorporation into fabric. Textile testing is done on fiber, yarn, and fabric throughout the production processes by the manufacturers and also prior to production by the sewn products manufacturer. The retailer may also perform various textile tests on the fabric in sample products. In addition to these performance tests, a visual inspection of the fabric is generally part of a textile company's TQM. The **fabric inspection process** is the activities comprising the visual checks of the fabric for flaws or defects and the grading of the fabric on the basis of those checks. Companies that have a high level of TQM in place at their plants do a visual inspection of 100% of the fabric that is produced, and then reinspect a 10% sample of the inspected fabric.

In a QR partnership, this information is shared with the fabric producer's customer (i.e., the sewn products manufacturer). Results of any fabric testing or inspection can be shared to reduce **redundant testing** or testing

of the fabric by both the fabric manufacturer and the sewn product manufacturer. This reduction saves time and money for all partners in the pipeline. Testing information can be transmitted electronically from company to company. Trading partners who share this information must have a good working relationship and a high level of trust between partners, as would be found in companies that have high levels of TQM implemented.

Inspection Process

A final inspection of fabric at the end of fabric production is important to assuring the customer that fabric received into the cutting area is the required quality. Quality fabric inspection requires a **fabric inspection machine** or **fabric inspection frame** (see Figure 5–1) and a well-trained fabric inspector or a computerized scanner.

During inspection, the fabric is unrolled from the fabric roll at the back or front of the machine and is moved across an angled and **lighted inspection table** (see Figure 5–2). The inspected fabric is then rerolled onto a new metal

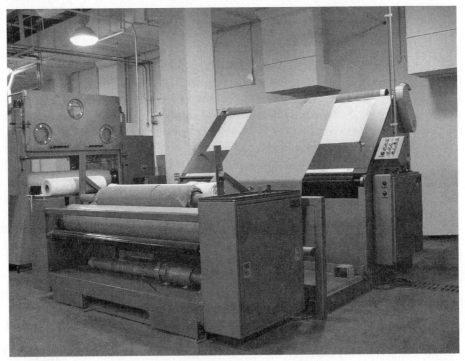

Figure 5–1
Fabric inspection table with a roll of fabric.
Courtesy of the College of Textiles, North Carolina State University.

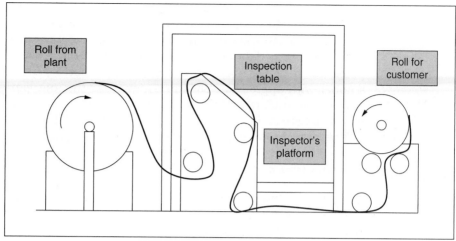

Figure 5–2
Diagram of inspection station set-up with fabric.

roller at the front or back of the table in preparation for shipping the required fabric length to the customer. For some **inspection stations,** as shown in Figure 5–2, the fabric inspectors stand inside the machine as they observe the surface of the fabric. In some plants, the shipping stations may be on a floor located below the inspection stations so that the fabric is sent from the inspection table through the floor to be rerolled at the shipping station. A roll of fabric traditionally contains 1,000 or more yards. For a fabric weighing about 16 oz. per square yard, the roll of fabric could then weigh 2,000 lbs. or a ton. Moving the rolls requires forklifts and many safety precautions.

The inspection machine must have the capacity to handle large rolls of fabric without introducing tension or bias. Inspection tables often have mechanical rolling features for moving the fabric and with push button controls on **jogging** or inching devices for stopping and moving small distances along the fabric. Controlling the movement of the fabric is important for inspectors to do a thorough job of noting and marking defects. However, inspection machines through a series of rollers should have the capacity to unroll and reroll the fabric without excessive tension that could alter the fabric alignment or thickness.

During the inspection process, the fabric moves rapidly down or up the table surface so that the inspector must look horizontally across the fabric from selvage to selvage and then back as the fabric passes in front of him or her. The fabric inspection table is usually **back lighted** or lighted from beneath the inspection table, and overhead lighting is also supplied to assist the inspector in spotting all defects. The process is similar to observing slides or other media on a slanted and back-lighted work surface. The lighting underneath the fabric improves the inspector's ability to see fabric defects.

The inspector is trained to spot defects according to one of the grading systems or by a company- or customer-designed system and to mark the defects with a company- or customer-specified marking system. The human eye is

often the best tool to observe the multiple and intricate changes that can occur in the fabric. **Optical scanning equipment** that uses computerized images of defects can also be used in inspection processes. The marking of defects found in the fabric is done with a variety of flags. With the use of a computer, the inspector with a keyboard at the inspection frame—or the optical scanner with appropriate software–may enter the information about defect type and location directly into a computer. This computerized information is used to create a digital map of the fabric and the defects.

The inspector is paid on the basis of both the accuracy and the speed of the inspection. Inspectors who can rapidly scan the moving fabric and can accurately observe and flag the defects are highly skilled and highly paid employees. Learning to be a fabric inspector takes years of training. This job is physically and mentally demanding because the inspector must constantly watch the moving fabric and must usually stand so that the full width of the fabric can be observed closely. A well-trained inspector and precision inspection machines are important to the overall quality of the fabric. The inspection table and associated equipment can negatively affect the fabric quality.

For effective quality control, fabric should be inspected at the textile production plant. Waiting to inspect the fabric as it is spread on the sewn products manufacturer's cutting table is a waste of time for the sewn products manufacturer, and it requires spreading and cutting personnel to be fabric inspectors when their skills are in other arenas. If the fabric does not meet the standards that the sewn products manufacturer has set, the fabric must be rerolled and removed from the cutting room. The sewn products manufacturer is then forced to try to return the rolls to the textile manufacturer at an additional cost of time and transportation. The sewn products manufacturer is better served by having the fabric inspected at the textile plant by skilled inspectors and by partnering with the textile manufacturer in agreements so that the information is trustworthy and shared efficiently.

Fabric Defects

Fabric defects are defined as errors that render the fabric inappropriate for the expectations of the consumer. Although some defects are considered generally unacceptable by most sewn products manufacturers and consumers, defects are often specified by the customer for specific products. A fabric characteristic that might be a defect for one customer could be a fashion statement by another customer. For example, the holes found in jeans could be there because the jeans had received extensive use and the fabric was abraded, or the holes could be placed there for design purposes (see Figure 5–3).

ASTM D3990 (available from www.astm.org) has a list of generally accepted fabric defects, their definitions, and some pictures. This listing includes the most common industry used terms and some synonyms when available. Fabric

Figure 5–3
Holes in fabric—design or defect?

defects can occur at various stages during the textile manufacturing process, such as in the set-up for weaving or knitting, during in-process or the actual production process, and in fabric coloring or finishing.

Set-Up Errors

Common errors in the **set-up** prior to production are loose ends and missing ends. The **ends** are yarns that run on the length-wise or warp direction (i.e., parallel to the selvages). A loose end or **slack end** occurs because the proper tension is not set for the twist, elongation, or strength of the end and results in a yarn that lies in lumps or loose loops along the lengthwise direction of the fabric (see Figure 5–4). A **missing end** or **end out** comes from the failure to thread a yarn at a specific point in the weave set-up and will result in what appears as a run or a column-like hole in the fabric. Even with fast-paced computer-operated looms, a human operator is needed initially to thread the loom and to establish the weaving or knitting pattern. Human error is always possible in this natural world and the appropriate yarns may be incorrectly threaded, completely omitted, or the pattern could be incorrectly set.

Figure 5–4 Slack end in denim.

The **picks** are yarns that run in the width-wise or filling direction on the fabric (i.e., selvage to selvage). **Missing picks** or **mispicks** may be set-up errors if the programming of the loom has an error from the beginning, especially in a patterned fabric. However, the mispick is more often an error that occurs during the weaving or knitting process. Missing picks are also called **broken picks** as they are often missing because the filling yarn was broken at some point.

In-Process Errors

After set-up, fabric production begins with the formation of the actual fabric. This process for most apparel and home furnishing textiles is formed through weaving or knitting, with additional processes for finishing and coloring. During the weaving or knitting process, the fabric travels through the loom or knitting machine and is then drawn along various rails or rollers to continue the production and finishing. Errors or defects that occur at this stage in the production process are **in-process errors.** These errors include defects in alignment, inclusion of trash, or breakage or loss of tension with the yarns and may also include slack or broken ends or picks.

The standard **fabric alignment** of the warp and filling yarns are at 90-degree intersections (see Figure 5–5). As the fabric is processing through various stages in production, the edges or selvages of the fabric are held with clamps on track chains. As the fabric moves along the process, the tracks holding the fabric may become misaligned so that the edges and the center of the fabric are not traveling at the same rate of speed. The result is a misalignment of the warp and filling yarns.

Figure 5–5 Standard alignment for warp and filling yarns.

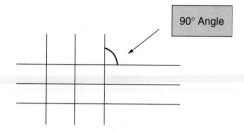

If misaligned, this 90-degree intersection is no longer in place. In **misalignment,** the alignment or angle of intersection for the yarns may be altered from the original pattern, which usually requires the warp and filling yarns to be at right angles to each other. The dimensions of the fabric should be periodically checked as part of a quality analysis process; however, high-speed production may allow errors to occur almost instantly, and the cost of checking for errors may deter a prompt and effective analysis process. Fabric defects or errors in distortion or alignment do occur. Two of the most common alignment defects are bias and bow. **Bias** is the shift of all filling yarns to an angle of more than 90% in relation to the warp yarns (see Figure 5–6). The defect occurs when one selvage is pulled faster in the process than the other selvage. When looking at a single filling yarn across the fabric, one can see that one corner of the fabric is longer than the opposite corner. The effect of this defect on a sewn product is that grain lines that are planned on the pattern pieces are not parallel to the yarn directions. The resulting product will tend to shift when hung. This defect is especially problematic in draperies or other large expanses of hanging fabric and may even cause problems in the stability of the hem of a garment.

A similar error or defect occurs when the sides of the fabric are pulled faster than the center of the fabric. This defect is called a **bow** (see Figure 5–7). The ruler or straight edge placed along the edge of the fabric in Figure 5–7 shows the straight line that should be followed by a single filling yarn on the cut edge of the fabric. However, because of the bow the center of the fabric sags in relation to the sides of the fabric. Recutting the fabric will provide a straight edge but will not improve the alignment of the yarns.

Hand or mechanical straightening of misaligned fabric might be done in short yardage (e.g., 1–3 yards) as used in home sewing or in sample rooms. However, in plants that use rolls containing 3,000 yards or more, such straightening techniques are usually not practical. The fabric should have

Figure 5–6 Alignment for warp and filling yarns when fabric has a bias defect.

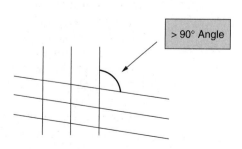

Figure 5–7
Bow along cut edge of fabric compared with straight-edge of ruler.

been manufactured in correct alignment—"do it right the first time." The defect is compounded if the fabric is covered with a finish that "sets" the yarn alignment.

During the fabric production process, loose yarns can create errors, which are similar to set-up errors. When extra filling is pulled off the spools or the filling is carried into the fabric too quickly the excess yarn bunches along the surface of the fabric. When the extra yarns are filling yarns, this can be called **slough off** (see Figure 5–8). This defect is particularly visible when the fabric is made of yarns from two different colors as in a denim fabric. The white filling yarns bunched on the surface of the fabric will make a dramatic show against the dark blue, black, or other color of the warp yarns.

During the production process, the weaving or knitting process may be stopped for various reasons, including the need to fix an error, to repair a machine, or because of an electrical problem. Problems with consistency in electricity are frequent problems in countries without standardized electrical systems. When the production line is stopped, defects may be introduced into the fabric. The starting and stopping motion can create an uneven flow of the warp or filling yarns, and slack ends or slough off can occur.

Another defect from the production process occurs because fabric may acquire foreign matter into the knit or the weave of the fabric. Textile production plants are often filled with dust or airborne fibers that are created by loose fibers, especially in plants that manufacture fabric made from cotton or other staple fibers. These loose fibers may be attracted to the fabric because of the static electricity that is generated in the production

Figure 5–8
Slough off in denim.

process. Loose fibers or other trash from the floor may simply come in contact with the fabric because the tension on the fabric is relaxed during the stoppage and the fabric touches the machinery or areas under the machinery. When foreign matter attaches to the back of the fabric when it is passing through the tenter range (i.e., one stage in textile production), the defect is called a **tenter-stop error** (see Figure 5–9). This defect may not affect the front or face of the fabric, as seen in Figure 5–9, but few customers would be satisfied with a lovely pair of gray corduroy slacks with brown fuzz on the inside.

Airborne fibers are a problem in textile production facilities, especially those that are processing fabrics with high cotton content. These airborne fibers present problems not only for fabric defects but also for workers' safety. Breathing airborne fibers can cause health problems for workers in the plants. In addition, airborne cotton is a fire hazard. Sparks from equipment can ignite fibers. Historically, to control the fire hazard, managers sealed windows and doors and burned candles in a plant to reduce the oxygen to reduce combustion potential. This method contributed to health hazards for workers in multiple ways. The best prevention to ensure safety for workers and to provide a defect-free product is to keep the air clean in production plants. The process to clean the air requires extensive filtration systems with controlled humidity and constant surveillance of the filtering process.

Figure 5–9
Tenter-stop error on back of corduroy.

Many additional errors including the accumulation of dirt or grease on the fabric may occur and cause defects in the fabric during **work stoppage.** Because the fabric is threaded through a long process during weaving, it cannot be simply removed or cut out when repairs are being made to a machine. Grease spots from a repair may cover a small section of fabric, but grease from a dripping or leaking machine may cause endless repeats of droplets on the fabric. When the defect is throughout the roll of fabric, the use of that fabric for sewn products production is very limited.

Because of the problems generated during a work stoppage, textile production plants often run 24 hours a day. This need to run continuously increases fabric manufacturers desire to make long runs of fabric and to make few changes in yarns, patterns, or colors. The need to service equipment periodically is part of a good TQM strategy. For this reason, many plants close completely during certain weeks of the year for maintenance. The traditional weeks for textile plant maintenance in the United States are the week of July 4th and the week of New Year's Day. Other weeks may be more appropriate in other cultures. Knowing when maintenance is done is an important issue for sewn products manufacturers. Periods of high defect levels in the fabric may occur prior to and shortly after maintenance shutdowns.

Figure 5–10
Missing pick in twill weave.

Broken ends or picks can occur anytime during the initial weaving or knitting process. The yarns are under extreme tension when being woven or knitted, and staple yarns are notorious for breaking. If the broken pick or end is not seen during production, a defect results in the fabric. In general, this error creates a very narrow but very visible defect in the fabric. With small diameter yarns, the defect may be as narrow as 1/8" but will be endlessly long if it is a missing end, and 45", 60" or fabric width-wide for a missing pick. A mispick may also create a wide defect if the pattern is distorted or if the blank space causes surrounding yarns to shift (see Figure 5–10). This defect can be cut from the roll and a **splice,** or the cut and overlap area, inserted in the lay-up for spreading. A missing end will make marker making very difficult because it is a continuous defect throughout the entire roll.

When broken picks or ends are observed during in-process inspections, the weave or knit room operator will stop the process and tie a knot in the yarn. This knot tying requires a great deal of skill because a large knot can become a problem in finishing, and a small knot may not hold. Even the ends of the yarn that protrude from the knot may become problematic as shown in Figure 5–11. This **weave knot** was left large and had long ends. During the finishing process, the knot became a big ball of fuzz.

Figure 5–11
Weave knot originating from a broken pick in flannel fabric.

Finishing Errors

Finishing can be a harsh process for fabrics and results in **finishing errors.** Fabrics are often wetted, heated, stretched, or roughened as part of the finishing process. While traveling through the production process, the fabric is clamped along the selvage. If the clamps or clips are not kept clean and rust free, they may damage the fabric, especially during finishing. A high quality stainless steel clip is needed to prevent **clip marks** on the fabric (see Figure 5–12).

The finishing process to create a flannel or velour surface can create an ugly defect in the fabric. Sharp needles are used to abrade or to nap the surface of a fabric to create the fuzzy hand or nap that is found in fabrics such as flannel or velour. When the adjustment of the needles to the fabric or the tension on the fabric is not correct, the napper machine may leave marks or **napper creases** on the fabric (see Figure 5–13).

At anytime, but especially during finishing, something may cut the fabric and a **hole** occurs (see Figure 5–14). Although the hole is very ugly and appears to be a major problem, this defect, if only occurring once in the fabric, is minor and can be removed with a splice in the spreading process for the sewn products manufacturer.

Figure 5–12
Rusty clip mark on selvage.

Figure 5–13 Napper crease.

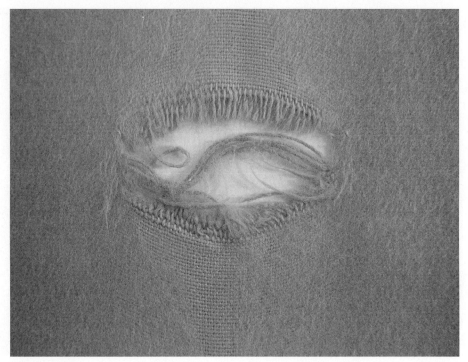

Figure 5–14
Hole in flannel fabric.

Various fabrics have their own special defects because of the unique process used to create that special fabric. For example, corduroy is created by weaving a third set of yarns into the fabric. The third set of yarns creates ridges or **races** along the warp direction of the fabric. As part of the finishing process, the races are cut to create the pile of the corduroy. The pile must be cut so that the **wales** or warp-wise ridges in corduroy are even and consistent along the length of the fabric. When cutting these races, sabers or long knives are inserted into each race. In much of the production process for corduroy, this insertion process is done by a human. If one or more races are omitted from the cutting process, the loops of the third yarns are visible on the fabric surface (see Figure 5–15). The potential for uncut races is very large in pin-wale corduroy in which the rise of the third yarn is very small and the races are very closely placed.

Additional finishing problems involve the **coloration** of the fabric. When the fabric is dyed or printed after the production, the color or the print may not be consistent within the entire roll. **Shading** or **barré** is a gradual color change from end-to-end and is a repetitive defect. With a barré defect, the color change appears as bars or bands of color that are not consistent with the intended color, usually a bit lighter or darker than the original color. The bars appear in a cyclic repeat that is spaced relative to some part of the production or the finishing process. A repetitive defect often creates fabric that is impossible to use because the defect-free spaces on the fabric may not support the pattern pieces, or the waste may render the fabric too costly.

Figure 5–15
Uncut race in pin-wale corduroy.

Inconsistent or incorrect color is a major problem for manufacturers of solid colored items and items that are part of a related separates or coordinated line. Most sewn products manufacturing firms are product specific, which means that one manufacturer produces jackets while another firm manufactures pants. If the color is not accurate to the sample, the individual pieces will not match when shown together on a retail floor or when worn together by a consumer. Shading or barré defects are problematic within a sewn products manufacturing plant because the marker for cutting may contain many of the pattern pieces for many sizes. With multiple ply cutting, as many as 300 layers or plies of fabric may be rolled onto the cutting table at one time (see Figure 5–16). When cutting multiple parts for a product, Part A and Part B may come from very distant places within a roll, especially if Part A that was cut from the bottom ply on the table is matched with a Part B that was cut from the top ply on the table.

With a cutting table that is 100 feet or more in length, the parts of an item could come from fabric that is more than 10,000 yards apart on the roll. With end-to-end shading, the two pieces may not match. In fact, they may be very different from each other and appear to belong to a different dye lot. To assist manufacturers with planning their spreading and cutting process, the shading differences are clearly marked on rolls of fabric, and the use of numerical color coding can indicate which rolls or parts of rolls should be used with which other rolls.

Figure 5–16
Multiple plies of fabric on a cutting table.

Criticality of Fabric Defects

Defects are of concern because they affect the outcome of the finished product. A color that is not accurate to the sample will be mismatched to the other products in that line. A broken thread can affect both fashionality and functionality. If the broken thread is visible on the surface of the item, the overall appearance of the item will be marred, unless that is the look desired by the designer, such as in distressed jeans. A broken thread could also reduce the strength of the item, especially if the break occurred in an area of the product that is often stressed, such as at the elbow or the knee of a garment or the front edge of a chair seat cushion. The **criticality of the defect** or the problem level of the defect depends on its placement and when it is discovered. The appearance of a defect in the front of a pant leg, on the seat cushion of a sofa, or on the surface of a bed coverlet would be considered highly critical. The product could not be sold as firsts and would result in a waste of labor and raw materials.

Defects are of concern to the sewn products manufacturer because they affect both the product production process and the final cost of the product. Fabric that has defects reduces the manufacturer's ability to use automated equipment. For example, a manufacturer who is using automated spreading and marking equipment will expect the fabric to be defect free so that the equipment can lay the fabric and place the marker without human intervention. If defects are found, someone will have to stand and observe each fabric ply as it is laid on the cutting table and will have to stop the spread and then splice the ply to remove the defect. If the defect is running in the warp direction and is repeated or continuous throughout the entire roll of fabric, the spreading process could be a very long process because of the length of the fabric roll and the length or extensiveness of the defect. When creating a splice in the fabric lay, the worker must know the organization of the marker and must consider the placement of pattern pieces so that a pat-

tern piece will not be cut into pieces by the splice. This adjustment requires time and skill by the workers in the cutting room.

In addition, when defects must be cut from the fabric and the ply must be spliced, the results are increased fabric wastes and higher fabric costs. Splicing fabric includes the cutting of the fabric before and after the defect and lapping the cut edges of the fabric on the cutting table so that the correct number of pattern pieces is maintained. When fabric is spliced, the overlapping of the cut edges can result in partial cut pieces and extra unused fabric. This waste can be significant if the defect is along the warp length or is pervasive in the fabric. Some defects can render the entire fabric unusable. A high level of fabric waste will dramatically increase the cost of the item. For example, a fabric with defects that results in at least 50% waste will double the cost of the fabric because twice as much fabric is needed to cut pattern pieces to avoid the defects. Therefore, fabric that costs $15.00 per yard with 50% waste is actually costing the manufacturer $30.00 per yard. In addition to the need for more fabric, the manufacturer will have the additional labor costs of hand cutting the splices and adjusting the marker. The manufacturer will also have the loss of time to market, which can be extremely critical in meeting the delivery deadlines for high-fashion or fashion forward products. If the sewn products manufacturer is late with delivery times, some retailers will not accept the products. The manufacturer is then without a sale even though the investment has been made in design, fabric, labor, and sales.

The size and shape of the pattern pieces also affect the use of fabric, both with and without defects. When the pattern pieces are large or are extra wide, the fabric defects complicate the placement of the pieces. The marker maker and the cutter will have to collaborate to rework the marker to make the pattern pieces fit as efficiently as possible on fabric with multiple or extensive defects. When the pattern pieces are large or very wide, the potential to move the pieces to cut around the defect is very limited. Large pattern pieces may decrease cutting time because of fewer pieces and may decrease sewing time by removing seams, but they could increase cutting time when the fabric has defects.

Sewn products manufacturers are often tempted to use fabric with defects because this fabric is often offered at a substantially lower cost than is defect-free fabric. This buying practice is not without risks and costs. Any defects that are in the fabric have the potential to make their way into the final product. If a sewn products manufacturer chooses to use fabric with defects, he or she must be willing to add additional inspection points in the production process to ensure that the defects do not become product flaws. Flaws in the product that render the item less than first quality are a loss not only of the sale of the product but also result in a loss of all of the resources (i.e., time, labor, raw materials) that were used to make the item. If the products with flaws make their way into the retail market, these items can damage the reputation of the sewn products manufacturer and the retailer.

Retailers who receive flawed products without knowledge of the defects may place these items on display and subsequently sell the items. Consumers

who purchase these items may be dissatisfied, may not return for future purchases, and may complain to their friends. The overall loss to the retailer includes both the loss of future sales and the loss of an expanded market. When defective items are returned, the retailer may choose to refund the consumer's money or offer other products. A retailer who has many returned items will try to return these to the manufacturer for a refund and may not wish to buy again from that manufacturer.

Grading Fabric

When fabric is inspected, it is also often graded. The **grading** of fabric is a process that provides an indication of the number and the criticality of the defects. Although defects can come from a variety of sources and at various points within the textile manufacturing process, the source of the defect is not usually important to the grading and usage of the fabric, only to the correction of the problem. To determine the grade, grading systems depend on the size and the frequency of the defect. These two factors are what are most critical to a product manufacturer as the fabric is cut and used. The size of the fabric defect affects the likelihood of the defect showing when the fabric is used for a product. The frequency of the defect affects the probability that the defect will appear in a finished product. Defects that are in the fabric of a finished product and that appear to the observer, especially to a buyer or consumer, will normally render the item undesirable as a full-price item.

The grade assigned to the fabric will provide the sewn products manufacturer with some information that can be used to determine the approach taken in the use and the cutting of the fabric. Fabric with a low grade (i.e., high number) will probably have to be spread with a manual spreader, spliced many times, and cut by using a manually made marker. Much waste will be expected and the manufacturer may find that, even with the added inspections and work, some defects may slip through the process and become part of finished items. The lower grades of fabric may have lower initial costs but may have higher hidden costs, including the hidden cost of dissatisfied customers.

The oldest **grading system** is known as the *10 point system* (Powderly, 1981). The system can be used with either greige fabric or finished fabric; however, finished woven fabric is the most common product graded with the 10 point system. The **10 point system** uses 10 points or penalties in four increments as indicators of the size of the defect in the warp direction. In other words, the size of the defect determines the value of the defect. For example, a defect that is from 10″ to 36″ will be given a value of 10 points. Defects in the filling direction are given one-half of the points according to the size. The range is as follows: up to 1″ = 1 point, 1″–5″ = 3 points, 5″–10″ = 5 points, and 10″–36″ = 10 points. The assignment of points is given for each yard, and no one yard can receive more than 10 points even if it has multiple defects that

could be totaled to more than 10 points within the yard. Each defect in every yard is counted (unless over 10 points per yard). The number of defects times the points gives the total penalty value. This value is compared with the number of yards. More is not better in a grading system. If the penalty points fall below the number of linear yards, the fabric is graded as a "first." Additional rules apply for fabric over 50″ in width and fabric that has a specialized finish or other fabric specific features.

Various **4 point systems** have been proposed by ASQ (formerly American Society for Quality Control [ASQC]), The National Association of Shirt Pajama Sportswear Manufacturers, The Knitted Textile Association (KTA), and the Textile Distributors Association (AAMA, 1975; Powderly, 1981). The principle of all grading systems is the same: Penalties are assigned for the size of the defect, and the number of defects is multiplied by the number of penalties.

The **Graniteville system** was created in 1975 (AAMA, 1975), and it is so named because it originated in a textile manufacturing plant called the Graniteville plant. The basis of the system is also set on the number and the size of the defects, but this system also recognizes the placement of the defects. The system is used for both knit and woven fabrics. Major defects are those that are greater than 9″ in length, whereas minor defects are those that are 9″ or fewer. The points or penalties are assigned according to the categories of major or minor defects. A major defect receives 1 point and a minor defect receives one-half of a point. Some systems are company- or product-specific, having been designed for a certain customer or to cover a unique fabric. The wording within the system may vary if the system was created for knit or woven fabrics. For example, the **KTA** system used for knit fabrics has a category for runs that are a problem in knit fabrics and not in woven fabrics.

The decision to use a grading system is not an easy one. A fabric grade will provide the product manufacturer a relative evaluation of the defect levels in the fabric; however, all systems use comparisons to yardage and averages within the calculations. Some systems provide a more generalized penalty count than do other systems. The fabric manufacturer must still make a judgment about the appropriateness of the fabric for the product and for the consumer. The grading system provides the manufacturer only with additional information in making fabric selection. It is not a final or finite conclusion.

Flagging Defects

In addition to grading the fabric, the fabric inspector will often flag the defects. **Defect flagging** is usually done to a standard set by the product manufacturer (i.e., the customer). The flagging is done so that the product manufacturer can readily see and remove the defects when spreading the fabric. The type of spreading equipment used by the manufacturer will dictate the type of flags that are useful. Three flagging methods are commonly in use: plastic

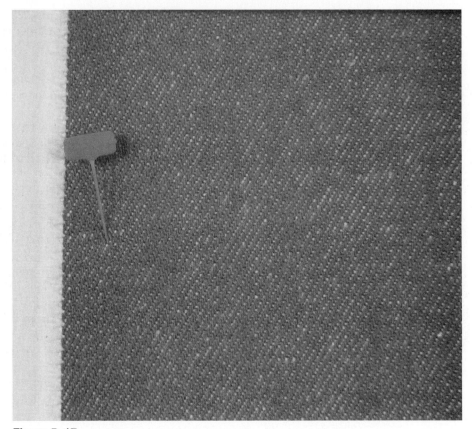

Figure 5–17
Plastic flag at selvage marking defect.

flag, metal sticker, or computer map. The system of flagging is used to mark, usually along the selvage, the location of the defects so that the spreading equipment can be stopped to splice out the defect.

The **plastic flag** is the more traditional and low-technology approach. This system is used for customers that use manual spreaders. Prior to the common use of plastics, a colored thread was used to mark the location of the defect. Usually the flag is red and is similar to the plastic strips used to attach price tags on fabric (see Figure 5–17). As someone is walking or riding along the cutting table, he or she will see the flag and know to stop the spread to check for a defect. If the defect will affect that final product, the fabric is cut at that point, the defect is removed, and a splice is made that is consistent with the marker at that place on the spread.

A flag that can be used with a more automated spreading system is the **metal sticker** (see Figure 5–18). This flag is placed along the selvage in the location of the defect. The flag can be read by automated spreading equipment. When the automated spreader crosses the metal flag, the machine will stop and alert someone in the cutting room that a problem or defect is found in the fabric. The operator or other personnel will have to determine

Figure 5–18
Metal flag at selvage marking defect.

whether the defect is to be spliced out of the fabric. A policy on what action to take relative to what defects should be in place to standardize these decisions. This policy is thus similar to the grading systems.

With the advent of computer technology in marker making and spreading, the flagging of fabric can now be done with computer mapping. The fabric itself is not physically flagged, but a computer software program is used and data about the type, size, and location of the defects can be obtained. The information is recorded by the fabric inspector as the fabric is being inspected and is then sent via Internet or other file transfer system to the product manufacturer who downloads the information into the computerized spreading equipment. This information can be prescanned by someone in the cutting room to determine whether the defects need to be removed when spreading.

Defect Prevention

The process of inspecting, grading, and flagging is part of final inspection. These activities are designed to prevent fabric with defects from entering the next production stage or, at least, to notify the customer that these defects

exist. TQM strategies, however, encourage manufacturers to prevent defects. A textile manufacturer should put a quality control program in place within the textile plant and throughout the operation to prevent defects. This quality prevention program would have the following four steps: defect prevention, in-process inspection, final inspection, and reinspection.

Step 1, **defect prevention,** is designed to correct defects before they happen. Several activities can be implemented to activate this step. All employees should be aware of the need for quality products that meet the customer's expectations. The employees should be trained so that they are skilled at their jobs and are aware of the standards for the production process and the product. Part of defect prevention is making employees responsible for their part of the product. Employees who are trained and aware can be empowered to take action when they see processes changing or outcomes that are off standard. With all production processes, the sooner the defect is acknowledged and the process is adjusted, the fewer the number of defects will be incurred. In addition to training employees, the manufacturer will want to develop a procedure of inspections and maintenance to ensure that equipment is performing at the level needed to produce the product to standard.

Step 2, **in-process inspection,** is a companion to defect prevention. Inspection of people, processes, and equipment is needed to determine when and whether activities are producing products or services that are not equivalent to the standard. This step can also be called quality control. Production processes for textile manufacturing may involve over 2,000 yards from start to finish within one plant. When a fabric producer depends on final inspection as the sole inspection on the fabric, over 2,000 yards with defects may be produced before the final inspector sees the fabric. That dependency on final inspection can result in enormous wastes. The fabric should be inspected as it is being produced or in-process. Samples of in-process fabric can be taken throughout the production line, or visual observations may be made at key points during the production. Some of the quality procedures that may be placed in-process are shade matching of yarns prior to their use; spot or roving inspection for shade control in the dye house; and bursting strength, fabric square-inch weight, and flammability testing on samples in the plant. If the knitter is trained to run not only the knitting process but also to inspect his or her goods, a defect can be spotted as soon as it emerges from the knitting machine. If a problem is observed, the line can be stopped and the problem can be fixed. Although this may cause a defect at the point of the stoppage, as previously discussed in the defect section, a few yards with a minor defect is preferable to yards and yards of fabric with a major defect.

Step 3 is the **final inspection.** During final inspection, fabric is inspected, graded, and flagged. Samples of fabric are reinspected to provide a quality check on the inspection process. Although final inspection is too late to correct flaws in the current roll of fabric, it is still an important process, and it is still important even though Steps 1 and 2 may be in place and working effectively. The production of textiles contains many activities and raw materials that are subject to change and variability. Defects may

happen even with a zero-defect control process. "Zero defects" is a goal, not a certainty. Besides checking for any defects that may have escaped previous inspections, final inspection is beneficial for additional reasons. Final inspection can prevent delays in process and delivery, which lead to more satisfied customers. If fabric is sent only when it meets the customer's standards, then the potential for dissatisfaction and the cost for returns is reduced or removed. The information gathered from final inspection can be used to correct problems in the manufacturing process and to lower future manufacturing costs. A rigorous and diligent defect prevention program may have initial costs and some daily operational costs, but the long-term benefits of satisfied customers from quality fabric are extremely valuable.

Step 4 is the **reinspection** of fabric. Many companies, especially those that inspect 100% of the yardage produced, reinspect a sample of that yardage. The sample size for reinspection is usually 10% of the total yardage produced and inspected. Reinspection serves a two-fold purpose. First, reinspection helps to ensure that the fabric meets the expectations of the customer and the standards that were agreed upon by the trading partners and/or the promise of the fabric manufacturer. This secondary check is vitally important in fabric that has critical or life-and-death outcomes, such as fabric for bulletproof vests, flame retardant suits, and fabric for heart valves. Although quality failures in most sewn products merely result in wasted raw materials and in disappointed customers, some products do have life-and-death outcomes. In addition to checking the product outcomes, the final check on the fabric also provides the fabric manufacturing company with a control or an analysis of their own inspection process. Through reinspection data, the fabric inspectors can be evaluated on their performance in inspection, and test labs can be evaluated for consistency of results. Fabric inspectors must inspect rapidly because they are often paid by the yardage inspected. The speed of inspection and the repetitiveness of the task can and often does reduce accuracy. Through this four step inspection process, a company is making maximum efforts to deliver a quality product to the customer.

Key Terms

4 point system	Coloration	Fabric defects
10 point system	Clip marks	Fabric inspection frame
Back lighted	Criticality of the defect	Fabric inspection machine
Barré	Defect flagging	Fabric inspection process
Bias	Defect prevention	Final inspection
Bow	End out	Finishing errors
Broken picks	Ends	Grading
Broken ends	Fabric alignment	Grading system

Graniteville system
Hole
In-process errors
In-process inspection
Inspection station
Jogging
KTA
Lighted inspection table
Metal sticker
Misalignment

Mispicks
Missing ends
Missing picks
Napper creases
Optical scanning equipment
Picks
Plastic flag
Races
Redundant testing
Reinspection

Set-up
Shading
Slack ends
Slough off
Splice
Tenter-stop error
Wales
Weave knot
Work stoppage

Review Questions

1. What does the inspector do during the fabric inspection process?
2. What is a defect, in general? List three general stages where defects or errors might occur.
3. Why are defects defined as company and product specific?
4. Identify the following defects in fabric
 a. Slack end
 b. Mispick
 c. Bow and bias
 d. Tenter stop
 e. Knot and hole
 f. Barré
 g. Color shading
5. Why do defects matter?
6. What does it mean to grade fabric?
7. What are the three grading systems?
8. What is the basis for establishing a grade?
9. What does it mean to assign points in a grading system?
10. Which fabric has better quality, one with 10 points or one with 2 points?
11. How are defects marked? (three methods)
12. What is the four-step quality control process to control defects?
13. Why is employee training important?
14. What training areas should employees be taught?
15. How can spending money to implement training and inspection save the company money?
16. What is in-process inspection? How is it different from final inspection?
17. Why is in-process inspection important in fabric manufacturing?
18. How much of the fabric produced is inspected?
19. What is a reinspection?
20. If you have in-process inspection, why do you need reinspection?
21. Which defect would be more problematic for a cutting operation? A 1″×1″ hole or a slack end? Why?

References

American Apparel Manufacturers Association (AAMA). (1975, June). Elementary comparison of fabric grading systems. *Bobbin,* 104.

Powderly, D. (1981, March). Fabric inspection. *Bobbin,* 112–125.

Findings, Including Thread

Findings, as part of raw materials, are the little things when compared with fabric, but they make a big difference in the design, construction, and outcomes of the product. **Findings** include the following categories: fasteners, thread, support fabrics, trims, and labels. These are all components of a product and include everything except the "body" or **base fabric.** For example, Blouse A is made of white, 100% polyester, plain weave fabric. Blouse A also contains six pearl-like buttons, thread, and ruffles. In Blouse A, the ruffles are made of the same white fabric as the blouse and are trimmed with red thread (the red stitching is a finding; see Figure 6–1a). The buttons and the thread are categorized as findings. The ruffle is made from the base fabric so it is not a finding, even though it is decoration for the blouse. Blouse B (see Figure 6–1b) is also made of a 100% polyester plain weave fabric with six buttons and an accordion pleated ruffle; however, the ruffle is a finding on this blouse. The ruffle on Blouse B is a finding because it is made not of the base fabric but of a strip of prefolded narrow fabric (i.e., trim). Findings, especially threads, zippers, and buttons are sometimes called notions by the home sewer; however, this term is more limited than findings.

Findings contribute to many of the topical dimensions within the three outcomes that are expected by consumers. Findings may provide or help create structure, openings, improved fit, aesthetic appeal, and other specialty functions. Functionality is a major role of many findings. For example, thread is

Figure 6–1
Ruffles on blouses: a = base fabric ruffle; b = trim ruffle.

used to form seams and hold fabric pieces together. Stays in the points of a collar can provide structure and stiffness to the collar points, and underlining can add structure and improve the hand of a soft fabric that is used for a straight skirt. An example of a specialty function is the D-rings and clips that are added to ski jackets, which can be used to clip on gloves, lift passes, and sun goggles.

Findings placed on a product can contribute to the fashionality of the item. Visual appeal or fashionality can be generated with ribbons, laces, buttons, fasteners, and a host of other trims or almost any finding. Zippers, buttons, and other findings normally used for functional purposes can be used for visual or nonfunctional purposes. Buttons without buttonholes can be placed along the front of a blouse (see Figure 6–1b). As with many aspects of sewn products, findings as well as fabrics and other inputs for the product can be multifunctional. In Figure 6–2, the zippers provide both functionality and fashionality for the garment. The zippers placed at the hem of the item are merely fashionable and not functional; however, the size and exposed teeth of the nonfunctional zippers are replicated in the functional ones. The large size of the zippers and the oversize rings provide both a certain look to the front of the garment and allow for the donning and doffing of the item.

Findings also affect the fit of the item. Zippers and numerous other fasteners can be used to create and to close openings. For example, a zipper that is placed at the back of a long dress can allow the dress to fit snugly with a small neck opening when the zipper is closed. When the zipper is open, the amount of opening will be ample for the doffing of the item. Zippers placed in sofa cushions allow the cushion fabric to be removed, cleaned, and replaced without the removal and replacement of permanent stitching. Fit of

Figure 6–2
Findings can provide both functionality and fashionality.

an item can also be improved with the application of elastic. Elastic placed on the corners of bed sheets can improve the fit and increase the ease of replacement.

General Quality Expectations of Findings

In general, consumers or users of sewn products have the expectation that the findings of sewn products will be defect free and that they will permit an expected amount of use for the product after purchase. This expectation relates specifically to the outcome of functionality. Zippers should zip, buttons should stay buttoned, and collar stays should keep collar points straight. In general, the expectation of a finding is that it is durable or that it will remain functional as long as the base fabric lasts so that all parts of the product have compatible life cycles. For some products, this life cycle might be short, such as for a bridesmaid dress. On the other hand, a pair of winter boots may be expected to last for several years, and the functionality of the findings should last as long as the functionality of the base raw material. If the consumer plans to wear a pair of jeans for ten years and the fabric will last that long, the studs, thread, and zippers should also last that long. Dimensions within fit and fashionality are also a concern, especially in the long-term use of the product. The cleanability of the item and

Figure 6–3
Failure of a finding.

the resulting appearance retention are general expectations of quality for sewn products. In all outcomes, findings must be compatible in durability and appearance retention with the base fabric. If a consumer plans to wash a knit sweater made of 100% cotton in warm water and dry it in a warm dryer, the findings should also survive the water and the heat, retaining their function, fit, and fashionality. When the life cycle and care of findings are not compatible with the product, the consumer will be disappointed during product end use and postuse care.

Defects or **failures** of findings can render the product unusable or, at least, can be inconvenient for the user. In the worst case scenario, the failure of a finding can produce a hazard for the user. For example, a pretty pink bow on a child's sleepwear item can pass the same flammability tests as the sleepwear fabric; however, when the bow is added to a child's sleepwear garment, the combination can become flammable. In a less serious failure, a zipper that pops open can be an embarrassment to the user and renders the item unusable for normal use (see Figure 6–3).

Failures of findings can also affect the fashionality or "look" of the product. This look is generally designed into the product to "catch the eye" of the consumer and then should last through use and cleaning to give continued appearance retention to the product. The findings should be compatible with

Figure 6–4
Findings failure during care.

the base fabric in all uses of the product. A fabric that requires dry cleaning for postuse care should have findings that can tolerate dry cleaning. For example, the buttons on the vest shown in Figure 6–4 failed during the care portion of consumer use. The care directions on the vest required the vest to be dry cleaned because of the fiber content of the base fabric, the lining fabric, and the structure of the vest and associated jacket. The buttons were simulated leather and the surface that contained the color dissolved in the dry cleaning fluid.

This type of failure should have been detected during the product development process. The fabric and findings should have been tested and evaluated for postuse care compatibility. To determine whether findings meet the minimum expectations of consumers, findings can be analyzed with the four-step quality analysis process. To assist buyers, merchandisers, and product developers in this task, a number of ASTM standard tests, specific for findings, can be used to provide test methods (ASTM International, 2004). Listings of these ASTM standards can be found on the Web site www.ASTM.org. For example, ASTM D6840-02 could have been used to measure the effect of dry cleaning fluid on the buttons shown in Figure 6–4. ASTM D2061-03 can be used to evaluate the strength of zippers, and ASTM D4846-96 (2004) can be used to evaluate the holding strength of snap fasteners. In addition, ASTM standard terminology documents provide standardized descriptions for some findings such as the parts of zippers (ASTM D123 and ASTM D2050) and the terms

used in describing buttons (ASTM D5497-94c (2000)). Testing of findings can be a daunting procedure because of the complexity of the sewn product and the integration of all properties of the raw materials.

In addition to considering the minimum expectations of the consumer for the outcomes of findings, designers and merchandisers must consider the performance of findings during the production processes and their impact on the outcome of the product. Failures in compatibility during the production processes (i.e., lack of manufacturability) may also render the product either unsewable, extremely costly, or both. If the item is not sewable in the usual mass-production facility, most consumers are unwilling to pay for the extra charges needed to sew items through couture or specialized techniques. When these problems are known in the early stages of product development, the product will not be produced or can be altered to bring the product within the desired price points. Something that looks good on the drawing table of a designer or is produced in the sample room is not always producible in a standard factory.

Unfortunately, incompatibility of a product can be created by the designer as he or she strives to get the fashionality dimensions that are desired and the price points that are demanded. In the item shown in Figure 6–4, metal buttons may not have created the desired look, and fashionality would have been compromised. Wooden buttons might have a similar look, but they are also not dry cleanable. Impossible products, relative to postuse care, do exist. The choice of findings is an important decision in product development because the decision affects all subsequent processes through, and including, the use by the consumer. Each component area of findings has specific characteristics and related quality standards.

Fasteners

Fasteners are also called **dynamic links** because they are used when the product is opened or closed. The relationships between parts of a fastener are dynamic or "with movement." Fasteners include an array of findings and range from very functional and simple findings such as a button and a buttonhole to very ornate findings such as an embroidered frog (see Figure 6–5). The following is a partial listing of the available fasteners: zippers, buttons and holes, buckles and tabs, hooks and eyes, snaps, frogs, and toggles and loops. Fasteners can be made of a variety of materials, including metal, plastic, wood, and textile fibers.

General Quality Expectations for the Outcome of Fasteners

For dynamic fasteners, the following three criteria are usually expected by the consumer when purchasing and using a sewn product: holding strength, kinematic durability, and locking. These criteria represent the consumer's expectation of the fastener to last for the life cycle of the product and to function as

Figure 6–5
Frog made from silk content cord.

expected. **Holding strength** is the ability to keep the fastener together in re-
sistance from a side-to-side motion. Failure for holding strength means that the
fastener opens when the user does not want an opening. For example, a plastic
zipper will often "pop" open in the middle when strained by a sideways motion
such as bending in a skirt that is too tight for the wearer (see Figure 6–3).

The second expectation is that working parts of the fastener continue to
function or work with no interruptions or that it will have **kinematic dura-
bility.** This expectation of the consumer, measured in the criteria of kinematic
durability for a zipper, is a smooth repetitive movement. Failure of this func-
tionality is the inability of the user to close the fastener or to keep the fastener
closed because of a malfunction of the fastener. For example, a zipper slider
that will slide part way up the zipper but will not travel completely along the
teeth and close the entire opening has limited kinematic durability. When this
failure occurs before the user is ready to abandon the product, the expectation
of the consumer is not met, and the product is not a quality product.

The third expectation is that of **locking** or continued closing. Fasteners
are expected to fasten and to stay fastened until the user wishes an opening.
Zippers that do not lock and ratchet downward at unexpected times and but-
tons that will not stay in the buttonhole are two examples of locking failures.
If the product is a garment, the consumer may suffer undue embarrassment
or other trauma from the unexpected opening.

Buttons and Buttonholes

Buttons and buttonholes are some of the oldest of the dynamic links. These fasteners can range from a hole slashed in the fabric and a simple plastic button to a very complex bound buttonhole and an inlaid gemstone button. The basic function of the button and the hole is to provide a fastener to close an opening. However, buttons can be used without holes in a decorative or visual function. Buttons and buttonholes help hold fabric parts together but do not completely close the hole. When analyzing buttons and associated buttonholes for their functionality, the designer or product analyst needs very exacting information about the degree of coverage that is expected and the modesty levels of the end user. Buttons in contrast to zippers can leave gaps when the placement and fit are not accurate.

Raw materials for buttons can be of numerous materials including the following: plastic, wood, metal, mother-of-pearl, bone, and stones both precious and semiprecious. The mother-of-pearl button is made from the inside of selected sea shells; however, many new plastic buttons provide a less expensive and to some a preferable simulation of that natural button material. Each of these buttons has intrinsic qualities that contribute to product outcomes. The following two styles of buttons are often found: a button with two or four holes (or a sew-through flange) and a button with a shank (see Figures 6–6a and 6–6b). The **button with holes** is attached by thread moving in and out of the holes and through the base fabric. A **button with shank** is sewn on by looping the thread through the shank and into the base fabric. The shank may be formed from plastic as part of the button as the pink or orange buttons in Figure 6–6b or metal and attached to the back of the button as the gold, gold and black, and silver buttons in Figure 6–6b.

A **shank** is used to provide a spacer between the button and the fabric. This space is needed when the fabric is thick. Without the shank, the base fabric would be distorted and perhaps pulled into the hole to accommodate the thickness of the fabric for the hole (see Figure 6–7). Shanks made of thread can be created on buttons with holes as the button is sewn on the base fabric. A thread shank can be of any length and requires some temporary spacer to be

Figure 6–6
Style of buttons: a = buttons with holes; b = buttons with shanks.

Figure 6–7 Distance accommodated by shank.

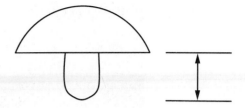

placed between the button and the fabric during sewing. The thread loops of the shank are wrapped with additional thread to stabilize the shank.

Choice of **buttonholes** is a consideration when developing the design, setting specifications, and evaluating outcomes for the product. A variety of buttonholes are possible, including the following: thread-made, bound, and in-line. Of the thread-made holes, stitches bind the hole, and the shape may be **straight, oval,** or **keyhole** (see Figure 6–8). In-line buttonholes are created when a portion of the seam is not stitched, and the button is fitted through the resulting open space.

The **bound buttonhole,** which is sometimes called a fabric buttonhole, is made by binding the edges of the cut hole with fabric. This fabric can be of the base fabric, a contrasting fabric, or a trim fabric. The construction is similar to a welt used for pockets (see Figure 6–9). Two fabric lips or **welts** edge the opening of the buttonhole. Fabric or thread loops can also be used with buttons, which is similar to the loop and toggle or frog and not a button and buttonhole.

Outcomes and Quality Considerations for Buttons and Buttonholes

In the **selection of a button and buttonhole** for a product, the designer must consider closely the product outcomes expected by the consumer. Some

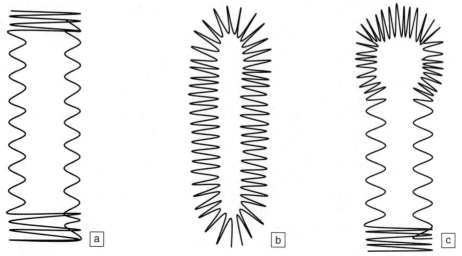

Figure 6–8
Buttonhole shapes: a = straight; b = oval; c = keyhole.

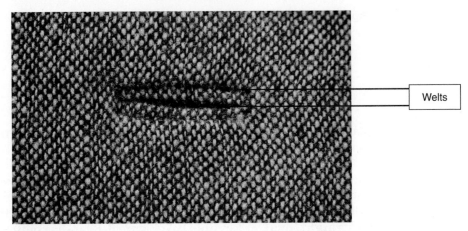

Welts

Figure 6–9
Bound buttonhole.

specific quality standards can be noted to meet the general functionality, fit, and fashionality outcomes expected by consumers. Postuse care during end use is a major consideration for many products, especially for cleanability and appearance retention. Various materials for buttons have different tolerances to washing or dry cleaning. The buttons as shown in Figure 6–4 were not compatible with postuse care and failed to meet expectations. Although these buttons were initially attractive and fashionable, they did not meet the consumer's functional expectations of use. The style of the buttonhole must also be compatible with the fabric and the end use. Thread, fabric, cording, or other materials used for making the buttonholes must also be tolerant of the postuse procedures for product cleaning.

Placement of buttons and buttonholes is another concern when evaluating the product with the expectations of the customer. Placement of these fasteners can affect functionality, fit, and fashionality. Functional buttons are expected to maintain a closure, keep the opening closed with no gaps, have no distortion of the base fabric, improve the fit of the product, and have no gapping around the button within the hole. In addition, the button should be easily inserted and removed from the opening. To keep the opening closed and the base fabric aligned, placement of buttons and buttonholes is usually made at or near the beginning and ending of the product opening. Between these two marks, placement would be determined by (a) amount of length to provide for even spacing and (b) placement in areas of high stress to improve the holding strength of the closure. Placement of decorative buttons, ones that have no closure purpose, can be at the discretion of the designers; however, some decorative buttons also function to provide stability or to secure product parts together without closures. For example, a button in the center of a pillow or on the back of a tufted chair provides a method for holding the padding in place, and is not placed for opening and closing the area but for stability. These must be placed to provide holding strength without distorting the fabric.

Figure 6–10 Buttonhole placement extending 1/4″ beyond seam line.

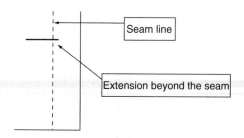

Seam line

Extension beyond the seam

Placement and size of buttons and buttonholes is also a consideration for the quality of an item. Buttons and buttonholes are placed in relation to the distance from the opening (i.e., **horizontal placement**) and in consideration of the space and placement along the length of the opening (i.e., **vertical placement**). For horizontal placement, **horizontal buttonholes** (i.e., buttonholes perpendicular to the seam line) are placed with an extension of 1/4″ beyond the seam line to allow room for the shank, whether plastic, metal, or thread (see Figure 6–10). **Vertical buttonholes** or those that are in line with the seam should be placed on the seam line. Some buttonholes are placed at a diagonal in relation to the seam line. This placement can provide extra holding strength but requires additional marking and alignment during assembly, which may add to the cost of manufacturing.

For vertical placement, buttonholes and buttons are placed so that they provide secure closings to the opening. This requires that the buttons and holes be placed at points of stress along the opening. For example on a shirt, the first button and hole should be placed, in vertical placement, at the fullest part of the chest for a man's garment and at the fullest point of the bust on a woman's garment. For a home furnishing product, such as a pillow sham, the first button and hole is placed at the point of most stress or midway from the ends of the opening on a pillow sham. On many products, the buttons and holes are then placed equidistant along the remaining opening space. For shirts, after placement at the point of stress, the next buttons and holes should be placed at the neck and at a point slightly above the waist. The remaining buttons and holes that are visible should be placed equidistant between the three previously placed buttons and holes. In addition, at least two buttons with holes should be placed below the waist line.

Buttonholes should be sized so that they are slightly bigger than the button but not big enough to gap when the button resides in the buttonhole. Buttons and buttonholes must also function together so that the button stays in the buttonhole when in use. A buttonhole that is too large not only gaps but also can release the button. A buttonhole that is too small will not only be difficult to use but also may not allow space for the bottom of the button and the shank (i.e., thread, metal, or other types). This misfit between button and buttonhole may result in fabric distortion around the button. Buttons with irregular shapes and high thicknesses become a challenge to the designer or the merchandiser to determine a hole size that is large enough for easy use and small enough to stay closed. Buttonholes must be large enough to accommodate

both the width and the depth of the button. In general, the **buttonhole size** is calculated by the following formula: Hole = Shank Height + Button Thickness + Button Diameter. The diameter of a button is traditionally measured in **lines** with one-half inch equaling 20 lines.

Shape of the buttonhole is another concern when selecting the button and buttonhole. Each buttonhole has a distinctive shape; however, all buttonholes should be well stitched without lose threads. The edges should be adequately bound so that the fabric will not ravel. Stitching on the stitched holes should be even and well placed. The bound button hole should have square corners and even welts.

The selection, placement, and shape of the buttonhole can also affect the ability of the closure to stay closed and, for apparel items, may have an impact on the modesty of some consumers. Buttons and buttonholes are often used to maintain a closing of the apparel product. Because this closure does not have as high of a holding strength or take as much stress on the closing as do zippers or snap fasteners, home furnishing items are usually not closed with buttons and buttonholes but have them only for decorative purposes. Seams that are closed with buttons are usually expected to close completely and to remain closed during wearing. This expectation is coupled with usability in that buttons are also supposed to slip into and out of buttonholes with limited force. As often found in designing consumer products, the designer must create a product that is multifunctional with functions that are in opposition to each other.

Zippers

Zippers are also called **slide fasteners** because the slider on the zipper slides along the teeth to close the opening. The quality analysis of zippers requires that the designer, merchandiser, buyer, or other product specialist understand the structure, operation, and application of zippers. Zippers create a closure by the interlocking of metal teeth or loops of a plastic coil (see Figure 6–11).

The fingers within the slider mechanism help the teeth to interlock. The slider pull is provided to help the user move the slider along the stringer to close the opening. The zipper shown in Figure 6–11 is one that is commonly used in home sewing. Zippers used in industrial sewing are usually ordered as the **zipper stringer** and the **retainers, sliders, pulls** and **stops** are separate parts. The stringers may be added independently to the right and the left sides of the seam and then put together when the seam is joined. This use allows the designer and the manufacturer to create zippers of varying lengths as needed for the product. A quality concern for this type of component assembly is that the two halves of the zipper may not be completely aligned to make a visibly even outcome and a fully functional zipper.

Styles of Zipper Applications and General Quality Standards

Four basic styles of zipper applications are used in sewn products: slot, lapped, fly, and invisible. Each application style has a traditional use and placement within products. Zipper placement within the product has a generally accepted or traditional standard for appearance of the finished sewn placement. The

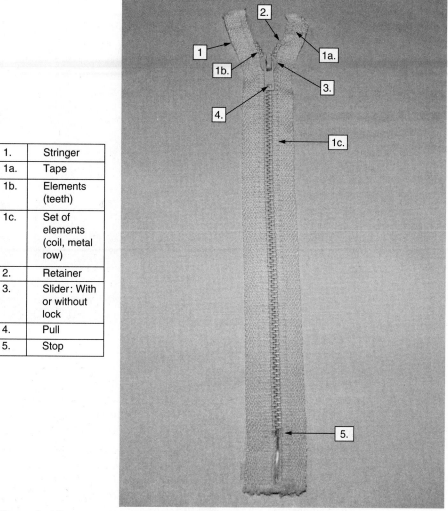

1.	Stringer
1a.	Tape
1b.	Elements (teeth)
1c.	Set of elements (coil, metal row)
2.	Retainer
3.	Slider: With or without lock
4.	Pull
5.	Stop

Figure 6–11
Zipper nomenclature.

slot zipper is used for center applications such as the back of a dress or skirt and for zippers in pillow covers (see Figure 6–12a). The basic appearance standards for the slot zipper are as follows: two equal lips with square ends and straight rows of stitching parallel to the zipper. Lips are wide enough to cover the zipper, meet in the middle of the opening, and do not overlap.

The **lapped zipper** is used for side applications in a product. The zipper is inserted with only one lip that covers all of the width of the teeth. This can be used on the side of a dress or a skirt or in an upholstery application in which the flap is turned downward to the floor, such as on a couch cushion. The standards for this zipper application include the following: one equal lip with a square end and one row of stitches parallel to the zipper teeth (see Figure 6–12b). As with

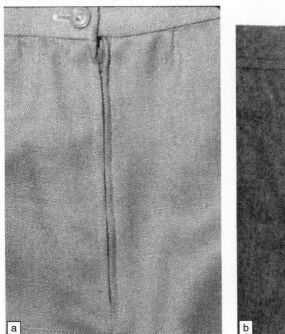

Figure 6–12
Zipper applications: a = slot zipper application; b = lapped zipper application.

the slot application, the lip should cover the zipper and not expose any part of the zipper, including providing space for the slider and tab.

The **fly zipper** is used commonly in the front opening of blue jeans, men's trousers, and women's pants with men's tailoring. It is rarely used in upholstery applications. The standard fly application has the zipper and the wide lip covering the zipper. The **French fly** has an added underflap or facing that lies between the zipper and the wearer (see Figure 6–13a). When used with heavy-weight denim and large-tooth metal zippers, the facing on the French fly application provides the functionality of comfort for the wearer. The facing is attached to the underside of one side of the zipper, opposite the side that has the covering lip. The **continental fly** is the French fly application with an added security tab with buttonhole and button that affixes just below the waistband (see Figure 6–13b). This additional closure provides security (i.e., a functionality of fasteners) for the wearer in case of zipper failure. The standards for the fly zipper are as follows: one wide but tapering width lip, a row of stitching that initially parallels the zipper but that tapers at the end of the zipper into a curve, and a bar tack at the end near the center seam.

The **invisible zipper** is often used for backs of dresses or other places where the stitching for the zipper would be a distraction for the user or the viewer. The invisible zipper is sewn with a special foot, different from the usual zipper foot. This foot guides the zipper and the fabric into a rolled formation as the fabric and zipper are stitched together (see Figure 6–14). No

Figure 6–13
Additional zipper applications: a = French fly application; b = continental zipper application.

Figure 6–14
Invisible zipper application.

stitching should show on the surface or outside face of the product, and no teeth should show when the zipper is closed. To achieve the flexibility needed to get the zipper and fabric to roll together, the zipper is usually made of lightweight materials. The holding strength of the invisible zipper is therefore weaker than other zipper types and applications.

Thread

Thread is a key component to product outcomes. Thread may be often invisible or unseen in a product, but its role in the outcome is huge. **Thread** holds on the buttons, keeps the hem in place, and most importantly keeps the seams of a final product together. When the threads break, the item begins to fall apart. To properly function as desired by the consumer, the thread should have the same physical features as the base fabric.

In contrast, thread may also provide a role in the fashionality of the item and be highly visible and decorative. For a special effect, a thread may be selected that varies in color, fiber content, or structure from the base fabric. For example, threads that are used for top stitching, tucking, and other specialty features may be a contrasting or complimentary color. For threads that are used for pleating, pad stitching, or other reinforcement, the stitching may be stiffer, stronger, or otherwise different from the base fabric. Thread can be used for embroidery and other nonstructural aspects of a final product.

The physical properties of thread (see Table 6–1) are the same as the properties of yarn that were discussed in Chapter 4. For example, thread is identified by type, which indicates the structure of the thread, such as spun, filament, or spun-core. A sewing thread is a yarn that is used for sewing a final product instead of used for weaving or knitting a fabric.

Table 6–1
Physical Properties of Thread

Properties	Descriptor Characteristics
Color	Hue, shade, tone
Content	Fiber percentage
Diameter	Measurement of size of thread
Finish	Smooth, textured, specialty
Ply	1-ply, 2-ply, 3-ply, multi-ply, or complex
Size	Tex yarn number, denier
Texture	Smooth to rough
Twist	S twist, Z twist
Type (Structure)	Spun, filament, spun-core, multifilament

Figure 6–15
Type of threads: a = spun-core; b = multifilament.

Filament thread may be either monofilament with one long filament fiber or multifilament with multiple filaments twisted together. The twist may be high or low depending on the hand that is desired for the thread. The **spun-core thread** is a combination structure that provides the physical properties of both the core and the outside covering (i.e., the spun part) for the thread's performance (see Figure 6–15a). The **multifilament thread** (see Figure 6–15b) is becoming more common among sewing threads in order to have threads that are more compatible with microfiber fabrics and other specialty fabrics that are currently on the market.

Physical properties of thread affect manufacturability of the product during production and outcomes of the product for the consumer. For example, a multifilament thread with a very low twist has the same silky hand that is found with microfiber fabrics and would be very compatible with the end use of a product made from that fabric; however, the silky hand of this thread could make the thread difficult to use in sewing. The spun-core yarns tend to be easier to use in sewing but are not always compatible with many of the new high-tech fabrics. Direction of twist is also important to manufacturability. Most commercial sewing threads are left-hand twist or a Z twist to prevent unraveling when sewing. In addition, thread should have a balanced twist to prevent kinking and back twisting during sewing. Size of the thread should also be noted. Several systems are used in sizing thread. One that is commonly found in commercial thread is the system using the tex measurement. The tex yarn number is based on the weight of the thread for 1,000 meters of thread. Other systems are used especially for 100% cotton thread and 100% silk thread.

To further improve manufacturability, some threads have a texture, especially **crimp,** added to the thread to keep the filaments together and to improve its hand during sewing (see Figure 6–16). If the crimp is too exaggerated, the thread may try to curl and will contribute to seam pucker.

Thread ply affects the performance or functional outcomes of the thread both in sewing and in end use. The ply of the thread also called **cord** can vary

Figure 6–16
Multifilament thread with texturization.

from single ply to a multiple ply. The three-ply and the four-ply threads are common ply numbers found in sewing thread (see Figure 6–17). Both of these threads are made from staple fibers so that each ply contains a multitude of tightly twisted staple fibers. The outcome or behavior of the thread depends on the fiber content, the twist of the staples, and the added twist joining the plies to make this a single strand for sewing.

Ply affects the diameter of the thread and also affects the movement one can achieve with the thread. Because the mechanical structuring of a two- or more ply thread requires that the single plies be wrapped or bent around each other, the resulting thread will have bends and curves already preset into the thread. This curving, unless excessive, helps the thread bend and twist through the sewing machine and into the sewn seam.

The physical properties, which are the result of the fiber content, the fiber's chemical structure or finish, and the thread's mechanical structure, affect the thread's performance and the outcomes of the product in which it is used. The thread properties also have an effect on the manufacturability and other aspects of the item in product development and in the design and assembly processes.

The characteristics of thread can affect product performance or outcomes, which can be measured by tests. The criteria and related tests for these outcomes are often similar to those of yarn and fabric. Some outcomes are important to the designer and the manufacturer to ensure the manufacturability of the product, whereas others are more directly related to consumers' expectations. A partial listing of criteria and definitions that are commonly used

Figure 6–17
Thread ply: a = 3-ply, b = 4-ply.

Table 6–2
General Criteria for Thread

Criteria	Definition for Sewn Products
Coefficient of friction	Resistance to passing through the needle hole
Color fastness	Ability to keep color
Elasticity	Ability to stretch and return
Elongation	Amount of lengthwise stretch
Flexibility	Amount of bending
Fusing	Melting by heat
Pliability (malleability)	Ability to be shaped
Resilience	Ability to bend and return
Scorching	Browning or burning with heat
Shrinkage	Reduction with heat and moisture

in describing thread outcomes are provided in Table 6–2. Criteria when discussing thread, which are not used as frequently with yarn or fabric, include the following: coefficient of friction, color fastness, fusing, pliability, and scorching.

Thread and Quality Outcomes as an Impact on the Final Product

In general, consumers expect thread to be compatible with the product in terms of use, life cycle or durability of the product, and cleanability of the product in postuse situations, as described in the previous section of this chapter. Thread, as with other findings, has a major impact on the outcome and thereby the quality of the final product; however, most consumers do not think about thread unless the thread of a seam breaks or the thread holding a button or hem unravels. In contrast, thread considerations are of major importance to the designer, merchandiser, and manufacturer of sewn products. In consideration of the final product quality, the physical and performance properties of the thread must be evaluated for their effect on the design, assembly, and product outcomes. Manufacturability, or the performance of thread during production, is a primary consideration that must be given when developing a product. When sourcing the thread for the product, the merchandiser must evaluate how the thread will perform when sewn with the base fabric. Compatibility between base fabric and thread must be achieved. Specific examples of how the physical properties of thread affect manufacturability are given in Table 6–3. Selecting the best quality thread depends not on getting a preset grouping of physical properties but on selecting the properties that will be compatible with the base fabric during production for the manufacturer and in postuse by the consumer, thus producing a product with the expected outcomes.

Table 6–3

Physical Properties Related to Manufacturability

Physical Property	Examples of Effect on Manufacturability
Color	Darker colors of thread weaken over time faster than light colors
Diameter	Bigger diameter thread is stronger but makes bigger holes in the fabric
Fiber content	Synthetic thread is stronger but melts with high temperatures
Finish	Soft finish adheres to fabric but weakens the structure
Ply	Multiple ply threads more often ravel or shred when sewn
Structure	Filament thread is stronger than spun thread but more often creates skipped stitches
Twist	A Z twist prevents unraveling when sewing

In addition, the performance criteria of thread are related to the relative manufacturability of the product and the final performance of the item. For this reason, the designer and the merchandiser must consider the performance criteria when selecting both fabric and thread. Examples of performance criteria and their relationship to manufacturability issues are given in Table 6–4. Compatibility between two raw materials when sewn is needed for the product to be able to be produced in a factory and for the final outcome to meet the consumer's expectations.

When thread is selected for sewing, designers and merchandisers must consider the physical properties in conjunction with the performance criteria. All of the properties of a thread are interrelated to the behavior of the thread in sewing and for the end use by the customer. For this reason, the two sets of properties are considered jointly.

Table 6–4

Criteria of Thread Related to Manufacturability

Thread Performance Criteria	Examples of Effects on Manufacturability
Coefficient of friction	Thread with a higher coefficient leads to slower sewing and/or more fusing
Color fastness	Without fastness, threads develop problems with bleeding/crocking/fading
Elasticity, elongation	Without sufficient elongation, threads will break in sewing and use
Flexibility, resilience	Low flexibility distorts seam structure
Fusing, scorching	Thread that has a low fusing temperature may not withstand high speed sewing
Pliability	Low pliability in thread reduces shaping in curves
Shrinkage	Excessive shrinkage in thread leads to puckering

Support Items

Some findings provide support for the sewn product. These items often provide invisible support, such as collar stays that are closed within the collar points, interfacing and stays behind the face fabric in the pleats of a sofa, and shoulder pads stitched into the lining of a jacket. Support findings are primarily expected to provide structure to the product without calling attention to the addition of the support. **Support items** include linings, underlinings, interfacings, shoulder padding, and stays. **Stays** include super stiffening materials such as the historical whale bones in women's corsets, metal or plastic strips in collar points (see Figure 6–18), nonroll strips in waistbands, and cardboard strips in the edges of sofa and chair skirts.

To accomplish the purpose of support items and to meet the quality expectations of the user, these raw materials must be compatible with the base fabric in manufacturability, usability, and cleanability. For example, a white oxford cloth shirt will most likely be sent to the commercial laundry for cleaning. The collar stays in the shirt must be either removable or stable when washed, bleached, dried, and pressed. If a stay rusts during cleaning, the shirt will be

Figure 6–18
Removable metal collar stay in collar stay pocket.

stained and use of the shirt will be lost to the consumer. In addition, support must be comfortable to the user of the product to the degree of expectation for that product. Although women often experience discomfort in wearing bras or other foundations with stays, they are usually not happy with this experience. Few people want a product that is close to their skin to be uncomfortable.

Labels

A number of **labels** are required by law to be placed in sewn products. The labeling laws vary according to the country for the intended sale. In the global economy with products designed in one country, made in a second country, and sold in a third country, designers, merchandisers, manufacturers, and buyers must be aware of the labeling laws in the countries where consumers are targeted for the sewn products. Labels are generally required for size, fiber content, care, and country of origin. Other concerns for labels in this global economy are obtaining an accurate translation when selling products in another country and obtaining a clear and readable print of the words or symbols.

As a quality concern, labels must have durability that equates to the life cycle of the product. The label must be able to resist the care of the product after the sale and to withstand any prewashing, product dyeing, or other treatments given to the product before the sale. For example, if a bed sheet can be washed in hot water and dried in a hot dryer, the care label must also withstand these procedures and be readable after the procedures. This ability to withstand a process also includes dry cleaning, bleaching, ironing, or any care procedure that is recommended for the sewn product. A product that is recommended for dry cleaning must have a label that will not run, fade, or bleed during the dry cleaning process. The consumer expects the care label to be readable as long as the product is in use. On the other hand, some labels can be removed by the consumer once the product is in use; therefore, these labels are not expected to have an extended life through product use and care.

In addition to durability, labels should not affect the fashionality of the product. Placement of labels is a consideration when designing the product. The placement of the label must not be sewn so that it mars the outside look of the product, unless the label is part of the design. The placement must also be comfortable to the user. If a label is harmful or painful to the consumer when the product is worn or used, the consumer will most likely remove the label, which defeats the purpose of the label and generally annoys the consumer.

When evaluating the durability of labels, the merchandiser or designer can also evaluate their comfort. Many labels that meet the criteria of durability fail in the measure of comfort. To cut costs on labels, some manufacturers make them from a 100% polyester fabric and cut them to size with a hot wire. The result is a small plastic-like bead along the edge of the

Figure 6–19
Printed label.

label. This bead is felt by the body as a sharp irritating edge. Alternatives to the 100% polyester label are a woven label from a polyester/cotton blend or a polyester/rayon or silk blend, which would greatly increase the cost of the label. Folding under the edges of the label could add as much as two cents to each label. In a price-driven product category, that amount could be too costly for the retailer (Carton, 2001). Consumers often remove the labels from apparel and home furnishings because they are unsightly or uncomfortable. As mentioned earlier, this removal defeats the purpose of the label. When the time comes to wash or clean the product, the label is gone. Solutions to the label problem include placing the label in a seam that is not likely to cause skin irritation or printing the label on a facing or other inside portion of the product (see Figure 6–19).

Manufacturers should avoid using labels that suggest the least aggressive level of care that the product can withstand. This practice is called **low labeling.** For example, a preshrunk cotton slipcover can be washed in warm water and dried in a warm dryer. However, the manufacturer places a label in the product that recommends dry cleaning. Dry cleaning will clean the product but probably not as well as washing it. If the product were washed, it might need to be ironed. By placing the dry clean label in the product, the manufacturer implies that the product is more delicate and therefore more valuable

than something that can be machine washed and thus avoids instructing the consumer that the product might need pressing. Low labeling is easier for the manufacturer, who can avoid doing extensive tests on a product to determine the best method for care, but it may cost the consumer more money in post-purchase costs for care that may not be necessary.

Trim

Findings also include a variety of materials called trim or narrow fabrics. **Trim** is additional fabric materials that are added to the base fabric, primarily for fashionality outcomes. A little black dress without trim is just a plain black dress, but a little black dress with trim makes a statement (see Figure 6–20). Items made of base fabric that are then added to the item are not considered trim. For example, a narrow strip of the base fabric is cut, hemmed, and gathered. This strip is sewn to the edge of the product as a ruffle. The ruffle is not trim because it is made of the base fabric. However, if the base fabric is satin and a lace ruffle is added, the lace is trim. Trim comes in a variety of sizes, styles, and colors. Three basic categories of trim are as follows: ribbon, lace, and braid. Ribbon includes, but is not limited to, grosgrain and satin. Lace includes, but is not limited to, Cluny, eyelet, and galloon. Examples of braid are gimp, piping, corded piping, bias tape, and seam tape.

Figure 6–20
The little black dress.

Quality considerations for trim include many of the same factors as other findings. The items should be compatible with the base fabric during sewing, while being worn, and in postuse care. A bright red braid that bleeds onto the white curtain during wash will not meet any consumer's expectation of a quality product. In addition to bleeding, shrinkage, skew, or other types of distortion are of concern when washing or otherwise cleaning the product. Trim is a type of fabric so many of the topical dimensions and criteria that are analyzed for wide or base fabrics can be used in the quality analysis of trim, as long as they address the consumer's expectation for the product.

Key Terms

Base fabric
Bound buttonhole
Button with holes
Button with shank
Buttonholes
Buttonhole size
Continental fly
Cord
Crimp
Dynamic links
Failures
Fasteners
Filament thread
Findings
Fly zipper
French fly
Holding strength
Horizontal buttonholes

Horizontal placement
Invisible zipper
Keyhole buttonhole
Kinematic durability
Labels
Lapped zipper
Lines
Locking
Low labeling
Multifilament thread
Oval buttonhole
Placement of buttons and
 buttonholes
Pulls
Retainers
Selection of a button and
 buttonhole
Shank

Shape of the buttonhole
Slide fasteners
Slider
Slot zipper
Spun-core thread
Straight buttonhole
Stays
Stop
Support items
Thread
Thread ply
Trim
Vertical buttonholes
Vertical placement
Welts
Zipper stringer

Review Questions

1. What is a finding?
2. When is a ruffle not a finding?
3. What are the five major categories of findings?
4. How are notions different from findings?
5. Are all findings functional? Why or why not?
6. How can a finding provide structure?
7. Give an example of a fashion use for a finding.

8. What tests can be used to evaluate the topical dimensions within the expected outcomes of findings? Provide examples of topical dimensions that are covered by these tests.
9. Why is the quality of findings important?
10. Give an example of a product that has no appropriate care procedure? What could be done to prevent this disappointing outcome?

11. What is appearance retention of findings, and why is this important?
12. What two findings will be in almost every garment?
13. List five dynamic links that are used as fasteners.
14. What are two performance properties that are rather unique to fasteners?
15. Identify the parts of the zipper.
16. Identify four zipper applications and their primary use.
17. Give quality standards for the four zipper applications stated in Review Question 16.
18. What are the two button styles? Identify four buttonhole styles.
19. How do the physical properties of buttons affect cleanability? Give an example.
20. What are three general consumer expectations of buttons?
21. Why is a shank important to the quality of a button and buttonhole?
22. Describe button and buttonhole placement standards.
23. Describe how to calculate the size of a buttonhole.
24. Why is the quality of thread important?
25. Identify structure, texture, and ply from pictures or thread samples.
26. Identify elasticity, resilience, and pliability of the thread samples.
27. What is coefficient of friction? What is fusing?
28. Understanding and using thread properties—Examples.
 a. Why would you want to use spun thread when sewing? Spun core?

b. What is a disadvantage of dark thread?
c. If the diameter of the thread is large, what type of yarn count do you want for the fabric? If you don't get a compatible count, what will be the outcome?
d. If the thread would not form a knot, what physical properties might it have?
e. If you were sewing a fabric with a blend fiber content, what thread physical properties might you need?
29. Understanding and using performance criteria for thread with topical outcomes— Examples.
 a. If the shrinkage rate of the thread does not equal the rate of shrinkage for the fabric what is the outcome?
 b. If you were sewing on a very stretchy knit fabric what are the three performance criteria that measure the "movement" of a thread?
 c. If you wanted thread that would sew well into tiny circles and swirls what thread performance criteria would you need?
 d. If a thread melts, burns, or changes texture when you are sewing, what performance criteria should you examine?
 e. If a thread frays as you sew, what performance criteria should you examine, and what physical properties should you check?
30. What are general quality expectations of labels?
31. Why should trim be compatible with the base fabric in a sewn product?

References

Carton, B. (2001, December 27). Must clothing labels be a pain in the neck? Legal rules, costs make tags cutting edge. *The Wall Street Journal*. Retrieved December 28, 2001 from http://www.wsj.com

chapter 7

Sewn Product Production Processes

The process of sewn product production includes a variety of activities that can be categorized into preassembly (i.e., preproduction), assembly (i.e., production), and finishing (i.e., postproduction). **Preassembly** includes the activities of production marker making, spreading, cutting, and bundling. **Assembly** includes the sewing of the product, and **finishing** includes a variety of activities such as wet-processing, pressing, finishing, and final inspection. Every product does not always process through every activity. Cost considerations, time to market, and retailer demands as well as the skills and capacities of the design team and the manufacturing facility govern the production process. Ultimately, the expectations of the final customer, the consumer, should dictate what happens to the product during production.

The quality analysis process is similar for the product processes as used in the manufacturing raw materials. Sampling, measuring, and evaluating must be done by a prescribed method and results must be compared with preestablished standards. Standards may be set by the retailer and/or the manufacturer to provide guidance for decisions affecting the quality of the product. Some standards are generally accepted by the industry and some standards are set by specific retailers or are demanded by certain consumers. Some standards for sewn products are available from the previously mentioned organizations such as ASTM and AATCC. A few federal standards for production in the United States are in place for product analysis,

but most of these are voluntary and are not required. Instead, most of the standards used to evaluate the quality of sewn products are created and implemented as needed by manufacturers and retailers.

Traditionally, final inspection, after the product is completed, is the major inspection process for the sewn product. More progressive manufacturers, who want to be competitive, have found that TQM strategies of in-process inspection, defect prevention, and continuous improvement are important tools for planning, manufacturing, and delivering a quality product. These concepts are important for manufacturing quality fabric as well as for manufacturing a quality sewn product (see Chapter 5). On the other hand, each step in the sewn production process has unique characteristics that require some specialized quality procedures or specialized knowledge possessed by the personnel that are performing the quality analysis process.

As with all inspection processes, inspection protocol of inspection processes and standards must be readable, accessible, and doable in a short time frame. Workers must be made aware of the standards and have training in the use of the standards and the performance of the inspections. Appropriate and well-maintained equipment must be readily available for inspection workers to use. Inspection workers must also have authority to make decisions about the rejection or the replacement of products and product parts, and the process for dealing with rejected parts or products must be clearly stated within the inspection protocol.

Automated processes, when possible to use, may provide faster and more consistent evaluation outcomes. Standards for automated processes in production are currently being developed by ASTM. ASTM D1366 Sewn Products Automation sets standards for cutting data to drive numerically controlled fabric cutting machines, sewn products pattern data interchange data format, standard practice for data exchange format for sewn product plotting devices, and terminology for sewn products automation. Trading partners who use these automated devices would benefit from the use of these standards to reduce time in set up and to increase seamless transfer of data.

Marker Making, Plotting, and Laying

The **marker** is a drawing, either on paper (e.g., a manual marker) or stored as a computer file, that shows the placement of pattern pieces for a product, including pieces for multiple sizes. **Plotting** is the process of drawing the pattern pieces on a cutting-table-sized piece of paper. Markers of smaller sizes may be plotted for reference or for other preproduction needs. The plotted marker is used as a guide for cutting the fabric, although some computerized cutting does not require a paper marker. The **laying** of the marker

is done after fabric is spread on the cutting surface and refers to the placement of the plotted marker over the stack of spread fabric.

In preproduction, the technical drawing, made initially or generated from a fashion sketch, is used to produce the pattern pieces for one item for a production pattern, unless this was made in the production development stage of product development. The pattern pieces, after being graded or resized for all sizes needed in the production run, are then used to make the marker. In mass production, the marker is made to cut multiple sizes and multiple numbers of pattern pieces for a high volume of products (see Figure 7–1). The combination of sizes, repetitions of pattern pieces, and the number of plies in the stack create the total number of pieces needed to complete the volume of products needed for the order. Figure 7–1 shows the technical drawing used as the guide for producing the pattern; the pattern pieces, including the front with a deep rounded V neck, the back with a round neck, one sleeve that will be cut twice for each shirt, and the complete front neck and one-half back neck facings; and the marker with multiple pieces for production.

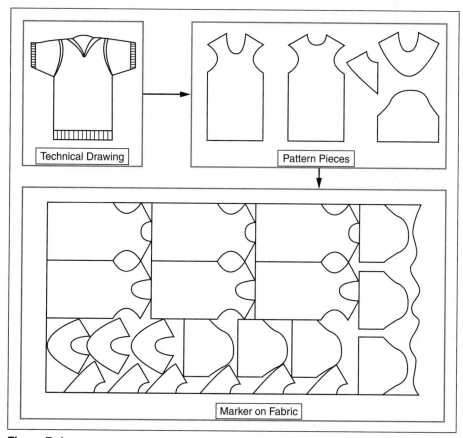

Figure 7–1
Technical drawing and pattern pieces with the resulting marker layout.

Cut order planning is done to determine the number of sizes needed in the marker with the number of plies in order to cut enough pieces for the entire order. The **cut order** or document written to direct the cutting for the entire volume of the order may require that more than one marker be made. Sometimes, multiple markers are needed to accommodate the matrix of sizes and items per size for the entire order. When writing the cut order, the length of the cutting table, the length of the marker, and the height of the fabric plies that can be stacked and cut must be considered. Usually a mix of large and small sizes is placed in a marker to achieve maximum utilization of fabric. In addition, indications are made on the marker where splices can be made if defects in the fabric require the cutting and lapping of the spread.

The marker can be plotted by hand using tag board pieces of pattern and a pencil. This process is very time consuming and requires someone with high levels of spatial relationship acumen so that a single sloper for each size can be used for tracing as many times as needed. The use of computer-aided marker software has greatly increased the speed of making a marker and has increased the speed of plotting the marker. Once the marker is created in a computer, the file can be sent to the plotter for drawing on the appropriate plotter paper. With computer-driven cutting, the marker file can be sent directly to the cutter, bypassing the plotter; thus, plotting time and paper may not be needed to guide the cutting head because the process is driven by the computer and the marker file.

Quality Considerations in Marking and Laying

The computerized marker making and automated plotting, laying and cutting contribute positively to a company's strategy for increasing quality. Automating the marker making and plotting process not only reduces the time needed for marking but also increases accuracy. The computer-driven plotter draws the pattern pieces with precise lines and exact corner angles with no wiggles, slants, or stray marks that might confuse the cutter. The shape of a pattern piece is replicated exactly, as many times as needed, with a computer-driven plotter. In addition, the utilization of fabric is normally increased with the use of computerized marking equipment. The average marker maker can manually create a marker with 80 percent utilization. Computer marker making software can generate a marker with about 75 percent fabric utilization. With the aid of this computer software, the same marker maker can create markers with 90 percent fabric utilization.

Computer-driven markers and plotters are very dependent on the reliability of the fabric quality incoming to the cutting facility. A marker that has maximum utilization is made to fit pattern pieces tightly together and to use all parts of the fabric from selvage to selvage. The entire width of the fabric is used as needed for the marker. If the fabric is expected to be 45.00 inches wide, then the marker is made with those specifications. If the fabric is 44.89 inches wide, then the marker will be too wide for the fabric

and a portion of all pattern pieces along the selvages will not be placed on the fabric. Manufacturers when laying the marker can use several "tricks of the trade," such as lightly spraying the fabric with water (i.e., **misting**) or weighting the fabric with stones or bricks to stretch it to fit the marker. Although seemingly workable solutions to a fabric with the wrong dimensions, these procedures ultimately result in pattern pieces that are smaller than expected when the weights, moisture, or other stretching devices are removed. A product made from fabric that was unduly stretched during marker laying will be smaller than expected. Cut pieces that come together in a product from various cut tables or that are distantly spaced within a marker may not align properly when sewn together.

Spreading

Spreading is the process of unrolling the fabric and pulling it across a long, flat table in preparation for cutting. Industrial spreading tables average 30 to 45 feet long and can be as long as 100 feet. The **ply** (i.e., one layer of fabric) can be stacked on the table to a depth of 4 inches to 6 inches or higher, depending on the length of the cutting blade and the volume of the order. The thickness and sometimes the weight of the fabric is also part of the calculation of how many plies can be placed and cut on one table. Single- or low-ply spreads are used when the production lot is low volume or if a specialty print or plaid is desired and the patterns are placed in specific locations on the fabric. The **spread** is the fabric that is pulled from the roll on the spreader or spreading machine and placed on the cutting table. It can be carried by hand or by machine down the length of the table.

Hand spreading is used for specialty fabrics such as plaids or super stretchy fabric. Hand spreading with machine assistance is also used when the number of plies needed is low, the fabric is narrow width such as a tubular knit, or the cutting table is very short (see Figure 7–2). Machine spreading can be human or computer controlled. As discussed in Chapter 5, defect levels and flagging methods can affect the choice of the spreading method. When metal flags or defect maps are used, automated spreaders are more feasible. With the input of a computer map for defects and reliable fabric data from the vendor, the spreading process can be automated with limited need for human intervention and down time.

The automated spreader has a roller that is machine-driven down a track on the spreading table to the end and then returned automatically. Some machines have a platform on which the spreading operator can ride to supervise the spreading along the cutting table. In addition, the automated spreader can use a computer map or read metal flags with machine sensors to stop the machine when defects are identified and signal for human intervention to

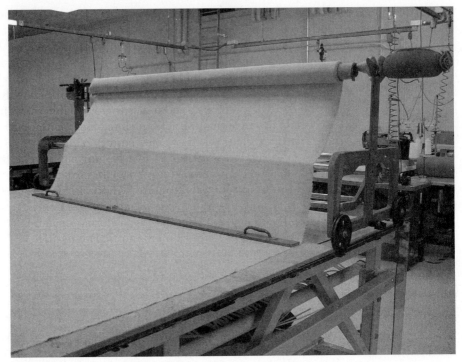

Figure 7–2
Manual spreader for low-ply spreads.
Courtesy of College of Textiles, North Carolina State University.

make a splice or other adjustment in spreading. This automation assures the manufacturer that all defects are recognized in the spreading process. This security should improve the removal of defects before cutting occurs and helps to ensure products are made of defect-free fabric.

Quality Considerations in Spreading

In general, fabric that is spread is expected to be the same width and length as the fabric when it is on the roll. As with the rolling and rerolling in fabric inspection, spreading can unduly stretch the fabric. Although time consuming, manual spreading can create a very smooth and bias-free spread with a skilled spreader who spreads a dimensionally unstable fabric. Manual spreading can also create width differential when the spreader is not skilled. Mechanical spreaders can give a more even spread than hand spreading if properly adjusted for the stretch, thickness, hand, and other physical properties of the fabric. When the type of fabric is changed, the tension, speed, and other facets of the spreader must be readjusted.

Fabric also may be spread onto an air table that can create an upward draft of air, evenly placed across the table, so that large stacks of fabric can be easily moved by two persons. The air table can be used when creating the

spread, and the fabric can be moved to a cutting table. This procedure provides a more even flow of work and allows the spreading equipment to be in continuous operation without waiting for cutting to be completed.

A variety of conditions that affect quality can be introduced into the product during spreading. A **slack spread** or a spread that allows for ripples or bubbles in the fabric will result in oversized cut pieces and will use more fabric than expected. A **taunt spread,** one that could result from excessive tension on the fabric during the spread, will result in pieces that are undersized and will result in finished products that are smaller than the appropriate size dimensions. For example, fabric that is stretched beyond its correct width or length will relax when it is cut and will create fabric pieces that are smaller than the intended finished size of the product. This error may not be found until the product is sewn and the final dimensions are checked. At that stage, the raw materials and labor are invested into the product and all are lost when the product is not the right size. The manufacturer may stretch fabric purposively for a variety of reasons. For example, fabric may be stretched to get more pieces within a roll and to reduce costs or to get a previously generated marker to fit on fabric that is slightly narrower than needed to save time and reshipping of better fabric. These reasons may sound logical, but if the end result is that the product does not meet the consumer's expectations then the manufacturer may lose current money and future customers.

Other conditions, especially distortions, affect the grain lines in the fabric. Bias or bow can also be introduced into the fabric during the spreading process. If the edges of the fabric are pulled at a faster rate than the center, the fabric will develop a **bow.** If one edge is pulled faster than the other edge, a **bias** is generated in the fabric. These errors are similar to the defects manufactured into the fabric as discussed in Chapter 5. Again, these errors can be created through both machine and hand spreading. In general, mechanical spreading gives a more even spread in most fabrics with average weight and a stable construction. When grain lines are distorted and bias is introduced into the fabric, the finished product has grain lines that are not true. Inappropriate bias in fabric causes the fabric to twist. For example, the side of a shirt or a pant leg may twist and the seam will wrap to the front when it should run down the side of the torso or the leg. Bow in a window curtain may create an uneven hem as fabric relaxes when the curtain hangs over time at the window. These defects are generally not tolerated by consumers, especially when the consumer has paid a high price for the product.

The **fabric direction** or the direction of the print, stripe, or other surface features of the fabric is another condition that must be considered when spreading. Various types of fabric may require special handling when spreading. When fabric has no direction in the design and no nap, the spread is made down the length of the cutting table and back with fabric being laid in both directions (see Figure 7–3). This method uses the maximum use of the spreading equipment without a **dry haul** or the return trip to the original starting spot for the equipment without laying fabric on the table. If a

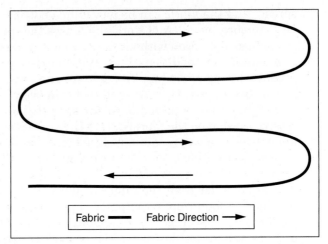

Figure 7–3
Spread for fabric with no nap and no direction in design.

dry haul is needed to spread fabric in only one direction, the process requires twice as much time to complete a spread as a back and forth lay up. However, certain fabrics will result in unsatisfactory products if cut with 50 percent of the fabric run in one direction and 50 percent run in the other direction.

Fabrics with nap, directional prints, and other surface details need to be spread in a more complex method. The spread in Figure 7–4 is appropriate for a fabric that has a **one direction print** such as an overall flower pattern that has all the flowers with the blooms in one direction or a **fabric with a nap** such as velvet with its plushy pile. Napped velvet appears dark when viewed from one direction and light when viewed from the

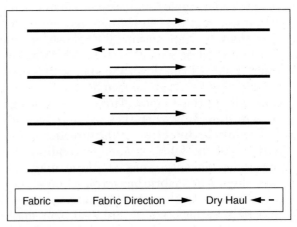

Figure 7–4
Spread for fabric with one-way design or one-direction nap.

other direction. For this reason, all pattern pieces must be cut with the fabric direction going the same direction so all pieces appear dark or all pieces appear light.

When fabric contains a plaid or other pattern that must be placed on a specific place on the pattern, **pegging** is used to keep the fabric aligned and correctly placed. Pegging involves the use of a peg board, which contains sharp slender spikes that stand away from the board. The peg board resembles a fabled bed of nails. Most peg boards are about two feet square with six inch spikes. The fabric is pressed on the spikes and each ply can be aligned exactly with the ply preceding it on the peg board. Marks on the pattern can be aligned with the plaids or other features of the print on the fabric, and the pattern can be pressed onto the pegs and on top of the fabric plies. This process must be hand done, is obviously time consuming, and requires a skilled cutter. Although the process is expensive in terms of both time and labor, the method ensures that each fabric piece cut for that pattern is appropriately and consistently placed on the fabric.

Cutting

Quality expectations in cutting require, in general, that the cut fabric pieces are sized the exact same size as the pattern piece and that the shape or outline follows exactly the shape of the pattern. Corners, curves, and other outline features must be exactly the same as the pattern or the final product will not be the same as the prototype. The amount of **tolerance,** or degree of difference that is allowed between the pattern and the final product, is determined by the customer in a consumercentric firm and by the product development staff or the retail buyer in more traditional processes. However, most consumers expect the dimensions of the product to be appropriate to the printed size. In addition, cut pieces must be the size of the pattern within a few tenths of an inch, or the joining process during assembly will be affected. When the size of a piece is not accurate, the final assembly may not be possible. For example, if the length of piping for a pillow is cut too short, the piping cannot be correctly applied to the pillow. Errors at this point in preproduction can result in partial-lot production and delays to retailer or consumer and may ultimately cause the product to be rejected or unsold.

Cutting of patterns and fabric, resulting in **cut parts** or pieces, can be accomplished by using a number of mechanisms, including, but not limited to, the following: cutting by hand with an electric "knife" or reciprocating blade or cutting by hand shears, laser beams, or dies. Each cutting method has associated costs with advantages and disadvantages. The advantages often improve the manufacturer's ability to meet the expectations of the consumer, and the disadvantages deter expected quality outcomes. In addition,

some methods are best suited to specific types of fabric or styles of products. Regardless of method, some companies have fabric cut in specialized cutting facilities, which is then shipped to sewing plants. Quality considerations in cutting are discussed within each section of cutting methods.

Quality Considerations in Knife Cutting

Knife cutting uses tools that are similar to a reciprocating saw or a circular saw. A cutting tool with a tall thin blade is called a **straight knife** or **vertical knife** and can be used for tall stacks of fabric (see Figure 7–5). The straight knife can cut quickly through multiple plies of fabric. This cutting method is ideal for large orders of products that are all the same and that use a dimensionally stable, nonslick, medium thick fabric. Woven fabric is more stable when cut with the vertical knife because the cut is in two directions (i.e., up and down). Cutting occurs as the knife slices into the fabric and pulls back to the machine. To get an accurate cut, the blade must be kept in a vertical position so that a piece cut from the top ply is exactly the same size and shape as a piece in a lower ply. The average weight of this type of knife is about 40 pounds. Accuracy with vertical blade cutting requires that the cutter have skill, practice, and upper body strength. The benefit of straight knife cutting is the ability to cut large stacks of ply, which is also a disadvantage because fashion products are often requested in low numbers and require few plies on a large cutting table.

Figure 7–5 Straight knife. Courtesy of [TC]².

Figure 7–6 Rotary knife.
Courtesy of College of Textiles, North
Carolina State University.

The **rotary knife** has a circular blade and is usually used for lower numbered plies than is the vertical knife, and makes only a forward cut into the fabric (see Figure 7–6). The rotary cutter is lighter in weight and easier to handle and causes less distortion of the fabric with its one direction cut. Disadvantages of either knife cutting method in terms of quality issues are the potential errors that can come from the cutting operator. A cutter who cannot maintain an exact vertical cut with the straight knife will create cut pieces of varying sizes when they should be exactly the same as each other and the pattern piece. Cutters who use the rotary knife can get incorrectly sized pieces because of the blade shape, cutting more into top layers than bottom layers. In addition, maintaining accuracy with the knife method is difficult when cutting pieces with very sharp or acute angles, multiple changes in curves, or very small pattern pieces because the width of the blade may be too wide to negotiate the turns. The size of the knife blade and the weight of the cutting tool also restrict the accuracy of the cut that can be obtained. When the blade of the knife is not sharp, has nicks, or is too small for the height of the ply, inaccurate cuts ensue.

Quality Considerations in Computer-Driven Cutters

Computer-driven cutters are used in conjunction with vacuum tables for cutting fabric (see Figure 7–7). These cutters use short blades, lasers, or water jets to create the cut. These methods are particularly good for small lots and intricate or complex cutting of multiple small pieces or pieces with many angles or curves. A computerized cutter can be guided by a computer-generated marker, removing the need for the paper marker. A top, over sheet of plastic is often used in conjunction with a vacuum to pull the fabric to the surface and to hold the fabric stable on the cutting bed.

Most cutters of this type are placed at the end of the spreading table so that the fabric can be drawn from the spreading table onto the cutter bed.

Figure 7–7
Flat bed with vacuum table and cutting head for low-ply lay ups.
Courtesy of [TC]².

This movement of the fabric can cause distortion in the alignment of the fabric. In contrast, the cutting table shown in Figure 7–2 has a frame attached so that the fabric can be rolled from its original roll directly onto the cutting table. This method would be useful in controlling alignment problems but would be possible only with small rolls of fabric.

Computer-driven cutting methods require expensive, technologically advanced equipment and many require the addition of the layer of plastic for every cut. This plastic must be separated from the fabric for recycling or it becomes a large volume of landfill-type waste. The accuracy of these cuts is excellent; however, if the fiber content is synthetic, the edges of the cut pieces may be sharp because of the melting that may occur with laser or high-speed cutting.

Quality Considerations in Dies

Traditional **dies** are small preshaped cutters that are similar to cookie cutters (see Figure 7–8). The sharp edge of the die is pressed into the fabric to create the cut pieces. Dies can be used to cut a single ply or a few plies if the fabric is thin. For very small dies, such as appliqué pieces and collars or cuffs, especially for children's wear, the dies may be pressed into the fabric

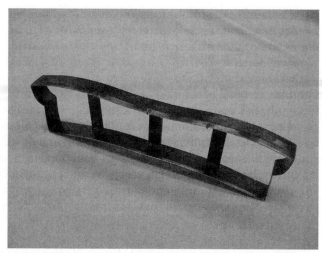

Figure 7–8
Die for shirt collar.
Courtesy of College of Textiles, North Carolina State University.

by hand; however, many die cutters, including those who use a small die, use automated presses to press the die into the fabric.

With newer and stronger flexible metals, dies are being created for larger pieces, in varying sizes but limited to an area of approximately 3 feet × 2 feet. These die are called steel rule dies. **Steel rule dies** are custom built to form the shape needed and can be used for very intricate shapes or for basic shapes (see Figure 7–9). The flexible steel strips have a blade edge. The steel blades are shaped into the desired configuration and pressed into a base material.

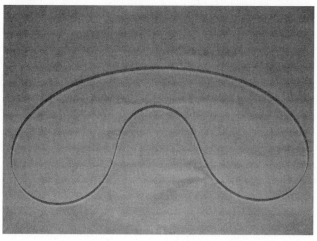

Figure 7–9
Steel rule die.

The base material may be a fiberglass epoxy resin, soft foam, or other composition materials, which are hardened after the steel rules are in place. Some techniques use steel braces, which allow for changes in positions of the steel rules. Most dies, whether fixed shapes or steel rules, are used for single-ply or low-ply cuts, as the depth of the cut ranges from less than 1 inch to more than 2 inches.

Die cutting is appropriate for pattern cutting that is repetitious because most dies are fixed in shape and require capital investment to have them created. The cost and time of constructing a die is only beneficial if the die can be used often. Steel rule dies that are changeable allow for some flexibility in pattern shape but are also expensive for the initial outlay. Die cutting has several benefits, especially for quality considerations. A main quality benefit of die cutting is the precision of the cut part that results from the die. The cut should result in a fabric piece that is the same over thousands of cuts. An added benefit is the quickness of the cut even for very complex cuts or cuts with extreme or exaggerated shapes. With automated presses, die cutting can be done rapidly and precisely with limited human intervention. This method increases speed of the cut and reduces potential harm to humans from knife blades. The die is enclosed within a press during cutting.

Bundling

Bundling involves the activities after cutting that include the following: removing waste or scrap fabric from the cutting table, checking for quality of the cut, stacking the cut pieces, and gathering associated pieces together along with findings. When the waste or scrap fabric is removed from the cut pieces, small stacks of pieces remain on the cutting table (see Figure 7–10). These pieces are stacked with other cut parts from the same pattern piece and the pieces that are to be stitched directly to the first piece. These are tied together or stacked neatly into a **bundle** with necessary findings and time cards or other tracking information. The bundles are then ready to go to the assembly line. The number of cut pieces per pattern piece in a bundle is predetermined by manufacturing standards, which take into consideration the time of the sewing operation involving the cut pieces, the weight and size of the bundle, and the order of the sewing operations. Bundling may

Figure 7–10
Cut pieces on a cutting table with waste removed waiting to be bundled.

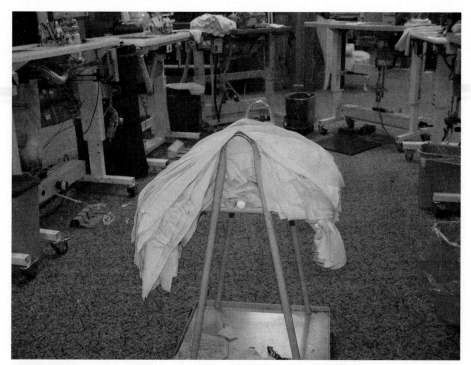

Figure 7–11
Stacks of cut pieces being delivered to a nearby sewing station.
Courtesy of [TC]².

be created simply by tying a cord or a spare fabric strip around the parts and findings needed for the product. For this reason, employees who work in bundling are often called **tie operators.** Tied bundles are placed in baskets, on rolling carts, or on conveyor belts to be sent or delivered to the sewing stations (see Figure 7–11). Bundles may also be placed in storage spaces to wait for the appropriate time in the sewing facility.

The stacked pieces, shown in Figure 7–11, are the fronts and backs for a shirt. The shirt sleeves are bundled together with the shirt cuff band and are placed on a second cart. Thread, buttons, or other findings are added to the bundles as needed. Bundles are then distributed to the appropriate sewing lines. For example, sleeves and bands are sent to the sewer who adds the band and closes the sleeve. The fronts and backs go to a different operator who assembles the torso or the body of the shirt. The two completed parts, sleeve and body, are then merged at a later place on the sewing floor. Each bundle also contains a bar-coded card to track the inventory and to keep account of the sewing time and the operators involved in the production.

Bundling can also be done by placing the cut parts on pincers, clamps, or other holding devices that are hanging from an overhead conveyor track. Thread, findings, and other materials or information may also be included in

Figure 7–12
Overhead conveyor system with enlargement of clamp at sewing station.
Courtesy of [TC][2].

the clamping devices or on the trays atop the clamps. This materials-moving system is an **overhead conveyor system** or a **unit production system** (**UPS**; see Figure 7–12a). The equipment setup has become synonymous with the system of moving the fabric from sewing station to sewing station. The clamp shown in Figure 7–12b is part of the overhead conveyor equipment, which can transport cut pieces to all parts of the sewing assembly area and into the finishing area. The clamps with arms are attached to rollers that travel along a red track and drop down to sewing level at each station.

Quality Considerations in Bundling

Keeping all parts of a product together is another important part of maintaining a quality process. Lost parts or dirty parts from dropping can result in a final product that does not meet expectations and can result in lost time and resources to repair or replace items. During bundling, the tie operator is given the task to check the cut pieces for accuracy and to check the fabric for defects, among other quality analysis tasks. The tie operator or bundler may check either every piece or "spot check" pieces for fabric defects, according to preset standards for the fabric and the customer. Pieces that have defects specified by the standards used to guide the bundling process are removed. When checking every piece, both sides of the piece are inspected. Defective pieces are replaced with additional pieces that must be hand cut or cut on a low-ply cutter to provide the correct number of pieces in the cut lot. This situation is a further reason for the use of quality control processes during the preceding stages of production to reduce loss of time and materials. The tie operator may place the defect piece into bundles that are allocated for garments with intentional seconds. The tie operator also removes partial pieces that result from the splices made during spreading.

Assembly

The actual assembly process can occur through several production systems. A **production system** is a work flow and associated layout for the workers and the machines, the workers' duties, and the methods for transport of the materials. The most common assembly system is the progressive bundle system (PBS). A newer system is the modular or team system. A hybrid system is the kanban system that incorporates parts of both the PBS and the modular system. The unit or sample method is used for creating samples at the design house. Other methods are sometimes used such as the unit production system (UPS), but this system is a method of delivery for parts from one operator to another instead of an overall production system.

The **progressive bundle system (PBS)** is characterized by workers or operators who continuously perform one task for the entire shift. For example, one operator sews in the zipper, and that is the only task that the operator performs. Workers are placed in rows or groups according to the sewing task (see Figure 7–13). Bundles or stacks of partially finished goods are called **work-in-progress (WIP).** When completed, these are passed into bins or holding areas located between sewing operators. WIP waits to be selected

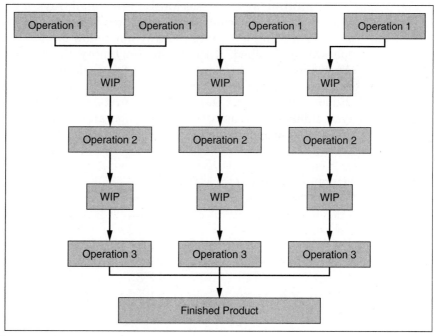

Figure 7–13
Bundle production system. WIP = work-in-progress.

by the next operator for the next assembly operation. The number of operators per sewing operation is determined by the complexity of the operation and the production speed of each operator. Sometimes unequal numbers are needed throughout the line to keep the work in balance or to **balance the line.** Workers traditionally have limited communication between each other, and each operator is paid by a **piece rate** or for the number of times he or she correctly sewed the designated operation. Speed on a single operation is the productivity measure for this system.

The **modular system** is staffed by cross-trained or multiskilled operators who form a team to complete one product. One product is started at the beginning of the team and is partially sewn and handed to the next member of the team. The single-item handoff continues through the entire assembly process. The machines for a team operation are normally placed in a **U shape** (see Figure 7–14). The number of operations that one operator performs is relative to the complexity of the operations, the time of completion for an operation, and the overall skill level of the operator. Instead of being assigned to only one operation, each operator is assigned to a range of operations, which fluctuate depending on the speed of completion for the adjacent operators. Operators often stand when sewing to ease their transition from machine to machine. As the last operator completes an item, he or she walks back to the previous operator and **pulls** the cut and sewn pieces from that previous operator. Operators are usually paid by the hour with a bonus or incentive for team productivity.

The **kanban system** uses **kanbans** or small trays or containers between sewing operators to control the work flow. When the tray is full, the sewing operator feeding work into the tray must slow or stop work until the next operator is finished. If the kanban is empty, the sewing operator on the other side of the kanban is waiting for work and the empty kanban encourages the first operator to sew faster. The arrangement of sewing machines and operators in the kanban system looks similar to the modular system but with bins between each operator. Kanban operators normally are seated when sewing. In the **sample system,** one sewing operator

Figure 7–14 U-shaped modular production system.

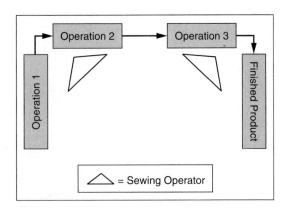

completes all sewing steps, generally at one machine. This system is found in businesses that perform custom work and in sample rooms in product development departments.

Quality Considerations in Assembly

The quality analysis process during the assembly can vary from no in-line inspection to constant in-line or in-process inspection. The modular or team system is most conducive to in-process inspection. As the partially assembled product is handed from one team member to the next, both members can observe the work that has been accomplished and measure either visually or mechanically to determine whether size and other standards are being met. If the observed work is not equal to the standard, the work can be held at that point in assembly and can be repaired or returned to the team member whose operation is inadequately completed. For inspection routines, whether in-process or final, methods should be established to help the operators or inspectors find errors that will cause the product to have poor quality or to not meet standards. The standards must be clear to those who learn them, the comparison of product to standard must be easy for operators or inspectors to make, and the action needed for any rework or adjustments must be easy for personnel to understand and perform.

The PBS system is the system that is most often associated with a final inspection only. Because operators are paid by the piece instead of by an hourly wage, operators are prone to sew as fast as possible with limited regard for the outcome of their assembly operations. In addition, one operator does not see the totality of the item through assembly but rather is focused on the single operation for which he or she is paid. The narrow focus of a single operator also contributes to the distance operators feel from the final product. The general assumption among operators is that the overall outcome is someone else's responsibility.

As discussed in Chapter 2 with TQM, training of operators is very important in achieving desired product quality. Operators must be trained for knowledge of the standard and to recognize the variance in the partial product from the standard. In addition, operators must be compensated for the time and the skills that are required to do the quality evaluation. Observing the outcome of the assembly operation and taking action to correct any variance requires time away from sewing. This time is called **off the clock** because the operator is not sewing and is therefore "off the clock" for piece-rate pay. Operators who are paid solely on a piece-rate basis will neither want to take the time to measure and evaluate quality nor wish to take the time to do rework to correct errors.

Returns on expenditures for inspection (e.g., satisfied consumers, no returns) and the money spent preparing for and doing in-process inspection should off set losses (e.g., wasted fabric, time spent sewing rework) that occur from nonstandard production or products that do not meet the standard. As described in Chapter 1, the cost of the quality is free when costs are

compared relative to the cost of failure. When final inspection reveals products that do not meet the standard, and are therefore of unacceptable quality, losses occur in time and other resources used to design the product, in time taken to cut and sew the product, in usage of raw materials in the product, and potentially in loss of customers through delays and dissatisfaction. For example, defects in fabric can be monitored, flagged, and removed if standards are set in place and determined in partnership between the fabric manufacturer and the sewn product manufacturer. However, if these standards for fabric defects are not flagged before the fabric leaves the textile manufacturing plant, the defects may remain unnoticed and may ultimately be present on a cut piece that is assembled into the final product.

If the sewn product manufacturer uses only final inspection, the fabric is spread, cut, and bundled, and pieces are assembled before the product is examined for fabric defects. All of the time and raw materials that are used in the product ultimately may be wasted if the defect is visible in final inspection. If the flaw is not visible but can affect the outcomes of the product, the error may not be discovered until the consumer uses and cares for the product. Ultimately, direct losses include the time of the operators, the use of the fabric, and the use of the findings. Indirect losses can include late delivery with associated penalties and delivery of partial lots with associated income losses. These product and pipeline losses are multiplied through dissatisfied customers with their "word of mouth" rejection and the loss of repeat business. The cost of training and off-clock inspection is small in comparison to these market losses in a competitive business. If errors are found and corrected earlier in the process, these losses are smaller and may be nonexistent.

In a TQM environment, operators should be trained to assemble correctly to prevent defects. With all assembly, defect prevention is easier than is defect correction. Sewing operators should be taught correct procedures for handling and sewing the product. Machines should be maintained with regular inspections and adjustments so that they function at optimal performance levels. The assembly area should be cleaned regularly to prevent the introduction of trash or soil onto the assembled product.

Some flaws or defects cannot be easily corrected once the fabric is cut, regardless of the time or resources applied to rework. For example, a buttonhole that is incorrectly sized cannot be easily redone because the hole in the fabric is made and cannot be uncut. A fabric that is misaligned with a bow or bias will sag with use and will cause the curtain that is hanging on the wall in a consumer's home to have an uneven hem. Fabric that is not cut so that plaids match cannot be sewn with matching seams even if the operator is trained to match the plaid lines along the seam (see Figure 7–15). To prevent this error, more time must be spent during the spreading, marking, cutting, and assembly processes.

If this item had been correctly cut but incorrectly matched, the cut seam lengths would not allow for the fabric to be shifted to match the connecting seams. Shifting the fabric along the seam so that the lines in the plaid match could result in additional distortion of the seam. Leather and other

Figure 7–15 Mismatched plaids along a seam line.

specialty fabrics are permanently marked when they are stitched, so removal of stitches for resewing when the seam is not correct is a waste of time and money because the original marks will continue to show. Additional sewing problems are covered in Chapter 9.

Finishing and Final Inspection

Finishing and final inspection are often done at the same station within the production plant. The tasks done within finishing, other than specialized processing, can be combined with the tasks needed to inspect the product. For example, the operator who attaches tags to a product can also measure the product for evaluation or comparison to the standard dimensions. Final inspection is the final check on the quality outcomes of the product.

Quality Considerations in Finishing

Finishing of a final product includes a number of specialized activities such as wet processing when color can be added, color can be removed or partially removed, and various finishes can be applied. Wet processing may affect the original outcomes of the product, and products should be checked carefully to assess their performance after wet processing. This situation is often true when wet processing includes bleaching, stone washing, or sand blasting, all of which affect the strength and other performance properties of the fabric. These chemical and physical processes may or may not be part

of the finishing process used for most sewn products; however, most sewn products will be pressed or steamed, clipped or trimmed of extraneous thread, and inspected in the final stages during finishing. Additional tasks at this time include adding hang tags, specialized bagging, and other packing procedures. For the final product to meet quality requirements, the finishing must adhere to preset standards and specifications established, measured and evaluated to meet the expectations of the customer.

Finishing often creates changes in the characteristics of the fabric and therefore the product. For this reason, most of the criteria for finishing standards and evaluation are related to raw material features. Standards that were established for the functionality, fit, or fashionality outcomes for the fabric would continue to be expected in the final product. For example, if expectations of strength, shrinkage, and elasticity of the fabric are important to the consumer, then these dimensions continue to be important for the final product. Fabric that had been tested prior to finishing must be retested in a postfinished state.

The finishing processes could also affect strength and elasticity of stitches and seams, which might impact fit outcomes. The dimensions and criteria explained in Chapter 4 for fabric could be used on the fabric in a product after finishing. Because the finishing process could alter the performance of threads, zippers, and other findings, these too would need to be tested in their postfinished state. When standards are written for the raw materials, they should state clearly whether the testing should be done prefinish, postfinish, or both. The exact performance expectation might vary with pre- and posttesting. For example, a product made and finished would have its dimensions evaluated before and after finishing. If no change is anticipated, the two sets of data should reveal the same dimensions and should be the same numbers as those listed in the specifications for the product. If finishing is supposed to alter the dimensions, this planned change should be noted and multiple sets of dimensions should be given in the specifications.

Quality Considerations in Final Inspection

Final inspection includes a list of check points that must be observed on the product. The percentage of items in a production lot that are to be inspected ranges from 100 percent of all items to some portion of the lot. The size of the sample is determined by the manufacturer or may be dictated by the customer. Usually a formula is used that considers the number of items in the lot, the number of items to be inspected, and the maximum number and type of defects to be inspected. Defects that are commonly placed in the standards for inspection include sewing quality, stitch consistency, fabric defects, and shading. The most common feature to be inspected is the size dimensions of the product. In addition, the final inspection standards include information about placement of hang tags, threads to be clipped, and other finishing or packaging information.

The final inspection standards are generally written as **protocols** to provide a procedure for inspection and rework or disposal. Protocols or standards for final inspection should clearly state the method for inspection, the tools or templates needed, and the numbers or pictures to be used for comparison to the visual data. Literacy rates or language skills of the inspectors should be considered when writing final inspection protocols. When product designs are created in one country and the production of the products are done in a second country, language differences can be a major difficulty in achieving accurate final inspection.

In addition, the customer or the plant may establish an **acceptable quality level (AQL),** which indicates that the customer is willing to accept a shipment of products that may have some percentage of products that do not meet the quality standards as specified. The AQL for many sewn products plants is 5–7 percent. A 5 percent AQL indicates that 5 out of 100 products when measured and evaluated will not match some portion of the standards. When the number of items in a lot with defects exceeds this level, the entire lot is rejected and sent back to the plant for rework. This method may seem reasonable for several reasons. One or two errors do not restrict the entire lot from shipment. Also, the level seems low, but for the five consumers who get a product that has a fabric defect, fades when washed, or comes apart at the seams, the defect level is 100 percent. That consumer will not be satisfied and may tell ten or more friends about the negative experience he or she had with the product. This negative marketing may be more damaging and costly than the resources needed to achieve 100 percent quality.

Overall product dimensions, according to size, are frequently checked during final inspection. A template on a table, floor, or wall may be used so that the product is not actually measured but is compared with an outline of the standard product. This type of support for final inspection increases the speed of the inspection and reduces human error from misreading a tape measure or writing incorrect amounts. Usually dimensions are accepted within a range or tolerance for the size. If templates are used, the range must be clearly marked for each size. Some companies do a second final check or recheck of a sample of products (usually 10 percent) similar to the reinspection of fabric that was described in Chapter 5. The need for reinspection to meet the quality expectations of the consumer depends on the consumer's tolerance for error and the skills of the in-process and final inspectors within the plant.

In addition, specific products or product parts may require a **visual spot check** for certain areas of the product (see Table 7–1). For example, the underarm area of a set-in sleeve may be checked for a four-way intersection of seams. The outer end of the gorge line on a jacket lapel may be checked for the tiny hole created where the ends of four seams merge in the notch. Hems are checked for lack of pucker where the stitches bite the skirt or pants fabric. Buttons and buttonholes are checked for alignment. Protocols may be written that focus on dimensions and a wrinkle free appearance or they may be product specific and identify focus points and criteria for areas of the product.

Table 7–1
Specific Style Areas with Quality Standards

Product	Style Area/Criteria	Quality Standard
Tailored jacket	Lapels with notch	The gorge line is smooth and straight from neck to notch. Notch has no wrinkles and a four-way intersection of seams to form a tiny hole.
	Two- or three-part collar	With a bluff-edge undercollar, the underseam is hidden, lies smooth, and is flat. The roll of the collar is smooth and is high enough to stand against the neck, keeping the design style. The left side of the collar is a mirror image of the right side. A two-piece undercollar or a one-piece felt is used to reduce unwanted bias in the grain of the undercollar.
	Two-piece sleeve	Sleeve seam is smooth and shaped to the curve of the arm. Undersleeve remains under the arm.
	Welt pockets	Corners are square and secure. Lip or lips are square at the corners and even along length.
	Lining	Pleat in center back allows for flex. Bagging method, attachment at arm scye, and internal tacks are used for a no show of lining on the outside of the item.
	Back vent	Lining is smooth and covers seams. Lining is secured at top of vent. Vent laps from center to sides.
Tailored pants	Curtained waistband	Centerback tack in curtain to prevent rollout. Deep seam allowance in centerback seam for alterations. Lining or facing of waistband covers bias interfacing and stay.
	Pleated front	Pleats are even width in depth and evenly spaced.
	French fly zipper	One equal width lip is stitched with straight stitching and a curved end. End of stitching is bar tacked evenly. The under flap behind the zipper lies smooth and is a no show.
	Exposed inseam pockets	Pocket bag is smooth and deep. Top stitching is even or understitching is used to hide pocket facing.
	Welt back pockets	See information on welt pocket for jacket—same criteria when two lips or welts are used.
	Blind stitched hem	No puckers are seen on outside. Hem depth is even.
Shirtwaist dress	Fitted bodice with darts	Fold of dart is pressed toward waist or to centerline of torso. Stitch line of dart is straight and smooth with tapered tip. Tip of dart shows no bubble or dimple. Stitching at tip of dart is secured with chain off or tied. Backtacking is avoided because of bulk and misshapen curve.
	Front facing with buttons	Convertible collar and front edge of bodice have left/right mirror images. Notch between collar and bodice is smooth, even, and equal.

Table 7–1
(Continued)

Product	Style Area/Criteria	Quality Standard
		Facing is wide enough (2+″) to prevent rollout. Grain placement and shaping is used to prevent distortion over bustline.
		Facing is tacked at shoulder to prevent rollout.
		Facing is interfaced for stability of buttons and buttonholes.
		Buttons are in straight row, securely fastened, equidistant with one button on fullest part of bust.
		Buttonholes are level, secure at both ends, large enough to accommodate button and shank.
		Buttonholes are placed so buttons reside on centerfront. For horizontal buttonholes, placement of end is 1/4″ passed center front.
	Set-in sleeves	Set-in-the-round sleeves have a four-way intersection of seams at the underarm area.
		The cap has fullness eased across the top with no pleats.
		Underarm seams are trimmed and finished.
	Long sleeves with continuous bound plackets	Top of V opening where placket folds has no puckers and no holes.
		Placket opening laps from front to back.
		Front edge of placket is turned under and resides on top of back one-half of placket when opening is closed.
		Placket is even width and smooth.
	Fitted waist with side zipper	Waistband is reinforced with tape or grosgrain ribbon.
		Side zipper application is used with single lip, top and bottom ends are square, and lip is even.
	Full skirt	Hem depth is even.
		Stitches do not show on the outside.
		Hem width is adjusted to prevent puckers if skirt pieces are flared.

Standards and specific methods must be established for pressing, clipping, and product packaging so that the final product arrives at the customer's loading dock as specified. For example, many customers specify the type of packing that is appropriate for the product. Each product may be folded and individually wrapped or covered, or a stack of the products may be placed in one large container. Retail customers may supply the manufacturer with packaging materials or may use what the manufacturer supplies. With large products, only sensitive areas may be covered before placing the product in large cartons or crates for shipping. Prices vary with the amount of postassembly services that are performed by the manufacturer. In addition, various packing methods can impact the condition of the product when it arrives at the customer's loading dock or the consumer's mailbox. Many of these operations are now done automatically with machines, and the errors caused by humans are removed.

Items that do not meet the standards as specified can be returned to the plant floor, specifically to the operator who created the error, for rework or to

a specialized rework area within the plant. Or, the items can be marked as seconds and sold through alternative retail outlets such as manufacturer's outlets or off-price retailers. Consumers at these retail stores may have different expectations of outcomes for the products. Some products may be so flawed that they are shredded and added to recycled scrap fabric.

As with fabric inspection, a reinspection process may be used at final inspection. The reinspection may occur at the end of the assembly after finishing or may be done as a warehouse audit. The warehouse audit is not used as often as it has been previously used because companies tend to reduce the amount of time merchandise is allowed to sit or to be stockpiled in warehouses, especially companies using JIT or QR strategies. Although this final inspection seems to be too late for defect prevention, it is a good way to monitor the effectiveness of the in-line and the final inspection processes and to provide feedback to operators and final inspectors. All previous quality procedures can be audited by using a random selection reinspection process. Plus, the reinspection is one more way of assuring the customer that all expectations have been met.

The fashionality outcome is basically dependent upon the "outside" of the product. Consumers purchase products by the product's color and overall look or appearance (i.e., fashionality outcomes). The image that the consumer perceives about the product must equate to the mental image that the consumer has during shopping and his or her expectations of the product. These expectations are developed on the basis of previous shopping experiences and other preshopping activities. Consumers come to a new shopping experience with mental images of products and stores from their past experiences. Consumers often use looks as an indicator of quality. A wrinkled and unpressed seam or an unclipped thread could signal to the consumer that the product is not securely sewn or that the fabric is of a quality that is lower than his or her expectations, when the only problem with the product is the lack of "clean up" during final inspection.

Key Terms

Acceptable quality level (AQL)	Cut order planning	Kanban system
Assembly	Cut parts	Knife cutting
Balance the line	Dies	Laying
Bias	Dry haul	Marker
Bow	Fabric direction	Misting
Bundle	Fabric with a nap	Modular system
Bundling	Final inspection	Off the clock
Cut order	Finishing	One direction print
	Kanban	Overhead conveyor system

Pegging	Pulls	Taunt spread
Piece rate	Returns on expenditures	Tie operators
Plotting	Rotary knife	Tolerance
Ply	Sample system	U shape
Preassembly	Slack spread	Unit production system
Production system	Spread	(UPS)
Progressive bundle system	Spreading	Vertical knife
(PBS)	Steel rule dies	Visual spot check
Protocols	Straight knife	Work-in-progress (WIP)

Review Questions

1. What are the three divisions and eight steps in apparel production?
2. What is an inspection protocol?
3. How should workers be trained for doing production inspection?
4. What is marker making and plotting?
5. What are three quality considerations for marker making?
6. Why should the fabric utilization be maximized when making a marker?
7. What is spreading?
8. What are plies?
9. What is a lay up?
10. Why is automated equipment beneficial for quality when used for spreading and cutting?
11. Why is fabric tension and alignment so important when spreading?
12. What is pegging during spreading?
13. What is a splice?
14. What are the considerations for quality when having nap or one direction fabric?
15. What are the three methods for cutting?
16. Which cutting method is both accurate and fast?
17. Why is computer-driven cutting not a good solution for some fabrics?
18. How can dies help create a quality product?
19. How can a defect map be used to get a defect-free garment during cutting?
20. What is a steel rule cutter?
21. What is bundling?
22. What is the role of the tie operator?
23. How can the plant manager help sewing operators create good quality seams?
24. What is the importance of equipment maintenance in a sewing plant?
25. How can pay rate in sewing affect quality?
26. How does TQM fit with modular sewing?
27. What activities are done in finishing?
28. What is wet processing?
29. How is garment dyeing (color addition) a consumercentric process?
30. Why is pressing and final inspection important to quality?
31. What is AQL?
32. Why is the low literacy rate among sewing operators a concern for achieving the needed quality products in a plant? How can this be overcome in planning the final inspection station?

chapter 8

Stitches

S**titches** are the loops or interconnections of thread that hold a seam together, or the row of stitches used for decorative purposes. **Stitching** refers to a series of stitches used to form decorative patterns on fabric or a series of stitches used to encapsulate the edge of a single-fabric ply, or the term can be used to describe the process of making stitches. Stitches are formed by the interlocking or interlooping of thread as it passes through fabric. The feed dog and pressure foot are responsible for moving the fabric forward to create the movement along the length of the fabric (see Figure 8–1). Stitches can be characterized by their method of formation and by numerous physical characteristics. Each of these characteristics can be used to write standards to describe and evaluate the stitches.

Traditionally, stitches were known by trade names or generic styles. **Trade names** were usually drawn from the name of the sewing machine manufacturer that had created a machine to form a certain stitch. For example, the Merrow Company sold a machine that was widely used in the industry. In the early 1900s, few companies made sewing machines and those machines were dedicated or single-style stitch machines. The Merrow machine created an overedge stitch; therefore, stitches of that type are often called **Merrow stitching.** Juki is a more recent sewing machine manufacturer that makes an assortment of machines (and stitch styles), but one of the most common machines is one that makes straight stitches. Thus, people sometimes ask for a Juki stitch when they mean a straight stitch. This practice can be confusing, as some manufacturers have diversified through

Figure 8–1 Sewing machine showing pressure foot and feed dog.

Pressure foot

Feed dog

research and development and through acquisition of other companies. Many companies now manufacturer and sell a variety of machines.

Another industry practice is naming stitches by **generic names** or the use of names that describe the functional purpose of the stitch. The overcast stitch, serge stitch, and coverstitch are examples of stitch names that say what the stitch does. The overcast stitch overcasts or covers the edge of the fabric with looping threads. The coverstitch creates a web of threads that covers or hides the seam and seam allowances. This system of naming is not as confusing as trade names, but it does not give exact information about the myriad of stitches that are available for specifications.

General industry standards do exist for stitches, which is in contrast to the many other aspects of the sewn product. These industry standards are widely used but are not required for all sewn products by the U.S. government and may or may not be recognized in other countries. The original U.S. standard for stitches and seams was **DDD-S-751** in 1930 (Solinger, 1988). The federal standard was initially developed and maintained so that companies wishing to create products for the U.S. government would have standards for use in measuring the quality of the product and meeting the expectations of the federal government. Such manufacturers were often those who made uniforms for the military. This early standard was replaced with **Federal Standard No. 751** in 1959. It became Federal Standard No. 751a when it was revised in 1965 (Federal Standard, 1965) and Federal Standard No. 751A in 1977. A similar standard has been issued by the Canadian government.

These early versions of the standard are commonly called the **stitch standard** but were more formally known as the **Federal Standard: Stitches, Seams, and Stitchings** (Federal Standard, 1965). The standard

Color Plate 6
101 stitch: a = top view; b = bottom view.

Color Plate 7
301 stitch: a = top view; b = bottom view.

Color Plate 8
401 stitch: a = top view; b = bottom view.

Color Plate 9
406 mock-cover stitch: a = top view; b = bottom view.

Color Plate 10
504 overedge stitch: a = top view; b = bottom view.

Color Plate 11
516 safety stitch.

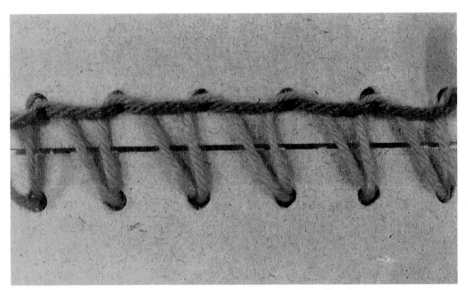

Color Plate 12
601 stitch.

Color Plate 13
Stitch length: a = 2 mm for regular seaming; b = 4 mm for basting.

defined and illustrated a variety of known stitches, seams, and stitching. After 1965, the standard was revised in 1977 and again in 1983 (Standard, 1983). Some of the early revisions were to clarify the classification of the stitches on the basis of the formation of the stitch and to categorize in a similar fashion the seams and stitching. Later revisions included adding new definitions for stitch length and deleting or inserting stitches. Stitches do exist that are not classified by the standard. Some stitches may be numbered or named by companies or in use by individuals but will not be found in the standard.

In 1997, the standard was adopted by ASTM and became part of a wide variety of standards available for industry use (ASTM International, 1997). ASTM, as discussed in Chapter 3, is part of a number of international organizations; therefore, the stitch standard should be available and recognized by companies around the world. The ASTM standard is formally known as ASTM Standard Practices for Stitches D6193-97 and can be ordered from www.ASTM.org. The "-97" in the standard's designation refers to the specific version or edition of the standard for ASTM. The ASTM stitch standard includes six stitch classes, four major seam classes, and two major stitching classes. It also includes an appendix with suggested seam types and stitch types for many of the most common sewing operations. Similar pictures and descriptions of stitches and seams can be found in the standards from ISO: ISO 4915 and ISO 4916 and available from www.ISO.org.

In general, the stitch standard categorizes the stitches according to two criteria: the **formation** or structure of one stitch and the **concatenation** or linking of one stitch to the next stitch. The stitch can be formed in one of two ways: looping or interlocking. When a **looping** formation is used to make the stitch, the resulting stitch is a **chain stitch** and is characterized with a degree of flexibility in the stitch (see Figure 8–2). The stitch is also subject to unraveling.

In the simplest version of the chain stitch, a first loop is made by the needle pushing the thread through the fabric and throat plate of the sewing machine. A **spreader** on the underside of the machine bed is used to spread

Figure 8–2 The looping structure of a chain stitch.

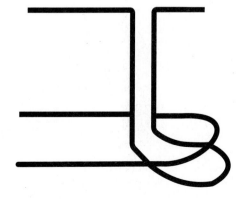

Figure 8–3 Needle and spreader for chain stitch formation.

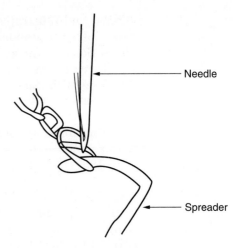

Needle

Spreader

or open this first loop to receive the subsequent loop (see Figure 8–3). The second loop of thread is formed by the needle and pushed through the first loop. The process continues as the needle thread is used to make a new loop and is pushed through the fabric and through the previous loop, which is spread open by the spreader. The chain stitch is formed by using, at the minimum, a needle and a spreader.

For more complex chain stitches, loopers are used to form the underside of the stitch (see Figure 8–4). The **looper** is a long thin rod with a groove along the middle that holds the thread and is similar in function to a second needle. Loopers carry thread from the bottom side of the fabric to meet the

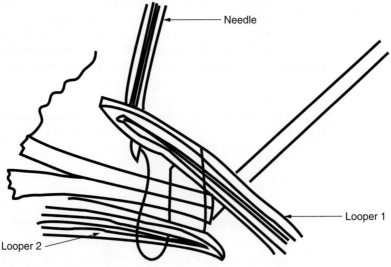

Needle

Looper 1

Looper 2

Figure 8–4
Needle with thread and loopers with threads forming a chain stitch.

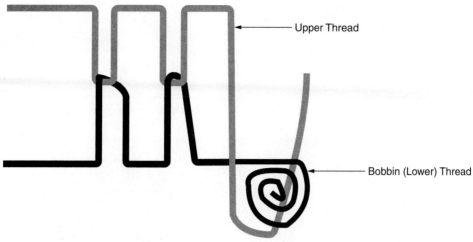

Upper Thread

Bobbin (Lower) Thread

Figure 8–5
Interlocking of the lock stitch with bobbin thread.

needle thread. Loopers hold the lower threads and guide the placement of the thread from the edge across the fabric and back to the edge.

Both loopers and spreaders are needed to form additional chain stitches. All threads forming this stitch are located as spools on spindles at the top of the sewing machine. For mass production, these spools can be large and can hold 10,000 yards or more. This structure reduces time needed to change threads when sewing.

The **lockstitch** contains an upper thread (i.e., the needle thread) and a lower thread (i.e., a bobbin thread; see Figure 8–5). A needle and a bobbin with a rotating hook or **race,** a small metal finger that rotates around the bobbin, form the stitch (see Figure 8–6). The lower thread is located on a **bobbin** under the flat sewing surface of the sewing machine. Interlocking is formed when the needle thread loop passes through the fabric with the downward rotation of the needle and is pulled around the bobbin thread with the aid of a hook. This formation creates a stitch that has less flexibility than a chain stitch but has increased holding power.

The use of the bobbin thread creates a time delay when sewing because the bobbin is small and can hold much less thread than the top cone or spool of thread. Because the bobbin is much smaller than a spool of thread, it must be frequently rewound with thread. Winding a bobbin takes time away from sewing. Understanding the structure of the stitches and the equipment needed to make the stitch allows the designer or merchandiser to better understand the functions and capabilities of each stitch and to have an improved ability to judge the quality of the stitch. When creating or buying a product in accordance with the ASTM or ISO standards, the formation and concatenation of the stitch should match the standard.

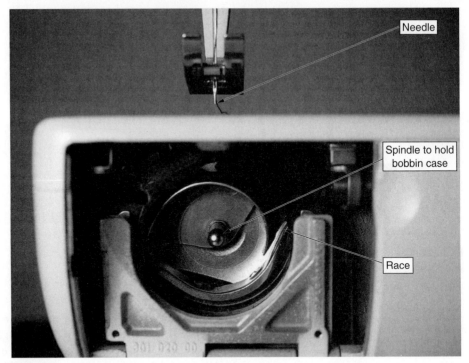

Figure 8–6
Bobbin arrangement for a lock stitch.

Information about stitches is also available from many sewing machine manufacturers and thread companies, such as Juki, Union Special, and American Efird. Much of this information is drawn from the old federal or ASTM standards or from the new ISO standards. However, other views of stitches are shown by some sources. Pictures of stitches may be given in a flat form showing the stitch from the top or face surface of the fabric or the bottom surface (underside), or the stitch may be shown in a cross-section view (see Figure 8–7). The flat view often shows both the top and the bottom of the stitch to include views that show all aspects of the stitch.

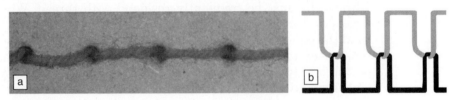

Figure 8–7
Views of the 301 stitch: a = top view; b = cross-section view.

Stitch Classes

According to ASTM D6193-97, the stitch standard consists of six stitch classes that are numbered from 100 to 600 (ASTM International, 1997). A seventh class of stitches (i.e., 700) was included in the 1965 version of the Federal Stitch Standard but was removed in the 1983 revision (Federal Standard, 1983). This 700-stitch class uses a single thread with a spreader but is rarely used in most industry applications. The 1965 and 1997 versions of the standard include sixty-two stitch types; whereas, the DDD-S-751 standard in 1930 had twenty-seven stitch types. Within each class, the associated stitches are numbers from "-01" to "-99" with the lower numbered stitches being more simple in structure and concatenation and the higher numbered stitches being more complex. Thread usage varies with the complexity of the stitch. Within each of the six classes, many stitches are defined and illustrated in the standard.

The 100-, 400-, 500-, and 600-stitch classes contain chain stitches. The 300-stitch class is a lockstitch. The 200-stitch class identifies hand stitches, which are rarely found on manufactured products; however, some machine stitches are used to imitate the look of a 200-stitch but would be otherwise classified. Occasionally, hand stitches are found in couture clothing or other custom work.

100 Class

The **100-stitch class** contains a basic **chain stitch.** A row of stitches appears as a series of straight threads on the top surface of the fabric and a series of single interlooped circles on the back surface of the fabric (see Figure 8–8 for the top and bottom view of the stitch; see also Color Plate 6).

Figure 8–8
101 stitch: a = top view; b = bottom view.

The formation and concatenation of the stitch is similar to the hand crochet stitch, and the stitch is formed by using a single thread spool. The formation and concatenation is simple and thereby has a relatively low thread usage. The **thread usage** is how much length of thread is needed for every unit of length for the stitching. For the basic 101 stitch, thread usage is about three times longer than the sewn length of the stitching. This indicates a 3-to-1 ratio or that 3 inches of thread is used to form every 1 inch of stitching. (Further consideration of thread usage is found in Chapter 14.)

The 103 stitch is used to sew hems, attach buttons, and make buttonholes. When used to attach hems, the fabric is folded back against itself and very small stitches are caught in the base area of the fabric. This stitch allows considerable flexibility for the thread and for the enclosed fabric. The two or more plies used in the seam are allowed to pull apart. The opening of the seam in this gapping way is called "grinning." Another disadvantage, or advantage depending on the purpose of the stitch, is that the thread can be easily removed by unraveling when one end of the thread is cut and pulled. The 101 stitch can be used for basting or seaming such items as bag tops when the opening is to be used later and the stitching can be easily removed.

300 Class

The **300-stitch class** is the **lockstitch.** Any 300-stitch because of its interlocking construction is a very stable stitch. With the interlocking, each stitch is "locked," which creates stitching that is hard to remove and will not ravel. Because the stitch has limited flexibility within its formation, the stitch is prone to causing puckering with many fabrics. The top and bottom of the 301 stitch are identical; both show straight lines of thread (see Figure 8–9; see also Color Plate 7).

A 300-stitch can be used for seams on woven fabrics, topstitching, and other decorative purposes. The 304 stitch can be used to create a **zigzag stitch** by changing the direction of the stitching with each stitch (see Figure 8–10). The

Figure 8–9
301 stitch: a = top view; b = bottom view.

Figure 8–10
304 stitch or the zigzag stitch.

angle of the change in stitch direction creates the zigzags. The zigzag pattern can be used for edge finishing but is not as secure as an overedge stitch.

400 Class

The **400-stitch class** is a **multiple thread chain stitch.** The 401 stitch is similar to the 101 stitch but uses two or more upper threads. One upper thread is used to thread the needle; the other thread or threads are threaded from spools on the top of the machine through to the bottom of the machine and into loopers. The stitch is formed in a manner similar to knitting. Along the top surface of the fabric is a row of straight stitches, similar to the 301 stitch, and the bottom of the stitch shows a complex chain (see Figure 8–11; see also Color

Figure 8–11
401 stitch: a = top view; b = bottom view.

Figure 8–12
406 mock-cover stitch: a = top view; b = bottom view.

Plate 8). The use of multiple needles and multiple loopers creates multiple rows of stitches.

The 406 stitch and other stitches within the 400-stitch class are used as **mock-cover stitches.** They have straight rows of stitching along the top surface and a chain-like web on the bottom surface (see Figure 8–12; see also Color Plate 9). The chain web covers the raw edges of the seam, and the topstitching helps hold the stitch in place and flatten the seam. The 404 stitch can be used to create a zigzag effect. This stitch is sometimes called the bobbinless zigzag to differentiate it from the 304 stitch, which is a zigzag made by the lockstitch method with a bobbin. Multiple needles can be used to create parallel zigzag patterns.

One disadvantage of any 400-stitch and other upper numbered stitches is the thread usage. The 401 stitch uses about twice as much thread as a 301 stitch and about one and one-half as much thread as a 101 stitch. The thread to stitch ratio is therefore about 5 to 1. Another disadvantage of this stitch

as with other chain stitches is that the fabric can pull away from the stitch and can create open areas within the seam.

500 Class

The **500-stitch class** is called the **overedge stitch,** which is also called an overlock, serge, overseam, overcast, or merrow stitch. The formation of the stitch is similar to knitting and uses a needle and two loopers. Multiple threads are needed, all of which are top threads. The stitch is created along the edge of the fabric, and loopers are used to move the thread from a narrow distance (e.g., one-quarter inch) within the base fabric to the outside edge of the fabric. The process creates two rows of stitching with loops between rows that appear on both the top and the bottom of the fabric (see Figure 8–13; see also Color Plate 10). A slight difference in loops appears between the top and the bottom of the stitch, but the look is very similar. This stitch takes approximately four times the seam length in thread, or as it can be stated, it has a 4-to-1 ratio. This high ratio and the process of forward concatenation and side overcasting create a more stiff stitch along a seam in contrast to the 100 or 300 class of stitches.

Figure 8–13
504 overedge stitch: a = top view; b = bottom view.

Figure 8–14
516 safety stitch.

The 500 class of stitches also includes a series of stitches called safety stitches. The **safety stitch** appears as a simple 500-stitch and a simple 400-stitch combined into one stitch. This stitch includes the 516 stitch. Two rows of stitching with loops between rows are formed along the edge of the fabric on the top and bottom, and a third row of straight stitching is on the fabric side of the overedge chains (see Figure 8–14; see also Color Plate 11).

The safety stitch is appropriately named because it has an overedge and a chain stitch to hold the seam together. This stitch has the flexibility of a chain stitch and holding power similar to a straight or lockstitch. The seam is less likely to open or to fail than is a similar seam made only with 400-stitch or a lower numbered 500-stitch. The seam is not subject to raveling but does have a higher thread-to-seam ratio than do lower numbered 500-stitches.

600 Class

The **600-stitch class** is called the **coverstitch.** The formation of this stitch is made with multiple needles, a spreader or hook, and a looper. The looper is used to guide the top threads that are used for the bottom of the stitch or the "other side," and the spreader or hook is used to help create the webbing that forms the covering part of the stitch. This stitch is characterized by two rows of chaining and a web of threads laced between the two rows (see Figure 8–15; see also Color Plate 12). The webbing of thread is seen on both the top and bottom sides of the stitch.

The 604 stitch, within this class, is also called the **flatlock stitch** because it is used over a seam sewn with another stitch to cover and to stabilize that seam (Solinger, 1988). This stitch uses nine threads through four needles, four loopers, and a covering thread. As shown by this example, some of the

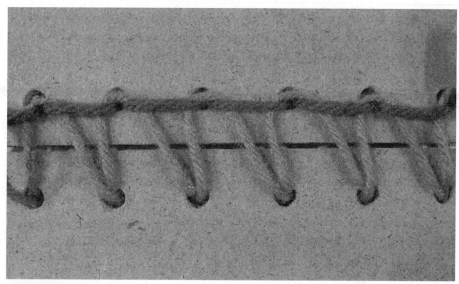

Figure 8–15
601 stitch.

stitches within this class use more thread than any of the stitches in the other stitch classes. For this reason, the stitch adds to the cost of a product and is used only when stability or decoration is required. With some seam types, overall cost can be reduced by the elimination or reduction of the seam allowance to compensate for the increased thread usage. The stitch, because of its complex formation and concatenation, is hard to remove and rarely ravels. Although the stitch is useful in keeping seams flat and secure, the excessive webbing of thread can be seen as unsightly on the surface of the product.

Physical Characteristics and Associated Standards of Stitches

Stitches vary both in formation and in concatenation. As a result, their physical appearances vary when used in sewing. Appearance or outcomes also can vary according to numerous physical characteristics, including length, width, direction, encasement, and balance. In addition to the accepted formation and concatenation described in the ASTM or ISO standard for stitches, these characteristics are to be considered in the determination of standards. A generally accepted correct appearance of stitches exists among the perceptions of many people. For example, the stitch should be straight and without width, have balanced tension, and travel in one direction—unless changes are intended by

stitch type. However, many variances can occur within these physical characteristics and should be considered when writing standards. In general, a **quality stitch** lies flat along the fabric without distortion and is compatible with the intended use of the product. A quality stitch is one that is appropriate for the weight and the hand of the fabric (i.e., fit), resists pulling apart during stretching of the seam without distorting the fabric (i.e., functionality), and is satisfactory for the look of the product (i.e., fashionality).

The **stitch length** is most commonly measured in the number of stitches that are fit into an inch of stitching. This measurement is identified as stitches per inch or **SPI.** The average or standard stitch length with this system would be a 10SPI or 12SPI, with a basting stitch being approximately 6SPI, and a tiny, secure stitch for fine fabrics would be a 16SPI. Some sewing machines and sewn product companies use the metric system and measure the length of each stitch. For these measurements, the stitches are measured in millimeters and generally range from 0 to 4 mm, with an average length stitch being 2.5 mm (10-12SPI) and a long basting stitch being 4.0 mm (6SPI; see Figure 8–16; see also Color Plate 13). Shorter stitch lengths consume more thread than do longer stitch lengths, but, in general, they produce a more secure seam. A standard length must be set so that the stitch is compatible with the fabric. If the stitch is too long or too short, the fabric will pucker.

Length of stitch should also vary by stitch class. The higher numbered stitch classes are more complex and often require a longer stitch length to ensure

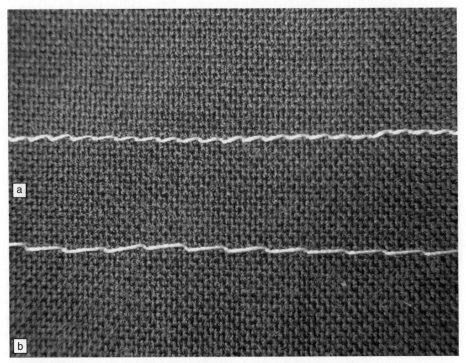

Figure 8–16
Stitch length: a = 2 mm for regular seaming; b = 4 mm for basting.

that the stitch is adequately completed within the space allocated and that the benefits of the specific stitch are realized in the outcomes of the product. For example, a safety stitch combines two rows of stitching and overcasting. The overcasting must be close enough together to ensure that the edge is covered enough to prevent raveling; however, the additional straight chain cannot be made from a stitch that is too short or the fabric will be stiff with puckers.

Stitch width is the amount of left or right movement that the thread follows because of the movement of the needle or the spreaders and hooks. This movement is used when creating stitches such as the zigzag, overedge, or coverstitch. The exact measurement left or right from the center line of the stitch is the width that the moving needle or spreaders create (see Figure 8–17). For a general standard to obtain a quality stitch, lightweight fabrics should be stitched with a small or narrow width to prevent rolling or puckering the fabric. Thick or heavy fabrics require a stitch width that provides a long or wide width to allow for the volume of fibers that are encompassed in the width. When fabrics are thick or have a high volume, a width that is too small will result in puckering or drawing together of the yarns in the fabric.

Direction indicates the direction of the formation and concatenation of the stitch as the fabric moves through the sewing machine. This direction is called the stitch direction because the arrows are used to indicate direction from the first stitch to the last stitch (see Figure 8–17). This indication is useful when deciphering sketches of stitches. It is also helpful in setting standards for the stitch because some fabric is very sensitive to the pressure of the pressure foot and feed dog combination. Stitch direction in the formation of the stitch is shown in the ASTM standards. With no other specification, the ASTM standard direction would be assumed to be the correct standard.

The ASTM stitch standards do show how the stitch direction is made for each class of stitches; however, the designer or merchandiser must determine how the stitch is to be placed on the product. The designer may wish to indicate stitch direction on specific seams so that rows of stitches are made all in the same direction to prevent the development of a torque or a bias in the fabric. The correct orientation of the warp and the filling yarns within a fabric can be incorrectly adjusted through stitch direction, which will affect the outcomes of the product. For example, if a zipper is stitched by traveling from the top to the bottom of the zipper, across the bottom and back up to the

Figure 8–17
Stitch direction and stitch width.

top, the lips of the zipper may be twisted. The twist in the fabric may be permanently stitched in place; therefore, the appearance of the lips will be distorted, and the coverage of the teeth will be reduced. In general, the standard for fabric is that it lay flat, that it be smooth, and that the yarns retain their original orientation within the fabric even when stitches are applied. Although the surface features of the product may be addressed in standards for final inspection of the product, information about stitch direction may be added within company stitch standards.

Encasement describes the thread from the stitch that is wrapped around the edge of fabric, as in the 500 class of stitches. The primary purpose of encasement is to entrap the raw edges of the yarns within the fabric. This encasement prevents the yarns of the fabric from unraveling. Unraveling can threaten the stability of the seams, including removing yarns from within the stitches of a straight seam and can form unsightly loose yarns on the inside and occasionally on the outside of the product. The depth of the encasement or the amount of fabric that is incorporated into the encasement is determined by the **bite** the needle takes into the fabric from the edge (see Figure 8–18).

For quality analysis, the amount of encasement should be determined from the exact stitch number and the thickness and density of the fabric. If the bite is too deep on a thin fabric, the encasement will result in a roll of fabric and thread within the stitch. If the bite is too shallow on a thick or loosely woven fabric, the encasement will not provide stability to the edge of the fabric.

Stitch balance is controlled by the tension or pressure on the threads as the threads pass through opposing plates within the sewing machine. Stitch balance becomes synonymous with thread tension because the balance of the threads in the stitch is an outcome of mechanical tension on the thread. In all stitch classes except the 100 and the 700, which are single thread stitches, multiple threads are used to form one stitch. How these threads lay within the fabric and where they intersect with each other are part of the standard needed for stitch tension. In general, a **balanced tension** is assumed to be the expected or desired tension. A balanced tension allows the stitch to have its intended flexibility and appearance.

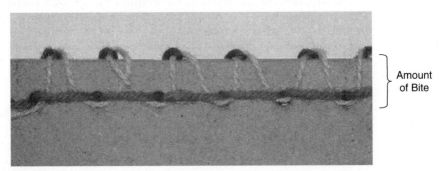

Amount of Bite

Figure 8–18
Dimension of the bite.

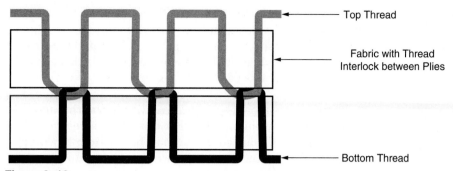

Top Thread

Fabric with Thread
Interlock between Plies

Bottom Thread

Figure 8–19
Cross-section view of a balanced stitch for a 301 stitch.

In a 301 stitch with the correct amount of tension on the thread, a balanced or quality stitch results in the top thread appearing only on the top surface of the fabric and the bottom or bobbin thread appearing only on the bottom surface of the fabric. For a quality stitch with the 301 stitch, the intersection of the two threads of the stitch should occur within the interior of the fabric (see the cross-section view in Figure 8–19).

No top thread shows on the bottom surface or on the underside of the fabric, and, conversely, no bottom thread shows on the top surface of the fabric. With very thin fabrics or sheer fabrics, some opposing side thread may show. Particularly, tiny dots of the bottom thread may show between the stitches of the top thread and conversely on the bottom or the underside of the fabric.

For quality analysis, balanced tension of threads results in the stitch that is formed as specified. With other classes of stitches besides the 300-class, balanced tension may indicate that the bottom stitch lies along the surface of the bottom of the fabric, whereas the top thread is pulled through the fabric and appears as tiny dots of thread along the bottom surface of the fabric. Examples of balanced tension thread are shown in the standards supplied by sewing machine manufacturers so that the operator or manager will know the capacity for the sewing machine.

Stitches that are not in balance for tension may pucker, have loose threads on the surface of the fabric, and may be unstable in the functionality of the seam. Occasionally, an out of balance stitch is desired. With the 301 stitch, the balance can be shifted so that one thread lies loosely along the fabric surface. This thread can then be easily removed by pulling one end so that it slips from the loops of the other thread. This method is appropriately used for basting when a quick removal of thread from the seam is desired. The 101 or 103 stitch with a long stitch length may also be used for basting without adjustment of tension.

Tension adjustment on machines must be checked regularly to ensure that the machine is producing the standard stitch. Variations in thread composition, thread color, and fabric characteristics can create a situation that requires adjustment of tension. In addition, as machines are used and wear is developed, readjustment of tension is needed. Machines should regularly

be cleaned as stray fibers, especially from cotton thread or cotton fabric, may enter the tension disks and cause faulty adjustments and incorrect balance.

Unbalanced stitches may be purposely created for a variety of reasons. An unbalanced stitch, in which one of the threads lies loosely on the surface of the fabric, can be used for basting and the loose stitch can be quickly and easily removed. The stitch balance may need to be altered for blind stitching or hemming to allow for some flexibility in the thread to prevent puckering on the surface of the product. For the effect of color or other design reasons a purposely unbalanced stitch may be created; however, unless otherwise specified, a balanced tension between upper and lower threads will produce the better holding stitch.

Importance of Standards for Stitches

Most manufacturers operate with a set of generally accepted standards for stitches. These standards include such physical features as smooth, straight, appropriately sized, balanced, and continuous. Most consumers would agree that they wish stitches to be smooth, straight, and secure. Assuming that this is a common expectation and that a quality product will be delivered is impractical for a designer, merchandiser, or other manager who wishes to have satisfied customers. With the variances that can be achieved in any sewn product, standards should be specified for stitches beyond just the desired stitch-class number.

For example, the length of the stitch should be specified according to fabric weight, fabric density, and fabric thickness. A stitch that is too short or too long for the characteristics of the fabric will result in puckering. The exact stitch length cannot be known without knowing the exact physical characteristics of the fibers, the yarn, and the fabric. Because of the multiple of combinations that are possible, no specific stitch length can be stated as the standard or best length; rather, the designer or merchandiser must evaluate each thread, each fabric, and each design combination to determine stitch length.

To ensure that the standards produce a satisfactory product, samples should be sewn to evaluate the outcomes of the stitches on the appropriate fabric. Only under the exact condition can the merchandiser or designer determine whether the appearance, functionality, and other outcomes are as expected by the customer. This need for samples or prototypes to determine standards is true of all the physical characteristics of the stitch.

Samples to test standards are also needed to be certain that the product's outcomes will match to design "image." As with style and pattern details, the designer may have a mental picture of the product that is not adequately transmitted through the design sketch or the CAD drawing. The use of samples to develop standards can be costly and time consuming. Detailed and

proportional CAD drawings with close ups of the stitching details can be used in place of samples if the detail is clear and accurate in dimensions. The maintenance of a history or log of standards for products is also useful in speeding product development.

With globalization of production and consumption, standards are vital in bridging both geographic and language distances. Standards that use the ASTM or ISO numbers and that provide graphic or other visual evidence of the additional details for stitches are very important when multiple firms are involved in design, production, and distribution. When languages are not the same across manufacturing partners, visuals are more dependable for standards information. In addition, digital information—created either during the original development phase or that has been subsequently scanned and/or digitally photographed—is useful for transmission to multiple computer networks, eliminating the need for personal trips or air freight of products.

Standards reduce waste for manufacturers, retailers, and consumers. When the product is developed according to standards that are based on accurate expectations, the product is more likely to result in something that satisfies the consumer. Rework and returns are reduced when the product is specified correctly at first and is constantly monitored during production for quality outcomes. By reducing wastes of time and materials, the use of standards in stitches and in all aspects of the product pipeline enable each trading partner to reduce or control costs, including the cost to the final consumer.

Standards for stitches should be part of the information developed for retail specification buying. If a retailer takes the time to note standards for the stitches, although only a small part of a finished product, the overall outcome will be more likely to meet consumer expectations.

Other Characteristics of Stitches Related to Quality

Other characteristics of stitches may be included in the standards written for stitches in a product. Several of the stitch classes produce stitches that can be easily removed by pulling one end of the cut thread or unraveling. The practice of **back tacking** or stitching in the opposite direction of the stitch direction is sometimes used to secure the end of a row of stitches. This practice, although fairly successful in securing the row of stitches, often results in the widening of the stitch line and can cause a lump, wrinkle, or other defect in the seam.

Chaining off, or stitching beyond the end of the fabric, is also used for securing the end of stitching. This technique can be used for 100-, 400- and 500-class stitches. The method is successful but does result in a length of chain or

Figure 8–20
Chaining off with a 103 stitch to secure the seam.

a tail of thread that extends beyond the fabric end (see Figure 8–20). Some consumers might perceive that this tail is an error and think that the threads were not properly clipped when the product was inspected.

Sometimes the row of stitches is naturally stabilized when it is crossed with another row of stitches as an additional piece of the product is added to the prior piece. In addition, the 300 class of stitches is difficult to ravel and is often not secured unless it is in a stress area. The method selected for securing the last stitch in a row should be specified, especially in products that have raw edges or areas that are not crossed with other sewing. **Hand tying,** when two or more threads are knotted together, provides the smoothest and the smallest stability; however, this method is very slow in production timing and greatly increases the labor time in sewing, so it is rarely used except for haute couture sewing. The selected method must be appropriate for the product, the fabric, and the customer.

Bar tacking is another stitch characteristic that needs to be noted in specifications. This stitch technique provides a number of zigzag-type stitches in a compressed arrangement (see Figure 8–21). A bar tack is used at the ends of buttonholes, at the corners of pockets, and at other areas that need reinforcement. Width and length of stitches in a bar tack should be specified when noting location.

Figure 8–21
Two bar tacks at end of zipper.

Stitch Defects

Defects in stitches create problems that cause the product to be below expected standards. Many of these defects are not only unsightly but also render the product unusable. The defect may cause seams to open or holes to appear in the fabric. Either of these situations could cause the consumer to reject the product. Some of the stitch defects should be obvious to the in-process and final inspectors, and affected products should be removed from the production lot of first quality products. Other defects may not appear until the product is in use because of the thickness of the fabric or the smallness of the defect, but the defect may enlarge with use and stress on the fabric and stitches.

Skipped stitches occur during stitch formation when the upper and lower threads do not interlock or interloop, depending on the stitch class. When the formation of the stitch is not complete, the top and lower threads will not be together, the threads will lie loosely on the surface of the fabric, and the seam or other structure will not be secure as intended (see Figure 8–22). The skipped stitch can result in weak seams, holes in the seams, and the failure of

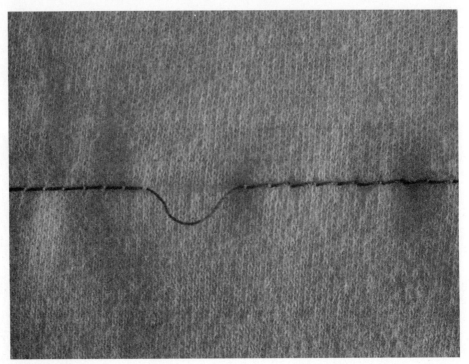

Figure 8–22
Skipped stitches.

parts of the product to remain together. All of these outcomes are generally unacceptable to most consumers; therefore, skipped stitches are usually unacceptable defects noted in a quality analysis.

Skipped stitches are caused by a number of reasons. The lower thread may break and not be continuous. The sewing speed can be too fast for the complex formation of higher numbered stitches. Although industrial machines sew much faster than do home sewing machines, they can be incorrectly powered in an attempt to make them sew even faster to increase production. When the machine is incorrectly powered, the problems created usually override the benefits from increased speed. Sewing machines are very complex pieces of machinery and should be adjusted and accurately maintained according to manufacturers' specifications. Problems with the foot feed or the tension disks can alter the timing of the needle and loopers, which causes an incorrect meeting of the threads. Needle size and thread size can be incorrect and can cause stitch problems. In addition, incorrect positioning of the needle or incorrect threading of a sewing machine can cause skipped stitches.

Corrective action should be taken immediately when skipped stitches are discovered. When a plant is using a TQM strategy and in-process inspection is being performed, skipped stitches will probably be spotted by the operator and corrections to the situation can be made before additional product is

sewn. When only final inspection is being performed, a large volume of product may be produced before the defect is found in the first item that comes to the inspector. At this point, additional fabric, thread, and other resources have been added to the product and the rework needed to fix the problem may be extensive or impossible. Corrective action can include readjustment of the thread tension for thread size, adjustment of loopers, and general rethreading, cleaning, and inspection of the sewing machine.

Needle cutting causes cuts in the fabric yarns when stitching. The needle actually cuts the yarns instead of pushing the yarn aside and going between the parallel yarns and the cross fillings. A cut yarn at this point in production is as problematic as a broken yarn created in the weaving or knitting process. Needle cuts result in holes in the fabric at the seam or at the site of the stitch (see Figure 8–23).

Needle cuts are caused by incorrect or damaged needles. The size of the needle and the tip of the needle should be selected as appropriate for the type of fabric. For example, knit fabrics require a rounded-tip needle; thick heavy fabrics require a large needle; and very sheer fabrics require a slender, sharp-tipped needle. Needles for fabrics with a high yarn count must be slender enough to press between the yarns so as not to cut them.

Blunt needles occur when the needle is overused and needs to be changed. Burrs occur when the tip of the needle strikes the sewing machine

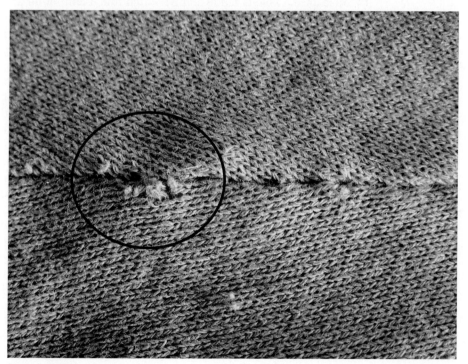

Figure 8–23
Needle cuts in a knit fabric.

throat plate or temporary pins in the fabric. The needle will strike the throat plate when the fabric is pulled too rapidly through the foot and feed dog or if the needle is not strong enough for the thickness or density of the fabric. Such needles should be replaced immediately as part of preventive action. Blunt needles may be in the machine from a previous use, which required a rounded needle, or blunt needles may be the result of overuse of a sharp needle in fabric that has a dense finish or other needle-dulling characteristics.

A needle that is incorrectly sized or has become blunt or burred will damage the yarns as it passes through the fabric. This damage results in cut yarns that in turn produce holes, thereby weakening the fabric. These holes generally enlarge with the use of the product and are considered unsightly and unsatisfactory by most customers.

The retailer or product manufacturer who contracts with a cut-and-sew firm for the production of the product should ask the contractor about the maintenance of his or her sewing machines. Changing needles often reduces production time and increases overhead costs; therefore, many sewing operators and plant managers are unwilling to change needles as needed for different fabric types and are often unwilling to change needles as they become worn or damaged. Preventive maintenance is important to prevent needle cuts, but costs and other competitive pressures often force managers to skip these quality procedures. However, prevention is the best quality procedure because once a hole is made along a stitch line it cannot be undone. Repairing the hole will result in a darned or a patched area, and replacing the damaged fabric piece may be impossible because cutting may be done in another geographic location or scrap fabric may not be available. Sewing operators should be encouraged to check needles often and to change them as needed.

Needle heating refers to the damage that occurs to fabric when the speed of the needle and thread passing through the fabric generates heat buildup. Heat buildup occurs from the friction that is created as the needle and thread pass through the fabric in the formation of the stitch. In fabric containing synthetic fibers, heat buildup can result in small melted places where the needle rubs the yarn; in fabric containing natural fibers, it may result in small singed places (Figure 8–24). The synthetic fibers may become distorted if pulled along the needle (see Figure 8–25) or may develop a hard, clear or black bead, depending on the exact fiber content.

Needle heating is caused by a needle that is too large pressing through fabric at a rapid speed. Industrial machines sew at a very fast pace. The speed is important to managers who wish to have high levels of production within a fixed time span, but the damage to the fabric is unsightly and can render the product unusable. The distorted areas in synthetic fibers can be sharp and scratchy, and the singed areas can become larger holes and leave discolored areas in the fabric. Corrective action should be taken before the heating occurs. Sewing machine manufacturers have accessories that can be added to machines to blow air on the needle or to drip oil along the needle. The addition of these accessories may be costly, but the lack of action reduces the quality outcomes of the product.

Figure 8–24
Singed cotton fabric from needle heating.

Figure 8–25
Melted synthetic fabric from needle heating.

Samples of the fabrics for the products should be tested ahead of the production sewing to determine whether needle cooling methods will be needed. The use of air would not harm fabric but might be annoying for some seam constructions. The use of oil is very effective but must be closely monitored because of the effect it could have on fabric. For example, oil if not correctly applied to the equipment could cause stains on the fabric, which would be impossible to remove on fabrics such as satins that stain readily. The use of a smaller needle and smaller diameter thread might be a possible solution if such action is compatible with the fabric and the seam structures of the product. Sewing slower is effective for preventing needle heating but is rarely desired in a cost competitive situation.

Industrial stitch standards provide the retailer, the buyer, the merchandiser, and the designer with established information about the formation and the concatenation of stitches with recommendations for their appropriate use. This information should be used as part of the standards for product lines and the specifications for individual products. The standards, which are becoming internationally recognized, provide trading partners with clear information about which stitches to use in production. Other physical characteristics of stitches and the maintenance of sewing equipment may also be included in standards. A company with TQM goals will be interested in quality analysis procedures and preventive maintenance for all sewing operations. Partnership agreements between product manufacturers and retailers are important to delineate sample procedures and operations maintenance that will be followed to ensure that quality is not only recognized in product development but also continued within the production process.

Key Terms

100-stitch class	Federal standard No. 751	Quality stitch
300-stitch class	Federal Standard: Stitches,	Race
400-stitch class	Seams, and Stitchings	Safety stitch
500-stitch class	Flatlock stitch	Skipped stitches
600-stitch class	Formation	SPI
Back tacking	Generic names	Spreader
Balanced tension	Hand tying	Stitch balance
Bar tacking	Lockstitch	Stitch length
Bobbin	Looper	Stitch standard
Chaining off	Looping	Stitch width
Chain stitch	Merrow stitching	Stitches
Concatenation	Mock-cover stitch	Stitching
Coverstitch	Multiple thread chain stitch	Thread usage
DDD-S-751	Needle cutting	Trade names
Direction	Needle heating	Zigzag stitch
Encasement	Overedge stitch	

Review Questions

1. What is a stitch? Stitching?
2. What was the first purpose of the Federal Stitch Standard?
3. What are the two traditional methods of naming stitches?
4. When was the ASTM stitch standard created?
5. What are the two basic types of stitches? Explain their structure.
6. How are stitch types numbered?
7. Define the following terms: spreader, looper, and bobbin.
8. Identify the basic stitch type in the 100, 300, 400, 500 and 600 classes.
9. Identify the stitch from the side view and top view, and be prepared to draw or create the 100-, 300-, and 400-stitches.
10. Identify at least one "named" stitch in each stitch class and note its function.
11. Identify the uses for stitches in each of the five classes from Question 8.
12. What are the five physical characteristics of stitches?
13. How is length of a stitch measured?
14. How long is the average stitch?
15. How does length affect quality?
16. What is balanced tension?
17. What types of stitches have "width"?
18. What is the thread-to-seam ratio?
19. If a stitch has a 10-to-1 ratio, how much thread is used for a 6-inch seam?
20. Why are standards needed for stitches?
21. What causes skipped stitches?
22. How can skipped stitches be avoided?
23. What physical properties of threads would contribute to skipped stitches?
24. What causes needle cutting?
25. How can needle cutting be avoided?
26. Why would a manufacturer resist changing needles on a frequent basis?
27. What is the cause of needle heating?
28. How does coefficient of friction relate to needle heating?
29. What is the outcome of needle heating in synthetic fabrics? In cotton fabrics?
30. How can needle heating be controlled?

References

ASTM International (2004). *Standard practice for stitches and seams*. Designation: D6193-97. West Conshohocken, PA: Author.

Federal Standard (1965). *FED.STD.NO.751a. Stitches, seams, and stitchings*. Washington, DC: Government Printing Office.

Federal Standard (1977). *FED-STD-751a. Amendment 1. Stitches, seams, and stitchings*. Washington, DC: Government Printing Office.

Federal Standard (1983). *FED-STD-751a. Change Notice 1. Stitches, seams, and stitchings*. Washington, DC: Government Printing Office.

chapter 9

Seams

Most products involving fabric are sewn together using rows of stitches; however, some materials can be combined using glues, heat, and electrostatic forces. Combining two or more ply of fabric together with stitches or other methods creates a **seam.** The process of making seams is **seaming. Sewing** is the process of making stitching or seams. Seams are needed for sewn products because the items are usually multidimensional of various shapes and fabric is typically two dimensional. One exception to this rule is some knit fabric. Knit fabrics can be created in tubes and other three dimensional shapes. Some knits are also flexible enough when created that they can assume the shape of an item that is covered by or inserted in the fabric.

The ASTM standard for stitches also includes a section on seams and stitching (ASTM International, 1997). This section has a similar history as stitches, in that the standard was first introduced as a U.S. Federal Standard for military sewn products. In 1997, the seam standard as well as the stitch standard was adopted by ASTM as part of ASTM D6193-97. ISO 4916 is the international standard for seams. The number and letter designations across the two versions remain the same, although not every stitch and seam appear in all versions. In addition, various thread and sewing machine companies publish listings and illustrations of seams, along with information to aid manufacturers, merchandisers, and designers in selecting the best seams for a product when developing specifications for that product.

Figure 9–1
Two views of a seam: a = 2-D or cross-section view; b = 3-D view.

Illustrations of the seams may be shown as sketches or actual photographs. The sketches are either 2-D or 3-D sketches, as are shown for stitch types. Figure 9–1 shows both a 2-D cross-section and a 3-D view of the superimposed seam with 301 stitching. Figure 9–1 shows two fabric plies with a row of stitching along the right edge. The 3-D sketches frequently show multiple plies as dotted lines to indicate overlapping layers. The 2-D views are usually shown as cross-sections with the fabric plies shown and straight or curved lines to indicate straight rows of stitches, overedge or coverstitch as appropriate for the stitch most commonly used with the seam.

Within each seam class are a number of similar but slightly varying seams. The seams are labeled with the appropriate two letter alphabet for the seam class, in capital letters, and other small letter alpha-characters to denote the exact combination of fabric plies, folds of fabric, and placement of the stitch. The simplest of seams in each seam class is labeled with a small "a." A more complex seam has an alpha label that is further along in the alphabet (i.e., closer to the "z") than a more simple seam. For example, the SSa seam is simpler than the SSf seam. In general, the "a" designation indicates that the fabric plies are not folded at the edge (see Figure 9–2).

Figure 9–2 Fabric edges for a, b, or c designations.

With the "b" designation one ply is folded and with the "c" designation both fabric plies are folded. This "a," "b," "c" designation and the associated number of folded edges is also true for the LS, BS and FS classes of seams. Seams that involve multiple folds and other complex positioning of fabric are labeled with two alpha-characters. For example, the SSaw seam involves three plies, two of which are folded before placing in a stair-step manner on top of the third ply. Numbers can be added beyond a dash, following the seam letters, to indicate the number of rows of stitching that show on the surface of the seam.

Some of the more complex seams have common use names that are often used in industry instead of the letter system. The use of common names can be confusing and will not assure quality compliance to the same level as the standardized labels. The selection of the seam class and the exact seam within the class should be made based on many factors including costs, manufacturability, and intended outcomes for the product. The following four classes of seams are identified in the seam section of the ASTM or ISO standard: superimposed, lapped, bound, and flat. Seams are classified by how the fabric plies are positioned as the seam is formed.

Standards and General Quality Considerations for Seams

Seams are expected to be sewn with straight and even stitching with balanced thread tension, unless otherwise specified. Occasionally, the seam may be specified to be sewn with uneven tension to achieve a specific purpose such as basting a seam or pearling the edge of a buttonhole. Rarely would a crooked or not straight row of stitching be desired unless scallops, curls or other patterns were specified. With patterned designs, stitching should still be smooth and follow guides or markings on the pattern. Seam formation and associated stitches should "work with" the fabric to create a finished seam. The hand and overall look of fabric should not be distorted by sewing, unless a specific gathering or other deformation is expected.

Placement of the stitching, a set distance from the cut edge of the fabric creates the depth of the **seam allowance** (see Figure 9–3). In a quality sewn product, seam allowances are expected to be even and wide enough to prevent raveling of the cut edge into the stitching of the seam but small enough to reduce costs for fabrics and prevent distortion of seam and surrounding fabric. Limited bulk is a desirable feature for most seams.

To maintain the original hand and fabric thickness of the base fabric, seam bulk or the amount of fabric extending from the stitching inside the product or folded into the seam allowances is often reduced. This reduction may require trimming the seam allowances or grading the allowances.

Figure 9–3 Seam allowance for SSa seam.

Seam Allowance

Grading seam allowances trims each ply of the seam allowance to a different width so that multiple lengths become stacked on top of each other. In addition to further reduce bulk and maintain original fabric hand, the type of seam selected should be considered because some seams with multiple folds and several plies will automatically increase bulk or overall thickness.

Reducing seam allowances after sewing must not be done excessively so that the seam is not weakened. The thickness can also be reduced by selecting another seam type or a less thread consumptive stitch type. For example, the superimposed seam with seam allowances trimmed or pressed open is less stiff and has less bulk than any of the lapped seams. And, a lapped seam stitched with a 401 stitch will have more flexibility than one stitched with a 301 stitch.

Many seams will often be pressed open during production before crossing with another seam or pressed smooth and open or to one side in finishing. A seam that is unevenly stitched will not be smooth after pressing. When pressed open, a seam that is not stitched with a straight row of stitching will have ripples or other deformation in surface contour. This uneven surface will be undesirable for fashionality and will affect fit of the product.

Stitches should be minimally visible in many seams, especially when the two plies are pressed apart after sewing or when side-to-side stress is placed on the seam. With all seams, stitching should hold the fabric plies together. The chain stitches in the 100-, 400-, and 500-stitch classes are more prone to allowing the fabric to move away from the stitches and seam than the 300-stitches. The stitch length or width can be adjusted to minimize stitch exposure.

To further maintain the desired fit or dimensions of the product, the seam allowances must be maintained at the specified width. This specified width or the distance of the stitching from the edge of the cut piece is needed to maintain the correct dimensions of the pattern piece, and to be compatible with other pieces that are to be sewn to the first piece. Raw or cut edges of fabric pieces are normally not expected to show when the seam is complete. If raw edges should not show, they should not show during in-process and final inspection and they should remain hidden during product use and after product laundering or dry cleaning. Stitches and seams should combine to hold the cut edges hidden or turned to the inside of the product. Stitch type, encasement amount, stitch length and other physical characteristics of stitches and type of seam must be chosen with consideration for the intended use of the product and the hand, construction, and other physical properties of the fabric.

Of course, the fashion look for the product could override any of the generally accepted standards and the expected quality levels. For example,

fringe or other fashion images could have intended raw edges visible on the outer surface of the product. Puckery fabric, gathers, or ripples along a seam or other distortions could be used for fitting in a curved area of the product, or an unsmooth surface could be the result of the surface contour of the fabric or the intention of the designer. All standards must be applied so that the outcome of the product fits the intensions of the designers and merchandisers and the expectations of the consumers.

Superimposed Seam (SS)

The **superimposed seam (SS)** is formed when stitching or other seaming methods join two or more fabric ply that are stacked on one another with the bulk of each ply touching the other ply (see Figure 9–4). The loose parts of the fabric plies can be separated after seaming. When only two ply are used, the loose edges are separated and the seam resides between the plies. Often the plies are pressed back from the stitching. This seam can be sewn with a 100-, 300-, 400- or 500-stitch. A 600-stitch is not appropriate for joining the SS but can be used later to cover the seam. The SSa seam is the most common of the superimposed seams, is the most commonly used seam for all sewn products, and is used for both woven and knit fabrics. The specific seam shown in Figure 9–4 is an SSa seam.

One of the "named" or specialized superimposed seams is the **French seam.** This seam is noted in the standards as an SSae (see Figure 9–5). The seam is formed by stitching an SSa seam, then the plies are turned back against the seam allowance and the excess or loose edges are again superimposed and the seam is stitched the second time. The effect of this seam is that the raw seams are inside of the final seam. The French seam is commonly

Figure 9–4
Superimposed seam: a = 2-D; b = 3-D.

Figure 9–5
French seam: a = inside view; b = cross-section.

used for products where the seam should be as finished or as attractive on the inside of the product as the outside of the product. Sheer fabric used for blouses, curtains, or other transparent uses can benefit from the French seam because no raw edges and no outside stitching shows on either side of the product. The seam also results in a very small width seam.

Superimposed seams are also used for attaching tape to edges for setting stripes to shirt fronts (SSaa, SSab), for seaming to add piping or cording to edges of pillows (SSk, SSq, SSaw), and for top stitching (SSe). Superimposed seams can also be pressed flat, and the raw edges of the seam allowance can be covered with coverstitching or taping. Wide elastic bands can also be attached using the superimposed seam (SSt).

Quality Considerations for Superimposed Seams

The stitching and seam allowances for SS are not visible on the outside of the product. For this reason, the quality of the stitching is often not considered important; however, the stitching must continue to be straight and even with good balance of thread tension for the seam to be smooth when viewed from the surface or public side of the item. Width of seam allowances become critical for seams that have self-contained allowances such as the French seam. These allowances must be trimmed excessively but not enough to weaken the seam.

Lapped Seam (LS)

The **lapped seam (LS)** is formed with stitching when a portion of the fabric bulk for the first ply overlays a portion of the second ply. The stitches are formed along the area of the overlap (see Figure 9–6). The two plies overlap each other for a small amount, the amount of the seam allowance. When stitching this seam, a 100-, 300-, 400-, or 600-stitch can be used. A 500-stitch cannot be used because the 500-stitch is designed to be stitched along an edge. When a 500-stitch is sewn on a machine with an automatic trimmer, one-half of the plies would be removed instead of attached.

Lapped seams are used for attaching elastic (LSa) when a band of elastic is used as the second fabric ply. Patch pockets (LSd), yokes (LSe, LSf), bibs (LSl), and waistbands (LSj, LSk) are also attached using lapped seams. One of the more common "named" lapped seams is the **flat felled** or **felled seam.** This seam is labeled as the LSc-2 (see Figure 9–7) and is frequently used for seaming the long inseams on jeans and the long underarm seam of men's dress shirts. The seam is very sturdy and smooth.

To form the felled seam the two plies are lapped, and the edges are folded under each other. The two rows of stitching with lapping and folding are performed in one operation with the aid of a folder attached to the sewing machine. The seam may be stitched with a double needle 300- or 400-stitch. A 400-stitch provides some flexibility to the seam that is not available when using a 300-stitch.

Quality Considerations for Lapped Seams

Making a felled seam that would be considered first quality with no defects takes a skilled operator. The average operator trains for approximately 18 months before achieving a defect free flat felled seam. For this reason

a

b

Figure 9–6
Lapped seam: a = 2-D; b = 3-D.

Figure 9–7
Flat felled seam for jeans inseam: a = outside seam; b = cross-section view.

requesting such a seam in a product specification would add more cost to the product but would provide a finished seam that lies flat and would withstand extreme stress. The choice of the felled seam is a good example of how a designer or merchandiser must evaluate the needs of the consumer and determine the best production methods for meeting these needs. A consumer who wants the smooth finish of the flat felled seam might be willing to pay the amount needed to recoup the additional production costs. Whereas, another product might be satisfactorily seamed using a safety stitch, which provides a secure seam but not a flat seam.

Bound Seam (BS)

The **bound seam (BS)** is made with one or more plies of flat fabric, and an additional ply, a strip of fabric for the binding, is folded over the edge of the flat plies (see narrow, fabric ply in Figure 9–8). The stitching is made through all plies including the fabric used for the binding. The seam can be made with a 100-, 300-, or 400-stitch. A 500- or 600-stitch is not usually used for the bound seam because the binding forms a covering over the seam allowances so that overedging or coverstitching with thread is not needed.

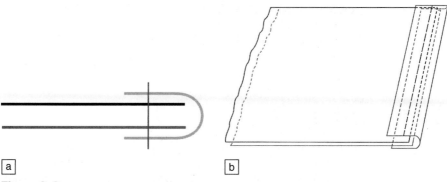

Figure 9–8
Bound seam: a = 2-D; b = 3-D.

The simplest bound seam as shown in Figure 9–8 has binding that has raw edges exposed. The binding can have edges turned under the binding as with the BSb (i.e., one edge turned under) and the BSc (i.e., both edges turned under) (see similar configurations for SSa, SSb, and SSc in Figure 9–2). For a BSa seam, a cover stitch is often used to cover the raw edges of the binding ply. When a BSb seam is used, a mock coverstitch may be applied to cover raw edges of the binding on the bottom side of the seam or inside of the item. The bound seam can be used to create waistbands, especially used on jeans (BSc) and to attach binding on knit products (BSa, BSd, BSe; see Figure 9–9). When creating a bound seam for edges of knit undershirts and for outerwear, the binding fabric may be specialized trim or other knit fabrics for color contrast or texture difference. The binding fabric for a waistband of jeans or other trousers is often a self-fabric.

Quality Considerations for Bound Seams

Maintaining the appropriate seam width becomes more complex when making a bound seam. The binding and base fabric must be examined and positioned during sewing. When the binding is properly in place over the cut edge of the base ply, the width of the seam allowance will not be visible to the

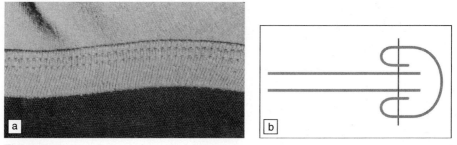

Figure 9–9
Bound seam on a knit shirt: a = outside view; b = cross-section view.

sewing operator. If the correct width is not maintained within the binding, the base piece may be improperly reduced in size, or the binding may be too close to the cut edge and will not remain in place although sewn.

Flat Seam (FS)

In a **flat seam (FS)** the two plies of fabric are touching but not overlapping. The seam is also called a butted seam because the fabric plies are considered to be butted together. The stitching used for this seam must cross over both plies to hold the fabric pieces together. The seam needs top and bottom coverage from the stitching that is used (see Figure 9–10). A 304 or 404 zigzag can be used or a 600-stitch is used because of the stitch width that allows the joining of the two plies. A 600-stitch provides a web of thread on both the top and bottom for improved coverage of the raw edges in the butted seam. The 304 zigzag is generally less effective in holding power than the 600-stitches.

The seam is also called **flatseaming** and is used where a very smooth seam is needed. The seam is used therefore in the seaming of underwear, fleecewear, and exercisewear (see Figure 9–11). The seam's strength depends, as do many other seams, primarily on the stitching that is used. This seam will be too weak to be satisfactory for seams that receive high levels of side to side force. Thread with high levels of elasticity, small stitch length, and high stitch coverage will increase the durability of this seam. The seam may also be used for decorative purposes to allow the two fabric plies to part and show other materials through the space between the two fabric plies.

Quality Considerations for Flat Seams

Flat seams naturally have no seam allowance bulk and become a choice for areas on a product that a ridge will either be uncomfortable, unsightly, or

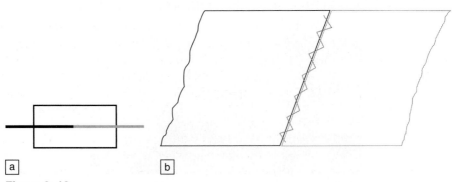

Figure 9–10
Flat seam: a = 2-D view; b = 3-D view.

Figure 9–11
Flat seam in knitwear: a = outside view; b = cross-section view.

cause friction. In contrast, this seam without seam allowances can be the weakest in ability to resist cross pressures. The seam is held together solely on the retention from the interlocking of the stitches. A stitch type that is also flat will be needed but must have a strong holding power. As previously noted, a 600-stitch is generally the stitch of choice; however, these stitches impart their own fashionality outcomes and can affect the hand of the finished product. Aligning the cut fabric so that the edges butt but do not overlap is also a challenge for the sewing operator. Machine holders that feed the fabric to the pressure foot and keep the correct alignment of cut pieces are needed to maintain the exact dimensions of the cut pieces and assist with obtaining the desired quality outcomes.

Specifying Seams

When writing product specifications, exact information about stitches and seams must be provided. The designer or product merchandiser cannot assume that the manufacturer will use a stitch and seam that will be satisfactory to the consumer. The manufacturer may choose a seam that is easiest for the operators to sew and a stitch that is made by the available machines. The cost of the stitch and the seam will also be a consideration. The more complex stitches use more thread and the more complex seams take more fabric and require more operations thus resulting in a more costly application. On the other hand, a complex stitch or seam may provide the functional outcome that is expected by the consumer. If the consumer is willing to pay for this type of seam or stitch, then the more expensive application should be specified. In addition, the merchandiser must consider the fabric type, thickness, fiber content, and

Figure 9–12 Stitch and seam specification for the 101 LSa-1 seam.

overall hand because these affect manufacturability. General design, image and other fashionality outcomes expected for the product must also be considered when selecting a seam.

To specify the seam and stitch, the designer or merchandiser should use stitch standards. The old Federal Standard, the newer ASTM standard, and the ISO standard use the same numbering system, although some specific stitches or seams are not listed in each of the standards. To write the specification, the stitch and seam are generally written together. A specification that uses the 101 or basic chain stitch and the basic lapped seam with one row of stitching would be written as **101 LSa-1** (see Figure 9–12). The "-1" is often not given if that row of stitching is what is generally expected for the stitch.

The stitch length should also be specified. Stitch length will vary with the price point of the product, the expectations of the consumers for the holding power of the seams, and the amount of visibility preferred for the stitching. In addition, the physical properties of the fabric such as yarn count, yarn diameter, type of construction, and fiber content will affect stitch length.

For example, a fabric with a large diameter yarn, a low yarn count, and a basket weave construction would necessitate a long stitch length or a low SPI for the seam. Stitch width for zigzags and other stitches with similar movement and bite amount for encasement may also be specified, especially if these amounts vary from traditional usage.

When specifying a seam, the designer or merchandiser must also specify the distance that the stitching will be placed from the raw edge of the seam or the seam allowance (see Figure 9–3). The amount of fabric for the seam allowance must be added to the pattern dimensions to ensure the correct final dimensions of the sewn product. The widths of seam allowances are on the inside of the product and are least visible for the superimposed seam. Although usually not visible, seam allowance measurements are also important to the lapped seams so that the sewing operator will know how much of the plies should be overlapped before or during sewing. Although 1/2″ to 5/8″ is the general range of seam allowances, the allowance should be noted in the standard so that the accuracy of the size of pattern pieces is maintained. If the pattern piece is intended to be 12″ wide in finished dimension with a 5/8″ seam allowance but a 1″ allowance is taken, the pattern piece will be smaller than expected when finished.

Exact widths of seam allowances will be dependent on the stability of the fabric, the enclosure amount of the seam, and the amount of binding or coverage given in the stitch from variances such as stitch length and stitch width. When specifying a bound seam, the width of the binding will control the positioning of the stitching on the fabric plies.

Defects and Other Problems with Seam Quality

Seams combine the plies of fabric through the use of stitching. The combination of thread, fabric, and the process of stitching can alter the flat and smooth state of most fabrics and can compress and flatten the textured state of other fabrics. For most sewing operations, the objective is to stitch the plies together without altering the surface texture or the hand of the fabric. However, this is a difficult objective to achieve because of the combined effects of the physical properties of the fibers, yarns, and fabrics in concert with the properties of the thread and the dynamics of the stitch and seam formation. A number of errors or defects can occur that will diminish the quality level of the product including: grin, seam slippage, and pucker. In addition, when the thread is not compatible with the fabric, additional seaming and sewing problems occur that reduce the quality of the product.

Grin is one problem with seam quality. Grin is the result of a seam opening wider than intended when pulled with a side-to-side motion. Grin is so named because the individual stitches show as if teeth in an open mouth (see Figure 9–13). Lack of holding power from loose stitches is the main cause of grin.

Grin is not only unsightly but is also detrimental to the overall strength of the seam. This weakness can be caused by several reasons. The chain stitch has a natural looseness because of its interlooping structure in both

Figure 9–13
Seam grin.

formation and concatenation. The loops allow the thread to slip slightly or excessively depending on the thread type and the exact number of the chain stitch. The 100-stitches show more grin than the 400-stitches. In addition, the stitch length of both the chain stitches and the lock stitches will affect grin. Longer stitch lengths provide larger gaps between stitches and the potential for more grin than found with shorter stitch lengths. The bite or width of the stitch will affect grin. A stitch such as the zigzag or the overedge stitch can have a bite that ranges in width from very narrow to almost 1″. The wider bite has more thread per stitch and therefore allows more movement of the fabric within the stitching, resulting in more grin.

Seam slippage occurs as the fabric pulls away from the stitching that holds the cut pieces together. In grin the threads are loose and allow the fabric to slide along the stitch. In seam slippage the threads are usually stable but the yarns within the fabric are unlaced and pull away from the stitches. Seam slippage can be identified by the raveling ends of the cut edge and often individual yarns are visible as seen in Figure 9–14.

If seam slippage goes unchecked, a hole will soon appear at the point of slippage. Causes of seam slippage include an incompatibility between the fabric and the stitching or the thread. If the fabric is soft because the fibers are staple or the yarns have a loose twist, the overall structure of the fabric can be weak. A superimposed seam or a flat seam from this soft fabric will often result in seam slippage. If a monofilament or other thread with limited pliability or other movement is used in sewing soft or semi-soft fabrics, the

Figure 9–14
Seam slippage.

thread may have more strength than the fabric. Seam slippage may also occur when the seam allowances are trimmed to very narrow widths such as needed to form welt pockets (as shown in Figure 9–14) or bound buttonholes. Sharp corners for cuffs, waistbands, patch pockets, collars, and pillows and seat cushions are also prone to seam slippage.

Puckering as an outcome of the assembly process is unacceptable to most customers. A smooth, straight seam is generally expected and is the accepted standard in the industry. Achieving this outcome is not always easy. The integration of thread, fabric, machines and operators within the sewing process make the probability of a puckered seam a reality in many cases. The unfortunate and all too often alternative to a smooth seam is the puckered seam as shown in Figure 9–15.

Seams may become puckered for a variety of reasons, but the outcome is still not desirable for most consumers. When examining seam puckers, yarn structure of the puckered fabric can appear distorted. This change in yarn structure of the fabric is caused by an incompatibility between fabric characteristics (i.e., size of yarns and space between yarns), needle size and thread size. In the example in Figure 9–16, the holes that were formed by the needle and/or thread during the sewing caused distortion of the yarns in the woven fabric as the needle and thread combined pushed through the fabric. The example shows the puckers or ripple effect that occurred as the fabric was compressed along and around the row of stitches.

A variety of reasons are possible for a product having puckering. Thread structure and fiber content; fabric structure, content, and yarn count; stitch

Figure 9–15 Puckered seam on jacket front.

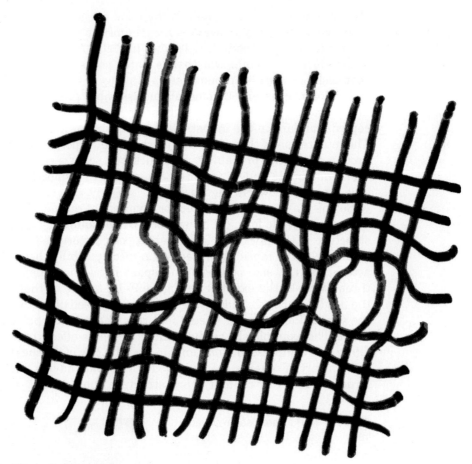

Figure 9–16
A close-up of base fabric puckered by sewing.

characteristics and type; and seam choice are all interrelated in the causes of puckering (see Table 9–1).

Selection of stitches must be made to be compatible with the fabric and the seam. For this reason, stitch type or class can also cause puckering (see Table 9–2). The space between the concatenations of each stitch can vary and should be compatible with the diameter of the yarns and the yarn count of the fabric. Operator error and machine conditions may also cause puckering. How the fabric is handled when the stitching is performed or the machine condition including feeddog and needles may affect puckering (see Table 9–3).

Few customers will be satisfied with puckered seams on a finished product, unless the "wrinkled" look is a popular fad or a specialized texture is desired for the product. One of the difficult issues with judging the best thread to use is the fact that many of the outcomes or outward signs of the performance properties will not be manifest until the consumer wears or uses the

Table 9–1
Raw Materials (i.e., thread and fabric) as Reasons for Fabric Puckering

Cause	Reason
Diameter of thread is too large compared to openings in fabric at intersection of warp and filling yarns.	Fabric structure is distorted by the large thread.
Flexibility of thread is too stiff compared to fabric.	The inflexible thread tries to remain straight although curved in stitching and pulls the softer hand fabric.
Structure of thread is too strong compared to soft structure of fabric.	The fabric with the weaker structure, such as loosely twisted staple yarns, will be more flexible; therefore, the fabric is bunched or shifted as the thread tries to remain straight.
Shrinkage of thread is greater than shrinkage of fabric.	The thread shrinks more and is shorter than intended so that the fabric is forced to distort because of the reduced length of the stitch.

Table 9–2
Stitch Incompatibility as Reasons for Fabric Puckering

Cause	Reason
Stitches are too long for the fabric type.	Stitches that are too long for the fabric are ones that span too many yarns and tend to draw the yarns together, especially common with long stitches and a high yarn count fabric.
Stitches are too short for the fabric type.	Short lengths of stitches on a fabric with an open weave (low thread count) or large yarn can cause the yarns to bunch together and create puckers.

Table 9–3
Operator and Machine as Reasons for Fabric Puckering

Cause	Reason
Operator pulls fabric or resists automatic feed of the sewing machine.	The fabric will be stretched during the placement of the stitches. When relaxed the stitches will try to push the fabric back to its stretched state.
Feeddog and pressure foot combination are not appropriate for the fabric.	Fabric thickness and other physical features of fabric can resist the pull of the feeddog if the pressure foot is not appropriately adjusted. The outcome is similar to operator pulling the fabric.
Needle size is too large	Needle size must be compatible both with the thread and with the spacing of the yarns within the fabric. If the needle size is too large the fabric will be pushed aside as the needle enters the fabric.
Wrong type of needle is used with a fabric.	Needles vary in the shape of the point and the taper of the shaft. These should be designed to press the needle into the fabric between the yarns but not to distort the yarn placement.

Table 9–4

Root Cause of Common Seam Problems Related to Thread Incompatibility

Common Seam Problems	Performance Criteria	Physical Features of Thread
Broken thread	Flexibility	Fiber content Structure
Fusion or scorch	Coefficient of friction	Fiber content Diameter
Lumpy stitches	Pliability	Fiber content Structure Ply
Skipped stitches	Pliability	Structure Ply
Unsmooth seams	Elasticity Pliability	Fiber content Structure

product, and then maybe only after it needs some washing or other cleaning. For this reason, end-use performance or outcomes from the perspective of the consumer must be considered as well as issues of cost and manufacturability.

Thread compatibility with the fabric and sewing machine is a major issue when evaluating the outcome of a seam for quality analysis. Five of the most common concerns when evaluating thread compatibility with the base fabric are enumerated in Table 9–4. For each sewing problem, the related performance criterion and the underlying physical properties of the thread used in sewing the seam are given.

The criteria, such as given in Table 9–4, provide the analyst with a point for examination and relate to possible tests that can be used (see Tables 4–6 to 4–10 in Chapter 4) for the analysis. In addition, the physical features list (see Table 9–4) gives possible features of the sewing thread that might contribute to the problem. The thread must be compatible with the fabric and with the stitch and the seam to produce a quality product.

The interrelationship of these properties and outcomes are complex and without a simple solution because of the complexity of the sewn product and the multiple facets of the raw materials within the product. For example, skipped stitches are a major problem when sewing with a monofilament thread. The monofilament thread in general lacks the pliability needed to bend through the sewing machine throat plate and tends to form a loop that often will not engage with the bobbin or looper mechanism to form the stitch. The stitch is not formed and skipped stitches result. If this problem is not corrected, holes will appear in the seams and will weaken the structure of the product, in addition to providing unsightly or inappropriate openings in the finished product. The lack of pliability in the monofilament comes from the lack of twisting because it is only a single straight filament and from the chemical structure of the single fiber content that forms the monofilament. One long straight smooth synthetic filament has limited pliability, especially when it is of a larger diameter. A micro-diameter thread would be more flexible but would

have the disadvantage of handling problems because of its small size. The problems with skipped stitches often outweigh the benefits (e.g., no problems in color matching and ease of stocking inventory) of the monofilament thread.

Stitching

The last section of the stitch standard contains the descriptions and pictures of the two stitching classes. Stitching is a row of stitches and can be applied to a single ply of fabric. The two types are ornamental stitching (OS) and edge finishing (EF).

Ornamental Stitching

Ornamental stitching (OS) is a series of stitches in the fabric made for decoration. The stitching may be straight, curved, or in any number of patterns (see Figure 9–17). Ornamental stitching is used to hold folds of fabric

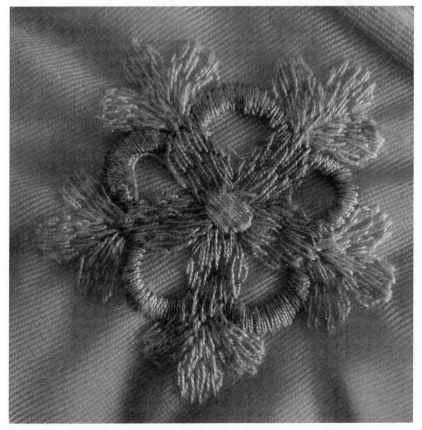

Figure 9–17
Ornamental stitching.

Figure 9–18
Pintucks made with OSf stitching, with enlargement of cross-section view.

together as in the OSe and OSf stitching to create tucks, permanent creases, or darts in fabric (see Figure 9–18). The cross-section view shows how the fabric is folded and then stitched near the fold. The stitching must be straight and equidistance from the previous tuck to render straight tucks. Width of the folded tuck of fabric can vary. If the width is narrow, pintucks are created, and wider folds create other styles of tucks. Permanent creasing with OS stitching is used to simulate the military type creases pressed into the back of a uniform shirt or the sharp crease seen in well-pressed trousers.

The stitching can also be used to hold cording to the fabric, as with the OSb, OSd, and OSh stitching. With this stitching, the stitching and the fabric encases the cording with the cording covered on the top with fabric and on the underside with the webbing created by a covering stitch (see Figure 9–19). The cording area may be backed with thread covering or with an additional ply of fabric, a narrow strip along the back of the cord. For a simulated cording look, the OSc creates a hump of fabric, where the fabric is raised to simulate the effect of inserting the cording.

The OSa stitching can be used for top stitching to display a row or multiple rows of stitching along the edge of sewn fabric. Top stitching can be done for ornamentation or for stability of the folded or seamed fabric. When done for stability, the stitching is often done through multiple plies including the seam allowances. To reduce bulk, seam allowances can be trimmed so that the

Figure 9–19 Cross-section view of OSd-2 stitching—stitching for cording.

stitching can be placed beyond their edges. Top stitching is usually a two step operation: (1) the seam is created and (2) the stitching is performed. The 406 stitch on a lapped seam or used on a pressed superimposed seam will create the same effect as a double row of top stitching with the OSa-2 stitching.

Quality Considerations for Ornamental Stitching

Stitching has similar quality issues as stitches and seams. Stitches should be in straight lines, smooth curves, or otherwise orderly alignments. Formation of the stitches should be according to the standard, and the fabric should lie smooth and flat around the stitching. Extra care using flat plates or framing may be needed to keep the fabric flat during the stitching. With a single ply and excessive stitching, the fabric may be puckered among the stitches. Another problem is that the fabric, if thin or flexible, may be easily pressed into the feeddog area of the machine.

Edge Finishing

Edge finishing (EF) is the stitching class used to cover raw edges of fabric and to create an ornamental or functional edge. Edge finishing can be used for creating belt loops, spaghetti straps, tunneled elastic, and centerplaits. Edge finishing for hems is done in at least three styles: serging, clean finishing, and blind hemming. Several variations of these three hems are also

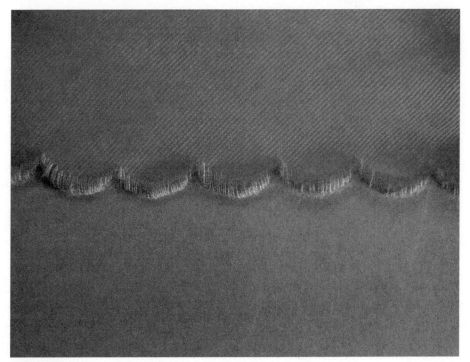

Figure 9–20
Serged hem.

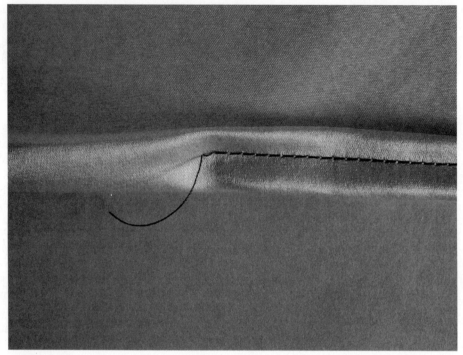

Figure 9–21
Shirttail hem.

possible with edge finishing. The **serged hem** is the EFd finish and covers the raw edge with an overedge stitch (see Figure 9–20). For the "shirttail" or **clean finish hem** (EFb), the fabric is folded twice, and the stitching is made through both folds of the fabric (see Figure 9–21). The double fold of the EFb hem is usually very narrow so that the overall placement of the stitching is close to the edge of the fabric. For both of these hems, the stitching will be visible on the face of the product.

The **blindstitch hem** or blind hemming (EFc) is created when the fabric is folded back upon itself in an S shape, and the stitching is made partially through the folded edge (see Figure 9–22). The stitching does not show on the outside of the fabric when the operation is completed and the fold is removed.

Figure 9–22 S curve of fabric for blind hemming with EFc-1 stitching.

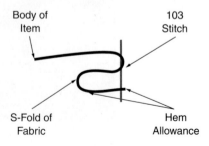

Quality Considerations for Edge Finishing

Edge finishing often occurs with narrow or specialized folds of fabric. This stitching requires a guide on the machine to keep the fabric folded the correct amount and to keep the edge of the fabric from being creased. Both the stitching and the folds of fabric must be kept even and straight. Over long seams or with curved edges this requirement becomes more difficult.

Key Terms

101 LSa -1	Flatseaming	Seam allowance
Blindstitch hem	French seam	Seam slippage
Bound seam (BS)	Grading	Seaming
Clean finish hem	Grin	Serged hem
Edge finishing(EF)	Lapped seam (LS)	Sewing
Felled seam	Ornamental stitching (OS)	Superimposed seam (SS)
Flat felled seam	Puckering	Thread compatibility
Flat seam (FS)	Seam	

Review Questions

1. What are the definitions of seams, seaming, and sewing?
2. What are general standards for the quality of seams?
3. What is grading of seams? Why is this done?
4. What prevents the raw edges of seams being visible on the outside surface of the fabric for a sewn product when the seam is complete?
5. Identify by picture, characteristics, and general usage the four main seam classes.
6. Identify by picture and class: French seam, flat felled, men's shirt underarm seam, neck binding, underwear/exercisewear seam.
7. What are some quality considerations for each seam class?
8. How are the quality considerations different between the superimposed seam and the bound seam?
9. What stitches are most appropriately used for each seam class?
10. Why is a 500-stitch not a quality choice for use on a lapped seam?
11. What equipment in sewing can be used to improve the outcome of a seam?
12. What should a designer or merchandiser consider when selecting the correct seam?
13. Why should specifications be written for seams?
14. What is the meaning of 101-LSae-3?
15. What are three major seam defects (problems), their causes and solutions?
16. What happens to yarn alignment in the fabric during seam puckering?
17. How does seam slippage differ from grin?
18. What construction process is most likely to result in seam slippage?
19. How is thread selection related to a quality seam outcome?
20. What would be the outcome of a seam when the thread is not as pliable as the fabric?
21. What are the two major stitching classes?
22. What would be the stitching specification for embroidery?

23. What is the stitching class for a tuck, crease, or dart?
24. How is cording held on fabric?
25. What is top stitching?
26. Explain two quality considerations for ornamental stitching.
27. List three standards for ornamental stitching.
28. What are the three ways to do a hem?
29. How are edge-finishes and bound seams similar and different?
30. Explain two quality considerations for edge finishing.

References

ASTM International. (1997). *Standard practice for stitches and seams.* Designation: D6193-97. West Conshohocken, PA: Author.

chapter 10

Fit

Fit is evaluated at many points during the entire production system and may be examined one more time in a reinspection during or prior to postproduction shipment to customers. Many of the factors that affect functionality must be tested and inspected during previous points within the overall production system; however, some random sampling for fabric and seams may be done during final inspection. Among the three outcomes, fashionality, once established during the idea and line development stages in the product development process, is the primary outcome to be evaluated during final inspection. At the final inspection stage, the manufacturer will take one last evaluation of all outcomes to ensure that the product meets the fashionality, functionality, and fit outcomes expected by the consumer.

Fit is primarily important for products that are worn on the body; however, it is also of concern for products that are intended to be used by humans such as upholstered furnishings. The conformation of the product to the human body is important when the product is in direct contact with some part of the body, and the fit of the fabric over the padding or interior structure of home furnishing products must be appropriate for the product. **Fit** can be determined by exact measurements or dimensions of the product relative to the dimensions of the wearer or user; however, it is more often a measure of how the consumer feels in the product or during the use of the product. Sizing or the dimensions of the product relative to the identified size of the product is another factor that is related to fit but is not the same as fit. For example, a size 12 shirt that is designed to be loose and baggy can have overall dimensions that are larger than those of a size 14 shirt that is designed to be worn

close to the body. An ergonomically shaped chair may fit the body very closely when the user is seated, and an overstuffed and oversized chair may have ample room for the user to place his or her legs sideways in the chair or may accommodate the user with extra space. Fashionality involves how the consumer sees or perceives the product and is closely integrated with the fit of the product. Properties from these outcomes are primary cues for consumers in their selection and continued use of the product.

Because fit and fashionality are often measured by consumer perceptions and other aesthetic criteria, setting standards and evaluating outcomes are often measured not by numerical counts or chemical tests but by human judgment. This situation makes a final evaluation difficult; but regardless of difficulty with the quality analysis process, the importance of these outcomes cannot be ignored. Specifications for fit and for final inspection are based on generally accepted criteria used by the industry and are based primarily on the aesthetic descriptors. For many consumers, fit is visualized as freedom from wrinkles. Consumers traditionally think that the appearance of wrinkles shows that the apparel item does not fit. The back of the jacket in Figure 10–1 shows long vertical wrinkles that indicate that the jacket circumference is larger than the person wearing the jacket. If the fit standard for this jacket is a smooth and wrinkle free appearance, the fit of the jacket is not meeting the quality expectations of the consumer. The exact match between specifications and outcomes in the evaluation stage of the product analysis process is very important because these outcomes directly and immediately impact the consumer's image of the product, the brand or designer name, and the overall image of the company or store.

Figure 10–1 Jacket back with wrinkles from undesirable fit quality.

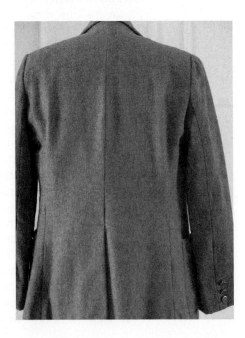

Definitions and Development of Fit

Fit is a measure of the conformance of the product to the body, with considerations for ease of style and ease of movement. In the case of products that are apparel items, fit becomes the relationship of the 2-D apparel item to the 3-D body. The outcome of a proper fit originates in the product development process. During line development the designer establishes specifications for product fit. These guidelines may be established on the basis of standards for all products in a line or for all products made by the company. Fit is often controlled by the product line or by the company. Companies with branded products desire that the fit be consistent across time and across products. Some consumers have very definite ideas about fit and others are insensitive to fit issues. In the *Women's Wear Daily* (*WWD*) study reported in Chapter 1, approximately 30% of the respondents said that fit was an important apparel feature for them (Consumers Report, 2002, p. 9) In another *WWD* survey of over 2,000 women, respondents reported which product brands they found most familiar, and many of these are brands with consistent and distinctive fit in their products (Blue Dreams, 2005). **Consistency in fit** not only is important in branded goods but also is important for companies that sell products through catalogs or Web sites. When the consumer cannot try on the product to determine the fit, she or he is dependent on previous experiences with the product to know what is the right size for a desirable fit. In branded products, consumers become dependent on fit consistency for immediate identification of appropriate size, again without the time consuming activity of trying on the product.

Concepts of fit are also related to the fashion image of the product, the age of the consumer, and the usage or function of the product. Again, these factors are important considerations or standards for the identification of specifications in the line development stage of product development. Understanding the target consumer, as to age, style preferences, and lifestyle activities, are important factors in determining fit. The fashionality of a product may be dictated by the fashion image of the brand or the company or may be variable depending on fashion trends and style changes within the product market. For example, the fit of a knit shirt may vary from a loose or baggy, long, oversized shirt to a close fitting, high-hip length shirt, or anywhere in between. Either extreme may be the right fit when it is right for the consumer, the product, and the situation (see Figure 10–2).

In product usage, the desired fit may vary across one product. For example, jeans can be worn for various occasions and by various consumers. The fit of jeans worn by an older teenager for a party or a date situation may be very different from the fit desired of the same jeans and the same consumer for outdoor activities or activities with the family. The fit of jeans for an older woman, a baby, and a teenager will probably vary because of different levels

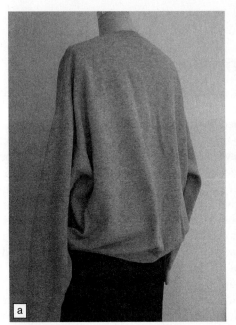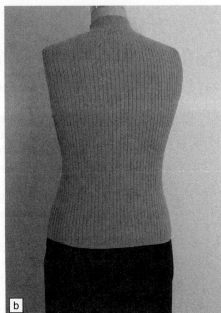

Figure 10–2
Fit variance in knit shirts; a = loose fit; b = close fit.

of personal activity and variety in body shapes. Understanding the target consumer is of maximum importance in establishing specifications that correctly interpret the expectations of fit for particular consumers.

Some companies deal in **vanity sizing** where the dimensions of the apparel product are inflated so that a small size will fit a larger customer. This sizing system is often found in designer or bridge brands. A woman who normally will fit into a size 12 may find that she can wear a size 8 or a size 6 in a brand that is vanity sized. The selling power of this technique has been a powerful tool in the past, but consumers are often perceived as wiser and more aggressive in their shopping in current markets. Vanity sizing is not as prevalent in brands as has been previously found.

Fit is monitored in the production development stage in product development. When samples are made, in both the initial sample and the production samples, the fit must be checked and rechecked to be certain that the fit prescribed in the specification remains the same. Changes in pattern pieces and sewing techniques can alter the intended outcome of fit. As the pattern maker creates a draft of the flat pattern from the sketch or the drape, adjustments made or estimations done can increase or decrease the dimensions of the product. For example, the pattern maker who is working from a sketch has to determine the placement of yoke lines, sleeve caps, and other linear dimensions. In addition, spreaders, cutters, and sewing operators who stretch or bunch the fabric can alter the fit of a product.

In preparation for marketing the product, or in the sales development stage, the fit is again monitored to ensure consistency with the initial dimensions and images specified by the designers. As samples are made for market showing, the fit is evaluated so that each sample of the product is identical with the original design. When the product is ordered and production ensues, the fit must be checked in final inspection. In addition, quality procedures for spreading, cutting, and sewing must be in place to ensure that the processes do not alter the fit of the product. Final inspection is too late to find that mistakes in cutting have altered the fit of 1,000 dozen units of a product.

Fit Approval Process

The **fit approval process,** or the measurement of fit, is determined throughout the product development process and during and after production. Getting the right fit begins with the idea stage of the product development process. As the designers and the merchandisers work to create new and revised products for a company, they must constantly keep the company image and fit standards in their minds. At the format meeting, the product development team and others in the meeting evaluate ideas for their compatibility with the company image. For example, products for a conservative company may need to be cut so that the fit is not too tight. A fashion-forward company may wish to have a fit that reflects the latest images in the fashion world. A company that has the image of expensive products may want the fit to reflect a generous amount of fabric.

During the line development stage of the product development process, the designer and the merchandiser use the company croquis and dress forms for creating the new or revised products. The use of standardized forms to create a product aids the designer or merchandiser in obtaining a quality product—one that fits the target consumer or the target space. Standardized sizes are important in maintaining the product sizes and dimensions throughout product changes. New ideas that are drawn with the standard company croquis start with proportions that match the consumer's expectations. During the slush meeting, the designer and other members of the product development team meet with top management to review the product ideas. Using the croquis for sketches and the product forms for draping, the product development team provides assurance to top management that the products have been designed with the consumer's input because that input was the basis for creating the shape and dimensions of the croquis and forms.

During production development, the product development team uses slopers to develop patterns. The **first sample** is made according to the slopers developed for a sample size for that product line, for that company, or for that brand or store. The **sample size** for products varies, but traditionally the sample size for misses' products has been size 8. However, with the

changing size of modern women, the sample size for many companies has increased and is now often a size 10. No federally or internationally mandated size 8 exists, so the dimensions of this product are dependent on the company and its understanding of the consumer. With the use of body scanning, more exact dimensions can be obtained than have been previously available with a person taking measurements with a tape measure. Body scanning and measurement extraction software can help a manufacturer or retailer determine the exact dimensions of their "average" customer (Bruner, 2004). This type of software would be extremely important to companies that are creating customized products for apparel consumers or that are intending to be consumercentric. The exact dimensions of the consumer can be identified, and these dimensions can be interpreted by the software into patterns. The final shape and size of the product is then determined by the designer and/or the consumer, depending on the product development process.

Sample sizes for evaluating fit should be appropriate to the sizing of the product. Petites, women's, and juniors all have appropriate sample sizes. Sample sizes for other textile products such as sheets, towels, and upholstered furniture vary. Some products that are of large dimensions are made in one-half sizes or in other dimensions for samples rather than in the final product dimensions. For many apparel items, after the pattern is developed and the first sample is created, the sample is tried on the fit mannequin or on a live fit model. Forms or **fit mannequins** come in a range of sizes and may be purchased from companies that supply these products. Companies that have definite dimensions for their products and who wish to have fit consistency have forms created to their specific size dimensions. Forms that have a texture more similar to human skin instead of the rigid surfaces of the common dress form are used by some companies. These forms have a surface that will provide resistence to compression and that are appropriate for fitting items such as bathing suits, leggings, and other active sportswear products. Samples that must be fitted over padding for home fashions should be evaluated on a form that has the same compression ratios as the padding in the final product. If a sample product is evaluated over a rigid surface, the analysis is not realistic when compared with the expectations of the product over a flexible surface. A full fit review or approval may be done at this time with both forms and a live model or may be done after the creation of production and showroom samples.

The **fit of production samples** and **showroom samples** are evaluated with fit models. **Fit models** are live models that have body dimensions equal to the dimensions of the ideal consumer for the product. Evaluating fit on the fit models is important because the movement of fabric on body flesh is not the same as fabric being fitted on a dress form. In addition, this fit procedure or **full fit review** allows the designer to see the product in action and to judge whether the product meets the designer's image in fashionality as well as fit. The art principles that were used in evaluating the fashionality of the product design are used again. The product can be judged for design detail, proportions and balance, and effect of color. Other measures of quality

that affect functionality and sometimes fit and fashionality, such as seam stitching, grain lines, and fabric hand may be evaluated at this time.

In addition to making the product in the sample size, many products are made in a multiple range of sizes. The dimensions of all sizes that are larger or smaller than the sample size are created through the grading of patterns. **Grading** of patterns usually follows a prescriptive process with grade rules that are established by the designer and the pattern grader. The dimensions of the larger and the smaller sizes are increased or decreased in dimensions so that the graded products appear in proportion to and appropriate for each size. For example, the neck area of a sweater does not increase at the same rate as the chest area. The boney structures in the area of the collar bone, shoulder bones, and other neck and shoulder structures do not increase in size at the same rate as other body parts. If the two areas were **graded** (i.e., increased or decreased in dimensions) the same amount in the neck area in larger sizes would become so large that the neck opening would fall off the shoulders of the wearer, which might be appropriate for some styles but is not generally accepted as appropriate fit. The full range of products in all sizes should be evaluated prior to or during production for quality analysis. A **nest of graded patterns** is the pattern in each size in a superimposed position so that all the sizes are stacked one on top of the other (see Figure 10–3). This nest can be reviewed quickly by an experienced

Figure 10–3 Nest of graded patterns.

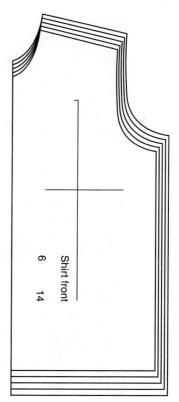

pattern grader or merchandiser to determine whether the grading appears to be accurate. The graded nest will have edges and corners that are smaller than expected in certain areas. For example, when the curve of the arm hole is enlarged from a size 10 to a size 16, the armhole is lengthened but is not cut further into the bodice or the width across the shoulders would be reduced for the larger size, which is the opposite of what is anticipated when increasing sizes.

An in-process inspection can be done as spot checks throughout the production process. Product can be pulled from the sewing line at any point, usually designed by a test method, to evaluate the fit or the dimensions of the product at that stage in the sewing process. If errors in product dimensions are being made in seam allowances, trim amounts, or fabric distortion, the in-process inspection will identify these problems before the entire product is sewn. The final activity for evaluating fit is to measure the products in final inspection. Measuring is done after inspection for obvious defects. **Protocols** are used during final inspection so that the dimensions of the product are measured consistently. A flat outline on a table or on other measuring devices might be used to assist with the measurements (see Figure 10–4). Tape measures can also be used but are more open to interpretation than are fixed measures with marks for each size.

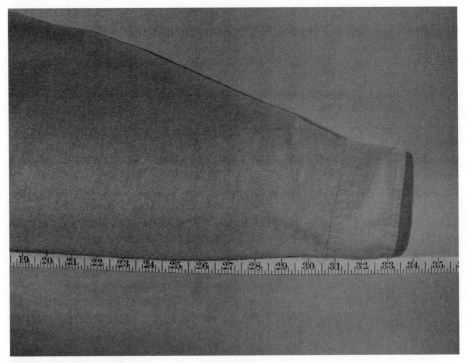

Figure 10–4
Fit protocol for final inspection.

A final check for fit, fashionality, and functionality may be done as a reinspection process. Some companies regularly pull a sample of products from each shipment that arrives from the manufacturer. The random samples are checked for packaging, labels, size dimensions, and other quality checks. This final reinspection helps assure the merchandiser that the quality that is designed in the product and inspected in the process remains consistent throughout the production run for that product line. In addition, companies should evaluate products that are returned by customers who are dissatisfied. Many of the returned products cause dissatisfaction among consumers because the product does not fit correctly, especially after postuse care. Manufacturers and retailers should also check the sell-thru on products. Fit problems may be indicated when consumers buy sizes in different ratios than are normally sold or when a size or a style of a product is not selling at the same rate as similar products. Consumers are the final judges of the fit of a product and their voices should be heard by manufacturers and retailers.

Standards for Fit

No U.S. federal standards exist for guiding the fit of apparel products or for the size of other sewn products, except those created for the U.S. military. Apparel products can be as loose and as baggy or tight and clingy as the designer or merchandiser desires. Window treatments can be as long or as short as the designer decides. The consumer can buy any product in any size variation that is offered in the market place. Consumers who do not like the sizing of mass-produced products and who can afford alternatives can have products customized to their personal dimensions. In addition, dimensions of the product for size ranges can vary from product to product, from brand to brand, and from company to company. The consumer readily knows that a size 10 in three national brands of jeans will all have different dimensions and different fits. Sizing of apparel products has been the subject of recent studies in the United Kingdom and in the United States. The study in the United States, called **SizeUSA**, was performed in collaboration among [TC]² and several universities and collected data from over 10,500 participants. These are the first comprehensive sizing studies ever done on civilian populations (King & Bruner, 2003). Using the data from these studies, designers and retailers can set the dimensions of the product to fit a majority of consumers, or the dimensions of the product can be altered to reflect the company image and the expected fashionality of the product.

Although based on older data than the recent sizing studies, some generally accepted industry guidelines have been in existence for fit and may still be appropriate for some apparel products, some consumers, and some

companies. These standards are generally acceptable for products that are not cut on the bias or by other off-grain methods.

The five topical dimensions for the fit standard are ease, line, grain, set, and balance. These five topical dimensions are interrelated and vary in importance across products. In addition, these items become summative to the overall fit of the product and perception of comfort or appropriate look for a consumer.

Ease

Ease is primarily a concern of products that are worn by the consumer and is divided into two types: design ease and wearing ease. The **design ease** varies with the fashionality outcome of the product. The design ease is developed in the line development stage to create the desired silhouette of the product. For example, a full or pleated skirt can contain many inches of design ease in comparison to a straight skirt. The fullness of the skirt can vary from a straight and closely fitted skirt to an A-line skirt, where only a portion of the skirt lies close to the hips, to a full or a pleated skirt where the entire skirt is many times larger than the largest dimension of the hip and the excess fabric is gathered or pleated into a fitted waist (see Figure 10–5). The amount of fabric used in the pleated skirt is many times more than the amount of fabric needed to cover the diameter of the body along the hips and legs. The amount of difference in the pattern from the slim straight skirt to the full swirling skirt is the amount of design ease.

Figure 10–5
(a) Pleated skirt with large amounts of design ease and (b) Straight skirt with minimal design ease.

Wearing ease is space in an apparel product for breathing and for performing regular muscular movements, such as sitting, bending, stooping, and arm raising. Sewn products for home fashions rarely have wearing ease unless the product is made to be removed or replaced such as a pillow cover for a bed pillow. The size of the pillow slip or cover must be a bit larger than the size of the pillow to allow for movement on and off. For apparel products, fit points to check for ease are the circumference areas of bust or chest, waist, and both high and low hip. In addition, fit for ease can be checked across the shoulders. The ease in the straight skirt in Figure 10–5b is wearing ease. The contours of the skirt follow the basic shape of the lower body with enough space between the body and the skirt for breathing and bending. Walking in a straight skirt with only wearing ease is facilitated by placing a pleat or vent in the back of the skirt from the knee to the hem. Lengthwise ease is checked for pants. Ease in products such as hats, gloves, or shoes have checkpoints appropriate for those products. An apparel product should have enough wearing ease that it conforms to the body without distorting the fabric and altering the look.

Line

Line is a multifaceted topical dimension and can be observed in numerous areas of a product: basic silhouette, circumference seams, and the lines of the design. The positions of the seams along the edges of the product or in relation to points of fit on the body are important indicators of fit. In general, circumference lines should be smooth and follow the natural curves of the body. For example, in an apparel product, the line around the neck follows the shape of the neck and actually dips a bit in the front and the back of the product to provide shaping and improved fit around the neck. This "dip" in the line would also be needed at the waist of products that fit closely at the waistline. Crosswise lines are generally parallel to the floor, with the exception of those lines that curve with the body shape. Linear or lengthwise lines should be perpendicular to the floor. The use of line can be seen in the skirt in Figure 10–6. With an appropriate fit for the skirt, the section of pleats at the side of the skirt falls straight from the hip area and is perpendicular to the floor.

Specific areas to evaluate for fit for length and width are shoulders, neck, wrist, knee, and ankle. The body scanning mechanisms provide measurements for a multitude of measurement points, which accounts for its accuracy in providing patterns that fit the body (Bruner, 2004). Design lines within the silhouette are also important, such as darts, princess seams, yokes, and center closings. The placement of these lines is determined by the product development team, and the line placement created by the team should be maintained and evaluated through the design and production process. Standards should note whether the placement of design lines vary from the normally expected placement of seams on products. For example, a yoke line that is placed very low from the shoulder should be specified so that the sewing supervisor can be sure that the yoke placement is correct during production.

Figure 10–6 Line with considerations
for fit in a skirt.

Grain

Grain is the lengthwise and crosswise direction of the yarns within the fabric. These yarns are more obvious in a loosely woven, ribbed, or yarn-dyed fabric and are less obvious in a high yarn count fabric or in a fabric made from fuzzy or highly textured fiber or yarn. The grain lines should be noted in specifications as lengthwise or crosswise on patterns to coincide with the warp and filling yarns of the fabric. In general, apparel products hang better from hangers and from shoulders or hips if the lengthwise grain lines are perpendicular to the floor.

The grain in a skirt with loosely woven fabric is obvious because the fabric is a yarn-dyed plaid, and the yarns are rather large (see Figure 10–7). If the pattern is intended to hang horizontal and perpendicular to the floor, the pattern pieces must be placed carefully in the marker to align the linear portions of the pattern with the grain lines in the fabric.

Most of the decisions on grain lines must be made as patterns are developed and markers are made. A direction that is 45 degrees from either grain line is considered to be the **bias** direction for fabric. Product pieces that are designed to curve around the body, such as a folded collar or lapel, may need to use the bias directions of the fabric to achieve a smooth transition in the shape of the fabric. In addition, the relationship between pattern pieces and grain lines may need to be adjusted for some persons because of specific body dimensions. Persons with body deformation or with asymmetry must have adjustments in the patterns and development of the apparel item to create an appropriate fit. Grain is closely related to the fit characteristic of balance when observing an apparel item with a linear pattern. Designers

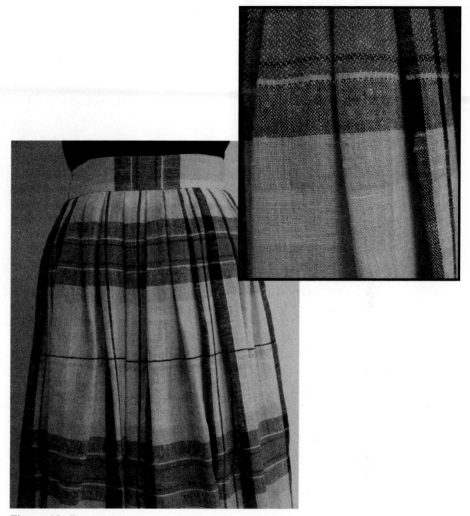

Figure 10–7
Grain of the fabric adjusted for fit with insert of grain detail.

may create product features and envision styles or images, purposefully altering the general rules for grain lines. A table cloth may be cut on the bias to create lovely folds as it hangs to the floor as may a swag or valance that is intended to be draped and looped.

Set

Set is the overall smoothness or freedom from wrinkles when a product is judged for fit. The product in Figure 10–8 has a smooth appearance because the set of the item is correct for the fit desired. The appearance of wrinkles gives information to the designer and the merchandiser about the fit.

Figure 10–8 Dress with a smooth set.

Crosswise or upward wrinkles indicate that the underlying body part is too broad or too long. For example, a shirt or bodice that is too tight across the shoulders would have wrinkles pointing to the shoulders or across the back. Downward wrinkles (see Figure 10–9) indicate that the apparel product is too large for the body or that the body area is too small to adequately fill the apparel product. This set of guidelines is true for pillows and for other upholstery items that are overstuffed or understuffed for the size of the fabric shell. Set is an excellent example of the interrelationship of the five dimensions of fit. When the wearing ease is too small or too large, the set of the product will be altered and wrinkles will appear.

Balance

Balance is the perception that the product is symmetrical when split into equal halves. For example, a hem should touch either leg at the same place. A plaid fabric should appear on the skirt at the same place on the body on both hips (see Figure 10–10a). A sleeve cuff should rest at the same point on the wrist or on the back of the hand, regardless of whether the cuff is for the right or the left hand. The collar points should extend an equal distance from the collar on both sides of the neckline.

When a body is asymmetrical, the balance of the apparel item may be affected and the item will appear to fit incorrectly. A frequent body adjustment in older women with aging bones is a curve in the spine, which may result in one hip being higher than the other hip. The outcome of this body asymmetry is seen in the plaid shirt in Figure 10–10b. The plaid that was

Figure 10–9 Dress with wrinkles
instead of a smooth set.

Figure 10–10
Balance in left-to-right dimensions of the skirt: a = balance; b = out of balance.

symmetrical and balanced is now rising on one side where the hip is higher than the other hip. Although most body configurations are minor and cause no apparent problems with fit, most people are actually asymmetrical.

In addition to a left-to-right balance, a front-to-back balance should be achieved for products. Hems should remain perpendicular and level with the floor, both left and right and front and back; however, when fitting humans, the circumference line of the waist may have to have a slight dip to accommodate the natural shape of the human waist. When the fit of a plaid skirt is adjusted for balance, the plaids will be perpendicular from the side view of the skirt (see Figure 10–11a) as well as the left-to-right balance from the front view. However, when body shapes are not symmetrical, the balance of the apparel product may be inaccurate and the problems in fit will affect the appearance (see Figure 10–11b). The plaids in the skirt seem to rise from the side seam to the back seam because of the curvature of the derrière. The back seam length must be extended at the waist to accommodate the extra length needed to cover the full derrière of the wearer in Figure 10–11b. Without adjustment in the dimensions from waist to hip, the hemline will also be affected. Necklines and waistlines are another area of the body that may need a slight rise or lengthening of pattern dimensions to follow the curves of the body. These curves are natural and expected when fitting apparel items. This planned curve is noted in Figure 10–10a, where the curve of the waistline rises above the wide, black horizontal stripe near the waist. If the designer intends to have some dramatic asymmetrical effect such as a side buttoned jacket, out of balance could be the

Figure 10–11
Side view of skirt in front-to-back dimensions: a = balance; b = out of balance.

standard fit; however, most consumers for many products expect a balanced look as the standard fit.

Fit Standards for Specific Products

Although no U.S. federal or industry standards exist for the fit of sewn products, some traditionally accepted standards are recognized in the industry and can be helpful to designers, merchandisers, and buyers as they prepare and select products for consumers. The following information on a pair of trousers, a tailored jacket, and a shirtwaist dress are given as guidelines for forming product-specific standards and needed specifications for evaluating fit.

Trousers or **tailored pants,** sometimes called dress pants, generally have the following style characteristics: waistband, smooth or pleated front, front zipper, front and back pockets, and blind stitched hem. The waistband, on trousers can be created with a curtained waistband, including a woven curtain to add stability and coverage below the waistband, a bias cut interfacing, and a **non-roll stay** to keep the smooth set in the pant below the waistband. In contrast, the waistband on jeans is usually a top-stitched bound seam. The front zipper on tailored pants is usually a French fly application with a modesty panel. Quarter open inseam pockets and back double welt pockets are generally found on the tailored pant. The hem is usually completed with a blind hem so that the hemming stitch does not show and may be cuffed or straight legged. The fit standards for any of these style features can be used in combination with other style features in similar or related products, such as shorts, jeans, more casual pants, the upper areas of skirts, and other lower body apparel products.

Standards for the fit of pants at the waist and for front areas include the waistband, the front, and the zipper area. In a classic fit, the waistband should lie at or near the navel, and the circumference dimension should allow enough wearing ease for room to breath. No strain or wrinkles should show at or near the closures. The front should be smooth and wrinkle free. If pleats are included in the front, the pleats should create vertical lines from the waist toward the floor. They should lie flat with no pulling across the tummy area. The French fly zipper, which covers the front crotch seam, should have an even lip that lies flat with no gaping. The crotch length should conform to the body curve with no horizontal or upward wrinkles from the lower crotch seam.

Fit in the crotch area is measured by the length and the rise of the crotch seam. To initiate the fit for pants, the fitter must first establish the waist or the desired waist position for the wearer. Once the waist location is established, a tape measure or other ribbon-like material can be tied or pinned in place to mark the waist position. **Crotch length** is measured from the front waist to the back waist between the legs. Therefore, a second tape measure can be used to measure the crotch length by starting at the front waist and ending at the center back waist area (see Figure 10–12).

Figure 10–12 Crotch length measurement.

Again, wrinkles can be used to evaluate the fit of pants. When the crotch length is not appropriate for the wearer, wrinkles will appear. If the crotch length of the pants is too short for the crotch length of the wearer, wrinkles that are basically vertical will rise from the crotch area to the hips (see Figure 10–13). Some fitters say that wrinkles point to the place on the item where the fit is not matching the standard.

The crotch rise measurement is taken with the person in a seated position. The **crotch rise** or crotch depth is measured along the side length from waist to the seated surface (see Figure 10–14). For a quality apparel product, the set of the pants should exhibit no wrinkles either radiating up or down from the crotch seam. Up wrinkles are indicators that the rise is too short, and down wrinkles indicate a rise that is too long. The fit is acceptable and the pants are generally considered to be a quality product when no wrinkles are seen on the body of the pants, indicating no pulling of fabric because it is too tight or does not amply allow for curvature of the body. In a quality product, the ease amount is correct for the body length and the curve is correct for the body shape.

Pockets for tailored pants should lie close to the body and conform to the overall curvature of the body. The front edge of an exposed or quarter open inseam pocket at the front hip should lie flat and not gape away from the body. The pocket should also not show any signs of pulling or opening because the wearing ease is too small. The back hip pockets should be equidistance apart. Alterations must be taken with care in the waistband area so

Figure 10–13 Crotch length of pants is too short for the wearer.

that the pockets have a balanced look and are neither too close together nor too wide apart.

In the thigh and calf area, the seams should create a vertical line from hip to hem. Horizontal wrinkles show pulling of fabric that is too tight in circumference for the body (see Figure 10–15). The side seam of pants should

Figure 10–14 Crotch rise measurement.

Figure 10–15 Horizontal wrinkles indicating the circumference of the pants is smaller than the hip measurement of the wearer.

hang perpendicular to the floor. The back and front edges or creases should be straight and show a smooth set. The front hem may be set with a **break,** which is a traditional look. The break should cause one wrinkle across the vertical crease about 4 or 5 inches above the hem (see Figure 10–16a). The hem grazes the top of the shoe. When the hem is set without a break, the hem sits on top of the toe of the shoe but does not touch or rest on the shoe (see Figure 10–16b). The hem of the pants or the ankle area, regardless of break or no break, should have a back hem that covers the collar or top edge for the back of the shoe.

When evaluating fit, especially the fit of pants, the fitter should be aware of the sensitivity of the client. Fit models may be accustomed to being touched and exposed during a fit session, but the average consumer is normally more sensitive to having another person in the fitting room. Fitters should try to explain their movements to the clients and should remember to cover clients, models, and dress forms to maintain modesty for all involved in the fit session. In particular, fitters should be careful with pins and the safety of those in the fit session.

The **tailored jacket** has the following style characteristics: lapels with notch, a two- or three-part collar, two-part sleeves with wrist opening, welt pockets, a full lining, and a single or double back vent. These style characteristics may be used in conjunction with other style features and may not always be present with each jacket. In addition, fashion images change over time, and some of these features may appear very differently or be missing in some jacket styles.

Figure 10–16
Pants: (a) with a break and (b) without a break.

Regardless of the exact style, these features and the fit areas that they address can be used to create standards for specific products that involve outerwear coverage of the upper body torso.

The **lapel** area of the jacket is characterized with a collar that meets the lapel in a **gorge line** that ends with a **notch** of varying sizes (see solid line a indicated in Figure 10–17). The classic lapel is 3 inches wide and is usually worn with a wide tie. This area should be smooth with no wrinkles and should roll in a balanced curve at both the left and the right side of the face and neck. The standard or quality fit of a collar can also be judged by the slope of the collar, both in the front and the back of the jacket.

The **slope** of the collar should follow the shape of the neck of the wearer (see the dotted line b in Figure 10–17). The collar edges should lie close to the jacket and should not protrude away from the body. The collar should hide the neckline seam of the jacket and should not show the buff edge of the under-collar. The two- or three-part collar can be made from a **felt under-collar** and a base fabric top-collar piece. The felt under-collar will enable the collar to have a smooth roll and better conformance to the curvature or line of the neck and shoulders (see dashed line c in Figure 10–17).

The tailored jacket is traditionally designed to be worn with a tailored shirt that has cuffs and a **collar with a band.** The jacket collar should be fitted so that the shirt collar appears about one-half inch above the jacket collar at the center back of the neck of the wearer. From this point, the shirt collar should be exposed as a nearly even amount as the jacket collar follows

Figure 10–17 Jacket collar and lapel:
a = gorge line; b = slope; c = curvature
of neck.

the natural curvature of the neck toward the front of the neck. At the point where the collar begins to roll downward to the lapels, an increasing amount of shirt collar would then show. The exact measurement of the arm should be taken to determine sleeve length in addition to placing the sleeve on the arm. When measuring or fitting sleeves, both for a jacket or a shirt, the measurement is taken from the center back at the largest protruding vertebra at the back of the neck, across one shoulder, around the curve of the shoulder, and down the arm to the wrist area. During the process, the arm should be bent at a natural curve.

The **two-part sleeve** consists of a main sleeve and the narrow undersleeve (see Figure 10–18). The sleeve area should have smooth seams and should follow the curve of the slightly bent arm. When evaluating the fit of the sleeve, the fitter should ask the client to bend his or her arm slightly at the elbow because sleeve fit and sleeve measurements are always taken with a slightly bent arm. For a standard quality fit, shaping created by the seams should conform to and allow for natural arm movement. This type of sleeve construction can provide the wearer with a fit that is closer to the natural shape and hang of the arm (see Figure 10–19).

The shaping in a two-part sleeve is developed by the shape of the two pattern pieces. The two edges of the back seam or the elbow seam area is very different for the two pattern pieces (see Figure 10–20). The larger piece has a straight edge for the seam and the smaller, underarm piece has a curved edge. During the sewing together of the pieces, the elbow shape is developed. Shaping can also be created by the placement of tucks or darts along the back seam at the elbow area of the sleeve. The lower end of the back seam can be

Figure 10–18 Two-part sleeve with buttons placed along back sleeve seam.

created into a vent opening so that the cuff circumference can be made smaller than the circumference of the hand. This opening allows the wearer to place the hand through and out of the sleeve without distorting it. Buttons that are functional for opening may be added; however, many vent and button combinations at jacket cuffs are nonfunctional findings (see Figure 10–18).

Figure 10–19 Side view of two-part sleeve showing curvature of the sleeve.

Figure 10–20 Pattern pieces for a two-part sleeve.

The set of the sleeve should be slightly forward of the vertical arm line, which should be perpendicular to the floor from the shoulder to the elbow. The grain line of the pattern pieces could be perpendicular to the cuff edge when the pattern is cut, but, when placed in the arm hole, the placement of the sleeve would provide for a slight forward rotation of the sleeve. The length of the sleeve should end or stop at the top of the wristbone to allow for exposure of the shirt cuff below the jacket sleeve hem.

In a traditional fit, the length of the jacket sleeve should be set so that the shirt cuff is exposed approximately one-half inch below the finished jacket sleeve. If the consumer were to wear shirt cuffs with cuff links, the jacket sleeve could be set at a slightly shorter length to provide more exposure for the cuff links. The cuff links should be hidden by the jacket sleeve when the arm is at rest but should be exposed when the arm is raised. The term "shooting the cuffs" is used to describe an arm movement that would raise the jacket sleeve enough to expose one's cuff links, an action that might be done if the wearer had very flashy or expensive cuff links.

Welt pockets with and without flaps are traditionally shown on the tailored jacket. These pockets should fit so that the corners remain square and the lips are closed with no gaping of openings or pulling of fabric. The back vent may be created with a **single vent** or a **double vent.** The double vent is easier to fit on the human body because of the additional seam for shaping. In Figure 10–21, the back vent on the right hand side is pulled open to show the construction of the vent. The flaps of the vent should lie flat and smooth. The lines of the seams and edges of the vent should be perpendicular to the floor, and the vents should not open when the jacket is worn standing.

The lining of the tailored jacket must fit within the base fabric of the jacket and must also fit the wearer so that the lining is not seen when the jacket is worn and the closures are buttoned. Several sewing operations and

Figure 10–21 Jacket back with double vent with right hand vent open to show construction.

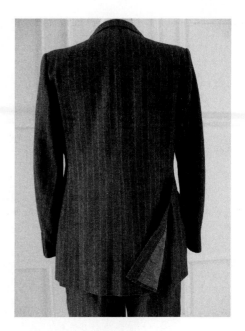

pattern adjustments can be made so that the lining will fit properly within the jacket and allow wearing ease for the wearer. The center back of the jacket lining should have a pleat so that the lining has some flexibility when the wearer moves his or her arms. In addition, the length of the lining should be long enough so that a small horizontal fold can be developed in the hem of the lining where the lining and the hem of the apparel product meet. This fold will also provide some wearing ease and will reduce the stress on the lining fabric and the lining hem stitches when the jacket is removed.

The **shirtwaist dress** is a fitted apparel product with features of both a shirt or blouse and a skirt. The specific style characteristics of this apparel product include the following: a fitted bodice with darts, a front facing with buttons, set-in-the-round sleeves, long sleeves with continuous bound placket and cuff, a fitted waist with side zipper, and a full skirt with a 1-inch hem.

Darts are important lines when determining the fit of an apparel product. A properly made dart is important before evaluating the fit. The properly made **dart** is a smooth line of stitching with a tapered tip, no bubble at the end, and chaining or other secure stitching to prevent raveling. The bodice darts should point to the fullest part of the body. This rule is true for any dart used in fitting. The **dart tip** should end 1 inch before the fullest point of the bust or the fullest point of any body bulge (see Figure 10–22). The area beyond the tip is the place where the extra fabric encompassed in the dart is released for fitting the curves of the body. A dart that extends beyond the fullest point of the bulge will cause the fabric to be stretched too tightly over the fullness, and a dart that releases the fabric too soon will create a pucker.

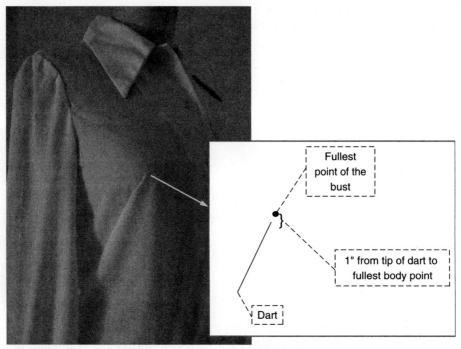

Figure 10–22
Bodice with dart and bust area shown in expanded view.

To determine product quality, another point of the front bodice to be examined for a fit analysis is the center front with the buttons and buttonholes. Buttons should be spaced close enough along the center front to provide a modesty of closing. The exact placement of the buttons should be determined so that one button is at the fullest part of the chest area (see Chapter 6 for more details on button and buttonhole placement). The two halves of the bodice should not pull apart at the button closures, and no strain or wrinkles should be visible.

The front and back of the bodice should be examined for set. A smooth set of the shoulder area is the traditional fit for a quality product. If wrinkles are present, they may be indicators of fit problems or product defects. Horizontal wrinkles, in the front or back of the bodice, indicate that the bodice is too tight or too short for the shoulder area (see Figure 10–23a). Vertical wrinkles, especially along the back of the bodice, indicate that the bodice is too loose or that the dimensions of the bodice are too large for the size of the body (see Figure 10–23b).

The lines of the bodice should be examined, including the top shoulder seam and the side seams. The line of the seam should lie on top of the shoulder, unless the bodice contains a yoke and has a forward shoulder seam. The seam line should end at the shoulder joint and the slope should match the slope of the shoulders. Side seams should be perpendicular to the

Figure 10–23
Fit of bodice circumference (back view): a = too tight; b = too loose.

floor for a quality fit. Twisting of side seams can be indications of improper fit or fabric distortion from fabric twist in processing or postuse care, or distortion developed in sewing.

The **set-in-the-round** sleeve will have the best fit of any of the possible sleeve applications. This fit is much better than that which is achieved in the flat or the shirt sleeve application. The four-way intersection of the seams under the arm and the crossing of the side and sleeve seams with the armhole seam allow for the independent movement of the armhole seam (see Figure 10–24). This independent seam action in conjunction with a properly sized bodice and sleeve circumference allows arm movement that does not pull upward on the bodice. The **armscye** of a sleeve should contain enough wearing ease, in relation to the circumference of the upper arm, so that the wearer is able to raise his or her arms freely. The sleeve cuff, on a long sleeve shirt, should end just below the wrist bone.

Finally, the waist of any apparel item that is fitted on the torso of the body (i.e., dress, skirt, pants) should have enough ease for the wearer's comfort, and the line of the waistline should curve to follow the curvature of the natural waist. This feature should dip slightly below horizontal in the front and the back waist to be proportional to the body. Any side opening zippers should not gape or pull. Inside stays, tabs with buttons, hooks and eyes, or other stabilizing findings, can be added to improve the fit at the waist. The hip area, as discussed in the fit of pants, should show no horizontal wrinkles and should hang in loose vertical folds or be smooth if a more tightly fitted skirt is designed.

The hemline should be level with the floor at a length that is either the prevailing fashion length or a length that flatters the wearer. Hemlines of apparel products should be measured and fitted from the floor to the product and not from the waist to the hem. When clients have hips that are not level or other body parts that are not symmetrical, measuring from the waist to

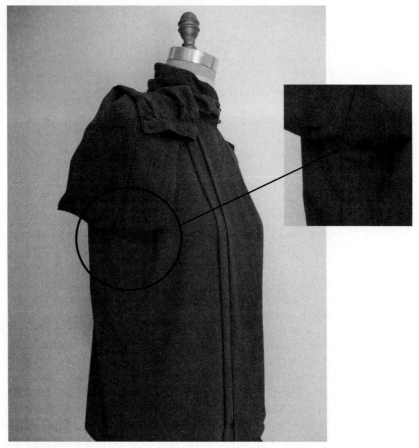

Figure 10–24
Location of four-way seam intersection for a set-in sleeve with detail showing exact match at intersection.

the floor may result in hems that are not parallel to the floor. The eye of the viewer will judge the quality of the product relative to the floor; therefore, the measurements should be taken in that manner.

Consumercentric Fit

Fit standards for most companies are based on the "average" or the ideal consumer who buys that product. Sizing studies in the United States and elsewhere in the world show that the ideal-shaped customer rarely exists. The average woman in the United States wears a size 12, which indicates that many other women wear larger or smaller sizes. The rapid growth of

sales for merchandise in the petite market also indicates that the average customer is probably not the ideal size 8 fashion model. Even if the company has realistic expectations about the sizes of its consumers, averages are only mathematical calculations and not the exact measurement of the majority of the consumers. In addition, many consumers have nonaverage body shapes or disabilities that preclude a good fit from the average dimensioned and sized apparel items for sale.

Many consumers today are interested in getting a more exact fit with their clothing. They source clothing from catalogs or Web sites for special sizes, (e.g., extra tall, petite, and women's sizes) that are not readily available in stores. With new computer technologies, a **consumercentric fit,** or one that is custom made for an individual consumer, can be offered by many companies. Some firms have Web sites with body images that allow consumers to enter their own body dimensions and see the resulting image on the computer screen. Upon this customized image, the consumer can place apparel items of choice from the selections offered by the company. In addition to this option or offered as a separate option, the consumer can request that the clothing items be manufactured to his or her specific body dimensions. This option is usually described as **mass customization,** which gives consumers choices in areas such as color of fabric, length of sleeves and pant legs, and more exact measurements for waist and hips. These fit and fabric options are provided within the framework of limited style choices offered by a manufacturer. These changes can be rather quickly done when the patterns are premade and the dimensions offered by the consumer are quickly entered into the computer and the pattern lengths are automatically resized. A low ply cutter driven by a computer pattern and marker making system can assist with shortening the time to fulfill this order and reducing the human labor needed to make these personalized or customized changes to the mass produced product.

This **customization of sizes and fit** often requires that the consumer, a family member or a friend, take measurements, which is rarely accurately done. Again, accuracy of dimensions is often not correct when measurements are taken by untrained people. Technology provides a solution for this situation. In **body scanning,** a laser or other "seeing" device measures the human body and records the measurements with exact precision (Bruner, 2004). The number and accuracy of measurements taken in body scanning is superior to those taken by hand. In addition to circumferences and vertical distances taken by hand, the body scanner can record slopes, curves, and shape placement that are not recorded by using a measuring tape by hand. The exact slope of a shoulder, the curve of a derrière, or the shape of a back can be captured with the body scanning equipment, recorded in the computer, and used to create patterns for an exact fit. This customized fit work then requires the use of computerized marker making and single-ply spreading and cutting to obtain the fabric pieces needed to make the special fit product. The cost of single-ply marker making and cutting and customized sewing results in a product that is still too expensive for most consumers. In addition, some consumers resist the process of body

scanning as being too invasive. However, as consumers become more adjusted to the presence of technology and costs of technology become lower, this option may become more popular with consumers and retailers in the merchandising of apparel products. Automated CAD renderings of home furnishing products are already popular and in use by many companies. Made-to-order items are common in some product categories such as sofas and other upholstered items. In addition, as consumers become more vocal in wanting their own choices recognized and rewarded, the options of customized products become more important to manufacturers and retailers and are more viable to consumers. As with many other apparel and other sewn products, one of the three outcomes of fit, fashionality, and functionality may dominate when the consumer makes the choice to purchase the item.

Key Terms

Armscye	First sample	Protocol
Balance	Fit	Sample size
Bias	Fit approval process	Set
Body scanning	Fit of production samples	Set in-the-round
Break	Fit mannequins	Shirtwaist dress
Collar with a band	Fit models	Showroom samples
Consistency in fit	Full fit review	Single vent
Consumercentric fit	Gorge line	SizeUSA
Crotch length	Graded	Slope
Crotch rise	Grading	Tailored jacket
Customization of sizes and fit	Grain	Tailored pants
Dart	Lapel	Trousers
Dart tip	Line	Two-part sleeve
Design ease	Mass customization	Vanity sizing
Double vent	Nest of graded patterns	Wearing ease
Ease	Non-roll stay	
Felt under-collar	Notch	

Review Questions

1. What is fit? Why is it important to the consumer?
2. How is fit related to fashionality and the fashion image of a product or a company?
3. Why is consistency in fit important across products within one company?
4. How does the age of the consumer impact the desired fit of the product?
5. Why would one product have various fit expectations by one consumer?
6. What is the fit approval process? When does this process occur?

7. Where is fit evaluated in the product development process? The production process?
8. How many ways can fit be evaluated?
9. What is the difference in fitting a live model and a dress form?
10. How can the sloper be used to get fit consistency?
11. What is done in reinspection for fit?
12. Why is reinspection needed if a company has a good in-process inspection procedure?
13. What is vanity sizing?
14. What organization or government agency provides fit standards?
15. What are the five topical dimensions for evaluating fit?
16. What is the difference between design ease and wearing ease?
17. How is the grain of fabric related to fit?
18. What can wrinkles tell you about the fit of a product?
19. When should the lines of the product follow the rules of balance and symmetry and when should they follow natural curves?
20. What are several fit standards that are specific for pants?
21. How is the crotch rise and length measured?
22. What are specific fit standards for a tailored jacket?
23. How should the sleeve measurement be taken?
24. Why is the double vent easier to fit than the single or no vent back?
25. Where should the point of the dart end? Why?
26. How should buttons and buttonholes be spaced along a blouse front?
27. Why does the set-in sleeve fit better than the flat or shirt sleeve method?
28. If horizontal lines appear along the hip, what is the evaluation about the fit?
29. What is mass-customization? Body scanning?
30. How can computers and other technologies assist manufacturers in preparing customized fit for a consumer?

References

Blue Dreams. (2005, July). *The WWD 100: A Women's Wear Daily Special Report, 8,* 46.

Bruner, D. (2004, January). An introduction to the body measurement system for mass customized clothing. Techexchange.com by [TC]². Retrieved April 11, 2005 from http://www.techexchange.com

Consumers Report. (2002, September 5). *Women's Wear Daily,* 9.

King, K. M., and D. Bruner. (2003, April). The sizing of America. *AATCC Review,* 7–9.

Product Specifications

The four step quality analysis process starts with the identification of consumer expectations. These expectations are gathered from target customers, established by brand identities and driven by company objectives. These expectations are often vague, lack specificity, and expressed in terms that are not equally understood by people in the industry. These rather vague and often confusing consumer expectations must be turned into concrete and specific guidelines (i.e., specifications) for the creation of a product. Creating these specifications requires the designer or merchandiser to incorporate (a) an in-depth knowledge of the consumer and the consumer's shopping and product selection behaviors; (b) an excellent understanding of the technical details of fibers, yarns, and fabrics; and (c) a mastery skill level in product assembly including knowledge of stitches, seams, and assembly methods. The person writing specifications must be able to capture the product image that was creatively developed by a designer and mesh that with the engineering and mechanical processes needed by the sewn product producer.

The geographic and cultural distances between the designer and the producer and between the designer and the consumer create challenges for someone who is writing specifications. Most sewn products are created by designers or product merchandisers who are thousands of miles away from the cut and sew plants that will make the product a physical reality. The product's creator may never see the sewing operators that will produce the product and may not speak the same language or write with the same alphabet that is used by the operators. In addition, the designer or merchandiser may have no direct or infrequent contact with most consumers who will purchase the products.

Great care must be given in developing the specifications so that they adequately reflect the intentions and the actualities of the designer's creation and correctly project the established image of the company.

Another challenge that faces the person who creates specifications is that many products begin as sketches in a flat or 2-D form. These sketches are often created without regard to exacting measurements or specific form. The designer of sewn products rarely works with a grid and ruler, as does the designer of a house, an automobile or other consumer products. In addition, fabric, and other raw materials, used to create the product are 2-D substances. In contrast, the sewn products as used by humans must exist in 3-D forms. The transition from designer sketch with limited measurements to the final product in 3-D form with specific dimensions requires skilled and careful management. New software that converts between 2-D and 3-D, and the reverse, is now available to assist product development team members as they struggle with the conversion. The specifications for the product become the guides needed to ensure that when the final step of the quality analysis process is completed, the outcome of the evaluation will be a satisfactory agreement that the product has indeed met the consumer's expectations. All of these technology improvements aid a company that is trying to be consumercentric because of the increased flexibility of outcomes and the improved points of input from all participants in the industry pipeline including the consumer.

Definitions

Specifications are both written and graphic guidelines for a specific product or product line. The product is identified by the **style number** by a manufacturer and would be comparable to the **stock-keeping unit (SKU)** level at retail. Product lines are frequently identified by name but may also receive a numeric identifier, which may or may not be part of the SKU number depending on the bar code and computer capacities of a company. The specification or set of specifications defines the product for the product development team, the product manufacturer, and the retailer. **Specifications** or **specs** are more detailed or specific than standards. Standards are usually written to cover general categories of products or services at the company or industry level, or even at the national or international level. For this reason, they are broad and can be applied in several ways to a number of products. Specifications in contrast are company specific and are identified for a product line or even more narrowly defined for a single product.

Specifications are used to ensure that products meet the target consumer's expectations. The specifications guide development of the product through the stages in product development, they control the assembly through the preproduction and production processes, and they are used for evaluation of the finished product in final inspection. Specifications are drafted for one

aspect of the production process or for the entire process. A **set of specifications** from design through fabric and findings to assembly and final inspection is considered a **specification book.** A set of specifications typically includes the following six categories of specifications: design, fabric and findings, size, assembly (i.e., cut and sew), fit, and final inspection.

A retail buyer may use specifications when evaluating new merchandise as it enters the distribution center or is placed on the retail selling floor. Retail buyers may operate with **specification buying,** meaning that they have a set of specifications that they use for guiding their purchases. Frequently, buyers who do specification buying are purchasing products for the retailer's private label or house (private) brand product lines. The specifications may help the buyer to select products from the samples shown or the specifications can be used when the buyer works with a manufacturer or contractor to develop new products specifically for the retailer.

Specifications developed by a manufacturer typically originate from the product development process prior to sending the product to production. In fact, the earlier that the specifications are developed the more likely they are to be used to evaluate the product throughout its development and production. The designer may be responsible for developing all the specifications; however, when product development is conducted in a team situation the designer may be responsible for one or none of the specifications. Within a large firm that creates many products, a person with specialization in writing specifications may be responsible for preparing the specifications. In a team approach, various individuals throughout the process may contribute pages or information to the development of the specifications.

The use of **product data management (PDM)** software helps the team share information and maintains a data base on a product or product line that can be accessed by multiple people involved anywhere in the entire process from initial design to final inspection and product sale. Changes that are made to the data at various input points are tracked by the system. Data from a PDM package can be integrated with CAD activities, pattern making and marker activities, and sales promotions (Tait, 2001). The PDM software data can also contribute information for digital printing and digital fashion shows. Although PDM information is accessible by multiple users in the process, the Product Development Manager or the Merchandising Manager may have the final responsibility for the approval of specifications and the permission for access to these files.

Format

To be beneficial in the global sewn product market, specifications must be concrete and precise with exact, technical wording. When working across cultures and countries, the specifications must be written and translated as

needed, and measurements given in the English system should be converted to metric measurements when appropriate. Data, when shared, must be compatible across multiple systems (Hiegel, 2005). The introduction and acceptance of ASTM standards for data exchange have improved the flow of data between trading partners in the sewn products industry. The specifications should include pictures or very simplistic language so that operators and floor managers with limited literacy skills can follow and abide by these guidelines. Measurements must be clearly stated and indications must be given as to how the measurements are to be taken. For example, the specifications may say that a sleeve length in the final product must be 24 inches long and measured from the shoulder seam's intersection with the sleeve cap to the finished hem edge along the sleeve length. To improve communication, specifications should contain graphics, pictures and symbols that can be recognized in any language. Use of international symbols and internationally accepted number systems and other forms of international standards will improve the usability of a specification.

Specifications that are in electronic form are a benefit to the consumer-centric company because of the time savings that can be achieved by sending information via email or other Internet protocols. Electronic communication is also important for autoreplenishment systems and specification buying, where the buyer may never travel to the product's source but uses the specifications as a guideline for having the manufacturer create or select products according to the specs. The use of Photoshop, PowerPoint, digital cameras, scanners, and other computer hardware and software become important skills for the product development team that creates the specifications.

The six categories or six specs cover the development and production of the product from idea to final inspection and together form a spec or specification book. This book could contain from six to an unlimited number of pages. Each specification category could cover one or several pages depending on the amount of information that is needed to cover all aspects of that category. Assembly specifications are frequently more than one page because of the detailed drawings that should be included in the specification. A few companies restrict their specifications to a total of one page. Although this may seem efficient, the result is usually an undercoverage of information, miscommunications in production, and failure to reach consumer expectations.

Each specification sheet within a book of specifications or in a stand-alone situation should have identifying information. At any time, the sheet could be removed from the book for a specific stage in the process or as is often found in the industry, various units or companies are involved at multiple stages within the process. For this reason, each page should contain complete information to identify the product and the company for the specification (see Figure 11–1).

In addition, each page should clearly state to which of the six specification categories the page belongs. This information is often clustered into a header at the top of the page; it could also be set into a block at the upper corner of a page or split between header and footer.

Kade's Kids	Design Spec
Boys will be Sports	Style # 32
Sportswear	Size 3–6

Figure 11–1
Sample header for specification sheet.

Many companies have a preset format for the specification pages, with much of the company information already printed on the page. Blocks are provided for entering the needed information about line and style. Company information would include the company name, address, contact persons, phone, fax, e-mail, and logo as found on most business correspondence. The line information includes the season for the line, the name of the line and themes as appropriate. The product information includes the style number, the product name, the gender for the user if pertinent, and the size range of the product.

Exact placement of each item on a spec page is not important—the contents of the page are important. Although format of the spec pages may change from company to company or may be driven by the PDM software, the basic contents of each spec remain the same for all companies. For the design spec, the product sketch usually occupies the most space on the page, with the fabric and trim sketches or swatches taking secondary positions. The upper right corner and lower right corner are frequently the placement locations for the product sketch; however, center of the page is preferred by some companies for the position of their sketch.

Design Specifications

The **design specification** is the introduction to the product for everyone who accesses the specification book. For this reason, the specification should contain an accurate picture of the product as well as a written description (see Figure 11–2). The picture could be a photograph of the product if the designer worked with a draped method of sample development but it is more likely a fashion sketch from the early stages of development. If the product is a reuse of a good body, the sketch could be an adjustment of a technical sketch from a CAD library. Surrounding the sketch should be notations about design details that cannot be easily determined from the sketch. Examples of notation type information could be the width of trim, the type of buttons, the placement of a yoke, or other styling details.

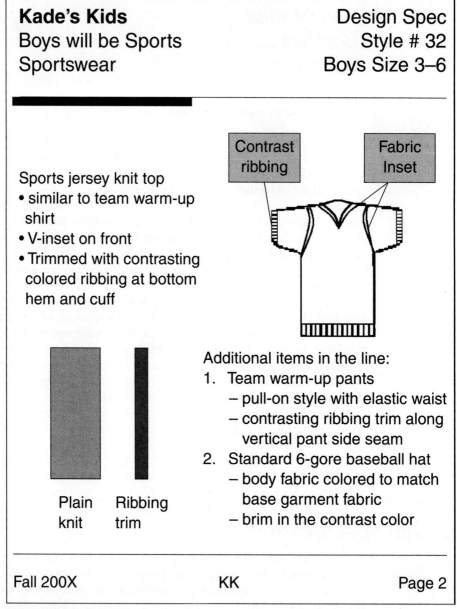

Kade's Kids
Boys will be Sports
Sportswear

Design Spec
Style # 32
Boys Size 3–6

Sports jersey knit top
• similar to team warm-up shirt
• V-inset on front
• Trimmed with contrasting colored ribbing at bottom hem and cuff

Contrast ribbing

Fabric Inset

Plain knit

Ribbing trim

Additional items in the line:
1. Team warm-up pants
 – pull-on style with elastic waist
 – contrasting ribbing trim along vertical pant side seam
2. Standard 6-gore baseball hat
 – body fabric colored to match base garment fabric
 – brim in the contrast color

Fall 200X KK Page 2

Figure 11–2
Design specification.

The design spec should also include a sample of the fabric and trim, buttons, or other findings that will be important to the style of the product. The complete findings list is included in the fabric specification. This section of the design spec is to be used for visual imaging of the product. The fabric and trim samples could be actual swatches that are neatly trimmed and glued to the spec sheet. Some sheets have a preset square left blank for the attachment of the fabric sample and needed trim samples. Fabric and trim could be represented with digital images or color printouts, depending on the availability of the swatches and the stage of sourcing for these items. The fabric could be a custom production for the product and not be available when the specification book is being developed. On the other hand, the product could have been created as an inspiration from the fabric, and sample lengths of fabric would be available to the product development team.

Other information that is needed to introduce the product is added to the design spec. For example, an explanation of companion items can be included. A short description of companion items is useful in understanding the exact style image that is to be achieved with the product and to ensure that when the products are placed in the retail selling space that they will be compatible. This situation is extremely important for products that are designed as mix and match items. A listing of previous products that this product replaces including obsolete style numbers is informative if the product is a continuation of product line. The suggested retail price and the expected wholesale price or restricted price point may be included in the design spec.

Fabric and Findings Specifications

The **fabric and findings specification** provides detailed information about the fabric used as the base or body of the product and all findings needed to complete the assembly. Sourcing information about fabric and findings should include the manufacturer and all pertinent contact information such as company name, address, phone or fax, and Web site. The information should be thorough enough so that the manufacturers of both the fabric and all findings could be accessed as needed. In addition, product names of fabric and findings and style numbers are important for tracking the raw materials.

For the fabric and fabric-like findings, the fiber content and structure should be noted (see Figure 11–3). For example, the information of 100 percent cotton in a twill weave would be written for a fabric used to make casual chino pants. The thread information should be specific as to the fiber content, structure and twist. The thread used to sew these pants might be written as 100 percent polyester staple, 2-ply, with a Z twist.

Buttons, zippers, and other closures should be detailed with exact style numbers, sourcing information, size or dimensions, and content. The purchase of these findings may be made on the basis of the specification sheet.

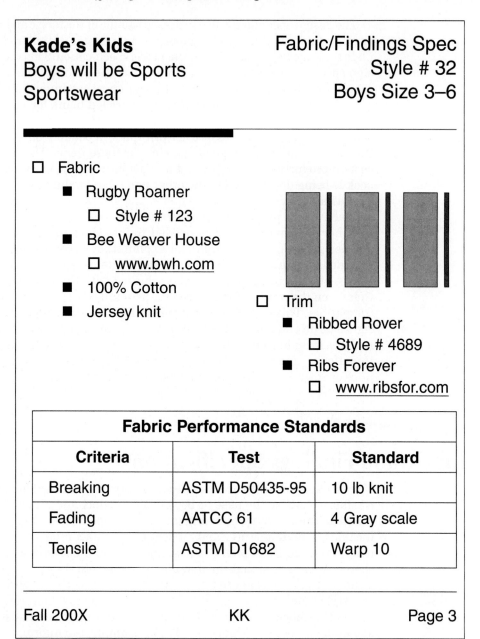

Kade's Kids
Boys will be Sports
Sportswear

Fabric/Findings Spec
Style # 32
Boys Size 3–6

☐ Fabric
- ■ Rugby Roamer
 - ☐ Style # 123
- ■ Bee Weaver House
 - ☐ www.bwh.com
- ■ 100% Cotton
- ■ Jersey knit

☐ Trim
- ■ Ribbed Rover
 - ☐ Style # 4689
- ■ Ribs Forever
 - ☐ www.ribsfor.com

Fabric Performance Standards		
Criteria	**Test**	**Standard**
Breaking	ASTM D50435-95	10 lb knit
Fading	AATCC 61	4 Gray scale
Tensile	ASTM D1682	Warp 10

Fall 200X KK Page 3

Figure 11–3
Fabric and findings specification.

This is true especially when the product development is done at one company and cut and sew operations are done at a separate contract work location. Another situation that requires great care with specifications of findings and fabric is when coordinating products or parts of products are contracted to various producers. With any products that require mix and match abilities, such as sportswear, coordinates or related separates, or bedroom or bath ensembles, the likelihood of multiple contractors is often the common practice. These contractors may not be in the same country as the product development team so the coordination of sourcing and assembly becomes critical to successful fulfillment of consumer expectations. Having the specs in a software package that can be quickly shared with trading partners will improve coordination and accuracy of the product outcomes.

Colorways are the potential color combinations found in a product or across a product line. Many companies now create a product in one main color but offer the product in an array of colors to reach a broader market. Color combinations within a product may be simply reversed in the alternative products. For example, the product may have a base fabric of pink with a yellow pattern, yellow trim, and yellow buttons. In the alternative product, the base fabric may be yellow with pink pattern and pink findings. Other color combinations may also be used with a set of products, such as red with white highlights, blue with red highlights, and green with yellow. The combinations of pink/yellow, red/white, blue/red, green/yellow, and the original pink/yellow form the colorways for the product. In general, colorways include at least three sets of colors. Many of the color-related software programs have features that allow the designer to automatically choose the reverse image for two sets of colors, such as the pink/yellow and the yellow/pink. The other choices can be manually changed in the computer sketching software or can be chosen from options that the computer functions provide. However selected, colorways, when chosen, should be shown on the fabric and findings spec.

As with the design spec, colorways samples can be shown with fabric and findings swatches, digital images of fabrics and findings, or colored pictures or blocks. Digital images may be retrieved from the Web sites of the fabric and findings sources or from CDs or other media sent to the designer or merchandiser. Fabric and findings sources could come from the retail buyer, sales representatives, or consumers, depending on the level of involvement from consumers and others into the product development process. In consumercentric product development, the consumer may suggest fabrics or provide color chips or other colored objects that are to drive the selection of the fabric and colors for the product. Actual samples of fabrics and findings are more informative than the alternative presentations, but they are not always available.

Fabrics and findings should be measured through rigorous testing procedures to assure the product development team and the manufacturer that the raw materials and the finished product will show outcomes that are expected by the consumer. Topical dimensions that will characterize the desired outcomes should be noted on the specification sheets. These are then

detailed with exact tests and desired standards for measuring and evaluating the findings, fabrics, and finished products. As presented in Chapter 2, several international organizations have established performance tests used to measure and evaluate fabric and other textile related products. The person responsible for developing the spec sheets should be certain to include all of the needed tests, their exact test numbers with associated years, if pertinent, and the standards that are expected for the outcomes. This listing is often displayed in a table and may be several pages long to include tests for fabric, findings, and finished product.

The product merchandiser cannot assume that the zipper will be strong enough because it is for a pair of little boy's jeans or that the product descriptions of "no shrinkage" will be enough information to assure that the manufacturer will automatically test fabric for shrinkage in washable curtains. Nothing can be assumed or left to chance when trying to achieve the quality product that the consumer expects. Everything must be specified and then tested and evaluated. For example, the priorities for a producer could be based on price point and productivity; whereas, the priorities for the designer and the consumer could be durability through low shrinkage and abrasion resistance.

Other important information about the raw materials for the product could include a variety of information. More fabric information may be desirable such as yarn count, yarn size, and fabric width. These notes would be necessary for marker makers in setting the width of the marker and for floor supervisors in assembly for determining needle sizes and other sewing machine adjustments. The type of dye stuff and finishes used for the fabric could be included to provide information about prewashing or other handling procedures. In addition, the grading system, the number and placement of defects, and the flagging system should be included to ensure that the fabric makes a rapid transition from the roll in the tractor trailor to the cutting table. When this information can be transmitted electronically this transition can be even faster.

Size Specifications

Size specifications include size ranges and dimensions, sample size information, and grade rules. This information is generally presented in tabular format with a table for size dimensions and a table for grade rules. In addition, figures and pattern pieces would be shown with letters or numbers corresponding to the rows in the tables. Contractors are now available to complete pattern work for design firms so that the pattern work may not be done in-house. Every possible communication tool must be used so that the measurements and pattern changes are made as accurately as possible. Measuring the product to evaluate exact dimensions for each size is an

important and critical inspection process for the outcome of the product. The exact location for the beginning and the end of each measurement must be shown.

For example, for a shoulder width (see measurement 3 in Figure 11–4), the directions could be given as measure shoulder width. This measurement could be taken starting and ending at several locations along the shoulder. Improved wording would be as follows: "The shoulder width measurement is to be taken from the arm joint of the shoulder across the back of the shoulders to the other arm joint." Even these descriptive words would be better if replaced with a diagram showing the shoulder and the area for measurement, as seen in Figure 11–4. Additional information should be given about the tools used to measure the sleeve—tape measure, fixed rule, or outline on a table.

Sizing

The size of the patterns and the associated product dimensions are relative to the dimensions or sizes of the target consumers and the design styling of the product. A system of dimensions and size ranges for a product are called the product **sizing.** In home furnishings, some products such as sheets have very clearly established sizes because they must fit on mattresses that are also clearly standardized in size. However, most sewn products for apparel items are sized dependent on the design ease and the wearing ease that are developed into the product and the company's impression of their target consumer. Initially misses' sizes in the United States were based on the age of the female and were instituted when mass production of clothing created ready-to-wear items in retail stores and through catalogs (Kim, 2001). As stated in Chapter 10, no international sizing information is currently accepted as a standard, although some older sets of measurements are generally available.

ASTM offers a sizing standard—ASTM D5219-99. In addition, an ASTM committee has recently developed ASTMD 6960, Standard Table of Body Measurements Relating to Women's Plus-Size Figure Type, Sizes 14W–32W (Textiles Committee, 2004). The ISO provides standards for product sizing, ISO 3635-1981, Size Designations of Clothes, Definitions and Body Measurement Procedures. Most information in these standards is more pertinent to the fit specification rather than the size specification because it provides data on the size or dimensions of the body and not the dimensions of a product; however, body size is an important factor in determining product size for apparel. The body dimensions plus the addition of design ease and wearing ease result in the dimensions of the apparel product.

Most sizing data in current use are based on studies done in the 1930s, 1940s and 1950s, which were created to assist catalog sales of Sears, Roebuck & Co. and Montgomery Ward (Earnest, 2005). The first study measured 15,000 subjects with 58 measurements. Women in this study did not adequately represent an "average" woman—they were primarily young, white women who lived in cities. Additional studies that used military personnel were conducted in the 1960s and 1970s (Bruner, 2004). In early 2000s,

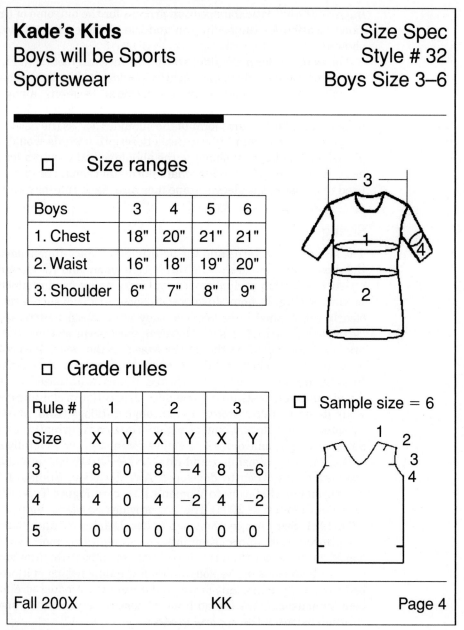

Kade's Kids
Boys will be Sports
Sportswear

Size Spec
Style # 32
Boys Size 3–6

☐ Size ranges

Boys	3	4	5	6
1. Chest	18"	20"	21"	21"
2. Waist	16"	18"	19"	20"
3. Shoulder	6"	7"	8"	9"

☐ Grade rules

Rule #	1		2		3	
Size	X	Y	X	Y	X	Y
3	8	0	8	−4	8	−6
4	4	0	4	−2	4	−2
5	0	0	0	0	0	0

☐ Sample size = 6

Fall 200X KK Page 4

Figure 11–4
Size specification.

two new studies were performed, SizeUK and SizeUSA. These studies used body scanning to collect body dimensions from thousands of subjects. The SizeUSA study scanned more than 10,000 subjects (The US National Size Survey, 2005). Data from this study are available to retailers and manufacturers, but many companies continue to use their own dimensions for size data because of their company image, product history, and target consumer research (Earnest, 2005).

In addition to selecting a sizing standard, the designer, merchandiser, and buyer must be aware that sizes and sizing systems used in various countries are not the same. When the product is a repeat product or is based on a previous product, the numbers, locations, or other file addresses for company slopers and other pattern library information can be provided to direct the evaluator to the exact company standard for a product.

Grading

Most sewn products begin as a specified sample size, which was picked by the designer or the design company relative to the range of sizes expected for the target product or consumer. The sample pattern will be created in the sample size. To move from the work of the sample-room hands to the production of the product, a **production pattern** must be created, first for the sample size, and then for all associated sizes being addressed. This process results in a complete set of patterns or **nest of graded patterns** for the product. To develop the production patterns, the sample pattern must be **graded** both up and down to achieve patterns for sizes that are larger and smaller than the sample size pattern. For some products this grading process may be simple because the company uses a small, medium, and large size for the full range of sizes; or with bed linens, the basic sizes are twin, full, queen, and king. Some products may have only one or two sizes for the product offerings. Other products such as missy clothing items may have a full set of sizes ranging from size 2 to 18 and then additional sizes in women's and petites. If the company also offers the product in juniors, additional patterns and appropriate sizing from 5 to 15 must be developed. And, the range in bed linens could be expansive and could include—beyond the basic sizes—beds in the sizes of quarter, dorm room, full/queen, and California king. A "one size fits all" sizing system is very simple for the production development team and the manufacturer but is less satisfactory for the consumer. Many consumers have come to expect choice in sizes for all consumer related products.

Grading can be done by hand but is most often done by computer with a grading software package. Regardless of method for grading, a grade rules table must first be established. A **grade rules table** contains each size and the grade points as numbered on the pattern with the amount of change needed to increase or decrease to the appointed size (see Figure 11–4). The amount of increase or decrease is given in direction of plus for increase and minus for decrease along the x-axis and y-axis, which correspond to the horizontal and vertical grain lines of the pattern. In general the vertical

grain line of the pattern is the predominate grain line and will match to the warp direction of the fabric. The x-axis corresponds then to the filling direction of the fabric. Pattern pieces with the corresponding numbers for the grade rules must also be shown in the size spec.

Cut and Sew Specifications

The **cut and sew specifications** are used during the preassembly and assembly operations in producing the product. In general, this spec sheet includes information about markers, cut order planning, and sewing requirements. The marker information may be as simple as indicating the number of the marker that is stored in the computer. Marker information may also contain information about specialized placement of patterns or lay-up of fabric as needed for plaids or other prints. Exact placement of plaids, direction of spread or lay-up of fabric, and the location of a print on the pattern piece may be provided. For example, if the broad blue stripe of a print is to run cross-wise across a yoke along the shoulder line, this information must be on the specification sheet so that the information is available to the marker maker. Prints that require exact placement on patterns must be noted and preferably illustrated. For example, the designer may want the main flower in a floral print to be positioned on a specific spot at the hip. The placement of this print with sketches and notations relative to the pattern piece help to ensure that the pattern will be cut as expected. This information must be on the cut and sew spec.

Cut order information can be placed on the cut and sew spec or may be sent directly from the planning software to the cutter. **Cut order planning** is the information about the total number of products to be cut and the ratio of products across the product sizes. This information may also include facts about cutting tables—their sizes and placement, cutting times for markers—how long it takes to cut, and cutting queue order—what markers should be cut first, second, last. General standards such as the ratio of numbers to be cut in each size, the size range, and the total cut order should be included with this spec sheet. When spec sheets are preset in a computer program, some of this information can be set to appear automatically. Even when cut order planning software is used and directly transmitted to the cut equipment, the basic details of the cut order with a visual check would be a good check and balance with the electronic transmission.

The majority of information for the cut and sew spec sheet is the detailed information about sewing the product. This information includes the stitches and seams as well as details about stitching, special assembly orders, or other specialized sewing information (see Figure 11–5). The information about stitches and seams should be given as the standard numbers and letters as written in the ASTM or ISO stitch standards. The number of rows

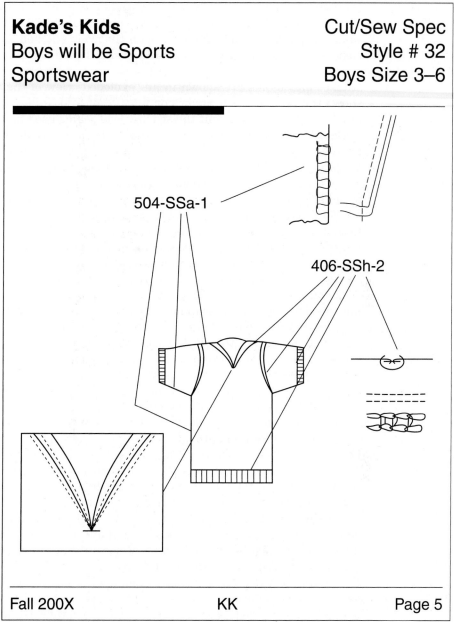

Kade's Kids Cut/Sew Spec
Boys will be Sports Style # 32
Sportswear Boys Size 3–6

504-SSa-1

406-SSh-2

Fall 200X KK Page 5

Figure 11–5
Cut and sew specification.

of stitching should also be noted. These standards are discussed in detail in Chapters 8 and 9. An example of this format would be 301-SSa-2. This seam would be a simple superimposed seam that was stitched with two rows of basic lockstitch. Inclusion of pictures or sketches of the stitches and seams would also be helpful in ensuring the accuracy of the assembly. Often the stitches and seams are shown in an "exploded" view of the product, which shows the product with arrows or lines from a location on the product to graphics or notations about the stitches and seams used for that area.

Details of sewing that are not standard or need special attention should have additional pictures, such as the top stitching that is shown for the V-shaped assembly on the front of the shirt (see picture in square in Figure 11–5) or may be highlighted on the main cut and sew spec page and shown on additional pages with more graphics or information (see Figures 11–6 and 11–7). Examples of items that are often shown in close-up views or notations are the stitching on a back pocket, the attachment of belt loops, the top stitching on collars and cuffs, embroidery or other ornamental stitching, and the intersection of seams in pant crotches and shirt underarms.

The stitches and seams should be given in standard phraseology of numbers and letters with ASTM or ISO stitch and seam information, but they may need to be shown in graphics depending on the sewing contractor. In addition to noting the numbers and letters for the stitch and seams, information about stitch length, width, encasement amount, and balance should be given. The detail could be too small in the exploded view to show clearly so that these graphics may also be shown on separate pages (see Figure 11–7). Top and bottom views of stitches and 2-D and 3-D views of seams or stitches can be shown (see Figure 11–6). When the stitch or seam is one that is not listed in the stitch standards, extra detail must be provided.

The final information provided on a cut and sew specification sheet would be the order of assembly for putting the pieces together. This order is particularly useful when the product is a new product or the contractor or the manufacturer is new to the process. By providing the order of assembly the product development team increases the chances that the product will be made similarly to the products that were made as samples. For some assembly processes, the order of product will affect the flexibility of the seams and the fit of the product. For example, sleeves that are inset into a finished bodice after being formed into tubes have improved fit over sleeves that are flat and inset into a flat and unfinished bodice. The same is true for crotch seams. Pants can be constructed in the order of front crotch, back crotch, side leg and inside leg seams or in the order of left leg, right leg, and back to front crotch seam. The order of the leg and crotch seams will affect the order of the placement of pockets and zippers and the flexibility of the crotch seam. Decisions on assembly order should be made in product development and should be controlled by the product development team to get the best fit and the desired look for the product. However, recommendations for the reordering of these decisions can be made in the production development stage in the product development process. Recommendations may be made relative

Kade's Kids Cut/Sew Spec Detail
Boys will be Sports Style # 32
Sportswear Boys Size 3–6

Stitch and Seam <u>Details</u>

401-LSc-2

Seam Cross-Section

Top View Bottom View

Fall 200X KK Page 6

Figure 11–6
Stitch/seam details.

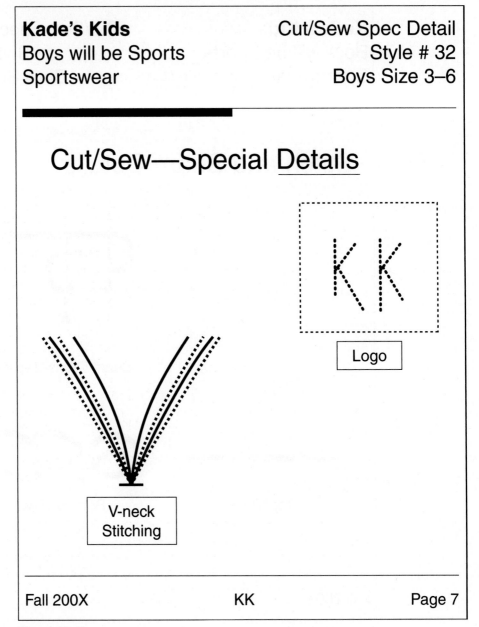

Kade's Kids Cut/Sew Spec Detail
Boys will be Sports Style # 32
Sportswear Boys Size 3–6

Cut/Sew—Special Details

Logo

V-neck
Stitching

Fall 200X KK Page 7

Figure 11–7
Stitching details.

to cost of the assembly, overall price of the product, and skill levels of the assembly operators. Negotiations on manufacturability between designers or product development managers and production engineers may be required to reconcile differences in opinion about assembly. Once the final decisions are made, the list should become part of the cut and sew specs.

Fit Specifications

The **fit specifications** include information to guide the fit approval process and to ensure that the resulting fit of the product matches the image of the product development team, the company standards for fit of the product line or brand, and the expectations of the consumer. Fit is one of the most difficult outcomes or steps within the entire product system to standardize, measure, and evaluate because fit is so individualistic to the consumer and so dependent on product type, usage, consumer age, and many other factors. Much of fit is within the perception of the user and not in the concrete measurements of the product. Companies develop entire product lines or brands with the purpose of promoting a certain fit of the product. Consumers depend on consistency of the product's fit and assume that they will get the same fit from the product when purchasing new items from the product line or brand. These fit characteristics of a product line may be very different from the fit of similar products in the same size. Fit in many cases with brands may be oversized or very tight, but the perception by the wearer is that it is "just right" because it portrays the brand's image. With these caveats, the product development team still must attempt to quantify the consumer's expectations of fit and strive to equate these to the company's standards for fit.

Fit specifications include information about the size and dimensions of the fit model, who should represent the target customer for the product (see Figure 11–8). The fit model can be named or identified through a code so that in a large company the exact person needed for the fit approval sessions can be contacted. The standard size for the sample size and the associated dimensions of the fit model are listed in a **fit dimensions table.** The dimensions of the fit model would be the body size of the model, which would vary from the dimensions of the product depending on the amount of design and wearing ease that were incorporated into the design.

The fit dimension table will be accompanied with a basic body sketch so that the location and type of measurements can be noted on the sketch. The company can use a croquis or other company sketch for the fit spec, a body scan of the fit model, or sketches and dimensions provided in ASTM D5219-99. ISO 3635-1981—Size Designation of Clothes, Definitions and Body Measurement Procedures and ISO 8559—Garment Construction and Anthropometric Surveys—Body Measurements are possible standards for

Kade's Kids
Boys will be Sports
Sportswear

<div align="right">

Fit Spec
Style # 32
Boys Size 3–6

</div>

Jeremy Dane	Size 6
1. Chest	21.3"
2. Waist	19.5"
3. Shoulder	8.5"
4. Arm scye	4.6"

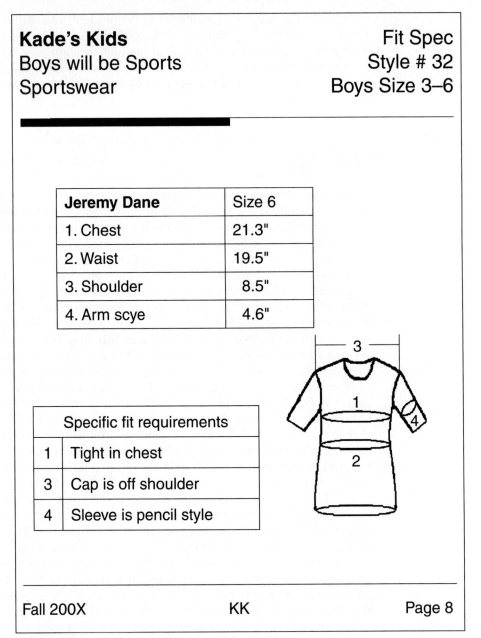

Specific fit requirements	
1	Tight in chest
3	Cap is off shoulder
4	Sleeve is pencil style

Fall 200X KK Page 8

Figure 11–8
Fit specification.

obtaining body dimension information. Additional sources of body measurements can be found in the National Bureau of Standards at the U.S. Department of Commerce; the U.S. Army Natick Army Laboratories (Natick, MA). In addition, body dimensions can be accessed from other countries such as those found at the Greek Productivity Center (Athens, Greece) and in *Hard's Yearbook for the Clothing Industry* (United Kingdom).

Body dimensions for consumers in many countries would be important for international companies or domestic companies that are shipping products overseas. Standards for women, men, boys, girls, and infants and for other products such as mattresses, towels, and other home furnishings products, are available from many of these sources. As body type, age, and size change across products, appropriate body dimensions must be used. In addition, the size of the average consumer is larger than previously known so that old standards and other data may be outdated. Additional information is now available from the SizeUK and the SizeUSA studies as discussed in the size specification section.

In addition, the fit spec should have a sketch showing the product with points for fit checks and a table with explanations of specific fit requirements or how the product should fit when used. For example, a fitted bed sheet is expected to fit close to the mattress with a minimum amount of wrinkling or bulging; whereas, the top sheet or flat sheet should fit with a set number of inches hanging on both sides of the mattress. For apparel products, body landmarks are given in ASTM D5219-99 that may assist the person writing the specifications to use terminology and locations that are accepted or recognized in the industry. The standard provides several figures with **body landmarks** and body measurements and with explanations of many of the definitions or terms that are used in measuring the body. These terms can be used in specifying size dimensions and showing or explaining how they are placed on the body or how the measurements are taken relative to the body. For the fit spec, a specific **fit requirements table** with terms and descriptions should be provided along with numbers or letters that correspond to the sketch. Every effort should be made to clarify what should be measured, where it should be measured, and how it should be measured.

When design ease is developed into the product, the fit may be altered from a standard size and shape of product. The styling of the product and the image that the designer is trying to achieve may drastically alter the traditional fit of the product. For example, low-rise jeans have crotch rise dimensions that are very different from jeans that are designed to "sit," or have a waistband to fit, at the natural waist. The check points for fit and the dimensions of the pattern and final product for low-rise jeans will be drastically different from those for standard fitting jeans. For the low-rise jean, the waist may not be of interest at all; instead fit points may be checked relative to the hip or other anatomical body location. Another area of the sewn product that is often unclear for fit is the placement of the shoulder seams and the yoke. The traditional shoulder seam lies along the

top of the shoulder from the base of the neck to the top of the arm. A dropped shoulder seam can be forward or backward from this location. The exact amount of drop may vary greatly with the design of the product. Distance from the traditional fit location should be noted. A fashion sketch may be exaggerated to highlight the design feature, but the actual seam placement may be less extended.

Final Inspection Specifications

Final inspection specifications are the final guidelines used to evaluate the product. Even in companies with the product development process governed by standards and the use of rigorous in-process inspections made relative to standards, the final inspection is critical to the success of the product. The final inspection at the plant floor may be the last check that the designer, merchandiser, or manufacturer has for the product before that product is shipped directly to the consumer with a catalog or Internet sale, or sent to the distribution center for a retailer. This inspection is the only time that the actual finished product is evaluated relative to expectations of the consumer, as interpreted in the specification. The overall look of the product and what can be seen on the outside of the product have a major impact on the salability of the product and ultimate success or profitability of the company.

The final inspection specification includes a sketch of the product, usually a flat or 2-D sketch, and the **final inspection protocol** or process (see Figure 11–9). The final inspection protocol includes the measuring information and a listing of additional tasks to be performed or checked during final inspection. As with information on the other five specification sheets, clarity, detail, and graphics are important to enable clear communication about the expectations of the inspection process.

Measurement information should include the sketch with locations for measurements and a table with measurement dimensions. As noted about other sketches and diagrams in the specification book, a sketch or product flat with clearly marked locations for measurement should be shown, labeled, and described. The descriptions in tabular form could contain only dimensions or could also contain descriptions of how and where to measure. The start and stop of the measurement and the associated tools used or recommended for measuring could be listed. Additional information about measuring was discussed in the section on size specifications. Also, measurements could be listed in both metric and English units depending on the contractor or manufacturer who will complete the assembly and final inspection.

Other inspection details in the protocol contain tasks and the procedures to perform these tasks, such as inspection of assembly processes and final

Kade's Kids
Boys will be Sports
Sportswear

Final Inspection Spec
Style # 32
Boys Size 6–10

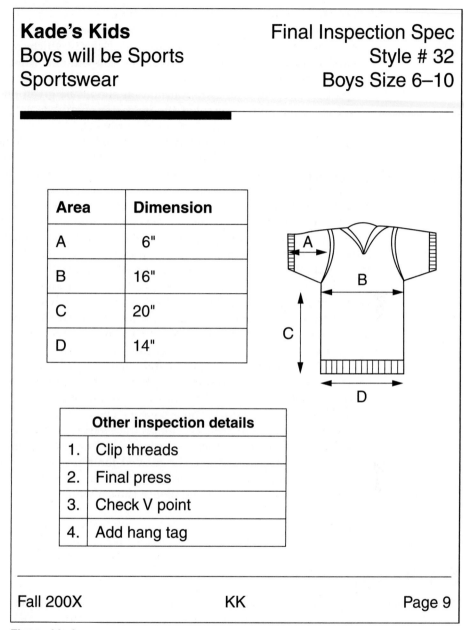

Area	Dimension
A	6"
B	16"
C	20"
D	14"

Other inspection details	
1.	Clip threads
2.	Final press
3.	Check V point
4.	Add hang tag

Fall 200X KK Page 9

Figure 11–9
Final inspection specification.

preparation for leaving the sewing plant. While inspecting the results of the assembly processes, final inspection personnel may clip threads, press or steam the product, and add hang tags. Exactly which threads should be clipped, to what length they should be clipped, and where and how the hang tags should be placed are important details to include in the final inspection spec. In addition, information should be given on how to mark defects when found and what the inspector should do with the product if defects are found. The product could be repaired or assigned to storage for seconds or thirds. What constitutes a second or third must be clearly communicated. Pictures of defects or written descriptions are needed, and the summation or totality of the defects per product for the item to be classified as other than a first must be described or shown.

The final tasks that must be specified for performance in final inspection are the folding or hanging, packaging, and shipping. For sewn products, the choices may vary from folded and multistacked into a large cardboard carton, which may or may not be lined with plastic, to being placed individually on a hanger and covered with a plastic wrap. Other products may need to be bubble wrapped, stuffed with tissue paper, cradled with spongy packing materials, or otherwise stabilized within a box. The retail customer may supply specialty hangers or request that the manufacturer purchase and use hangers that match a specification, including the placement of a logo or color scheme on the hanger. Plastic wrap comes in various widths, thicknesses, colors and lengths. These details must be specified or left to the discretion of the manufacturer. When not specified, the lowest cost materials will probably be used in order to reduce the production costs of the product. The producers' choice of materials and processes may or may not ensure that the product arrives fresh, wrinkle free, and undamaged to the customer or consumer. For catalog and Internet customers, the packaging may be needed for reuse in returning products. Boxes and materials that are convertible to resending the product will speed the return process and please the consumer.

Key Terms

Body landmarks	Fit requirements table	Size specifications
Colorways	Fit specifications	Sizing
Cut and sew specifications	Grade rules table	Specification
Cut order planning	Graded	Specification book
Design specifications	Grading	Specification buying
Fabric and findings specifications	Nest of graded patterns	Specs
	Product data management (PDM)	Stock-keeping unit (SKU)
Final inspection protocol		Style number
Final inspection specifications	Production pattern	
Fit dimensions table	Set of specifications	

Review Questions

1. What are the four steps of the quality analysis process and where do specifications fit within this process?
2. What skills and knowledge are needed for writing specifications? What are several challenges that make writing a specification difficult?
3. What is a specification? And which specifications are covered in the specification book?
4. Why would a retail buyer need to know about specifications?
5. Who writes the specifications? Why?
6. What are the desired characteristics of a good specification?
7. Why is a visual specification important today?
8. What information should be on each page of a specification sheet? Why?
9. What information should be on a design spec sheet?
10. Why would a design spec include only a digital image of a fabric and not the actual swatch?
11. Why are other items in a product line included on a design spec for a specific product?
12. What information should be included on a fabric and findings specification?
13. What test specifications should be included in the fabric and findings spec?
14. Where can the spec writer find information to help develop the size specification?
15. Why are new standards needed for sizing?
16. Why would a company choose to use its own sizing information rather than change to a national or international sizing standard?
17. What is the standard sample size? Explain why this is not the same size for all products.
18. How and why is a pattern graded from the sample size to the full size range needed for making all product sizes?
19. What are grade rules?
20. How are grade rules linked to the pattern pieces?
21. What is included on the cut and sew specification pages?
22. What is cut order planning?
23. Why are the stitch standards useful in developing cut and sew specs?
24. What aspects of a product might be covered with additional pages in the cut and sew spec?
25. Why is order of assembly important?
26. What information is provided on a fit specification sheet?
27. What standards are available to help write the fit spec?
28. How do the changing body dimensions of the world's population affect fit specifications?
29. What affect does design ease have on the information in the fit spec?
30. What information should be included on the final inspection specification sheets?
31. What is the final inspection protocol?
32. What choices can be made in final inspection? How are these decisions made?

References

Earnest, L. (2005, May 1). What's with women's clothing sizes? Industry balks at uniform standards, *Los Angles Times* [Online version]. Available from http://www.latimes.com

Kim, J.-H. (2001, May 30). Downsizing figures, *Chicago Sun-Times* [Online version]. Available from http://jaehakim.com/articles/misc/features/sizes.htm

King, K. M., and D. Bruner. (2003, November). The sizing of America, *AATCC Review,* pp. 7–9.

The National Size Survey. (2005). SizeUSA. [TC]². Available from http://www.tc2.com/what/sizeusa/index.html

Tait, N. (2001, November). CAD, PDM technology at turning point. *Bobbin,* pp. 27–30, 32.

Textiles committee completes standards plus sizes for women. (2004, April). *ASTM Standardization News,* 17.

Basic Tools for Performing Quality Analysis

Quality Analysts use numerous tools from mathematics, statistics, and other fields when evaluating raw materials, products, services, for determining level of quality and for maintaining the desired quality within business practices. These tools aid the Analyst in determining whether the features of a product or service are equal to the requirements needed or desired for that product or service. The tools provide Analysts with ways to measure and evaluate various aspects of any product, service, or process. To use the tools effectively, the analyst must have previously determined what specifications, standards, or other benchmarks are to be used for comparison with the results of the measurements. Common tools used in quality analysis include the following: mathematical calculations; visual models or charts, graphs, and other diagrams or models; and some activities that are broad enough to be considered processes.

These tools are used to obtain, organize, and present data so that the information may be shared with others within the quality team, across departments within companies, or with partners within or across industries. Communication of specifications and the conformance or nonconformance of a product to these specifications is critical for success in a global marketplace. The process of production and distribution includes various steps, which for one product may be performed by several companies, located in more than one country, and may require input from multiple employees

within each of the companies. With all of these channels, connections, and inherent barriers, clear communication becomes a vital factor in the development and delivery of a satisfactory product. Many of the tools provide graphic or visual communication of the process data, transcending languages, and are, thereby, extremely useful in a cross-cultural marketplace. Other tools, used as part of numerous quality procedures, quality practices, and more general operational philosophies may be incorporated into the activities within an entire organizational structure of a company or across a distribution channel.

Overview of the Quality Analysis Process and the Use of Tools

As introduced in Chapter 1, the four step quality analysis process uses the following activities: (1) expectations are determined on the basis of information about target customer preferences; (2) with these established expectations, standards are set and interpreted into specifications, products or services are produced, samples are drawn, and data are collected; (3) measurements are made from the data drawn from the processes and/or from the final product or service; and (4) data are evaluated by comparing results of the measurements to the known specifications. This four step process follows the basic scientific principles of setting objectives, obtaining results, and evaluating the results relative to the objectives. Measuring any of the physical properties of raw materials or a finished product can produce usable data for comparison with specifications. For example, fabric can be measured for tensile strength, weight, and fiber content. Some aesthetic or functional properties can also be measured. Perceptions of fit, hand of fabric, and variables such as allure of a color combination or softness of a silhouette may be difficult to measure in concrete terms.

Accuracy of some measures can be held specific to very minute measures, whereas others must be stated in more general terms or expressed in pictures or qualitative expresses. Consumer expectations are not often expressed or reported in such detail. For this reason, the direct correlation between measures from data collection and actual consumer perceptions may include much variance, especially when measuring features other than the measurement and comparison of physical properties. However, every attempt should be made to quantify, measure, and match the expectations of the purchasing customer.

The samples and resulting data should be collected and measured through an approved process, often called **the method** or the **test method.** The data collection processes for many of the tests used in textiles, findings,

apparel, and other sewn products are delineated in the test manuals for the American Association of Textile Chemists and Colorists (AATCC) or the American Standards for Testing and Measurement (ASTM). The test descriptions can be obtained in both printed and electronic forms. The U.S. government has some data collection methods in product-specific federal standards that must be used when producing products for the military or for other government uses. Other tests with associated data collection and test methods can also be obtained through the International Standards Organization (ISO). In addition, data may be collected according to approved company methods or quality related procedures.

Any data that can be collected can be measured and evaluated. Sampling and measuring or data collection will result in a data set. The **data set** is composed of data points. Each **data point** represents one measurement from the data collection process. For example, nineteen squares of fabric at a specified size were cut from a piece of fabric according to a standardized test method. Each sample was weighted and the weight was recorded. The results of the tests are the nineteen weights, one from each sample. A data set, from the measurements of fabric samples when tested for weight, is shown in Table 12–1.

Selection of the samples from which the Analyst will collect the data should be done according to the method, which often indicates the use of a random process. **Random process** in this situation does not mean acting without a plan but does mean performing the data collection according to some method that will not introduce bias. Bias may be introduced from data that were collected as the first items, as the last items, or as some other systematic method. The selection often represents about 10 percent of the entire product, time span, or other aspect of a service or process. For the sample to be collected randomly, the collection will be based on a random number system or some computer-generated draw pattern. The samples may be collected on a periodic basis such as every tenth roll of fabric or one yard every ten yards. This method is called **stratified random.** Once the sewn product, fabrics, findings, or processes are determined and the samples from these are collected or drawn from the lot, tests may be run to generate data for the evaluation. For example, fabric weight can be collected from various rolls of fabric or the length of a sleeve

Table 12–1
Data from Measurement of Fabric Weight in Ounces

Data Points
2.00, 2.00
4.00, 4.00, 4.00
5.00, 5.00, 5.00, 5.00, 5.00, 5.00
8.00
9.00, 9.00, 9.00, 9.00
10.00, 10.00, 10.00

can be measured from a random selection of shirts from various production lines. In addition, data can be collected from production processes including data about the machines, other equipment, delivery times, length of process, and employee actions.

Basic Mathematical Tools— Mathematical Calculations

After data are collected and the tests are run or measurements are taken, an assortment of mathematical tests can be performed to provide information for evaluating the product or service. A variety of mathematical symbols are commonly used in the directions of the test methods or quality processes (see Table 12–2).

Initially, data, such as that represented in Table 12–1, can be analyzed to determine basic or descriptive characteristics of the data. These analyses are called descriptive statistics because their results describe the data. For example, the simple features of frequencies, averages, and deviation can be determined. **Frequency** of data is a count of how many of any one data point appear in the data set. In Table 12–1, the frequency of the data point 5 is 6, meaning that the data point of 5 appears 6 times in the data set. The frequency of the data point 3 is 0, meaning that the data point of 3 does not exist in the set. The **range** is another measure that can be used to express characteristics of the data. The range is calculated as the difference between the highest value of the data set and the lowest value of the set and is a representation of the variance or differences in the data. In Table 12–1, the range is 8, calculated by the difference between 10 and 2.

Averages can be measured with the following mathematical calculations: the mode, the median and the mean. The **mode** for a data set is the

Table 12–2
Symbols Used for Mathematical Calculations for Quality Analysis

Symbol	Meaning
Σ	sum
\bar{x}	x-bar (average of sample)
$\bar{\bar{x}}$	double x-bar (average of population)
r	range (high—low)
N	number in population (capital).
n	number in the sample (lower case)
σ	sigma, used for variance or standard deviation

most frequent response within the data. This point could be anywhere within the data: near the middle of the data or near either end of the data. Placement along the continuum of the data is not a measure of mode but rather the frequency of the data is the measure. To determine the mode, frequency must be noted for each data point. The data point with the highest frequency, or that which occurs most often, is the mode. If the data point of 5 appears 6 times and that is the highest frequency for any data point, the data point of 5 is the mode. This statistic could be important when examining numbers of defects, productivity of an operator, sell-thru of products, and other situations in which the Analyst wants to know the best, most, or other frequency related responses.

The **median** is the middle point of the data and is the point that is equidistant from the highest point and the lowest point of the data. Summing the highest and lowest data points and dividing by 2 can calculate this average. In Table 12–2, the highest data point is 10 and the lowest is 2, making the median 6. The calculation may not have resulted in a data point that appears in the data set, but it is still the median point.

The **mean** for any data set is the mathematical average of that data. The value of each data point is summed, and the summation total is divided by the number of data points. The formula for finding mean is as follows:

$$m = (\Sigma\, x_i)/n.$$

In this formula, m represents the mean, and the symbol Σ tells the Analyst to sum. The x_i indicates each data point in the set. The small n equals the number of data points in the data set. The sum of the data in Table 12–1 is 120, and 19 data points are in this data set. The mean is calculated by summing all data points and dividing by the number of points. In Table 12–2, the mathematical average is 6.42 (rounded to two decimal places). Decisions on the number of decimal places reported in data sets and in company reports are standardized and are often related to the number of significant numbers used in the reporting of the data in the data collection process. General scientific procedures may prevail or company policies may be implemented for decisions on number of decimal places in reporting data.

Although this result does not appear in the actual data, the mean is 6.42. The mode, median and mean in the data are similar but are not equal for the data set in Table 12–1. This finding is frequently the result, and in some situations, the mode, median, and mean may vary greatly from each other, depending on the disbursement or spread of the data.

The **standard deviation** or **sigma** is a mathematical measure, used as a tool, that expresses the way the data are spread around the mean. This measurement is another way to express the **variance** in the data or differences between the data points and the average. If the data points are all similar to the mean, then the standard deviation will be small. If the standard deviation is large, this finding is an indication that the data are spread widely or distantly around the mean. The standard deviation is a measure that is used to help the Analyst examine the data. When the standard deviation

is calculated, the Analyst examines the distance that each data point lies from the mean. Standard deviation can be used as a measure of how well the product is matching the expectations of the consumer. When a standard deviation is high, the match between the outcome of the tests and the expected outcome set by the consumer will be low. The consumer who receives a product that contains high levels of standard deviation on many measures probably will not be satisfied because this product will not represent a quality product to the consumer. This measure will be used in Chapter 13 in the discussion of the statistical process control tool.

Visual Representation Tools

In addition to or in conjunction with mathematical calculations, the data may be visually represented in graphs, charts, and various other diagrams and models. For some people, the visual representation is more meaningful than the mathematical numbers. Either can be transmitted electronically, precluding the need for textual explanations because formulas and visual modeling methods are rather standard across languages.

Histograms

The simplest of visual models drawn from a data set is the histogram. The **histogram** is a bar graph of the frequencies for a data set (see Figure 12–1).

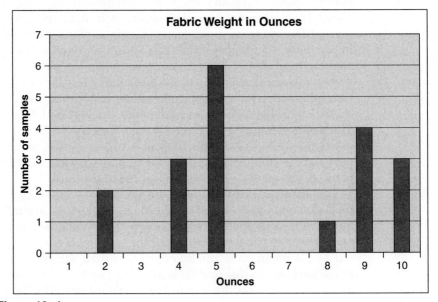

Figure 12–1
Bar graph of fabric weight.

The **x-axis** of the graph contains a scale of the data. For example, a bar graph for the data in Table 12–1 would have the points of 1 to 10 ounces. The **y-axis** of the graph is a count of the number of points for each of the possible values from the measurement. Each axis is labeled so that the reader will know the measure and the value for the axis. The number of samples can also be called the frequency. In addition, the chart or graph should have an overall title to readily explain the content of the figure.

Pareto Charts

Pareto charts are a specific type of histogram (see Figure 12–2). The unique feature of the Pareto chart is that the data points are organized from the most frequent to the least frequent or vice versa. The data is thereby organized in descending or ascending order. The choice of ascending or descending is left to the developer of the chart and should reflect the contextual information in the chart. For example, a chart that is made to show numbers of defects might have the defect with the highest occurrence listed first to highlight this problem. A chart showing the amount of production from each operator in a plant might be arranged with the lowest amount to the highest amount to show productivity. The visual representation of the Pareto analysis helps the Quality Analyst determine what is the most important idea, point, or feature within a set of data. The charts are often used when analyzing problems. The frequency for the occurrence of each type of problem is counted. Then the problem that occurs most frequently will appear at the extreme left or right of the chart. This problem can be addressed first in a preventive process.

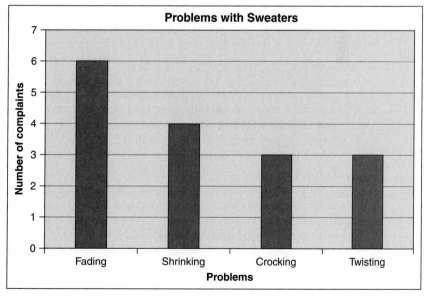

Figure 12–2
Pareto chart.

Figure 12–3
Trimodal distribution curve.

Distribution Curves

Distribution curves plot the data in a method similar to the bar graph but smoothes the data. The distribution curve for the data in Table 12–2 is shown in Figure 12–3. A line graph is used for a distribution curve, and the smoothing of the data adjusts for potentially missing data in the graph, or is created by using a large number of data points from a large sample or an entire population. The distribution curve in Figure 12–3 has an irregular shape and is **trimodal,** meaning that it has three major peaks or modes. **Bimodal** distribution curves would have two major peaks, where the data points increased and decreased twice. Although only one primary mode was expected, the value for 9 is a secondary mode. The third mode appearing at 2 ounces is more minor but may also have an important meaning when interpreting the data. A distribution with multiple modes may indicate that another intervening factor is affecting the data beyond the intended actions.

Most researchers and students have used distribution curves in school or other applications. People are usually familiar with the normal distribution curve or the "bell" curve. This curve has the peak or mode of the curve in the center of the distribution with equal and descending amounts on both sides of mode.

For the **normal distribution** curve, the mode, median, and mean are all equal. When the curve represents average populations or average data, the center portion of the curve represents about 68 percent of the data. The outlying data points are further from the mean. When combined with the concept of standard deviations (or measurement from the mean), two standard

Figure 12–4
Negatively skewed distribution.

deviations from both sides of the mean encompass over 95 percent of the data points. When considering data on either side of the mean or any other data point, the phrase "plus or minus," which is represented by the symbol "±," is used. Three standard deviations ± from the mean includes over 99 percent of all the data in the set. Other shapes of distribution curves are commonly found and reported in quality analysis.

Data, which have some repetition or other abnormality, may be **skewed** to the right or to the left (see Figures 12–4 and 12–5). Skewed data have distribution curves with exceptionally long tails. Skewed data generally indicate that some problem or abnormality exists within the process, in the perception of the evaluator, or in the data collection process; however, some skewed data may be normal. For example, data from tests of abrasion resistance on fabric destined for luggage should be skewed to the higher end of the scale because this application needs an extremely high-abrasion resistance fabric.

Scattergrams

Scattergrams are another technique used to plot or visually represent the data. **Scattergrams** are also called scatter plots or scatter diagrams. The graphing technique of the scattergram is useful when two variables are examined at the same time. The two variables may or may not have direct or indirect correlations. For example, the price of sweaters are examined for correlation with the amount of cashmere in each sweater. This situation, as represented in Figure 12–6, contains the two variables: the price

Figure 12–5
Positively skewed distribution.

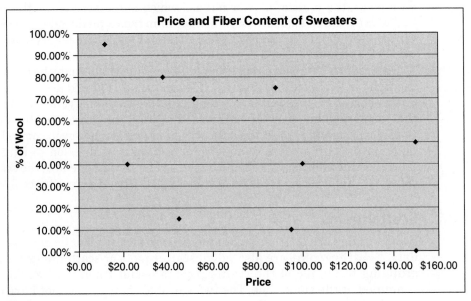

Figure 12–6
Scattergram with no correlation.

of the sweater and the amount or percentage of cashmere in the sweater. The prices of the sweaters are plotted along the x-axis, and the percentage of cashmere in the fiber content for the sweaters is plotted along the y-axis.

Cashmere is a more expensive fiber than acrylic, which is in the blend for the sweaters. For this reason, one would expect that the sweaters containing a higher percentage of cashmere would be more expensive in price. In other words, one would expect these two variables to be directly correlated; however, when tested, the results appeared as noted in Figure 12–6. The scattergram displays data points which appear to be randomly plotted across the graph. In more technical words, this scattergram shows limited to no correlation between the two variables. A cause of this finding may be an intervention of other variables. For example, if some of the sweaters were a well-known brand, the cost of some sweaters might be reflective of the brand and not of the fiber content. Additional ornamentation, country of origin, or fashionality of the sweaters also might be affecting or controlling the price.

When a correlation exists, the data appear to be plotted along and around an imaginary diagonal line. A **positive correlation** or direct correlation shows that as one variable increases so does the other (see Figure 12–7). This test result could come when all other factors are held constant and the only variables are the price and fiber content. For example, all the comparison sweaters were similar in store brands and basic color, and only varied

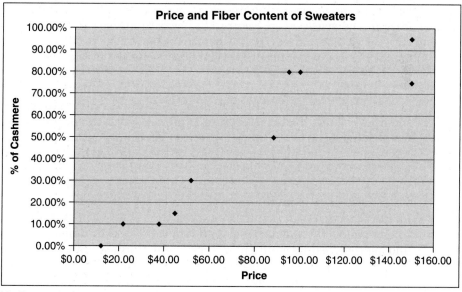

Figure 12–7
Scattergram with positive correlation.

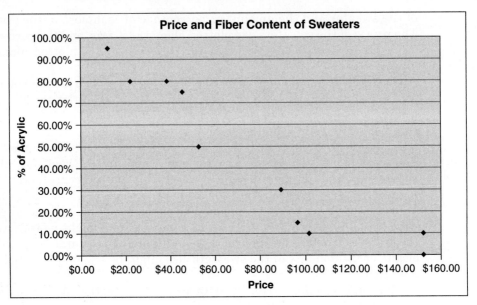

Figure 12–8
Scattergram with negative correlation.

in fiber content, which was directly related to the cost. A **negative correlation** or indirect correlation shows that as one variable increases the other variable decreases (see Figure 12–8). For example, the content of the other fiber in the sweaters in Figure 12–7 was analyzed. The cashmere in the tested sweaters varied from 0 percent other fibers to almost 100 percent acrylic. As the percentage of acrylic fiber increased in the fiber content, the price of the sweaters decreased.

In addition to observing the relationship as plotted on the graph, a mathematical analysis can be done to measure the strength or amount of the relationship. The scattergram is often used with additional statistics for plotting data to evaluate a process. With inferential statistics, linear regression can be used for analysis of the relationship between the two variables. Numerical values can be calculated to show the amount of correlation and to determine the statistical significance of this correlation. With these additional findings, the Analyst must observe the plot and examine the statistical results in view of the target customer's expectations to determine the meaningful significance of the findings. Mathematical and plotted results may show significant findings, but the findings are only meaningful when observed relative to the customer's expectations. For example, the fiber content may be directly related to the price, but if fashion, and not price, is the most important variable, the findings may have no significant meaning relative to the customer's expectations of the product.

Models

Models or other visual representations of data and relationships can be built with other purposes besides displaying the results of mathematical calculations (i.e. graphs or charts). **Models** can be used to represent visual images of processes or other forms of analysis. The determination of what processes to document is a company decision and is often part of an overall quality plan. Companies may use models to aid in decision making, to document processes, to provide evidence for quality analysis and evaluation, and to represent the results of the quality analysis steps. For example, companies that use Total Quality Management (TQM) or other quality strategies and philosophies may find that many processes, both production-related and organizational, are in need of documentation. Documenting a process is important before the process can be analyzed for changes, improvements, and potential problems or rewards. Documenting and modeling a process is part of the measurement step in quality analysis.

Process Flow Diagram

The **process flow diagram** is a visual model used to document the steps in a process and to show the direction of the movement within the process from beginning to end (see Figure 12–9). The process flow diagram shows a series of steps starting with the initiation of the process to the final or concluding step. Text boxes are used to represent and name the steps of the process. Arrows are used to show direction of the flow as one step leads to the next step. The flow can include a loop, where the process steps return to an earlier step, or a reverse, where one step repeats a previous step. Decision points within the process are shown with diamonds and arrows leading from two or more sides of the diamond to show the outcome of the decision.

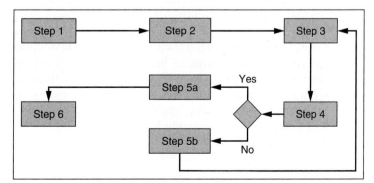

Figure 12–9
Process flow chart.

For the use in quality processes, the decision points are often placed when the step or activity is an inspection. If the product meets the specifications dictated by the consumer's expectations, the result of the decision is a "yes." If the product does not meet the specifications, the result is "no," and the product or part of the product must be returned to previous steps to be removed and reworked. In-process inspection could prevent the completion of the product and the waste of labor and raw materials when an error has been created. Using process flow models, a plant manager or other personnel can consider the best locations for placing decision points or in-process inspections.

To create a process flow chart, an Analyst must first study the process. To complete a flow chart, the observer must identify each step that is done to complete the analyzed task. If the Analyst is documenting the production of a sewn product, he or she must go onto the plant floor. If the Analyst is examining the customer service capabilities of the company, he or she might listen to taped conversations between customer service representatives and customers. The order of the current process must be affixed before any changes can be recommended. Not only production processes but also the flow of business processes and every day activities can be documented with a process flow chart. Each stage of the product life cycle could be documented from idea to sourcing of raw materials, through production of the product, to distribution and sale of the finished product.

To evaluate the process of inserting a zipper into a cushion or pillow, time would be spent in the production facility observing the operation or set of operations. The Analyst would record the movements of the operator, the flow of materials into the operation and out of the operation, and the equipment used for each step as well as the activities completed from when the operator first picked up the fabric to the exit of the finished zipper application. The list from observing the sewing operation would begin as follows: pick up top fabric of cushion, place fabric under machine foot, select zipper tape, and place tape one-half inch from needle and align along cut edge of fabric. Using a variety of print fabrics, the operator must select and check the appropriate color of the zipper; therefore, the decision point is a double check on the color of the zipper. With information about this sewing process and an in-process inspection point, a diagram such as the one in Figure 12–10 could be created.

For a good flow chart, each step of the operation must be identified and named. The steps should be relatively small increments of work or should represent one finite activity or one person within a total process. If the content of one step is too large, an important task or detail may be masked. If the steps are too small, the flow chart has too much detail, which results in an unwieldy and unusable chart.

Fishbone Chart

Another visual model that is used in analysis is the fishbone chart. The **fishbone chart** is used to model a "total picture" of a situation, a process, a

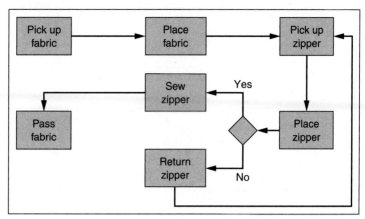

Figure 12–10
Process flow diagram of a zipper application.

product, or some service (see Figure 12–11). The chart contains the components of the situation or product. The model does not show process or flow but rather identifies all information about a situation or product. This model may be called a **cause and effect diagram** when used to determine the reasons, issues, and activities associated with an unwanted outcome (or problem). The fishbone chart is so called because it resembles the skeleton or bones of a fish, including a box for the head area that displays the situation, goal, or problem that is being studied.

In each component box, the Analyst should place the heading or identifying label for a related group of information. For example, if the goal is a pair of shoes, the components could be raw materials, design, production, and distribution. The box at the head of the fish would contain the goal—a quality shoe. Each box along the spine would contain aspects of the product

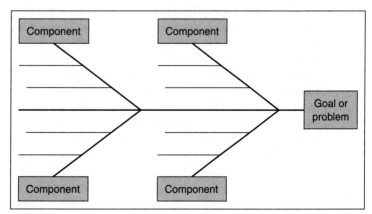

Figure 12–11
Fishbone chart.

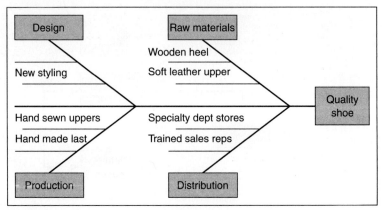

Figure 12–12
Fishbone for development of a quality leather shoe.

or the process that should be considered (see Figure 12–12). Along the individual small bones for each component there would be a listing of the individual items within each component. For the pair of shoes, the raw materials might include the following listing: soft leather for the uppers, the manmade insoles, the heavier leather for the soles, and the fabric lining of the toe box. Each item in the raw materials component would be listed on a separate little bone or line along the raw materials bone.

Checksheets

Checksheets are also used for quality analysis. Checksheets are good tools when performing a final inspection. On the **checksheet** or rubric, the Analyst itemizes, in detail, the points that are to be considered in the inspection. Again this tool can be used for products, processes, or services, during both in-process inspection and final inspection.

For analysis of the customer service process, the checksheet could include a list of items that should be covered or used when completing a customer service call. In this analysis, the checksheet would cover all the items that should be said to the customer such as the following aspects: the greeting, asking for background information, determining the problem, and a final closing. The company may specify that each of these items must be covered with every service call. An inspector should observe employees handling service calls and use the checksheet to ensure that each item was stated in the call. The overall quality of the call could be observed, and further items such as warmth of greeting, calling the customer by name, and politeness in responding could be checked. Everything to be checked should appear in the

Table 12–3
Checksheet

Item-Tasks	Well Done 3	Average 2	Poorly Performed 1	Missing 0
Greeting				
Asking for background information				
Determining problem				
Final closing				

listing. A grid or some scale for evaluating the item should also be shown. Again, standards or specifications specific for the situation and/or the company must be determined ahead of the measurement and evaluation process. A checksheet for this situation would appear as shown in Table 12–3.

The checksheet is also used for final inspection of a sewn product. Whatever is required in final inspection would be listed on the checksheet. A checksheet or list would be needed to guide the inspector for all the items to be checked. The item should have been checked in-process as part of a quality management procedure; however, one final overview inspection is also useful to ensure a quality product. At the end of the production process, as the sewn product is steamed and prepared for packaging, the item can be checked one more time for its comparison to the standard. Clipping threads, attaching hang tags, and other customer-required services may also be performed at this time and would be itemized on the final checksheet or inspection task list. Sometimes the scale is a simple *yes* or *no*. Either the product matches the standard or it is rejected. In that situation, the checksheet might have only two columns on the grid and would be similar to the checksheet in Table 12–4.

A check for size measurements may also be used at final inspection. Such a sheet would contain a listing of the sizes of the products (e.g., small, medium, large) and the dimensions for specific areas within the product (e.g., length, width). A grid or checksheet would be used to ensure that each measurement is checked and noted as correct or incorrect. A range of acceptable variables may be listed. A length that should be 11″ may be listed as 11″ ± 1/4″. A seam that was 10 3/4″ would be acceptable as well as a seam

Table 12–4 Checksheet for Final Inspection

Characteristics	Yes	No
Wrinkle free	✓	
Hang tag Other		✓

that was 11 1/4″. A seam that was 10 1/2″ would be unacceptable. Diagrams or outlines of the product could also be used in conjunction with the checksheets for faster measurement of dimensions.

Other Tools

Other tools used in quality analysis are more complex and actually become merged with, or an outgrowth of, a complete process or philosophy of quality management. Total Quality Management (TQM) is such a philosophy (see TQM in Chapter 1). Within the application of TQM are processes and activities that assist the Analyst in determining the final quality evaluation of the product (Pyzdek, 1991). Six Sigma and 5S are also quality philosophies that contain processes and activity-specific tasks that can be used in developing, maintaining and evaluating quality in a product, a process, a company or a business partnership (see Chapter 1; Benbow, 2004; Bullington, 2003; Smith, 2001).

Less encompassing processes that can be used in quality analysis are the **Voice of the Consumer (or Customer; VOC), nominal group techniques (NGT), House of Quality,** and statistical process control (SPC; Hauser, 1988; Kendall, 2005). These processes contain information on ways to collect and analyze data and for this reason are more than basic mathematical or analytical tools. VOC, NGT, and House of Quality involve collection of data from consumers about their expectations for a product or their perceptions of a product. The collected data are qualitative, meaning that they are measured with words or pictures with limited numeric or counting measurements. These tools include instructions for the Analyst on ways to evaluate and use this type of data. Often the qualitative data are very important when measuring aspects of sewn products, including fashionality, that are difficult to quantify. These tools are used in product development or in product revision when consumer input is important in defining the components and outcomes of the product. SPC is a process that concludes in quantitative data and also involves specific processes and techniques for analysis and use of the data. SPC and its application and interpretation are discussed in detail in Chapter 13.

All of the quality analysis tools are used to help the Analyst determine whether the product or service is resulting in a quality outcome. The tools help in the evaluation step of the quality analysis process. With visual and mathematical representations of the data the comparison to standards can be readily viewed. If the data appear to result in values below those expected for specifications, then dissatisfaction can occur when the customer receives or uses the product or service. Values above expectation or specifications may also result in a negative or dissatisfactory outcome. Fabric that is too

heavy for the intended use would have values higher than the specifications. More of something is often considered to be better than less of something; however, this old adage is often not true when evaluating quality. For example, more weight in fabric when the sewing machines are set for a specific (and lesser) weight could cause needle breaks, skipped stitches, or puckers. If the design depends on a set weight for the correct hand and drape of the product, and the fabric has less weight than specified, the lighter weight of the fabric could be a problem, causing puckering, ripping, or other product failure. When the comparison to the standard results in sameness and the data reveal values equal to the expectations, the Analyst has some confidence that the product or service is meeting the expectations of the customer or conforms to requirements.

Key Terms

Averages	Median	Sigma
Bimodal	Mode	Skewed
Cause and effect diagram	Models	Standard deviation
Checksheet	Negative correlation	Stratified random
Data point	Nominal group techniques (NGT)	Test method
Data set	Normal distribution	The method
Distribution curves	Pareto charts	Trimodal
Fishbone chart	Positive correlation	Variance
Frequency	Process flow diagram	Voice of the Consumer
Histogram	Random process	Voice of the Customer (VOC)
House of Quality	Range	x-axis
Mean	Scattergram	y-axis

Review Questions

1. What are the basic tools that can be used for performing a quality analysis?
2. At what stage in the quality analysis process are mathematical tools needed?
3. What is the best process for data collection? Why is this important?
4. What is the symbol for summing the data?
5. What are some descriptive statistics used to characterize a data set? How are these calculated?
6. What does X_i mean in a formula? If the data set has 100 pieces of data, what is the value of the "i"?
7. What is a data set?
8. Why is mode an important concept for quality analysis?
9. How is standard deviation related to consumer satisfaction?
10. What is a histogram?
11. What is the order of the data on the *x*-axis of a histogram?

12. What is a Pareto chart?
13. Why would Pareto charts be particularly useful in a company that uses TQM?
14. What is the average shape of data in a normal distribution curve?
15. What does the Analyst know about the data that is in the "tail" of the distribution curve?
16. What is known about the measures of average in a normal distribution?
17. How much of the data is represented between the points of plus and minus two standard deviations from the mean in a normal distribution?
18. Describe a distribution curve with a negative distribution.
19. What is a scattergram?
20. How can the scattergram be used in quality analysis?
21. Describe the distribution of data when a scattergram plot shows a correlation.
22. What is a process flow diagram?

23. How can the quality of a product be improved by using a process flow model?
24. How is a decision point shown in a process flow model?
25. What is a fishbone chart?
26. How is the fishbone different from a flow model?
27. How might a product development team use a fishbone chart?
28. What is the format and content of a checksheet?
29. What specification sheets use checksheets?
30. How do any of the basic quality tools help someone in the sewn products industry get a product that is more satisfactory to the consumer?
31. Why are tools that result in qualitative data useful in determining sewn product quality?
32. Compare the use of SPC with House of Quality or VOC.

References

Benbow, D. W. and T. M. Kubiak. (2004). *The certified six sigma black belt handbook* [Online]; Milwaukee, WI: ASQ Quality Press. Available from www.asq.org

Bullington, K. E. (2003, January). 5S for suppliers. *Quality Progress*. [Online version]. Available from www.asq.org

Hauser, J. R. and D. Clausing. (1988, May–June). The house of quality. *Harvard Business Review*, 66 (3) 63–72.

Kendal, K. (2005). Selective listening: How Voice of the Customer (VOC) approaches musts change along the organizational life cycle. Retrieved April 4, 2005, from www.asq.org

Pyzdek, T. (1991). *What every manager should know about quality*. Milwaukee, WI: ASQC Quality Press.

Smith, L. R. (2001, November). Six sigma and the evolution of quality in product development [Electronic version]. *Six Sigma Forum Magazine*. 1 (1) 28–35. Available from www.asq.org

chapter 13

Statistical Process Control

Statistical process control (SPC) is a quality analysis process or procedure that uses specified data collection techniques that result in data sets for calculating statistics and creating line graphs or control charts. This process has its origins in the work of Walter Shewhart in the 1920s and has been discussed, supported, and described in numerous references and resources since that time (Shewhart, 1931/1980). Both Deming and Juran, who were early quality gurus, wrote explanations and advice on the use of SPC (Hare, 2003; Shainin, 1990). Reading and interpreting the charts can provide information about processes to achieve quality products and services. Although the process contains procedures for data collection and measurement, the control charts, the essence of SPC, are created and read at Step 4, evaluation, of the quality analysis process. Using spreadsheet software such as Excel and its Chart Wizard function, line graphs can be quickly created from small to large data sets. When doing an evaluation of a finished product, of raw materials or of a service or process, a manager who uses SPC can identify and analyze variance within the creation of the product or the steps within the process. The data in the control chart can be visually, mathematically or graphically compared with the standard, established in Step 2 of the quality analysis process, to determine whether the product or process represented by the data fulfills the expectations of the consumer as established in Step 1 of the quality analysis process.

Some **variance within process** is to be expected because people and soft raw materials are involved in the design, production and delivery of fashion products; however, variance should be limited to ensure that the

product or service will match the standards dictated by customers' expectations. Many factors, not always controlled by machines, contribute to and are, in fact, the source of variance in processes and in products and services. For example, cotton fibers, grown naturally in fields, vary some in weight and conformance from one staple fiber to the next. In a bale of cotton, the staple pieces may vary in length, in individual weight, and in diameter. In fact, one fiber piece may vary even along the length of the fiber. Variances can occur in many stages along the production process. Fabric is rarely stiff enough to resist stretching, and, even with care, some alterations in yarn orientation within a ply of fabric will occur during spreading and cutting. Sewing is performed primarily by human labor. Although visual guides such as marks on the machine's throat plate and metal edges, folders and ridged pressure feet are used, variances in the straightness and tension of a stitch will occur. As the stitch is formed over the weave or knit of a fabric, pressure on the fabric will vary and affect the stitch formation.

A small amount of variance is usually tolerated in fashion products. Most standards for these products are written with an expected or standard value and a plus and minus amount are added to the value. For example, fabric weight for a lightweight fabric might be expected to be 8 ounces per yard, but the standard will be written as 8 oz \pm 0.5 oz. This standard indicates that fabric weighting exactly and between 8.5 oz and 7.5 oz would be within the standard. Warp shrinkage, specified for a product, would be written as 4.0% \pm 1.0%.

When variance becomes excessive or is beyond the limits of the standard as defined, it becomes a concern for the manager and others who must handle or sell the product. For example, a size 15 shirt should have a neck measurement of 15″, and an expected standard of 15″ \pm 1/4″. If the variance in the final measurements are as great as 1/2″ or more, the shirt would no longer be a size 15 shirt but would be a size 15 1/2 shirt, or the next larger size. **Tolerances,** or amount of variance allowed within a standard, vary with the characteristics of a product and the situation or usage intended for the product. Product characteristics or usage situations could include the fiber content of the raw materials; the style or fashionality of the finished product; the precision or range of consumer's expectations; and the manufacturer's, brand's, or retailer's image. Some manufacturers or retailers have customers with high tolerances for variance; whereas, other retailers or manufacturers base part of their brand marketing on the consistency of their product and the lack of variance. Consistency could be expected for amount of shrinkage, color fastness, or other performance properties. Consistency in sizing, or the "trueness" of the dimensions of the product for the printed size, or dimensions of the item may be an expectation of the consumer. Once a brand is established as having a certain fit for a garment or established dimensions for a product, the consumer usually continues to expect the same fit or dimensions in additional products created by this manufacturer or retailer. This consistency of size is especially important for catalog and Internet companies. When consumers are

buying items from these sources, they cannot try them on their bodies to judge fit or place them in their rooms to evaluate the size dimensions in relationship to other spaces and furnishings. These consumers often depend on the consistency of outcomes that they expect when buying branded products.

Controlling variance is also important when the raw materials or products are produced with machinery. Automated machinery, such as automated cutting machines that cut pattern pieces from a computerized marker, depend on limited variance in width. The marker is developed on the basis of an established or expected fabric width. The pattern pieces are laid on the marker in a tightly packed placement to maximize the use of the fabric and to reduce fabric costs. The marker, created in the computer, can have fabric utilization as high as 80 or 90 percent. The pattern pieces may be laid very close to the selvages, or almost on the edge. If the fabric is expected to be 45″ but is actually 44.5″ then a pattern piece at the marker's edge (and the fabric's edge) would be off the fabric. Adjusting the pattern pieces requires additional time for the manufacturer and will introduce additional labor costs as well as will decrease fabric utilization and increase fabric costs.

Data Sets for SPC

Statistical process control can be applied to products and services that are developed from processes. Data can be drawn from raw materials or products at any point or at any stage along the entire product system from development through production to sale or from fibers to finished products. Data can also be drawn from the services that are offered or performed along with or in place of the product. Samples of products or processes are selected for testing according to the test methods established in Step 3 of the quality analysis process. For measurements taken at any manufacturing stage, these data come from tests performed on product samples in a quality lab, from observations on the floor of a production facility, or from measurements taken at a final inspection table in the plant. Measurements for data could also come from events and products at the retailer. The retailer may have testing lab facilities separate from the manufacturer or may source the needed testing services from an independent laboratory facility. In addition, the retailer may also collect data on services performed in the buying and selling of the product or on information gathered from consumers as they buy or use the products.

As an example of production or manufacturing data, data about size measurements or dimensions can be collected from the final inspection process in product production. The sleeve of a jacket can be measured. For another example, defect types and numbers can be collected at the inspection

station in fabric production. Or, the weight or strength of a polyester fiber could be measured from samples collected during fiber production and could be noted in a chart for a data set. Expected criteria, such as the launderability of a finished fabric or the hand of stone washed pants, based on physical characteristics and representing desired outcomes, can be measured. Some fiber and fabric data are collected from samples that are drawn from the plant floor, from the final inspection station, or from product in the distribution center. These samples are often sent to the in-house textile laboratory, a corporate laboratory, or an external and independent lab. The data in a data set will be recorded from the results of simple or sophisticated equipment and tests performed in various locales such as the lab facility or the plant floor.

Process data is data that is gathered from observing activities within a production or service process. Processes are very varied and might include such items as the measurement of the time to sew one step in the construction process or the number of eye contacts or smiles that a customer service representative shared with a client. Table 13–1 shows data that was obtained by measuring the time for a specific sewing operation.

In the situation represented in Table 13–1, five operators sewed collars in preparation for placing them into a shirt that was prepared by other operators. Each operator received bundles of collar parts and sewed the collar. In order to keep the lines balanced and to keep the shirt-body operators adequately supplied with finished collars, twenty bundles of collars or one cart full of cut pieces should have been completed in 22.5 minutes. The plant manager found that over the past several weeks, the work of the operators seemed to be faster or slower than the standard time, and this variance has caused flow problems within the factory. The manager instructed the plant engineer to collect data to analyze the process. The engineer went on the floor once each day for twelve days and observed the five operators as they completed a twenty bundle load of collar pieces. The times or data in Table 13–1 are the results of the observations from the engineer.

Other time frames could be used for other data sets. Data might be collected every hour, once during every production shift, at some random interval during one stage of a process, on every nth product reviewed at an inspection

Table 13–1
Minutes Per Operator for the Acme Sewing Company

	Days											
Operators	**1**	**2**	**3**	**4**	**5**	**6**	**7**	**8**	**9**	**10**	**11**	**12**
1	22.10	20.10	23.20	19.80	23.70	20.30	23.70	23.20	22.40	21.60	22.70	23.20
2	19.30	25.10	21.80	19.00	25.30	22.50	21.70	22.10	23.00	21.30	21.70	23.10
3	19.60	23.90	21.30	20.60	24.30	22.90	22.00	20.50	22.50	21.40	22.00	20.50
4	20.40	21.70	25.30	21.90	23.40	23.10	22.60	19.90	19.40	20.60	22.60	19.90
5	21.50	22.40	22.70	24.20	22.40	22.30	23.20	19.30	20.90	21.20	23.20	19.20

station, or from the measurement of the overall throughput time from the beginning of a process to the finish of the process. This technique can be used in many applications in both a factory and a retail situation. For example, data could be collected from situations that involve a service instead of a product such as observations in the call room of a catalog company or the complaint center for a retailer.

Although the source of data can be varied, the data set is relatively standard in form. The data is usually collected or drawn at a predetermined time, periodic or random, as established by the test method or standard being used. The decisions on how and when to collect data must be determined when establishing the standard. The data set for developing the SPC chart would be written as a series of rows and columns. The columns represent the days during which the data were collected. The rows represent the points or times when the data were collected during the day. Each cell represents one piece of the data set or one observation from the measurement process.

All data have units that are associated with the numbers. The units in Table 13–1 are minutes. The units may be time (e.g., minutes), weight (e.g., ounces), or force (e.g., pounds of pressure per inch). The manager who uses a control chart must be careful to maintain the units and the integrity of the data in the chart. Data can be collected from almost any source and can be used in making SPC charts. However, data that are collected under strict scientific method conditions that control bias in the collection and measurement produce SPC information that is more dependable than data that are casually collected by an inexperienced person. Whatever the location and type of data collection procedure, a clear sampling plan should be established when test methods are selected.

Control Charts

Variance in the sewn product and related processes can be very important in the successful creation, development and sale of fashion products, but, on the other hand, it can be the reason for unhappy customers. Variance in a product can be the difference that distinguishes one upholstered couch from another. The unique blending of fabric, style, and construction of couch x is what appeals to the customer and is why the manufacturer can price the couch 20 percent higher than couch y. However, unwanted variance can have a negative impact on the perception of the products or services. A couch that is expected to be 6 feet in length arrives in a home and is actually 6 feet 6 inches. The couch does not fit in the designated spot, does not match the size of the custom rug, and is not wanted by the customer. The customer who waited for three weeks for this custom-made couch and has the special rug ready is an unsatisfied customer. Numerous tools and

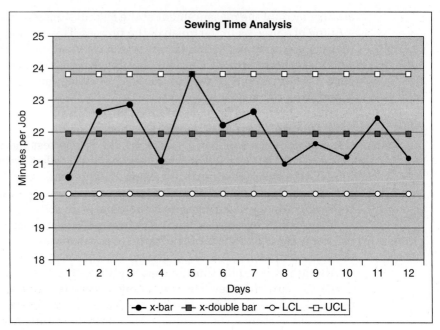

Figure 13–1
SPC chart.

activities can be used to assist the manufacturer in reducing the variance in the product outcomes, including the use of SPC. For many reasons, SPC is a very valuable tool for the sewn products industry. Control charts or SPC charts are used to evaluate the variance in processes used to produce and distribute products and services. These charts are the outcome of the SPC process and become useful in analyzing variance. Control charts can be calculated for both averages and ranges. The focus of this chapter is on SPC charts for averages.

Control charts are visual representations of the variance within a process. A manager can use the control charts with the expected standards and evaluate a situation or a product. The control chart created in Figure 13–1 is based on the data from Table 13–1. Five sewing operations were performed in the manufacturing of a simple shirt. Each operation was observed one time during 12 days. The standard for the company is that every operation in the process covered in the Table 13–1 data set should take 22.5 minutes to complete. After the data was collected and recorded, the manager evaluated the data to determine whether the process met the standard and, if not, how much variance was found within the process. If the variance was within the expectations of the manager, as dictated by the standard, no immediate action would be taken; however, if the variance was not within the standard, or patterns in the data were shown that indicated potential problems, the manager would want to take immediate action for corrections to the process.

The components of the SPC chart or control chart include the x- and y-axes, the upper and lower control lines or limits, the average line and the data plot. The scale along the y-axis is the measurement of the test or the value of the data points. This scale would be ounces when measuring fabric weight, number of returns when tracking customer returns of a product, or inches when measuring the dimensions of a finished product. The scale does not have to start at zero but can be set to show the detail of the range of the data. For example in Figure 13–1 the scale of the y-axis is set from 18.00 minutes to 25.00 minutes. This allows the observer to "zoom in" to the data fluctuations that might be hidden in a scale that ranged from 0 to 100. The scale along the x-axis is the period of the data collection. This period is usually number of days, but it could be shifts or weeks, whatever is required by the periodic sampling plan for the SPC process.

The basic control chart has an upper and lower control limit (see the lines with the open round and open square marks on Figure 13–1). Control limits are developed from data that have been collected over a period of time. At least 12 days or periods of sampling are needed to adequately calculate control limits. Some companies keep extensive historical data to calculate and establish the control limits. The control limits are an expression of the expected limits for the process. The distance between the upper and lower control limits express the variance that is normally found in the process or product. As stated previously, most all sewn products and related processes within the fashion goods industry have natural variance; however, excessive variance will not be desirable and will usually create products or services that are not acceptable to the customer.

Control charts also have an average line. The **average line** is the center line that occurs between the upper and lower control limits and represents the mean of the data used to develop the chart (see the line with the solid squares on Figure 13–1). For most processes, the mathematical average of the data collected from the service or product should equal the value of the standards, but the average is not the same as the standard. The data represented in the control chart are drawn from the process to create the service or product and are representative of the situation or capacity in the plant, retail store, or other location. On the other hand, standards are developed on the basis of the expectations of the consumer, not on the capacities of the process or product, and are created in Step 2 of the four-step quality analysis process. These standards should be created or determined before any test method is selected and any data are collected. The standard is set independently of the capacity of the process. Lowering a standard to meet the average of a process is allowing the process to control the outcome and is not focused on customer expectations and the ultimately satisfied consumer. If the average and control limits shown in a control chart do not conform to the standards or expectations for that process, then the process is to be adjusted or another supplier must be located. Standards are not plotted on the SPC chart but may appear in the title or subtitle of the chart. Data from the data set, collected through the measurement

process, are plotted on the chart after the control limits and the average are plotted (see the line with solid circles on Figure 13–1). Every data point for every data collection time is not plotted; instead, the plot for the data is the average of several samples for each day or for each period. For example, in Figure 13–1 the data for each day are averaged and the daily average is plotted on the control chart.

Calculating Values for the SPC Chart

A number of mathematical symbols are used in the formulas and charts for the SPC analysis. The list in Table 13–2 shows several mathematical symbols and associated meanings. Some symbols are Greek letters and frequently written in italics. For example, **sigma**, or the symbol for variance, is shown as the Greek symbol σ and is called **standard deviation**. To be exact, this measurement of variance is the standardized difference or amount that all the data varies from the mean. Sigma, once calculated, contributes to the observer's ability to examine the data distribution, or how the data lies on the chart relative to the average.

An x represents one data item or information in one cell on a spreadsheet chart for the data set. The symbol Σ represents the mathematical calculation of **sum.** For averaging, various symbols are used to represent types of averages. The symbol \bar{x} is called **x-bar** and is the mean or arithmetic average of a sample, usually within a larger group of data. The symbol $\bar{\bar{x}}$ is called **x-double bar** and is the mean or arithmetic average of a set of \bar{x} s. Sometimes this is also called the **grand average.**

Widely dispersed data or data with large variance give a larger sigma and plot in a wide area around the mean. Data that cluster close to the average

Table 13–2
Symbols used for SPC Calculations

Symbol	Meaning
Σ	sum
x	data point
\bar{x}	x-bar (average of sample or subgroup)
$\bar{\bar{x}}$	x-double bar (average of population or the larger group), grand average
r	range (high−low)
n	number in the sample (small)
N	number in the population (capital)
σ	sigma or standard deviation

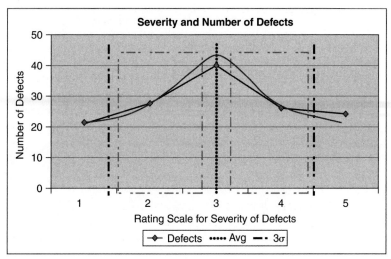

Figure 13–2
Bell curve with ±3 sigmas.

when plotted result in a sigma with a small mathematical value and represent data with a limited amount of variance. The amounts of large or limited in measuring data are relative measures. Exact numbers vary with the process, the product or service, and the environmental or situational conditions. An amount that is considered large variance in one product might be considered small variance in another product. Again, the importance of consumer expectations and standards is noted for setting the parameters for judging the data and for evaluating what is seen in a control chart. In data that contain a normal or average amount of variance, the distance of the daily or periodic averages from the grand average can result in a **bell-curve** when plotted (see Figure 13–2).

The center aspect of the bell curve when dissected with a line is the equivalent of the grand average or $\bar{\bar{x}}$ (see the dotted line in Figure 13–2). The data on number of defects is plotted by the line with the solid diamonds, and a smoothed line shows the similarity to a bell curve (see Figure 13–2). The sigma value is a measure of distance from that average. When measuring the value of three sigma units away from the grand average, the space that is enclosed within the bell curve should include slightly more than 99 percent of the data (see the dashed and dotted lines in Figure 13–2). For many processes or products, values that occur within plus or minus three sigma units are considered normal. Normalcy would then be considered to be an expected amount of variance. The basis for the Six Sigma philosophy has its foundation in the use of sigma as the determination of variance in data representing processes. Data within the six sigma range are considered "normal" or within the expected ranges. In very simplistic terms, striving to keep a process, product, service, or organization within the normal bell curve becomes an organizational strategy when applying the Six Sigma philosophy.

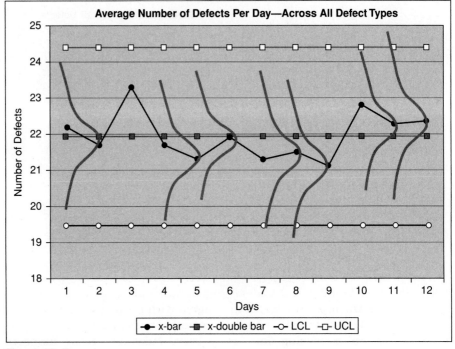

Figure 13–3
Control chart with distribution curves.

A completed control chart is made of data points. Each **data point** is an \bar{x} and represents an average of data collected for a time period. For example, in this data set, the samples were taken at multiple times for each day across several weeks of days. Because each plotted data point represents averages the control chart is actually formed from many distribution curves (Pyzdek, 1991). This concept can be represented by examining the control chart and superimposing a distribution curve for the data points in the chart (see the bell curve lines in Figure 13–3). A distribution curve overlays some of the daily averages or data points on the figure. The overlay of multiple bell curves on data points in Figure 13–3 illustrates that these daily averages represent averages of several data collection points within a data set. Variance is found at every data point.

Steps for Making SPC Charts

Steps for making a SPC chart begin with calculations of basic descriptive statistics of the data and progress to inferential statistics to profile more characteristics of the data set. As numerous as the references for describing and

applying SPC, the lists of steps for doing the SPC chart calculations are also plentiful (e.g., Burr, 1989; Hare, 2003; Juran, 1988; Ledolter & Burrill, 1999; Montgomery, 1996). Although many sources vary in exact steps, an essential set of steps include calculations of average and variance. Many methods for SPC calculations vary in the calculation of sigma. Numerous measures of sigma are available through various statistical calculations. A very quick method of examining variance is to measure the difference between the average and the standard. Although this method is useful in a preliminary analysis, this variance does not capture all differences in the data and is not appropriate for SPC calculations.

The choice of calculations and exact steps for creating the SPC chart are made on the basis of a number of factors. The Analyst who designs the procedure must consider the accuracy of the data outcomes that are expected, the criticality of the outcomes, the size of the sample, the type of sampling methods, the equipment available to the person doing the analysis, and the knowledge level and time for the Analyst. In a production plant, the equipment available and skill levels of those doing the calculations is very different from those characteristics found in the personnel and equipment in a state-of-the-art quality laboratory. Products also vary in the amount of variance that would be potentially in the product and the amount of variance that would be tolerated or expected by the customers. The methods described in this section are very simplistic and are designed for calculation with limited equipment and can be taught to in-plant personnel with minimum training time.

The following steps are suggested to calculate values and plot the SPC chart for averages:

1. For each day calculate the sample average $\bar{x} = (\Sigma x)/n$.
2. For each day calculate the range $r = (x_{high}) - (x_{low})$.
3. Calculate the overall average (grand average) $\bar{\bar{x}} = (\Sigma \bar{x})/n$.
4. Calculate the range average $\bar{r} = (\Sigma r)/n$.
5. Calculate the sigma or standard deviation (*SD*) for the data set $\sigma = (\bar{r})/d_2$.
6. Calculate the average of the sigma or *SD* avg $\sigma_{avg} = \sigma/\sqrt{n}$.
7. Calculate the upper control limit (UCL) and the lower control limit (LCL) $UCL_{avg} = \bar{\bar{x}} + 3 \times \sigma_{avg}$ and $LCL_{avg} = \bar{\bar{x}} - 3 \times \sigma_{avg}$.
8. Create the x- and y-axes for the chart by using the period for the x-axis and the value scale for the y-axis.
9. Plot the UCL, LCL, grand average, and sample averages.

To calculate values needed for making an SPC chart for the data in Table 13–1, an Analyst would start with Step 1 and find sample average for each day. By using data for a day, the average would be found by summing the x values in that day and dividing by the n or the number of samples in the

day. This calculation would be repeated for each day. Determining the n or the divisor is often a challenge when making these calculations. The Analyst must remember what each calculation is representing and the data within that aspect of the calculations. For example, the n for the **sample average,** or \bar{x}, is the number of samples for a single period, such as the number of samples for one day. In Table 13–1 this number is five because there are five operators that are timed during the day. If ten operators were observed and reported in one day, the sample number would be 10, and the n associated with \bar{x} would be 10. The five operators were observed once every day for 12 days. To facilitate plotting the SPC chart, values for each \bar{x} and other calculations are placed in a spreadsheet in rows below the sample values for that day (see Table 13–3).

In Step 2, the values for the **range** for each day would be calculated. This calculation is basically a hand calculation subtracting the highest value for the day from the lowest value for the same day. For example, in Day 1, the high value is 22.10 and the lowest value is 19.30, and $22.10 - 19.30 = 2.80$. The calculation for range would be repeated for each day, and the value would be placed in the spreadsheet (see Table 13–3).

Steps 3 and 4 are calculations to find the overall averages and the range average. When the data are placed in a computerized spreadsheet, the appropriate rows can be averaged. The n for the divisor in these two calculations refers to the number of days in the data set or the number of averages that are used to make the grand average or the number of ranges used to make the range average. The n for the **grand average,** or $\bar{\bar{x}}$, is the number of periodic events that are within the data set. In Table 13–1, n would be 12 for the 12 days. If the data were collected for 30 days, the n would be 30. For any data set, only one grand average is found. For the data in Table 13–1, a **range average**, or \bar{r}, is calculated. The n associated with the average of the range is the number of periodic events (e.g., days, weeks) used to find the average range. For Table 13–1, although five data items were used to find one range, the n is 12 because 12 daily ranges are calculated or one range for each of the 12 days. Again, if the data were collected for 30 days then the divisor for the range would be 30. These values can be placed in the spreadsheet at the end of the appropriate rows (see Table 13–3).

Step 5 is to calculate **sigma** or **standard deviation (SD)** for the data set. The calculation starts with the \bar{r} that was found in Step 4 and uses the d_2 number as a divisor. To find the correct d_2 number, the Analyst must know the number of samples in the daily average and then locate the appropriate number in a d_2 chart. The values in the d_2 chart shown in Table 13–4 are from Table 27, in ASTM STP12D (ASTM International, 1976). The d_2 numbers are but one part of the extensive set of tables listed for control chart development. The d_2 numbers appear on charts in tables in numerous statistical textbooks. Sample size for this calculation is the number of samples or n within a sampling period, such as number of samples in a day for Table 13–1. For the data in Table 13–1, the d_2 number is located in the d_2 chart under the heading of 5 for sample size 5. This method of calculating sigma is not as

Table 13–3
Minutes per Operator for the Acme Sewing Company with SPC Calculations

	1	2	3	4	5	6	7	8	9	10	11	12	Avg	SD	SD avg
\bar{x}	20.58	22.64	22.86	21.10	23.82	22.22	22.64	21.00	21.64	21.22	22.44	21.18	21.95		
UCL	23.82	23.82	23.82	23.82	23.82	23.82	23.82	23.82	23.82	23.82	23.82	23.82			
LCL	20.07	20.07	20.07	20.07	20.07	20.07	20.07	20.07	20.07	20.07	20.07	20.07			
$\bar{\bar{x}}$	21.95	21.95	21.95	21.95	21.95	21.95	21.95	21.95	21.95	21.95	21.95	21.95			
\bar{r}	2.80	5.00	4.00	5.20	2.90	2.80	2.00	4.20	3.60	1.00	1.50	4.00	3.25	1.39	0.62

reliable as some more complicated methods, but the method is easy for plant personnel to learn and use, and provides a satisfactory calculation for sewn products where tolerances are often large and some variance is expected and accepted.

Step 6 is for calculating **sigma average** and is performed by dividing sigma by the square root of n. The n or number used for finding the square root is the sample number, which is also the sample size used for locating the d_2 number. In the case of the data in Table 13–1, this calculation would require finding the square root of 5. If the sample size were 3, the calculation would be made by finding the square root of 3 as the divisor. Finally, the **upper control limit (UCL)** and **lower control limit (LCL)** are found using the grand average and three times the sigma average. The calculation of three times sigma average relates to the area of normalcy shown in Figure 13–2. Values from completed calculations for the data set in Table 13–1 are shown in Table 13–3.

Plotting the data on the chart is easy when the data is kept in a spreadsheet and a chart-making software is used. To facilitate the plot, the rows of data needed for the plot—daily averages, the grand average, the UCL, and the LCL—are in sequential rows of the spreadsheet (see location of data in Table 13–3). The grand average is the same for each day and can be copied along one row in the spreadsheet. The same is true for the UCL and LCL. The range should not be placed within these rows because it is not plotted on this type of SPC chart. The plot for the data found in Table 13–1 is shown in Figure 13–1. Data for this data set were reported in one or two decimal points; however, the appropriate number of decimals would be determined on the basis of the significant numbers in the data set and the precision in collection of the data. Whatever the format and integrity for the original data, the calculations should maintain those characteristics.

Table 13–4
Values for d_2 used for Calculating Standard Deviation

Sample Size	3	4	5	6	7	8
d_2	1.69	2.06	2.33	2.53	2.70	2.85

Reading SPC Charts

A manager uses the SPC process and creates control charts for maintaining a controlled process and reducing or preventing unwanted variance. Once the charts are developed, the manager can use the information obtained in reading the charts to assist in determining whether the process is in statistical control. Interpreting or reading the data is the ultimate use of the SPC chart. The manager will want to ask the question of "What do you see in the data about the process?" In addition, the chart will be used to respond to the question of "How does the data represented in the chart compare to the product or service specification set by the company and the standard expected by the consumer?" The Analyst or other personnel, by using the charts, must determine two aspects of the situation: (a) whether the process is in control, and (b) whether the process is producing a product or service that meets the standard. The two questions are related and answers stem from the same data set, but the responses are independent of each other. SPC charts can provide information so that the manager can control the process, evaluate the process's success in creating a product or service that is within specifications, and control changes in the process. These managerial functions are best done when the control limits are developed over time and the data set has regular inputs of data.

To control a process, the manager must determine whether the process is within control or out of control. Processes that are within control show a plot that has data points from sample averages that all appear between the upper and lower control limits. The chart in Figure 13–4 shows the average number of minutes needed to complete the sewing of a simple T-shirt in a team production unit. The number of minutes varies over the time of observations, but the averages per day are all within the limits of the process, or within the upper and lower control limits. The process is considered **in control.**

Next the manager would need to consider whether the process is acceptable as represented in the chart. Again, the manager spends time observing the charted data. In Figure 13–4, the charted data would be compared with the standards for time for sewing and variance in the time, which have been previously established by the plant. If the standard were set as 22.5 minutes with a variance of ±1.5 minutes, the process would be both in control, as discussed in the previous paragraph, and **in spec** when compared with the standard. With this information, the manager can determine whether the process is acceptable. If the variance and average time are within the standards, the manager has a reasonable assurance that the process is a quality process. If the process is in control and meets the expectations from the standards and from the customer (e.g., in-house customer, trading partner, final consumer), the manager can consider the process to be a quality process and should be satisfied with the process. If the process or the result of the

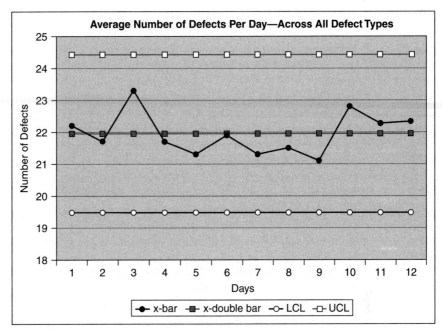

Figure 13–4
Process is in control.

process is not acceptable to one of the customers serviced by this process, the members of the partnership must reexamine the standard including the tolerance within the standard for variance.

A process may be statistically in control and in spec for the company but still may not satisfy all the customers for that company. For Customer X, the standard for sewing time of this shirt is 20 minutes ±1 minute because they want the shirt completed in a shorter time span for a faster and more continuous delivery. A limited variance is accepted because of the coordination of this product with other items made in the same plant. When compared with the grand average, the plant manager determines that although the process is acceptable within the plant, the process does not meet the time standard needed for producing shirts for Customer X. This finding is made by observation. When the data in the chart do not satisfactorily match with the standards, the process is not a quality process—in other words, it does not meet the expectations of the customer. The manager may have already expected this truth because the work-in-process in the plant was observed to be an excessive amount in some areas and was limited or missing in other areas. When the fact is verified that the process, although in control, does not meet the standards, the manager can make decisions about change. When the decisions are made by a customer, the data in an SPC chart can be used to make determinations regarding the purchase or refusal of a product. Outcomes from SPC charts can have very far reaching and dramatic effects in channels of distribution.

Using the SPC charts, an observant manager can also determine when a process is out of control or predict when the process seems to be trending or going out of control. When 50 percent or more of the data lies above or below the upper and lower control limits, the process would be considered **out of control.** An example of an out of control process is the increased return rate on a new product. If the customer return rate on a new product is more than 5 percent and the control limit for the return rate is 3% ±1%, something in the process is out of control. With this information, the manager might not even check on the standard or customer expectations but would want to take immediate corrective action on the process and fix the process.

Trends are important to recognize because a process that can be corrected before going out of control may prevent dissatisfied customers in the future. By watching changes in the data, the manager can signal a need for corrective action to be taken. The chart shown in Figure 13–5 is based on data from a process that is **trending** or showing evidence of going out of control. Day 1 shows an average that is below the lower control limit, and the plots for Days 1–4 are below the grand average. A few days in the middle of the 12 day period show data that are near the average, but the last two days of the observations show data that have risen above the average and ends on the upper control limit. The trend is from data that are below average to data that are above average. The sewing time for this situation is getting longer and longer with the passage of time. If the change trend continues, the data will be out of control at both the beginning and the end of the observations.

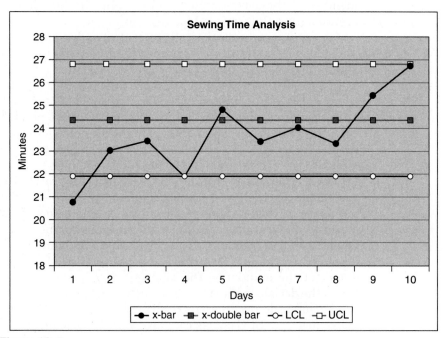

Figure 13–5
Process is going out of control.

Using SPC Charts

When completing the four-step quality analysis process, Step 4, evaluation, is used to compare the data from measurements with the standard. The SPC chart allows the observer quickly to see the data and, through comparisons, identify whether the data are within standards. The plotted data are easily observed and can be compared with the standard for expected conformance to the standard. Although this comparison is a major use of the SPC charts, standards do not appear as plots on the chart. The standard may be written in the labels, in the title, or somewhere on the chart, but it is never plotted as a line on the chart because the plot represents the process capability not the standard or customer expectation.

Although closely tied to each other in the quality analysis process, the data in the SPC chart are independent of the standard. For this reason, one cannot assume that a process that is in control is within spec. The process that is in control is within the statistical limits of the chart, but that is not the same as within standards or within specifications. A process can be in control but out of specification range. This situation does not mean that the process is bad, wrong, or needs correction. This finding means that in its current condition, the process cannot generate a product or service that is equal to the specification. If the process is being supplied by a vendor, the customer must decide whether the vendor can change the process to meet the specification or whether the vendor must be dropped and a new vendor sought who can supply a product or service that is within spec or is producing products or services that have data within the desired range for the specification. If the product or service is generated in-house, the managers must determine whether the specifications are accurate for the customer, and, if they are, the managers can then alter the process to supply the desired outcomes.

When recognizing that a problem (e.g., out of control, trending, not within spec) exists, the manager must determine what is wrong with the process and how the problem or problems can be fixed. The manager will want to look for the **root cause** or the primary source of the problem. One way to search and identify the causes of a process problem is to collect data on the process and develop a Pareto chart. For example, a retail manager is receiving many complaints about a red sweater. Consumers are returning the sweater and asking for refunds or credits for new products. When examining the return slips with a Pareto chart, the manager and the retail buyer can see that most of the returns are because of fading problems (see Figure 13–6). Having many unhappy customers may have multiple and often far reaching impacts on the retail business as well as on the businesses throughout the entire supply chain.

In addition to having to refund money, the manager at the retail store has had to pay for dry cleaning bills for other items damaged with the fading,

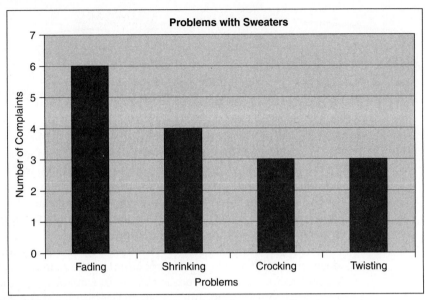

Figure 13–6
Pareto analysis of sweater returns.

and the store may lose future sales from the customers that encountered the problem. The retail buyer is now unhappy with the vendor or manufacturer of the product and will try to seek retribution from the vendor. A retail buyer who continues to be unhappy will not seek merchandise from that manufacturer in future purchases. And, all of these unhappy customers, both at retail and at wholesale, will tell their friends, family and colleagues. The unhappiness spreads and can greatly damage a business.

Managers faced with unhappy customers and excessive returns must take immediate and swift action to seek solutions to the problem. After identifying the root cause, the retail buyer decides that action is needed. The determination of what action to take is the next step in solving the current problem and preventing future problems. Additional investigations involving data collection and further analysis may be needed to determine the correct course of action. Flow charts and fishbone models may be used to examine visually the process and the problem. The buyer may decide to create a fishbone model to analyze all potential components that could contribute to the problem.

When starting the fishbone model of the problem, the retail buyer first identifies several major reasons or concepts related to the problem (see Figure 13–7). Using both merchandising and textile knowledge, the buyer itemizes issues within each concept, and the problem is more closely identified. Within the marketing concept, the buyer investigates the promotions for the sweater and the training for the sales associates. By all indications, the sweater was advertised and sold correctly. No misinformation was given to sales associates or to consumers. The product care labels were found to be easy to read and

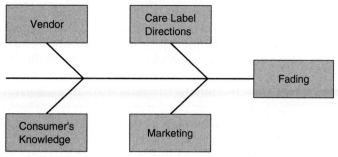

Figure 13–7
Fishbone analysis of crocking problem.

clearly stated to "wash in cold water." A sample of consumers are interviewed, and all stated that they had washed the sweater in cold water in a short machine cycle and tumble dried as described on the care label.

When the buyer investigates issues at the vendor's plant, the root cause is revealed. The vendor of the product did not supply the product in the original contract with the buyer. The vendor changed yarn suppliers. With the type of dye and the fiber content, the vendor was not capable of preventing the fading but failed to provide this information to the buyer. With these results of the tests and analysis, the buyer then has to decide what action to take. Possible future actions could include the following: to work with the vendor for improved products or to drop the vendor and find another source for the item.

Fixing a problem after it happens costs extra time and money beyond the costs to fix or correct the problem. In the case of the red sweater, the buyer had to spend many hours interviewing consumers, sales associates and the vendor, plus additional time preparing the charts and examining the results of the interviews. If the vendor had shared the information concerning the changes in product with the buyer or had worked with the buyer to select other raw materials for the product, the fading problem could have been prevented. Partnerships that encourage collaborative planning are important in producing quality products and services. In addition, preventive action or prior planning and vigilant observations are important in keeping quality that is planned. The concepts of preventive action and sharing of information are very closely related to the partnership and information sharing aspects of Quick Response (QR). In the QR strategy, trading partners are encouraged to test products, to analyze processes and to share this information between partners to reduce redundancy of testing and increase information flow for better product quality and customer satisfaction (Kincade, 1995).

Before a process gets out of control, the manager or other responsible person should begin to take corrective action. **Corrective action** includes tasks that prevent variation. If a process that is being charted shows trends of going out of control, the manager should take immediate action to prevent further undesired variance. Action before, during, and after the production

process is important to maintain quality control and to achieve or maintain customer satisfaction. With proper process controls in place, the manager is constantly watching the process, will take action if the process begins to move out of control, and does not wait for final inspection to know if the product is meeting specifications.

For many manufacturers and retailers, corrective action would include employee training, regular supervision with checksheet analysis, and equipment service and maintenance. Corrective action, although seeming to be unneeded work, is actually cheaper than fixing problems. Problems such as the one with the fading often result in additional costs beyond the basic costs of fixing the problem. A customer who is dissatisfied will tell other customers about the problem, which is negative publicity for the business. Some problems also create secondary problems that must be repaired or addressed. All of the time and effort spent in fixing a problem could be spent in preventing problems and doing the work right the first time. This quality philosophy keeps customers happy from the beginning, reduces the expenses of rework, and helps the business maintain its desired and developed image.

Key Terms

Average line
Bell-curve
Control charts
Controlling variance
Corrective action
Data point
Grand average
In control
In spec
Lower control limit (LCL)

Out of control
Process data
Range
Range average
Root cause
Sample average
Sigma
Sigma average
Standard deviation (SD)
Statistical process control (SPC)

Sum
Tolerances
Trending
Upper control limit
 (UCL)
Variance within process
x-bar
x-double bar

Review Questions

1. What is statistical process control?
2. Why would a quality team want to use SPC?
3. Why is variance to be expected in any process?
4. Give examples of normal variance to be expected in a sewn product process.

5. Why is controlling variance important to a company interested in quality?
6. What are the components of a data set used for SPC charts?
7. How are samples drawn for an SPC analysis? Who decides?

8. How are upper and lower control limits developed?

9. What is the mathematical definition of the average?

10. What is the grand average?

11. What is plotted on a control chart?

12. What are the Greek symbols for average of the sample and average of the population?

13. What is standard deviation? What is the Greek symbol for standard deviation?

14. What are the nine steps for creating a control chart? (Be able to complete these steps and plot a chart.)

15. How do you determine what "d_2" value to use when creating a chart?

16. How is variance shown on the control chart?

17. Discuss standard deviation in relation to the average or bell-curve distribution chart.

18. How does the bell curve help someone understand the Six Sigma philosophy?

19. How can you determine if a process is in control?

20. What does in control mean in terms of the process? In terms of quality?

21. How does the data plot look if the process is going out of control?

22. How can trends be predicted from a SPC chart?

23. Where are the standards marked on the control chart?

24. How is data in the SPC chart compared to the standard?

25. How can a process be in control but not be in standard?

26. When should a process be changed or improved?

27. How can the control charts be used to improve a production process?

28. What quality analysis tools can you use to find the root cause of a problem?

29. How does corrective action fit with the concepts of Quick Response and partnerships?

30. Why is corrective action including prevention better than fixing the problem "after the fact"?

References

Burr, J. T. (1989). *SPC: Tools for operators*. Milwaukee, WI: ASQC Quality Press.

Hare, L. (2003, July). SPC: From chaos to wiping the floor. *Quality Progress* [Electronic version]. Available from www.asq.org

Juran, J. M. (Ed.) (1988). *Juran's quality control handbook*. New York: McGraw-Hill.

Kincade, D. H. (1995). Quick Response management system for the apparel industry: Definition through technologies. *Clothing and Textiles Research Journal, 13*, 245–251.

Ledolter, J. and C. W. Burrill. (1999). *Statistical quality control*. New York: Wiley.

Montgomery, D. C. (1996). *Introduction to statistical quality control*. New York: Wiley.

Pyzdek, T. (1991). *What every manager should know about quality*. Milwaukee, WI: ASQC Quality Press.

Shainin, P. D. (1990, August). The tools of quality Part III: Control charts. *Quality Progress*, 79–82.

Shewhart, W. A. (1980). *Economic control of the quality of manufactured product*. Milwaukee, WI: ASQC Quality Press. Original work published in 1931.

chapter 14

Costing in the Sewn Products Industry

During the early stages of product development, an approved sample is sent to the merchandiser for a preliminary costing. This quickie costing is done during the early stages of product development because, before further product development, merchandisers determine whether the product, as designed, will meet the price expectations of the company and of the target market. Final costing is done when the product line is priced for market, and charges for sewing labor, fabric and findings are finalized. Final costing in the sewn products industry is performed traditionally by one of two methods—market-price or cost-plus. Sometimes both methods are used for the same product as a system of checks and balances for determining the price of a product. The market-price method is usually used for very new products, highly competitive products, and very high-fashion products. Although most appropriate for basic goods that have limited changes, the cost-plus method is the one used by most sewn products manufacturers and for most products.

Product costing is a critical decision for the manufacturer in reaching the expectations of the retailer and the consumer. In the traditional pipeline, the entire product development process for a sewn product occurs before order placement by the retailer with no assurance that the product will be saleable (see Figure 1–4, for review). A product development team must not only forecast style and color for the product but also the price of the product

that will meet the consumer's expectations. Finding a design solution with a price that meets the designer's plan, the required price point, the consumer's expectations, and the production facility's capabilities is often difficult. Because the look of the product is frequently the main selling point and may have been extensively researched, sewn products designers are sometimes unwilling to make changes in the design; however, the product design must be compatible with the product price for the overall product image (i.e., product outcomes) for it to be considered a quality product by the consumer.

Quickie Costing

Quickie costing is performed early in the product development process, generally during the line development stage, so that an estimated price can be determined for the product and target price ranges can be checked. **Quickie costing** provides a tentative price for the product. It can be done within a very short time (i.e., minutes) and with limited information (i.e., product dimensions and fabric cost estimates). Many companies employ a **cost estimator** who determines quickie costs, or the job may be performed by a merchandiser on the product development team. If the product's price estimate (i.e., quickie cost) does not fall within the target price range for the product line, the product will be dropped from the line, altered in fabric or style, or replaced with alternate products. This preliminary costing saves time, labor and raw material resources that the designer and other product development members would spend on a product that is destined to be removed from the line when the final costing is done.

Quickie costing has as its foundation the fabric yardage estimate for the product, the sourced price for the fabric, and a mathematical calculation for tripling the yardage cost. To start the process, the **fabric yardage estimate** is taken from the estimated length with a consideration for the width or diameter of the product. The length of the product, or the longest side, is measured or estimated. This length would be divided by 36 inches to convert to yards (see Figure 14–1). The width or diameter may also be measured or estimated; however, the estimator may assume that many apparel products and some home furnishing products can be made by placing the pattern pieces across the width of most fabric.

Figure 14–1 Fabric yardage estimate.

- Fabric Yardage Estimate =
- Longest Pattern Length ÷ 36″ per yard

Figure 14–2 Fabric yardage cost.

- Fabric Yardage Cost =
 - Fabric Yardage Estimation × Fabric Price

The price of fabric may be estimated based on prices of similar fabric for previous products, fabric may be sourced by a merchandiser or other member of the product development team, or the fabric price may be a set standard, providing a price range that must be used for all fabrics of a specific product line. Standards for fabric prices and history of fabric prices for previous products are normally kept by the product development team or the cost estimator. Once determined, the estimated price of the fabric is multiplied times the fabric yardage estimate for the quickie **fabric yardage cost** (see Figure 14–2).

In quickie costing, the fabric yardage cost becomes the basis for the **quickie** or **preliminary price.** A **rule of thumb costing** for quickie costing is 1/3, 1/3, 1/3. The "thirds" represent the costs of the fabric yardage, the labor, and the overhead. When determined, the fabric yardage cost is multiplied times three to account for the fabric, the labor, and the overhead (see Figure 14–3). This calculation results in the **wholesale price** of the product. To provide a **suggested retail price (SRP)** or **retail list price,** this wholesale cost is usually doubled. This SRP may be rounded to a standard company price point.

The product development team and others reviewing these ideas during a slush meeting must determine, by using company and product line standards, whether the price is acceptable for their retailer and the final consumer. A sample calculation for the quickie costing of a child's simple top is shown in Figure 14–4.

Quality Considerations in Quickie Costing

Quickie costing is performed early in the product development process. During this process, extensive emphasis can be placed on the development of a quality product. The quickie costing is used in conjunction with the quality standards that are implemented during the idea and line development stages of the product development process. During quickie costing, the product development team must consider the consumers' expectations for the product and the company's standards. Products that do not meet these

Figure 14–3 Wholesale and retail prices.

- Wholesale Price =
 - Fabric Yardage Cost × 3
- Suggested Retail Price =
 - Wholesale Price × 2
- Rounded to Company Price Point

- Fabric Yardage Estimate for Simple Top =
 - 24″ (longest length of product) ÷ 36″ =
 - 0.67 yards
- Fabric Yardage Cost for Simple Top =
 - 0.67 yards × $2.50 per yard =
 - $1.68
- Wholesale Price of the Simple Top =
 - $1.68 × 3 =
 - $5.04
- Suggested Retail Price for the Simple Top =
 - $5.04 × 2 =
 - $10.08
- Rounded to a company price point =
 - $10.29 for the simple top.

Figure 14–4
Quickie price calculations for a simple top.

guidelines for quality should not be passed on to the next stage in the product development process.

Fabric utilization is reviewed when making the quickie marker. Decisions made to adjust pattern sizes and shapes should be made with care at this point. Although a style change could result in lower fabric usage, the change could result in a product that no longer meets the consumer's expectation for the product. When the quality of the product is no longer appropriate for the price point or the brand image, the consumer will be disappointed in that product. Fabric utilization and other cost decisions must always be made with quality outcomes in mind.

Market-Price Method of Costing

The **market-price method** requires no mathematical calculations; instead, this method requires exacting merchandising knowledge and a clear understanding of the competition, the status or positioning of the current product or brand for the company, and the expectations of the target consumer for the product. The price is decided by a prediction of what is the maximum selling price for a product—what the market will bear. A price, which is developed by this method, is set without regard for the associated design, fabric or manufacturing costs. The price is often set as high as possible, in

contrast to the cost-plus method that sets the minimum price. The high price provides a larger margin for the manufacturer to recoup product development and production costs. Setting the price high is compatible with the consumer's expectations that a new product will be expensive, and product release is timed when the consumer is often willing to pay more money for a product in order to have the fashion-forward appeal of the product.

An accurate price is most difficult to establish by this method. With a new product or a high-fashion product, the market may have few competitors to scan for similar products. The price may be set relative to other products offered from the manufacturer, or the price may be set at an arbitrary and extremely high point. The estimated product price or **market price** is evaluated in terms of **price line** or price points. In the sewn products industry, there are five basic price lines that range from low to high: budget (or popular), moderate, better, bridge, and designer. Most manufacturers set prices for their product lines to be priced within one of these price lines. Within each price line, the **price points** are high, medium, and low. Price of an individual product will need to be within the set price line and generally at or near a targeted price point. The price lines are based on the strategic plan of a company, on the brand image for a branded product, or on the price lines of the competition. By using this method, a **target price** or suggested retail price with a desired final cost is set for the product.

Quality Considerations for Market Pricing

Because market pricing is focused on the product and the consumers' expectations of the product, the issue of meeting quality is usually a primary concern when developing the product and setting the market price; however, if the price is too high and the product must be reevaluated, quality issues must be monitored. If the estimated price of the product is too high, the features of the product are reevaluated for potential cost reductions. This process can result in a point of conflict between the designer who creates the product, the merchandiser who does costing, and the engineer who evaluates manufacturability. When negotiating changes in a product to bring it within the price line, the product development team must continue to monitor the consumers' expectations for the product and the effect that changes for price reasons may have on product outcomes.

At each price line, consumers have perceptions of what characteristics or outcomes they expect (i.e., quality) for the product. Although the market-price method is not scientific, it can provide the product with an aura of uniqueness. In the sewn products industry, high price points are associated in the consumer's mind with high quality and high fashion. For this reason, price is often used as a tool in product or brand image development and in cost recovery for product development expenses and failures. In a market-price situation, setting the price below the competitive market price is rarely done in the U.S. sewn products industry. If the final calculated price would result in a price that is actually below the market price that was

targeted, the company would usually take the difference as a higher product margin. In contrast, the usual occurrence is that the estimated cost-plus or final price will be higher than the target price.

Cost-Plus Method of Costing

The cost-plus method of costing or the component addition method is used by most sewn products manufacturers. Although this method is not completely appropriate for all variable and volatile sewn products, it is the method most commonly in use. This traditional method of costing is driven by several factors in the sewn products industry. Labor and raw materials are major components of the price, and bills for these items must be paid prior to receipt of payment from retail customers for finished goods. The **cost-plus method** builds the final price on the basis of labor cost so it most directly relates to the bills that must be paid first by a manufacturer. This calculation is usually made during the production development stage, when the team is sourcing labor and investigating the manufacturability of the product.

The cost-plus method involves a series of eight calculations, most based on the labor component: direct labor, indirect labor, fabric yardage, findings, miscellaneous, total manufactured costs, overhead, and wholesale cost (see Table 14–1). This wholesale price of the product is built from the component costs associated with manufacturing. Use of the cost-plus method assumes that the manufacturer will sell a large volume of the product with limited changes in design or production over time. These assumptions are not realistic for most sewn products manufacturers when considering the amount of speculation involved in design and sale of the sewn product. Realistic or not realistic, this is the method most often used in the sewn products industry.

Table 14–1
Costing Worksheet for Cost-plus Method

Items	Explanation		Total
Direct Labor			
Indirect Labor			
Total Labor			
Fabric			
Findings			
Miscellaneous			
Total Manufactured Costs (TMC)			
Overhead			
Wholesale Price			

Table 14–2
Average SAMs for Sample Product Assembly

Product	Average SAMs
Complex (tailored) jacket	6 hours
Pair of trousers	120 min
Simple (unlined) jacket	3 hours
Simple skirt	70 min
Simple top	20 min

Labor Costs

Standard labor is the base component of labor costs and covers sewing labor needed for stitching the product. Standard labor is measured in **standard allowable minutes (SAMs)**. SAMs are established for each step in assembly (i.e., sewing). Each step in assembly is engineered, standardized, and timed. Many companies keep a record of these steps, called the method. **The method** is a standard for how to pick up, hold, and sew each cut fabric piece when sewing. Some companies use industry averages for assembly to estimate SAMs (see Table 14–2). If the exact product is not in the table, a similar product is selected.

Once determined, the total SAMs needed to sew the product are summed. The total SAMs for a product are divided by 60 minutes per hour to convert the SAMs to hours or a portion of an hour. This value is multiplied times the base rate or sewing wages, given in dollars per hour (see Figure 14–5). The base rate for wages is determined when the merchandiser sources the production facilities for the product. If the wages are given in currency other than the domestic currency of the company, currency rate conversions are needed to complete this calculation.

Excess labor costs are needed to cover activities associated with sewing such as the costs of rework from sewing errors, overtime needed to complete a job within the deadline, training for new sewing operators, and other off-the-clock expenses. These costs are calculated as a percentage of standard labor. Excess labor percentage for most sewn products manufacturers is an estimation based on experience. Standard labor dollars and excess labor dollars are added to determine an estimated direct labor for the sewn product (see Figure 14–6).

The term standard labor is often interchanged with the term **direct labor,** meaning the labor that is used directly to sew the product. However,

Figure 14–5 Standard labor calculation.

- Standard Labor =
 - (Σ SAMs ÷ 60 minutes per hour) × wages per hour

Figure 14–6 Excess labor
and direct labor calculations.

- Excess Labor =
 - Standard Labor × Excess Labor Percentage
- Direct Labor =
 - Standard Labor + Excess Labor

the term, direct labor, is more accurately used to describe the cost calculation of standard labor plus excess costs (see Figure 14–6). This dollar amount becomes the basis for indirect and other overhead costs. **Indirect labor** covers wages for people who work to get the product from being an idea in a designer's head to being shipped out the door to the customer but are not involved in sewing. These costs are based on a percentage (see Figure 14–7). From the direct and indirect labor costs, the **total labor** cost is then calculated by a summation of these expenses (see Figure 14–7).

Quality Considerations for Labor Costs

Sewing is the point in the process where the idea becomes a product that is almost ready for the consumer. Standards that were written during product development are implemented during sewing. The manufacturer may wish to reduce sewing costs but this should never be done to the detriment of the product quality. Selecting a contractor or plant manager that can maintain product standards is important in delivering the expected product quality.

In determining SAMs, some sewing companies keep detailed and accurate records of each sewing operation, including the exact pick up and hold for each operation, the actual stitching process, and the time needed to complete the operation. This collection of information about the assembly process is called the method and can be combined with other methods for each sewing operation to make a complete set of guides for how to sew the product. The use of the method to determine SAMs helps to standardize the sewing process. If the methods are kept accurately and updated with regular time and motion studies, the estimation of SAMs can be determined from **the method book,** which becomes a standard for the sewing process. This standard can be shared with partner companies who are on contract for sewing the product. In a reciprocal sense, the sewing company can share their standards with the company developing the product. If the product is new or if

Figure 14–7 Total labor
calculation.

- Indirect Labor =
 - Direct Labor × Indirect Labor Percentage
- Total Labor
 - Direct Labor + Indirect Labor

any of the methods are being reengineered, time and motion studies on the plant floor will be needed to determine the new method and SAMs needed to sew a product.

Fabric Costs

Fabric costs generally account for one-third to one-half of the total product cost, depending on the source of the labor. These costs are direct and easy to track. Once the fabric is selected, the costing work involves determining the amount of fabric needed for the product and sourcing a manufacturer and a price for the fabric. The determination of fabric costs for the cost-plus method is accomplished in five steps: (1) identifying size and shapes of pattern blocks, (2) creating an estimated marker or minimarker, (3) determining the yardage for the product, (4) sourcing a fabric for manufacturer and price, and (5) calculating the fabric costs.

Step 1 is to identify the size and shape of potential pattern pieces. The product should be "eyeballed" for **pattern blocks** or major component parts of the item. For example, a decorative pillow is made from two squares of fabric and, if corded, a long strip of fabric for the covering on the cord. These pattern blocks can be measured from a technical sketch if drawn to scale, sized from standard product dimensions for the company, or estimated by judging the placement and positioning of the product relative to a standard company model. Blocks can be drawn on a fashion or technical sketch to help the cost estimator visual all the needed parts (see Figure 14–8).

In Step 2 of fabric costs, the cost estimator starts the **minimarker** by drawing a length of fabric to represent the fabric on a cutting table. When sketching and not drawing to scale, dimensions of the fabric can be added to the sketch to remind the estimator of the size. For a production marker, the fabric will be laid flat or one ply thick and open from selvage to selvage. The **selvages** are the finished edges of the fabric that parallel the length-wise grain of the fabric. Most fabrics are either 45″ or 60″ from selvage to selvage. A few fabrics are made at 36″ widths (e.g., laces, specialty prints)

Figure 14–8 Pattern blocks drawn on product sketch.

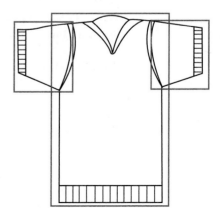

Figure 14–9 The minimarker or fabric spread with pattern blocks.

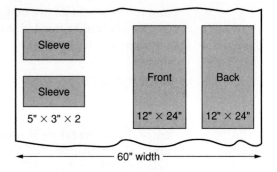

Sleeve

Sleeve

5" × 3" × 2

Front

12" × 24"

Back

12" × 24"

◄——————— 60" width ———————►

and a few are made at 72″ widths (e.g., sheeting). The cut edges of the fabric are parallel to the filling yarns in the fabric and are shown in a sketch as uneven or wavy lines. In the cost estimator's sketch, the pattern blocks with estimated dimensions are sketched onto the length of fabric. The pattern blocks should be arranged on the fabric for maximum fabric utilization, as appropriate for a production marker (see Figure 14–9). With the width dimension of the fabric and the dimensions of the pattern blocks marked on the sketch, the estimator can determine whether the pattern pieces will fit across the fabric even when the sketch is not drawn to scale.

In Step 3, the pattern blocks are evaluated for their fit on the fabric in order to determine the **yardage** or the length of fabric needed to cut the pattern blocks for the product. When measuring across the pattern blocks, the estimator can determine whether the pieces fit easily on the planned width of the fabric. If the blocks fit across one width, the length of the yardage is the length needed to accommodate the longest pattern block. If the pattern blocks will not fit across the minimarker, the blocks must be placed one following the other and the length will be an addition of the pattern block lengths (similar to the quickie costing method for yardage). When the fabric length is determined, the cost estimator will divide by 36″ to determine the needed yardage (see Figure 14–10).

Figure 14–10 Determine yardage length.

- Determine if pattern blocks fit across fabric width
 - Block A + B + ... + X = Calculated Width
 - Calculated Width < Fabric Width
 - Only one length is needed.
- Determine the longest pattern block
 - Block B > Block X
 - Block B is the longest block
- Yardage Length =
 - Block B ÷ 36″ = X yards

Figure 14–11 Excess fabric
yardage estimation.

> • Excess Fabric Yardage Estimation =
> • (length of longest block + length for
> additional blocks that exceed width) ÷ 36″
> per yard

If the summed width of the pattern blocks is excessive (i.e., goes beyond the estimated width of the fabric) additional calculations are needed for the **excess fabric yardage estimation** (see Figure 14–11). An example of the excessive width is an extra long, upholstered sofa with no arms. Because of the fabric pattern the designer recommends that the fabric on the sofa back be cut in only two pieces. The overall width from end to end of the sofa is 72″. For sofas, this measurement may be called length. The height of the back is 40″. The fabric used to upholster the sofa is only 60″ wide. With the center seam one-half of the back, or 36″ (i.e., 72″ ÷ 2), is the width of the piece to be cut. Only one of these pieces will fit across the fabric width; therefore, two lengths (40″ × 2) of fabric are needed to cut the back of the sofa. Additional lengths will be needed for cutting the front pieces and the cushions.

Price of the fabric needs to be sourced prior to this point, unless it was sourced during quickie costing. Accuracy at this point is important to yield an accurate product cost. The cost of the fabric as sourced is multiplied times the yardage for the **fabric yardage cost** (see Figure 14–2).

Quality Considerations for Fabric Costs

Fabric decisions and pattern development are first done relative to the standards set in the idea development stage, according to company policy and target consumer expectations. Fabric standards are finalized in the line development stage. As fabric is sourced and changes are contemplated, these standards must be constantly reviewed and compared with potential fabric selection. If the fabric cost is too high, the product development team may contemplate design changes to reduce fabric yardage rather than reductions in cost from inferior fabric. Fabric yardage for the product is relative to size and shape of pattern pieces, which affect the fashionality and fit of the product. Size, shape, and combination of pattern pieces also affect the fabric utilization of the marker. Although the production marker will be more efficient than the minimarker because of the mix of sizes within a production marker, the minimarker should provide a good first estimate of the fabric use.

Type of fabric can also affect fabric utilization and, therefore, costs. Fabric with a nap such as velvet or corduroy or with a pattern such as buildings, words, or trees requires directional placement of the pattern pieces. Fabrics with an obvious weave or knit can also require directional pattern placement. A marker for use with directional fabric has much lower fabric utilization than a plain fabric. Under these conditions, the cost of fabric becomes a major factor in the cost of the sewn product. Labor for maker

making and cutting would also increase. Outcomes of the product are affected by pattern and fabric decisions. These decisions control the cost of the fabric but also affect the product quality. When selecting the fabric the designer must consider the expectations of the consumer. If adjustments are needed in fabric because of the final price, decisions must be made while considering cost as well as quality.

Findings Costs

Findings for the product include thread, closings, trims, and all other materials needed to complete the product, such as bows, buttons, appliqués, embroidery, zippers, and pockets. Although findings can contribute extensively to the cost of the product compared to the size of the items, designers often consider findings the essential component of the design. These items may create the "pop" that the product needs to be a best seller, or may be expected by the consumer because of the brand, image or product price.

One finding that needs specialized costing is thread. Thread is a critical expense for many products, especially with competitive pricing. To calculate the thread usage and the cost of thread for a sewn product, the cost estimator needs to know the stitch to seam ratio of the stitch type being used, the average seam length in the product and the cost of the thread. The **stitch to seam ratio** indicates the length of the thread needed to sew one unit length of a seam. Stitches vary in thread usage from a low of about three times the stitch length to over ten times the stitch length. Stitch to seam ratio of a low number 500-stitch is a 4-to-1 ratio, which means that the thread usage is four lengths for each length of stitching or seaming. When measuring in inches, the 4-to-1 ratio is 4″ of thread for 1″ of stitching. If the seams are measured in inches the calculation must be converted to yards by dividing by 36″ (Figure 14–12).

Thread usage is determined by calculating the stitch to seam ratio relative to the seam lengths of the total product. Average stitch lengths and other stitch characteristics are assumed, or some variation must be entered to account for changes from the average. Thread usage can also be estimated using standardized charts available from several thread companies (e.g., www.amefird.com). An additional way of estimating thread usage is to measure actual usage. To implement this method, a product would be sewn and then taken apart. Each thread piece would be saved and measured. Upper threads, bobbin threads, and any secondary threads as needed for a stitch formation must be included in the measurement.

Figure 14–12 Thread usage.

- Thread Usage =
 - (Stitch to Seam Ratio × Length of Seams) ÷ 36

Figure 14–13 Thread cost.

> - Thread Cost =
> - Thread Usage × Cost of Thread per Yard

To complete the calculations for thread cost, the cost estimator must know the cost of and thread amount on an industrial spool. The yardage on the industrial spool is divided into the cost of the spool to obtain the cost of one yard of thread. This cost is multiplied times the thread usage to find the cost of the thread needed for one product (see Figure 14–13). When combined or summed together the cost of a label, thread, trim, and other findings become the findings cost.

The costs for most other findings, such as buttons, zippers, and bows can be calculated by taking the number of items needed and multiplying times the unit cost of one item. For trim, the unit cost is given in inches, feet, or yards, depending on the trim. The length of trim needed would be estimated from the sketch or dimensions for current or previous products. Adjustments to length would need to be made to convert inches to feet or yards, depending on the unit costs. The cost of the trim would be calculated by multiplying the length dimension times the unit cost per length (see Figure 14–14).

In addition to buttons, zippers, and other findings, most sewn products by law in many countries must have labels such as ones to identify country of origin, fiber content, and care instructions. These may be printed on the fabric or a label may be permanently affixed to the product.

Quality Considerations for Findings Costs

Thread can have a major impact on the cost, appearance, and durability of the product design. Although the cost of thread for one product unit is very small, the impact of this cost can be particularly prominent when the thread is used on a product that must be sold at a discount or low price point. This cost can become a further concern on products that require complex stitching or thread intensive stitches for seam security or product design. As discussed in Chapters 6 and 8, thread usage is affected by stitch type, stitch length, stitch width, and encasement dimensions. Increases in width and encasement may improve functional outcomes of the product such as durability; however, they contribute to higher thread utilization. In contrast, an increase in stitch length (i.e., making a longer stitch) makes a weaker stitch for holding a seam but reduces the thread usage. Higher numbered stitch classes and higher numbers within each class generally use more thread than

Figure 14–14 Calculation for trim costs.

> - Cost of trim =
> - (length of trim in inches ÷ 36″) × cost of trim per yard

stitches from lower numbered classes or from lower numbers within a class. The holding power of the stitch, with regard to grin, tensile strength and other measures generally increases as the class number increases.

The choice of stitch type and the exact characteristics of the stitch can vary depending on the targeted price of the item and on consumers' expectations. For example, a sweatshirt is a relatively simple garment in pattern pieces, but for seam security, this product can be sewn with a safety stitch that requires extensive thread utilization. Or, the seams can be coverstitched for flatness and style. This additional stitching requires additional thread. The total thread usage for a sweatshirt may be as high as 30 yards because the average sweatshirt has 18 feet of seams, and the coverstitching and the safety stitch use thread at a 5-to-1 ratio.

Thread usage is a consideration that affects costs, manufacturability, and quality issues. Stitch classes with high thread utilization may require that the manufacturer purchase lower cost thread to compensate for the higher usage. Lower cost thread may affect performance characteristics of strength, durability, and abrasion resistance. A less complex stitch may be used, but this may also reduce strength and durability of the seam. In addition, grin is more often a problem with less complex chain stitches. The decisions for cost must be weighed relative to the decisions about meeting consumers' expectations in other outcomes for a product.

Miscellaneous Costs

Miscellaneous other charges may be added to the product cost. Some of these items may be "signature" additions by the company, may be required by law, or may be added at the request of the customer. For example, hang tags and specialized packaging may be requested by the customer, and may be added into the cost of the product and itemized separately. The addition of other informational tags required by law may be itemized so that the addition of the tags is clearly visible to anyone who reviews the product cost. Packaging each item in a poly-bag or adding a hangtag with the company Web site may be items that are signatures of the company's products and may be itemized in miscellaneous costs.

Total Manufactured Costs

Regardless of the exact content, the costs of fabric and findings, as well as miscellaneous costs, are added to the total labor cost. The result is the **total manufactured cost (TMC)** (see Figure 14–15).

Overhead Costs

After finding TMC, the manufacturer adds an overhead to complete the cost of the product. This **manufacturing overhead** is needed to cover profit

Figure 14–15 Summation of costs to equal total manufactured cost.

- Fabric costs
- + Findings costs
- + Labor costs
- + Indirect labor costs (% of labor)
- + Miscellaneous costs
- = Total Manufactured Cost (TMC)

and other costs of running the business. These costs may include fixed or variable expenses such as salaries and expenses, design costs, rent, heat, insurances, and supplies. Overhead dollars for these administrative expenses and profit are calculated by applying a percentage based on total manufactured costs. The administrative costs can include salaries and expenses for plant managers and the activities of marketing, merchandising and selling. Design development costs are often included in the administrative overhead costs. For most manufacturers, these costs are also expressed as percentages and rarely calculated as a composite of the individual expenses. Individual expenses associated with design or other administrative functions are often not itemized or reviewed. Overhead cost can be calculated by multiplying the overhead percentage times the TMC (see Figure 14–16).

Figure 14-16 Overhead cost.

- Overhead Cost =
 - TMC \times Overhead Percentage

Wholesale and List Prices

After calculations for raw materials, labor and overhead, the wholesale price is found by summing the TMC (i.e., raw materials and labor) with the overhead cost. This final wholesale price is often doubled to create a manufacturer's SRP, as was done with the quickie wholesale price (see Figure 14–17) and may be rounded to a standardized company price point.

The simple top that was costed by the quickie method can also be costed using this cost-plus method. The calculations that use this method are shown in Table 14–3. The wholesale price would be doubled to achieve a SRP of $11.60. Many times both calculation methods are used—the quickie method is used during the idea or line development stage and the cost-plus method is used during the production development stage. In addition, these prices may be reviewed relative to company standards and to estimated market pricing. The wholesale price of $5.80 from the cost-plus method

Figure 14–17 Wholesale and retail prices.

- Wholesale Price =
 - TMC + Overhead Cost
- Suggested Retail Price =
 - Wholesale Price × 2

is very similar to the quickie wholesale price of $5.04 (see Figure 14–4). The amount of trim for the shirt is a large expense that was added to the fabric costs in the cost-plus method and accounts for most of the difference in the price. The calculated labor and the quickie estimate of labor are very similar (i.e., $1.56 vs. $1.68).

Table 14–3
Spreadsheet for Costing a Simple Top by the Cost-Plus Method

Items	Explanation		Total
Direct Labor	Standard labor • 20 min ÷ 60 min per hr = 0.30 hr • $4.00 per hour × 0.30 hour = $1.20 Excess labor • $1.20 × 15% = $0.18	$1.38	
Indirect Labor	$1.38 × 45% = $0.18	$0.18	
Total Labor			$1.56
Fabric	Use one width • 10″ + 12″ + 12″ = 34″ • 34″ < 60″ Longest block • 24″ Yardage length • 24″ ÷ 36″ = 0.67 yard Fabric cost • 0.67 yards × $2.50 per yard = $1.68		$1.68
Findings	Thread	10.89 yards × ($25.00 ÷ 15,000 yards) • 10.89 yards × $0.0017 = $0.02	
	Trim	44″ ÷ 36″ × $0.50 per yard • 1.22 yards × $0.50 per yard = $0.61	
	Label	$0.02	$0.65
Miscellaneous	Preticketed		$0.03
Total Manufactured Costs (TMC)	$1.56 + $1.68 + $3.09 + $0.03 = $6.36		$3.92
Overhead	$3.92 × 48.00% = $1.88		$1.88
Wholesale Price	$3.92 + $1.88 =		$5.80

Quality Considerations for Wholesale and Retail Prices

At the end of the costing procedure, the marketing team or other administrative personnel may announce that the product is too costly for the target market—in other words, it would not meet the customer's expectations. When the detailed cost is higher than the planned or estimated cost, the result is a **cost overrun.** For example, the simple top in the cost-plus method was $5.80 or $0.76 higher than from the quickie cost method. At this point, product development activities, including manufacturability, and other processes affecting costing will be reexamined to determine what can be altered to maintain the company's theme or brand's image and outcome characteristics of the product while reducing the cost. As an alternative to rework or repricing, the product may be removed from the line. The dropout rate of concepts or products from idea development to premarket preparation is high, especially among companies without a quality analysis process that includes in-process checkpoints evaluated with clearly defined standards and specifications.

Recosting to Meet Quality and Cost Standards

Reducing Raw Materials Costs

Raw materials are the items most often reviewed for cost reduction. For most sewn products, raw materials, including fabrics and findings, usually account for one-third to one-half of the total product cost. The raw materials' costs are direct and easy to track. The first materials, usually examined for recosting, are the findings. Items, which are easy to rework or replace, include bows, buttons, appliqués, embroidery, zippers, and pockets. Although easy to see and to remove, changes in findings are often resisted by sewn products designers who may consider the findings the essence of a design and important in meeting the company's or customer's specifications.

For example, bows can be reduced in size, made of less expensive fabric, made by alternative methods, or removed from the design. Custom-made bows of high-quality fabric would be the most expensive solution. Premade bows of standard quality fabric would have a lower cost. The simplest and lowest cost solution is to remove the bow; however, the look of the design could be drastically altered by the removal of the finding. Such a change may be in contrast to the information that was collected early in the product development process about the customer's expectations. Although the rework or removal may be cost effective and valid, suggestions to reduce or remove findings may have negative effects on the salability of the item.

Buttons are additional findings that are replaced easily. Buttons vary in composition from very inexpensive plastic to very expensive bone, wood, stone, or metal. The designer may have selected a button for its distinctive color or shape. If this look can be reproduced in a less expensive material, the exchange

may be quickly made. The replacement of bone or mother-of-pearl buttons with plastic can be done often with sizable cost differentials and with limited appearance change. Plastic buttons also vary in price with custom color matching or simulated stone or pearl buttons being more expensive and stock colors or white buttons being less expensive. Another solution to reduce costs may be to reduce the number of buttons. If a closure has six buttons along 16 inches, the solution may be to have only five buttons in the same linear space. This reduction eliminates the cost of one button and the cost of manufacturing one buttonhole. Objections to this solution could be made from the product development team. They may argue that respacing the buttons changes the look of the design. Objections may also be made by the product manager that respacing affects the fit and security of the closure. Each cost reduction must be carefully evaluated for the resulting effects on fashionality, fit, or functionality and the consumer's expectation of these dimensions.

Fabric is the second area that is often investigated for easy cost reductions; however, **fabric replacement** with a lower cost fabric is not a simple solution to a cost overrun. The initial selection of fabric is made usually with considerable time investment. Resistance to fabric changes, from designers and product managers, is based often not on investment costs but on the impact of the change on the overall design and the lack of quality in the ensuing product. Color and the external appearance of the sewn product is a major factor in consumer selection.

Reduction in fabric utilization can be an alternative cost reduction method to fabric replacement. Removing a seam can reduce the fabric utilization. Typically, 1″ to 1¼″ of fabric width per seam is saved by seam removal such as removing a back seam in a skirt and placing the zipper in the side seam. However, this saving can be offset by the need for wider fabric or two lengths of fabric for an exceedingly wide pattern piece. Removing a back seam may also alter the fit outcome of the product. Changing the shape of a pattern piece is another way to reduce fabric utilization; however, fit and fashionality would be affected. The amount of ease in a sewn product is associated with the fit of the item. Maintenance of a standardized fit is important in a branded product and necessary for meeting customer expectations for a quality product. Changes in fabric and product design must be made with caution.

Another consideration in changing pattern design and fabric utilization is that changes in pattern size and shape may reduce the overall size of the pattern piece. In addition, the size of one pattern piece is relative to the total fabric usage of all pattern pieces and the layout of the pattern pieces on the fabric. After a redesign of a pattern piece, the change could be multiplied into a significant fabric savings or it could be insignificant. If a small change in a pattern piece could be used to reduce the overall marker length, a savings of fabric yardage could occur. If the change would result only in unused fabric width but no reduction in fabric length, the change would not be beneficial.

Another savings can be gained in a **reduction in ease** in a sewn product. A sewn product has a certain amount of ease or extra space in the diameter

of the item. The fullness in the skirt on an upholstered chair or the amount of gathers in the skirt of a dress can be varied according to the design ease for the product. A one-quarter inch reduction in design ease could result in a significant savings in fabric utilization across a high volume product order. If the product has high brand recognition, the product manager may resist this method of cost saving. The amount of ease in a sewn product is associated with the fashionality or look of the item, and in apparel with the fit of the item. Reduction of ease that affects wearing ease or fit can have a negative impact on the perception of quality for an apparel item. Standardization of fit is important in a branded product. In sewn products that lack brand recognition, the reduction of ease may be more acceptable to the customer. This cost solution is used frequently in budget and moderate price lines.

Type of fabric can also affect costs. As mentioned previously, napped fabric or fabric with directional prints are more expensive to use because they require extra fabric for color or pattern matching and extra labor for cutting. Although fabric is a large part of product cost, extreme changes in fabric type or fabric print would be unlikely because the print or surface treatment of the fabric is an integral part of a product's fashionality outcome. If the estimated cost of the item were over the target price point, a product that depended totally on print or fabric surface for fashionality would probably be dropped from the product line. An alternative to product removal might be the use of the more expensive fabric in one portion only of the product or for trim instead of base fabric. This choice is also true for fabric that is extremely expensive in yardage costs. For example, a fabric with a high percentage of cashmere might be used for trim; whereas, the base fabric might be regular sheep's wool.

Reducing Production Costs

If simple replacements or adjustments in raw materials do not bring the estimated cost within the specified price point, more extensive design modifications must be undertaken. **Removal of a seam** for fabric utilization was discussed in the previous section. The second savings in seam removal would be in labor time. If a seam was removed from the design and replaced with a pattern piece on a fold of fabric, the SAMs needed to sew the seam would also be removed from the labor calculations. Because most overheads are based on total labor, the removal of the seam could have a cascading effect in cost reduction. For this reason, seam removal is often suggested by those persons who are interested only in cost reduction. This cost-cutting method is not desired by most product developers because seams are used for many of the product outcomes including style and exterior shape or silhouette for fashionality and product fit. Few seams are used without a design reason. If cost cutting requires seam removal, the fashionality and fit of the product would have to be reevaluated. If fit were affected, the same restrictions would apply as with changes in ease. Other sewn product features can be examined for both fabric utilization and production time.

Unique or new designs can increase production costs in many indirect ways. A product that differs from previous products can affect line balance and sewing worker use in production. With the PBS method of production, the maintenance of line balance becomes an important consideration. If a product requires many detailed operations or equipment that is in short supply, the production supervisors may have difficulty in getting the line in-balance and in maintaining the quality of the work. If workers are not cross-trained, the plant will have workers who are overutilized and those who are underutilized. Many specialized operations in construction require training times of 6–18 months for an untrained operator to reach production speed. If the product is seasonal, the selling season will be passed before new operators can be trained to production speed and product quality to improve line balance. Contract work is a possible solution, but this solution also has time delays for negotiation and logistics of timing the return of parts to the production line in time for deadlines, and expected quality would have to be specified and met in samples before production could begin. Shipping to a contractor is costly and has potential for delays and quality defects. If offshore contractors are used, the direct costs may be reduced but indirect costs rise. Reduction in labor costs may offset increased shipping and handling costs; however, the complications of clearing customs, maintaining quality, and other language or currency restrictions must be managed when contracting offshore.

Even simple designs may exceed the capabilities of the sewing workers or may cause confusion in assembly, which results in unmet quality with the need for rework. For example, most sewn products are symmetrical in design. Asymmetrical designs or designs with large variation between the left and right sides can create major quality control problems. For example, an upholstered product with one red arm cover and one blue arm cover has a large impact on production. The red cover requires red thread, and the blue cover requires blue thread. The normal operation is to sew two covers in alternating pairs. With the two colors, the thread would have to be changed between each cover. An obvious solution is to sew all red parts and then to sew all blue parts. This solution affects line balancing and work flow. If the red and blue arm covers were sewn at the same time, two machines and two operators would be required in place of the usual one machine and one operator. The equipment and personnel are probably not available. If the red arm covers are sewn sequential to the blue ones, the rest of the upholstery must wait until all red and some blue parts are sewn, which creates large bundles of work-in-process.

Finding a solution that meets the product development team's plan, the required price point, and the production facility's capabilities is often difficult but necessary in meeting customer expectations of a quality product. Because the look of the product is the main selling point, product development teams for sewn products are often unwilling to make even the smallest changes. Rework time can be extensive until all aspects of the specifications are met, including price. The product development team of the average sewn products manufacturer will spend four to six additional weeks on product changes to bring the sewn product within target price points. When evaluating costs of alternative solutions, most sewn products manufacturers consider

only the direct costs of these changes. For example, the price difference between two buttons or the cost reduction of bow removal would be a direct cost for materials. The personnel costs of searching for alternatives and the costs of delays for rework are not included in the decision and are rarely tracked. However, these costs do ultimately add to the cost of the product through indirect costs, excess costs, and overhead. Additional costs of rework include delays that may result in lost sales, termination of business partnerships, and products that remain unsold at the end of the season.

Activity Based Accounting

Within any costing system including the cost-plus method of costing, **activity based accounting (ABA)** can assist the manufacturer or retailer to track all costs associated with a product and in turn to improve product quality. ABA tracks each activity as needed to produce a product and assigns a value to that activity. The spreadsheet for this type of accounting would look more like a set of processes with associated costs than the current spreadsheets that are divided into the three categories of labor, raw materials, and overhead. ABA would require manufacturers to investigate the daily operations of administrative and support staff and evaluate what their contributions are to the eventual production of a product. Such analysis is highly compatible with quality practices such as TQM and Six Sigma.

The big difference that would be seen in the costing of products would be in the overheads assigned to product. For example, carry-over products or those that are revisions of successfully selling products from previous seasons would require much less product development time than completely new products. The overhead assigned for revising a product should be less than the overhead for developing a new product. The ABA system would account for these differences. Maintaining quality for carry-over products may also be easier and less costly because of the established specifications and the potential feedback from consumers from the sales during previous seasons.

Future for Sewn Product Costs

Some sewn products manufacturers purchase forecasting services, marketing reports, and focus group records to better predict the sell-in of products, to reduce the number of unused designs, and to predict more adequately the expectations of consumers. The results of these prediction techniques are rarely evaluated, and the industry is undecided about the value of these efforts. Many manufacturers and retailers assume that the sewn product is a

shopping product and that an excess of product is needed to provide a selection range for the consumer. Unused designs are considered part of the cost of doing business. Studies show that the assumption about consumers needing a range of products to enable selection is true; therefore, some excess product development work is necessary. Even using customization methods and a consumercentric product development process, customers will still expect some choices to enable their visualization and may request some changes and reiterations before the product meets their expectations.

Other product development overhead may not be necessary in the future. Remake of samples, redesign of products, and other preproduction rework may be caused by the sequential product development process, the lack of in-process quality practices, or unclear specifications. The traditional approach is that designers design and someone else worries about cost and manufacturability. Costs in product development team's time, sketch materials, sample fabrics, pattern maker's time, and sample hand's time have been incurred before anything but the quickie costing is derived. Rework after the sample has been made is more expensive than rework at the idea or line development stages. Earlier and more accurate costing is needed, along with clear and well-developed specifications. Methods for inexpensive but effective rapid prototyping are needed. All samples are traditionally made full size and in actual fabric to capture the correct look, fit, and feel of the sewn product. Substitutions with paper, on the computer, and in miniature are not generally accepted as satisfactory replacements. Color image and fabric texture are very hard to quantify. At present, no replacement exists for the evaluation with the hand and human eye of a sewn product; however, advances in technology are being made in the use of 3-D imaging and in color reproduction through computer and other digital equipment. Even with improvements in computerization of the sewn product image, acceptance of these methods is slow. Consumers buy sewn products both with their hands and their hearts. The complete substitution of the actual sewn product, either in sample or merchandise selection, is still an illusive dream for most products, most companies, and many consumers. The growth in sales of products through the Internet and with catalogs, where products may exist only in pictures until ordered, shows that change can occur. However, in an industry where costing is still rule of thumb and overhead is on a percentage basis, room for improvement exists.

Key Terms

Activity based accounting (ABA)	Direct labor	Fabric yardage cost
	Excess labor	Fabric yardage estimate
Cost estimator	Excess fabric yardage estimation	Indirect labor
Cost overrun		Manufacturing overhead
Cost-plus method	Fabric replacement	Market price

Market-price method
Minimarker
Pattern blocks
Preliminary price
Price line
Price points
Quickie costing
Quickie price
Reduction in ease
Reduction in fabric utilization

Removal of a seam
Retail list price
Rule of thumb costing
Selvages
Standard allowable minutes
 (SAMs)
Standard labor
Stitch to seam ratio
Suggested retail price (SRP)
Target price

The method
The method book
Thread usage
Total labor costs
Total manufactured cost (TMC)
Type of fabric
Wholesale price
Yardage

Review Questions

1. Why is finding the perfect product design difficult for a manufacturer?
2. What is the time line of activities and cost outlay for a sewn product from idea to retail sale for manufacturers?
3. How is a quickie cost calculated?
4. What are the three main components in a sewn product price and what are their relationships?
5. What is the procedure for calculating market-price costs?
6. What skills does a price estimator need when doing market-price costing?
7. What is the basis for most calculations in cost-plus costing?
8. Why is cost-plus costing the most popular form of costing?
9. How are SAMs determined?
10. What are some average product assembly SAMs?
11. Explain the calculation for standard labor.
12. What are the costs directly and indirectly related to outsourcing of assembly?
13. Why do excess costs happen?
14. What is included in indirect labor costs?
15. How does product width or the width dimension of a single pattern piece affect fabric utilization?
16. What are pattern blocks?
17. What affects fabric utilization?

18. Why is fabric width important in costing and producing a sewn product?
19. How is the fabric utilization for a sewn product estimated?
20. How can type of fabric affect fabric costs?
21. Explain the basic calculation for costing of findings.
22. Explain the basic calculation for costing thread.
23. How does the choice of stitch type affect thread utilization, product quality, and price?
24. What miscellaneous charges may be added to the product costs?
25. Why is departmental and administrative overhead needed in cost calculations?
26. How are total manufactured costs calculated?
27. What is included in the wholesale price?
28. How can raw material costs be reduced? How may this affect the quality of the product?
29. How can labor and other production costs be reduced? How may this affect the quality of the product?
30. What are the benefits and costs of using an activity based accounting system for a manufacturer?
31. How can technology reduce costs?

Index

10 point system, 117
100-stitch class, 183–184
101 LSa-1 seam specification, 216
2-D diagrams, 33
 product specifications, 262
 seams, 206
 stitches, 178
2-ply yarn, 78
3-D diagrams, 33, 206, 262
300-class stitch, 184, 196
304 stitch, 184–185
301 stitch, 208
3-ply thread, 140
4 point system, 117
400-stitch class, 185
401 stitch, 208
406 stitch, 186
4-ply thread, 141
5 S, 18, 304
500-stitch class, 187–188
504 overcast stitch, 187
516 stitch, 188
600-stitch class, 188–189
604 stitch, 188
601 stitch, 189

AATCC (American Association of Textile Chemists
 and Colorists), 34
 outcome tests, 84
 sewn product production process standards, 149
 tests, determining appropriate, 94
Acceptable quality level (AQL), 171
Account executives, 66
Activity based accounting (ABA), 349
Administrative overhead costs, 343
Air and water transfer, 86
Airborne health and safety issues, 107

Air table, 154–155
American Association of Textile Chemists and
 Colorists. *See* AATCC
American National Standards Institute (ANSI), 34
American Society for Quality (ASQ), 34
Ankle, evaluating fit at, 239
Appearance retention, 94
AQL (acceptable quality level), 171
Armscye, 255
Assembly
 balance the line, 166
 inspection during and after, 167–169
 kanban system, 166
 materials transport methods, 164–165
 modular system, 166
 production system, 165
 progressive bundle system (PBS), 165
 quality considerations, 167–169
 sample system, 166–167
 sewn product production processes, 149
 stage in production, 149
 work-in-progress, 165–166
ASTM
 body landmarks, 281
 fabric defects, list of acceptable, 102
 fabric fashionality test, 90
 fabric functionality standards, 86–87
 findings test methods, 127–128
 outcome tests, 84
 sewing machine stitch information, 181
 sewn product production process
 standards, 149–150
 stitch standards, 179, 205, 274, 276
 Subcommittee D13.66, 33–34
 tests, determining appropriate, 84
Asymmetrical body, fit and, 242–244
Automated spreader, 153–154

Average line, control chart, 313
Averages, calculating, 290

Backlighted inspection table, 100–101
Back tacking, 195
Balance
 back-to-back, 244
 fit standards, 242–245
 front-to-back, fit, 243–244
 stitch, 192–194
 thread tension, 192
Balance the line assembly, 166
Bar tacking, 196–197
Barré color problems, 112–113
Base fabric
 findings versus, 122
 seams, maintaining thickness of, 207–208
 trim versus, 146–147
Basic bodices, 48
Basting stitch, 190–194
Bed linens, grading (patterns), 273
Bell-curve, variance for SPC control chart, 315
Bias (fabric)
 grain, fit standards, 240–241
 in-process errors, 105
 spreading, 155
Bias (statistical), testers' tendency for, 37
Bimodal, 294
Bite, stitch, 192
Blindstitch hem (EFc), 226
Blunt needles, 199–200
Bobbin, 181, 182
Bodice, shirtwaist dress, 254–255
Body dimensions, fit specifications, 279, 281
Body landmarks, ASTM, 281
Body scanning, 234, 257–258
Body sketch, fit specifications, 279–280
Bound buttonhole, 131
Bound seam (BS)
 described, 212–213
 quality considerations, 213–214
Bow error (fabric)
 in-process errors, 105
 spreading, 155
Bows (finding)
 costs, 341
 reducing to meet quality and cost standards, 345
Brand
 colors, 56
 products, 29
 quality and, 2–3
Break, trousers or tailored pants, 248
Broken ends, 109
Broken picks, 104, 109–110
BS. *See* Bound seam

Bundling
 bundles, 162
 overhead conveyor system, 164
 process, 162
 production costs, reducing, 348
 quality considerations, 164
 stacked pieces, 163
 tie operators, 163
 unit production system, 164
Buttonhole
 bound, 131
 choosing, 131–132
 horizontal, 133
 horizontal placement, 133
 keyhole, 131
 oval, 131
 placement, 132–133
 shape, 131
 size, 134
 straight, 131
 vertical, 133
Buttons
 cleanability and appearance retention, 132
 costs, 341
 fashionality, 124
 with holes, 130–131
 horizontal placement, 133
 outcomes and quality considerations, 127–132
 placement, 132–133
 postcare, 132
 reducing to meet quality and cost standards,
 345–346
 with shanks, 130–131
 tailored jacket, 251
 vertical placement, 133

CAD drawing, 194–195
Care. *See* Postuse care
Carry-over style, 59
Catalogs
 market presentations, 67
 size specifications, 271
Cause and effect diagram, 301
Census, data collection by, 37
Chain stitch, 179, 183–184
Chaining off stitches, 195–196
Checksheets, quality analysis, 302–304
CIELAB system, 91
Classifications, sewn product, 7–10
Cleanability and appearance retention. *See* Postuse care
Clean finish hem (EFb), 226
Clip mark, finish errors, 110–111
Clothing. *See also individual items of clothing listed
 by type*
 fit, 229–230

Coefficient of friction, thread, 141
Collar stays, 143–144
Collar with a band, tailored jacket, 249–250
Color
 application or dyeing procedures, 92–93
 criticality of the defect, 114
 fabric property, 80
 fashionality tests, fabric ,90–92
 matching, 91–92
 theme, 49
 thread, 142
 viewing and matching, accuracy of, 96
Coloration finish error, 112
Color board, 49–50
Color fastness
 thread, 141
 tolerance for variance, 308
Colorways
 company policy, 55–56
 fabric and findings specifications, 269
 line development, 51, 52
Comfort
 fabric functionality standard, 87
 labels, 145
Communication specifications, quality analysis tools, 287–288
Company standards
 colorway policy, 55–56
 croquis, 55
 for fabric quality, 54–55
 specifications, 31
 standards, publishing, 34
Competition versus cooperation between trading partners, TQM and, 19–20
Complexity of design, manufacturability and, 63–64
Complex
 yarn, 78
 ply, 78
Computer software. *See also* Statistical process control
 cutting, 159–160
 fit measurement extraction, 234
 grading packages, 273
 idea development, 47
 line development, 54
 markers and plotters, 152–153
 marker specifications, 274
 product data management software, 263
 specification buying, 263
 spreadsheet, 307
 tools, 54
Concatenation, stitch, 179
Concept boards, 48–49
Conformance to requirements
 definition of quality, 3
 process of, 28

Consistency
 fit, 231
 tolerance for variance and, 308
Construction of fabric, 80–81
Consumer, 5, 28
 being consumercentric in quality environment, 13–17
 conflicting outcomes and inconsistencies, 12–13
 feedback, 13
 findings, quality expectations for, 128–129
 fit, 256–258
 input, 15–16
 quality, image on, 4
 satisfaction, 42
Consumercentric
 diagram, 15
 firm, 16, 29
 fit, 257
 process, 15
 sewn products pipeline, 15
Continental fly, 137
Continuous improvement, total quality management (TQM), 19
Contractors, 60
Control charts
 described, 312–313
 upper and lower control limit, 313
 variance, importance of controlling, 309
Controls, on the line, 48
Cooperation, trading partners, 19–20
Cord, thread ply, 139
Cording, 224
Corduroy races and wales, 112, 113
Corrective action, 325–326
Cost estimator, 330
Cost overrun, 345
Costing
 activity based accounting, 349
 cost-plus method, 334–345
 as critical decision, 329–330
 criticality of the defect, 115, 116
 described, 329
 future, 349–350
 market-price method, 332–334
 production, adjusting, 347–349
 quickie, 330–332
 retail price, 60
Cost-plus method of costing
 calculations, 334
 fabric costs, 337–339
 findings costs, 340–341
 labor costs, 335–336
 miscellaneous costs, 342
 overhead costs, 342–343

Cost-plus method of costing (*continued*)
recosting to meet quality and cost standards, 345–349
spreadsheet sample, 344
total manufactured costs (TMC), 342
wholesale and list prices, 343–344
worksheet, 334
Cotton
airborne health and safety issues, 107
needle heating, 201
U.S. Department of Agriculture fiber standards, 75
Cotton Incorporated, 55
Courses, knit, 81
Coverstitch, 178, 188
Crimp, thread, 139
Criticality of the defect
cost, 115
pattern piece size, 115–116
placement and discovery timing, 114–115
Croquis, 52–53, 279
Crosby, P., 3, 20, 28
Cross-section, fiber, 73
Crotch length and rise, fit standards, 245–246
Customer
meeting expectations, 3, 31
quality image, matching to product, 10
satisfaction as part of TQM, 22
specifications, defects versus, 102–103
tolerance for variance, 308
Customization of sizes and fit, 257
Customized product forms, 55
Cut and sew specifications
described, 274
sample, 275
seams, 276–277
stitching, 274, 276, 277
Cut order, 152
Cut order planning, 152, 274
Cut parts, 157
Cutting
computer-driven and quality considerations, 159–160
dies and quality considerations, 160–162
knife cutting and quality considerations, 158–159
of patterns and fabric into cut pieces, 157
tolerance, 157
Cutting table
bundling, 162
multiple ply cutting, 114, 153–154
single or low ply cutting, 154, 160

Dart, shirtwaist dress, 253, 254
Dart tip, shirtwaist dress, 253, 254

Data
point, quality analysis tool, 289, 316
tests, 40
Data evaluation
standards, 41–42
tester, 41
Data set
mode for, 290–291
quality analysis tools, 289
statistical process control, 309–311
DDD-S-751 stitch standard, 178
Defect flagging
computer map, 118
described, 117–119
metal sticker, 118–120
plastic flag, 117–118
Defect prevention
before they occur, 120
final inspection, 120–121
in-process inspection, 120–121
reinspection, 121
Defects
ASTM list of acceptable, 102–103
final inspection, 102, 170
flagging during fabric inspection, 100–102, 117–119
seams, 217–223
stitches, 197–202
Degradation, fabric functionality dimension, 86
Demand uncertainty, 66
Deming, W. E., 21–22
Density, fabric, 80
Descriptor characteristics, 73
Design development overhead, 343
Design ease, 238, 281–282
Design process reiterations, 53
Design specifications
complexity, manufacturability and, 63–64
described, 265
fabric sample and findings, 267
production costs, reducing, 348
sample, 266
Designer-approved sample or prototype, 60
Diameter, thread, 139, 142
Dies, cutting, 160–162
Digital images, fabric and findings specifications, 269
Dimensions, fabric swatch, 35–36
Direct labor costs, 335–336, 344
Direction, stitches, 191–192
Distribution channel, 5
Distribution curves, 294
Double vent, tailored jacket, 252
Draping, 53
Drawing samples, 35
Dry haul spreading, 155
Duplicate samples, 66

Dups, 66
Durability
 fabric functionality standard, 87
 labels, 145
Dyeing procedures, 92–93
Dynamic links, fasteners as, 128

Ease
 design ease, 238
 reducing to meet quality and cost standards,
 346–347
 reduction, 346–347
 wearing ease, 239
Easily understood standards, 31
Edge finishing (EF)
 described, 225–226
 quality considerations, 227
 stitching, 223
Edges for a, b, or c designation seams, 206–207
EF. *See* Edge finishing
EFb (clean finish hem), 226
EFc (blindstitch hem), 226
Elastic fit, 125
Elasticity, thread, 141
Electronic access tools, idea development, 47
Electronically communicable standards, 33
Elongation, thread, 141
Encasement, stitch, 192
End out, 103
End use, 8
 evaluation, 9
Ends,
 defined, 80, 103
 broken, 109–110
End-to-end consistency, 92
English system, 32
Equipment, testing, 39
Evaluation of data, 41
Excess costs, labor, 335
Excess fabric yardage estimation, 339
Excess labor, 335
Excessive returns, 324
Expectations
 of consumer, 28
 determining, 28–30
 findings, 125–128
 interpreting, 30
 of quality, 6
External customer, 5, 28

Fabric
 alignment error, 104
 company standards on quality, 54–55
 construction, 80
 costing, 344

 defects versus customer specifications, 103
 defined, 79
 design specifications, 267
 development and production, 13
 direction, spreading, 155
 fashionality standards, 87–89
 fit standards and tests, 88–89
 functionality standards and tests, 85–87
 grading, 116–118
 inspection, 99–102
 nap, with, 156
 needle heating, 200–201
 reducing yardage to meet quality and cost
 standards, 346
 replacement with lower cost, 346
 seam slippage, 218
 spreading with a nap, 156–157
 swatch, sample, 35–36
 type, changing to meet quality and cost
 standards, 347
 yardage cost and estimate, 329–331
Fabric costs
 excess fabric yardage estimation, 331, 339
 fabric yardage cost, 339
 minimarker, 337
 pattern blocks, 337
 percentage of product cost, 337
 quality considerations, 339–340
 selvages, 337–338
 yardage, 338
Fabric defects
 criticality, 114–116
 defined, 102–103
 finish errors, 110–114
 in-process errors, 104–110
 set-up errors, 103–104
Fabric inspection frame, 100
Fabric inspection machine, 100
Fabric specifications
 colorways, 269
 digital images, 269
 sample, 268
 testing procedures, 269–270
Fabric standards
 knit types, 82
 names listed by weave or knit types, 81–82
 outcomes from multiple contributing
 components, 79–80
 quality considerations, 82–84
 weave types, 80–81
Fabric, unrolling and pulling along long, flat table.
 See Spreading
Face of fabric, 81
Failure, findings, 126
Fashion model, ideal, 55

Fashion sketches, 53
Fashionality, 12
 demand uncertainty, 66
 fabric fuzzing or pilling, 94
 final inspection and, 174
 findings, 124
 fit, 230, 231
 fit models, 234
 labels, 145
 seam standards, 208–209
 sewn product system, 11–12
 thread, 138–139
 variance, allowable, 308
Fasteners
 as dynamic links, 128
 general quality expectations, 128–130
Federal Standard No. 751/751a, 178
Federal Standard: Stitches, Seams, and Stitchings,
 178–179
Feedback, consumer, 13
Felled or flat felled seam, 211
Felt under-collar, tailored jacket, 249
Fiber
 content and price, 297
 content in fabric, 80
 defined, 73
 measurements and statistical process control, 310
 thread, content of 139, 142
 yarn, content of, 77
Fibers standards
 cotton, 71–72, 75
 descriptor characteristics, 73
 man-made, 74
 natural, 74
 physical properties, 73–76, 7
 quality, 74–75
 raw materials, 71
 textiles, 71
Filament
 physical properties of, 74
 standards, 76–77
 thread, 139
Filling, 81
Filtration systems, air, 107
Final customer, 28
Final inspection
 acceptable quality level, 171
 checksheet, 303
 defect prevention, 120
 defined, 120
 fit protocols, 236
 protocols, 171, 282
 quality considerations, 170–174
 style areas by standards, 172
 visual spot check, 171

Final inspection specifications
 measurement information, 282
 sample, 283
 tasks and procedures, 282, 284
Findings
 base fabric versus, 122
 buttons and buttonholes, 130–134
 costing, 344
 fashionality, 124
 fasteners, 128–138
 labels, 144–146
 quality expectations, 125–128
 reducing to meet quality and cost standards,
 345–346
 ruffles examples, 123, 124
 specifications, 267
 support items, 143–144
 trim, 146–147
 zippers, 134–135
Findings costs
 buttons, zippers, and bows, 341
 quality considerations, 341–342
 stitch to seam ratio, 340
 thread usage, 340, 342
Findings specifications
 colorways, 269
 digital images, 269
 sample, 268
 testing procedures, 269–270
Finish
 fabric, 80
 fiber, 73
 thread, 139, 142
Finishing
 quality considerations, 169–170
 sewn product production processes, 149
Finishing errors
 clip marks, 110–111
 coloration, 113
 corduroy races and wales, 112, 113
 holes, 111, 112
 napper creases, 110–111
 shading or barré, 112
 uncut race, 113
First sample, fit approval process, 233
Fishbone chart, 300–302, 324
Fit
 approval process, 233–237
 clothing, importance for, 229–230
 consistency in, 231
 consumercentric, 256–258
 definitions and development, 12, 229–233
 fabric standards and tests, 87–88
 fashionality, 230, 231
 findings, 124–125

jeans, varying levels of, 231–232
 mannequins, 234
 models, 63, 64, 234
 monitoring before marketing, 233
 protocols, 236
 sewn product system, 12
 standards, 237–256
 requirements table, 281
 upholstered furnishings, 229–230
 vanity sizing, 232
Fit approval process
 body scanning, 234
 first sample, 233
 fit mannequins, 234
 grading, 235
 measurement extraction software, 234
 nest of graded patterns, 235–236
 production samples and showroom samples, 234
 protocols, 236
 sample size, 233–234
Fit dimensions table, 279
Fit specifications
 body dimensions, 279, 281
 body landmarks, 281
 design ease, 281–282
 sample, 280
 table, 279
Flags, inspection, 102
Flat felled or felled seam, 211
Flat form product specifications, 262
Flat seam (FS), 214–215
Flatlock stitch, 188
Flatseaming, 214
Flexibility
 of seams, cut and sew specifications, 276–277
 thread, 141
Floral print, marker specifications, 274
Fly zipper, 136–137
Format meeting, 48
Format, product specifications, 263–265
Formation, stitch, 179
Four steps, quality analysis process, 27
Free of deficiencies, 5
Freeze meeting, 64
French fly, 137
French seam, 209–210
Frequency of data, calculating, 290
FS (flat seam), 214–215
Full fit review, 234
Functionality, 12
 fabric, 85–87
 sewn product system, 11
Fusing, thread, 141
Future costing, 349–350
Fuzzing, 94

Gender, apparel product category, 7
Generic
 stitch names, 178
 textile names, 74
Geographical and cultural distances, product
 specifications and, 261–262
Gorge line, 249
Grade rules table, 273
Grading
 allowances, seam, 208
 definition, fabric, 116
 definition, patterns, 273
 fit approval process, 235
 size specifications, 273–274
 system, fabric inspection, 116
Grain, fit standards, 240–241
Grand average
 calculating, 317, 318
 control chart, 314
Graniteville system, 117
Graphs. *See* Statistical process control
Grin, seam, 217–218

Hand, fabric, 89
Hand straightening, misaligned fabric, 105
Hand tying, 196
Hemline, shirtwaist dress, 255–256
High heel shoe croquis, 52–53
Hip pockets, back, 246–247
Histograms, 292–293
History of quality, 21–23
Holding strength, fastener, 129
Holes, button with, 130–131
Holes (flaw), 110, 112
Home furnishings market city, 67
Horizontal buttonholes, 133
Horizontal placement, button and
 buttonholes, 133
Hot sellers, 48
House of Quality model, 304
Humidity, controlled, 108

Idea development
 activities, 46
 outcomes, 48–50
 standards, 48
 team, 47
 timeline, 46
 tools, 47
Implementation, total quality management
 (TQM), 19
Inconsistencies, conflicting outcomes and, 12–13
In control
 process, 321
 SPC chart, 320

In spec, SPC chart, 320
India, classification system in, 7
Indirect labor costs, 336, 344
Industry standards terminology, 31
In-process errors, 104
 bias, 105
 bow, 105–106
 broken picks or ends, 109–110
 fabric alignment, 105
 slough off, 106–107
 splice, 109
 tenter-stop error, 107–108
 weave knot, 109–110
 weaving or knitting process, 104–105
 work stoppage, 108–109
In-process inspection, 120–121
Input, sewn product system, 10, 11
Inspection, product
 assembly, during and after, 167–169
 skipped stitches, 198–199
Inspection process, fabric
 fabric inspection frame, 100
 fabric inspection machine, 100
 inspection stations, 100–101
 jogging or inching devices, 100–101
 lighted inspection table, 100–101
Inspection stations, 101
Intangible features, 8
Interfacing fabrics, 83
Internal customer, 5, 28
International Organization for Standardization (ISO),
 34, 75, 271
International Standards Industrial Classification of
 All Economic Activities (ISIC Rev. 4), 8
Interpreting the expectations, 30
Invisible zipper, 136–137
ISO (International Organization for
 Standardization), 75

Jacket
 fit, 230
 storyboard, 58
Japan, history of quality in, 21–22
Jeans, fit of, 231–232
Jogging or inching devices, inspection process, 101
Juki sewing machine, 177
Juran, J. M., 22
Just-in-time (JIT) strategy, 46

Kanban, 166
Kanban system, 166
Keyhole buttonhole, 131–132
Kinematic durability, fasteners, 129–130
Knee, fit at, 239
Knife cutting and quality considerations, 158–159

Knit fabric
 bound seam, 213
 fashionality outcomes, 95
 fit, variance in, 232
 flat seam, 214
 in-process errors, 104–105
 needle cutting, 199
Knit types, 81–82
KTA system, 117

Labels
 low labeling, 145–146
 fashionability, 145
 legal requirements, 144
 quality and, 2–3
Labor costs
 direct, 335–336
 excess costs, 335
 indirect, 336
 the method, 335
 method book, 336
 quality considerations, 336–337
 reducing, 347
 standard allowable minutes, 335
 total labor calculation, 336
Lapel, tailored jacket, 249
Lapped seam (LS)
 described, 211
 flat felled or felled, 211
 quality considerations, 211–212
Lapped zipper, 135
Launderability, 86. *See also* Postuse care
Laying, marker, 150–151
LCL (lower control limit), calculating, 319
Legal requirements for labeling, 144
Length
 crotch fit standards, 245–246
 fiber, 73
 stitch, 190, 194
Light, effect on color, 92–93
Lighted inspection table (see also inspection process,
 fabric), 100
Linear process, traditional sewn products pipeline, 13
Line
 fit standards, 239–240
 skirt, 240
Line development
 activities, 51
 described, 50
 outcomes, 57–59
 product line, 50–51
 standards, 54–57
 tools, 51–54
Linear process, 13
Lines, 134

Lining, tailored jacket, 252–253
List price, 331, 343–344
Live models, (see also Fit models), 64
Locking, fasteners, 129
Lockstitch, 181, 184
Looper, stitch, 180–181
Looping formation, stitches, 179
Lost products, bundling, 164
Lower control limit (LCL), calculating, 319
Low labeling, 145–146
LS. *See* Lapped seam

Made-to-order items, fit, 258
Maintenance, total quality management (TQM), 19
Malcolm Baldrige National Quality Award, 22–23
Management policy on quality, 18
Man-made fibers, 74
Mannequins, 234
Manufacturability
 complexity of design and, 63–64
 costing, 345
 sample or prototype, 60
 thread properties, 142
Manufacturing overhead costs, 342–343
Marker making, plotting, and laying, 150–153
Market city, 66–67
Market price, 333
Market research, 28
Market sales, 13
Market system, 65
Market weeks, 66
Market-price costing method, 332–334
Mass customization, 16, 29–30, 257
Master production pattern, 66
Mathematical calculations
 averages, 290
 frequency of data, 290
 mean, 291
 median, 291
 mode for data set, 290–291
 range, 290
 standard deviation or sigma, 291–292
 symbols, 290
 variance, in data, 290, 291–292
Mean, mathematical calculation, 291
Measurable standards, 33
Measurement extraction software, 234
Measurement information, final inspection
 specifications, 282
Measurement system, 18–19
Measurements, statistical process control (SPC),
 309–310
Measure product
 drawing samples, 35
 outcomes from tests of samples, 40

samples, 35–37
sampling plan, 35
testing, 37–40
Mechanical straightening, misaligned fabric, 105
Media
 color viewing and watching, accuracy of, 96
 tools, idea development, 47
Median, calculating, 291
Meeting customer expectations, 3
Menswear market city, 67
Merrow stitching, 177, 187
Metal sticker, defect flagging, 118–119
Metamerism, 92–93
Method, the, (see also The method), 335–336
Method book, labor cost, 336
Metric system, 32–33
Microscope, use in testing, 39
Military
 sizing studies, 271
 testing textiles for, 84
Milliken & Company, 23
Minimarker
 fabric costs, 337
 making the marker, 337–338
Misalignment, 105
Mismatched plaids along seam, 168–169
Mispicks, 104
Missing end, 103
Missing pick, 104
Misting, 153
Mock-cover stitches, 186
Mode, data set, 290–291
Models, quality analysis tools
 checksheets, 302–304
 fishbone chart, 300–302
 House of Quality, 304
 nominal group techniques, 304
 process flow diagram, 299–300
 Total Quality Management, 304
 Voice of the Consumer/Customer, 304
Modular system, assembly, 166
Monofilament yarn, 77
Montgomery Ward, 271
Movement
 fashionality outcome dimension, 90
 fit outcome dimension, 88
 functionality dimension, 86
Multifilament thread, 139–140
Multiple ply cutting, 114
Multiple thread chain stitch, 185

NAICS (North American Industry Classification
 System), 7
Names, company brand, 74
Names listed by weave or knit types, 81–82

Napped fabric, spreading, 156–157
Napper creases, 110
National Retail Federation (NRF), 8
Natural fibers, 74, 75
Neck line, fit, 239
Needle cutting, 199
Needle heating, 200–201
Negative correlation, 298
Nest of graded patterns, 235–236, 273
Niche markets, 29
Nominal group techniques, quality analysis
 tools, 304
Nonconformance, costs of, 20
Non-roll stay, 245
Normal distribution curve, 294–295
North American Industry Classification System
 (NAICS), 7
Notch, tailored jacket, 249
Notions, 123
NRF (National Retail Federation), 8
Nth sample, 37
Numbering systems, standards, 32
Numerical data, 40

Objective, seam, 217
Off the clock operator time, 167
One-direction print, spreading, 156
Openings, findings and fit, 124–125
Operator errors
 puckering and, 221
Optical scanning equipment, 102
Ornamental stitching (OS), 223, 224, 225–226
OS. See Ornamental stitching
OSd-2 stitching, 224
OSf stitching, 224
Outcome
 buttons and buttonholes, 132
 conflicting, 12–13
 fabric from multiple contributing components,
 79–80
 idea development, 48–50
 line development, 57–59
 production development, 64–65
 sales development, 68
 testing textile to examine product, 84–85
 from tests of samples, 40
Out of control process, 322
Output, sewn product system, 10
Outside company, sampling by, 37
Oval buttonhole, 131–132
Overall average, calculating, 317
Overcast stitch, 178, 191
Overedge stitch, 187
Overhead conveyor system, bundling
 (see also UPS), 164

Overhead costs
 administrative, 343
 calculating, 343
 design development, 343
 manufacturing, 342–343
 product development, 350
 spreadsheet, 344
Overlock stitch, 187
Overseam stitch, 187

Pantone system, 91
Pareto charts, 293
Pattern blocks, 337
Pattern library, 62
Pattern maker, 59
Patterns
 cutting, 157
 fabric fashionality tests, 91
 marker laying, 151
 nest of graded, 235–236
 size and criticality of the defect, 115–116
PBS (progressive bundle system), 165
PDM (product data management) software, 263
Pegging, 157
People intensive, 19
Performance
 properties, tolerance for variance, 308
 tests, 84
Physical properties
 fibers, 73–76
 raw materials, 9
 yarn, 76–79
Picks, 81, 104
Piece rate, 166, 167
Pieces, cutting patterns, 157
Pile knit, 82
Pile weave, 81
Pilling, 93–94
Pintucks, 224
Pipeline, 5
Placement and discovery timing, defects, 114–115
Placement, buttons and buttonholes,
 132–133
Plaids, mismatched, 168–169
Plain knit, 81, 82
Plain weave, 80–81
Plastic flag, defect, 118, 119
Pliability (malleability), thread, 141
Plotting, (see also Markers) 150
Ply
 dies, cutting, 160
 spreading, fabric, 153
 thread, 139, 140–141, 142
 yarn, 77
 yarns standards, 77–78

Pockets
 tailored pants, 246–247
 welt, 252
Point-of-sale evaluation, 9
Positive correlation, 297–298
Postuse care
 buttons and buttonholes, 132
 fabric functionality standard, 87
 findings' failure during, 126
 low labeling, 145–146
 support items, suitability for, 143–144
Preassembly process, 149
Preliminary price, 331
Prelining, 66
Preselling, 66
Preset format, specification pages, 265
Preshaped cutters (dies), 160–162
Price line, market price, 333
Price points, 333
Problem recognition, 51
Procedures, final inspection, 282, 284
Process flow diagram, 299–300
Process of conformance, 28
Processes
 sewn product system, 10, 11–12
Processes, statistical process control (SPC)
 data, 310
 variance within, 307–308
Product
 designs, 53
 final inspection, 170
 sizing, 271
 testing for specific characteristics, 39
Product data management (PDM) software, 263
Product designs, 53
Product development, 13
 idea development, 46–50
 line development, 50–59
 overhead, 350
 process, 11, 13, 45
 production development, 59–68
 sales development, 65–66
 sewn product system, 11
 stages, 45–46
 system, 11–13
Product line, 50
Product outcomes, 12
Product production, 12
Product specifications
 cut and sew specifications, 274–279
 definitions, 31, 262–263
 design specifications, 265–267
 fabric and findings specifications, 267–270
 final inspection specifications, 282–284
 fit specifications, 279–282

format, 263–265
geographical and cultural distances, bridging, 261–262
product data management software, 263
set of specifications, 263
size specifications, 270–274
specification book, 263
Production
 controls, 63
 costs, adjusting, 347–349
 pattern, grading, 273
 product, 12
 sample, 60, 234
 sewn product system, 11, 13
 stage, 13–14
Production development
 activities, 59–60
 outcomes, 64–65
 production development, 61–62
 standards, 62–64
 tools and people, 61–62
Production patterns, 273
Production system, 165
Progressive bundle system (PBS), 165
Protocols
 final inspection, 171
 fit, 236
Prototype, designer approved, 59
Puckering
 appearance, 219–220
 customer satisfaction, 220–221
 operator and machine errors as reasons for, 221
 raw materials, reasons listed by, 221
 stitches, 220
 thread incompatibility as reason for, 222
Pulls, cut and sewn pieces (see also Bundling), 166
Pulls, zipper, 134

QR (Quick Response) strategy, 46, 325
Qualitative data, 40
Quality
 assembly, 167–169
 bound seam, 213–214
 bundling, 164
 buttons and buttonholes, 132
 definition of, 2–5
 edge finishing, 227
 expectations, 6
 fabric costs, 339–340
 fabric standards, 82–84
 fasteners, general expectations for, 129–130
 fiber standards, 74–75
 final inspection, 170–174
 findings, 125–128, 341–342
 finishing, 169–170

Quality (*continued*)
 flat seam, 214–215
 image, customer matching to product, 9–10
 knife cutting, 158–159
 labor costs, 336–337
 lapped seam, 211–212
 marker making, plotting, and laying, 152–153
 organizational approach to, 17–21
 ornamental stitching, 225
 policy, 18
 quickie costing, 331–332
 seams, 207–209
 spreading, 154–157
 stitches, 189
 superimposed seam, 210
 thread, 142–143
 yarns standards, 79
Quality analysis process
 evaluating data, 41–42
 expectations, determining, 28–30
 four steps, 27
 measurement, 35-40
 set standards, 30–34
Quality analysis tools
 communication specifications, 287–288
 data set and data point, 289
 mathematical calculations, 290–292
 models, 299–302
 random process, 289
 stratified random, 289–290
 test manuals, 289
 test method, 288–289
 visual representation tools, 292–298
Quick Response (QR) strategy, 46, 325
Quickie costing
 cost estimator, 330
 described, 330
 fabric yardage estimate, 330, 331
 quality considerations, 331–332
 suggested retail price, 331
Quickie price, 331

Race, 181
Races, corduroy, 112
Racks of dups, 68
Random
 process, quality analysis, 289
 selection, 37
Range,
 average, 318
 calculating, 290, 317, 318
Raw materials
 puckering, reasons listed for, 221
 recosting to meet quality and cost standards,
 345–347

sewn product system, 11
 standards, 71
 testing procedures, 270
Recosting to meet quality and cost standards
 production costs, 347–349
 raw materials, reducing, 345–347
Reduction
 in ease, 346
 in fabric utilization, 346
Redundant testing, 99
Reinspection, 121–122
Reiterations, 53
Removal of seam, 347
Repairs, grease spots from, 108
Repeat purchase, 2
Resilience, thread, 141
Results, test, 40
Retail price or retail list price
 costing, 60
 list price, 331
 quality considerations, 345
Retail sales stage, 14
Retainers, zipper, 134
Returns on expenditures, 167–168
Rework pattern or sample, 60
Rise, crotch fit standard, 246
Road samples, 66
Roger Milliken Center, 23
Root cause, 323
Rotary knife, 159
Ruffles, findings versus base fabrics, 123, 124
Rule of thumb costing, 331
Rulers, testing with, 38

S twist, 78
Safety, fabric, 86
Safety stitch, 188
Sales development
 activities, 66–67
 demand uncertainty, 66
 market system, 65
 outcome, 68
 standards, 67–68
 tools and people, 67
Sales representatives or sales reps, 66
Sales volume goal, 68
Sample average, calculating, 317, 318
Sample hand, 60
Sample room sample, 60
Sample size, 55, 233–234
Sample system, 166
Samples
 assembly system, 166–167
 cut and sew specifications, 275
 design specifications, 266

designer-approved, 60
fabric swatch, 35–36
measurements, eliminating bias, 37
patterns, creating, 59
production and showroom, 234
sample room, 60
size specifications, 272
stitch, 194
Sampling
drawing samples, 35
plan, 35
SAMs (standard allowable minutes),
labor costs, 335
Satisfaction, customer, 22
Scales, testing with, 38
Scattergrams, 295–298
Scorching, thread, 141
SD. *See* Standard deviation
Seam
armhole, shirtwaist dress, 255
ASTM standard for stitches, 205
bodice, shirtwaist dress, 254–255
bound seam, 212–214
defects and other problems, 217–223
details sample, 277
edges for a, b, or c designations, 206–207
fit standards, 247–248
flat seam, 214–215
flexibility of, 276–277
grading seam allowances, 208
grin, 217–218
hand and fabric thickness of base fabric,
maintaining, 207–208
lapped seam, 211–212
mismatched plaids along, 168–169
objective, 217
puckering, 219–223
removal to meet quality and cost
standards, 347
seam allowance, depth of, 207
slippage, 218–219
specifying, 215–216
standards and general quality
considerations, 207–209
stitching, 223–227
superimposed seam, 209–210
2-D or 3-D sketches, 206
Seam allowance
depth of, 207
seams, specifying, 216
top stitching, 225
width of superimposed seam, 210
Seaming, 205
Sears Roebuck & Co., 271
Seasonal products, 66

Sell-in, 68
Sell-thru, 68
Selvage, 81, 337–338
Separates,
color matching, 91
shading or barré color problems, 112–114
Serged hem, 226
Serge stitch, 187
Service, testing for specific characteristics, 38
Set
sleeve, tailored jacket, 252
standards, fit, 241–242, 243
Set of specifications (see also Specification book), 263
Set standards
easily understood, 31
electronically communicable, 33
English system, 32
expectations, interpreting, 30
measurable, 33
metric system, 32–33
numbering systems, 32
organizations that publish, 34
specifications, 31
standards defined, 30
terminology, comparisons for consumer
expectations, industry standards, and
company specifications, 31
written, 32
Set-in-the-round sleeve, shirtwaist dress, 255
Set-up, 103
Sewing, 205
Sewing machine
ASTM stitch information, 182
manufacturers, stitch information from, 182
pressure foot and feed dog, 178
puckering error, 221
tension adjustment, 193
Sewn product classifications, 7–10
Sewn product production processes
assembly, 149, 165–169
bundling, 162–164
cutting, 157–162
finishing, 149, 169–170
marker making, plotting, and laying,
150–153
preassembly, 149
spreading, 153–157
standards, 149–150
Sewn product system, 10
Sewn products
classifications, 7–10
processes and outcomes, 10–13
Shade sorting, 92
Shading color problem, 112
Shank, button with, 130–131

Shape
buttonhole, 134
Shape retention (see also Postuse care)
fabric fashionability characteristics, 94
fit outcome dimension, 88
Shewhart, Walter, 307
Shirt
attaching tape to fronts, 210
Shirt collar die, 161
Shirttail hem, 226
Shirtwaist dress 253
bodice, 254–255
dart, 253, 254
dart tip, 253, 254
hemline, 255–256
quality standards, 172–173
set-in-the-round sleeve, 255
Shoulder fit, evaluating, 239
Showroom
market system, 65
sample, 234
Shrinkage
thread, 141
tolerance for variance, 308
SIC (Standard Industrial Classification), 7
Sigma, 291, 314, 318
Sigma average, 314, 317, 319
Single vent, tailored jacket, 252
SITC (Standard International Trade
Classification), 7–8
Six Sigma, 18, 304
Size
buttonhole, 134
fiber, 73
thread, 139
yarn, 77
Size 8, as ideal sample size, 55, 233–234
Size dimensions, final inspection, 170
Size measurements checksheet, 303–304
Size specifications
catalog sales origins, 271
described, 270–271
grading, 273–274
product sizing, 271
sample, 272
SizeUK and SizeUSA, 273
Size 12, 256–257
SizeUK size specification, 273
SizeUSA
fit standards, 237
size specification, 273
study, 55
Sizing (see also Size), 271
Skewed data, 295, 296
Skipped stitches, 197–199

Skirt
design ease, 238
line, evaluating fit, 240
SKU (stock-keeping units), 262
Slack end, 103–104
Slack spread, 155
Sleeve
shirtwaist dress, 255
tailored jacket, 252
Slide fastener. *See* Zipper
Slider, zipper, 134
Slippage, seams, 218–219
Slope, tailored jacket collar, 249
Slopers, 61–62
Slot zipper, 135
Slough off, 106–107
Slush meeting, 57
Smoothness from wrinkles, 241–242, 243
Soft product lines, 7
Software. *See* Computer software
SPC. *See* Statistical process control
Specification book, 263
Specification buying, 264
Specifications, 31, 63, 262. *See also* Product
specifications; Size specifications
pages, preset format, 265
standards, 30–31
Specific fit requirements table, 281
Specs (see also Specifications), 262
SPI (Stitches per inch), 190
Splice, 109, 114, 164
Spread, fabric lay-up, 153
Spreader, sewing machine, 179–180
Spreading, fabric
air table, 154–155
automated spreader, 153–154
bow, 155
described, 153
dry haul, 155
fabric direction, 155
fabric grade and, 117
fabric with a nap, 156–157
one direction print, 156
pegging, 157
ply, 153
quality considerations, 154–157
slack spread, 155
table for computer-driven cutting, 160
taut spread, 155
Spreadsheet software, 307, 344
Spun yarns standards, 76
Spun-core
thread, 139
yarn, 77
SRP (suggested retail price), 331

SS. *See* Superimposed seam
Stacked pieces, bundling, 163
Standard allowable minutes (SAMs),
 labor costs, 335
Standard deviation (SD)
 calculating, 317, 318–319
 control chart values, 314
 mathematical calculations, 291–292
Standard Industrial Classification (SIC), 7
Standard International Trade Classification
 (SITC), 7
Standard labor, 335
Standards
 costing, 63, 64
 defined, 30
 evaluation of data, 41–42
 idea development, 48
 fabric quality, 54
 line, 64–65
 manufacturing, 64
 natural fibers, 74
 production development, 62–64
 sales development, 67–68
 seams, 207–209
 sewn product production processes, 149–150
 stitches, importance of, 194–195
 style areas by, 172
Standards, fit
 balance, 242–245
 ease, 238–239
 grain, 240–241
 line, 239–240
 set, 241–242, 243
 shirtwaist dress, 253–254
 SizeUSA and Size UK, 237
 specific products, 245–246
 tailored jacket, 248–251
 topical dimensions, 238
 trousers or tailored pants, 245
Staple length, 74
Statistical process control (SPC)
 control charts, 311–314
 data sets, 309–311
 described, 307
 reading charts, 320–322
 root cause of problem, 323
 steps for making, 316–319
 tolerance, 308
 using charts, 323–326
 variance within processes, 307–308
Stays, 143
Steel rule dies, 161–162
Stitch balance, 192
Stitch length, seams, specifying, 190, 216
Stitch standards, ASTM, Federal, ISO, 178, 274, 276

Stitch to seam ratio (see also Thread usage), 340
Stitch width, 191
Stitches
 back tacking, 195
 balance, 192–194
 bite, 192
 chaining off, 195–196
 chain stitch, 179
 classes, 183–189
 class, varying length by, 190
 concatenation, 179
 coverstitch, 178
 DDD-S-751 standard, 178
 direction, 191–192
 encasement, 192
 formation, 179
 generic names, 178
 Juki sewing machine, 177
 length, 190, 194
 lock, 181, 184
 looper, 180–181
 looping formation, 179
 Merrow stitching, 177
 overcast, 178
 puckering, reducing, 220
 quality characteristics, 189
 seam allowances, 208
 sewing machine manufacturers, information
 from, 182
 sewing machine pressure foot and feed dog, 178
 skipped, 197–199
 spreader and, 179–180
 standards, importance of, 194–195
 stitching, 177
 stitch standard, 178–179
 trade names, 177–178
 width, 191
Stitching
 cut and sew specifications, 274–279
 details samples, 277, 278
 edge finishing, 223
 ornamental stitching, 223, 224, 225–226
 seams, 223–227
 stitches and, 177
Stock-keeping units (SKU), 262
Stop, zipper, 134
Storyboard, 57, 58
Straight buttonhole, 131–132
Straight knife, 158
Stratified random quality analysis tools, 289–290
Strength
 fabric, 86
 fastener holding, 129
Structure, thread, 142
Style number, 262

Suggested retail price (SRP), 331
Sum, control chart values, 314
Superimposed seam (SS)
 French seam, 209–210
 quality considerations, 210
Support items, postuse care suitability, 143–144
Surface contour
 fabric fashionality outcome, 90
 fabric property, 80
Surface texture, 73, 74
Swipes, 49
Symbols
 mathematical calculations, 290
 statistical process control calculations, 314
Synthetic fibers
 described, 74
 needle heating, 201

Table fit specifications, 279
Tailored jacket
 buttons, 251
 quality standards, 172
 standards, fit, 248–251
Tailored pants
 pockets, 245–247
 quality standards, 172
 storyboard, 58
Tail, thread, 196
Target price, 333
Tasks, final inspection specifications, 282, 284
Taut spread, 155
[TC]², 55
Team, idea development, 47
Technical drawing, 151
Technical sketches, 53
Tension
 sewing machine, 193
 stitch balance, 193
 superimposed seam, 210
Tenter-stop error, 107–108
Test
 AATCC, determining appropriate, 93
 ASTM methods for findings, 127–128
 determining appropriate, 93–97
 method, 84, 288
 outcome from, 40
Tester, data evaluation, 41
Testing, 37–38
 fabric and findings specifications, 269–270
 fabric inspection, defects, and flagging, 99
 fabrics for needle problems, 202
 textile to examine product outcome, 84–85
Test manuals, 289
Test methods, 85, 288–289
Textile plant maintenance weeks, 108

Textiles, 71, 84–85
Texture
 Fabric surface, 73, 74
 thread, 138
Theme, fabric fashionality, 90
The method (see also Method), 288, 335, 336
The method book (see Method book)
Thread
 compatibility, 222
 cord, 139
 crimp, 139–140
 criticality of the defect, 114
 defined, 338
 fashionality, 138–139
 filament, 139
 findings costs, 340, 342
 general criteria, 141
 as key component, 138
 multifilament, 139–140
 physical properties, 138
 ply, 139
 puckering, incompatibility as reason for, 222
 quality outcomes as impact on final product, 141–142
 seam slippage, 218
 skipped stitches, 198
 spun-core, 139
 texture, 140
 usage (see also Stitch to seam ratio), 184, 340
Tie operator, 163
Time delay, bobbin change, 181
Time frame, statistical process control (SPC), 310–311
Timeline, idea development, 46
TMC. *See* Total manufactured costs
Tolerance, cutting, 157
Tolerances, variance, 308
Tools
 idea development, 47
 line development, 51–54
 production development, 61–62
 sales development, 67
Topical dimensions
 fashionality outcome, fabric, 89–93
 fit outcome, fabric, 87-89
 functionality outcome, fabric, 85–86
 standards, fit, 238
Top stitching, 224–225
Total labor calculation, 336
Total manufactured costs (TMC), 342, 344
Total Quality Management (TQM), 17, 304
 continuous improvement, 19
 cooperation versus competition between trading partners, 19–20
 functionality standards and tests, 85–87
 history, 21–23

implementation and maintenance, 19
sewn product production process, 149
Six Sigma programs, 18
skipped stitches, 198–199
strategy, 18
training assembly operators, 167
TQM. *See* Total Quality Management
Trade names
fiber, 74
stitch, 177–178
Traditional sewn products pipeline, 13–14
Traditional tools, line development, 51–52
Training assembly operators, 167
Translations, label, 144
Transporting materials during assembly, 165
Trends
process control, 321
trending, 322
Trim, base fabric versus, 146–147
Trimodal distribution curve, 294
Trousers
fit standards, 245
Twill weave, 81
Twist
thread, 138, 142
yarn, 78
Two-part sleeve, tailored jacket, 250–251
Two-sided view, sewn product, 8
Type
fabric, 80, 347
fiber, 73
thread, 138
yarn, 77

U shape, production, 166
UCL. *See* Upper control limit (UCL), calculating
Unit production system (UPS), 164
Upholstered furnishings, fit of, 229–230
Upper control limit (UCL), calculating, 313, 317, 319
U.S. Consumer Product Safety Commission, 34
USDA (U.S. Department of Agriculture), 75
U.S. Department of Agriculture (USDA), 75
U.S. stitch standards
DDD-S-751 stitch standard, 178
Federal Standard No. 751/751a, 178

Vanity sizing, 232
Variance
calculating values, 314–316
control charts, 311–314
in data, expressing, 291–292
importance of controlling, 311–312
mathematical calculations, 290
within processes, statistical process control, 307–308

Vertical buttonholes, 133
Vertical knife, 158
Vertical placement, buttons and buttonholes, 133
Video images, 68
Visual representation tools
distribution curves, 294
histograms, 292–293
Pareto charts, 293
scattergrams, 295–298
Visual spot check, 171
Voice of the Consumer/Customer (VOC), 304

Waist, fit of, 245
Wales, corduroy, 81, 112
Warp, 80
Wear testing, 38
Wearing ease, 239
Weave knot, 109
Weave types, 80–81
Weaving errors, 104–105
Weft, 81
Welts, 131
Weight, fabric, 80
Wholesale price, 60, 331, 343–345
Width
fabric property, 80
stitches, 191
WIP (work-in-progress), 165–166
Women's apparel market city, 66–67
Woof, 81
Wool fiber quality considerations, 75
Work stoppage, 108–109
Work-in-progress (WIP), 165–166
Worksheet, cost-plus method of costing, 334
Worth Street Textile Market Rules, 96
Wrinkles
crotch, 247–248
fit and, 230
smoothness from, 241–242, 243
Wrist fit, evaluating, 239
Written standards, 32

X-axis
grading along, 273–274
histogram, 293
X-bar, control chart, 314
X-double bar, control chart, 314

Yardage, 338
Yarn
count, 80
filaments, 76–77
physical properties, 76–79
ply, 77–78
puckering seams, 219–220

Yarn (*continued*)
 quality, 79
 seam slippage, 218
 spun yarns, 76
 twist, 78
Yarn-dyed fabric, 93
Y-axis
 histogram, 293
 pattern grading along, 273–274

Z twist, 78
Zigzag stitch, 184–185, 196–197
Zipper
 continental fly, 137

 costs, 341
 described, 134–135
 failure, 126
 fashionality, 124
 fit, 124–125
 fly, 136–137
 French fly, 136–137
 invisible, 136–137
 lapped, 135–136
 nomenclature, 135
 slot, 135–136
 stringer, 134
 testing procedures, 270